Harems of the Mind

Harems of the Mind

Passages of Western Art and Literature

Ruth Bernard Yeazell

Yale University Press
New Haven and London

For Sandy, again

Designed by Adam Freudenheim

Printed in China

Library of Congress Cataloging-in-Publication Data
Yeazell, Ruth Bernard.
Harems of the mind: passages of Western art and literature
Ruth Bernard Yeazell.
p. cm.
Includes bibliographical references and index.
ISBN 0-300-08389-0 (cloth : alk. paper)
1. Harem in art. 2. Arts, European — Themes, motives.
3. Arts, Modern — Europe — Themes, motives. I. Title.

NX650.H37 Y43 2000
700'.455 — dc21 99-089406

10 9 8 7 6 5 4 3 2 1

Contents

Acknowledgments

Among the chief pleasures of working on this book has been the opportunity to talk it over with friends and colleagues. At different times in its history, I have been inspired and encouraged by conversations with David Bromwich, Jill Campbell, Elizabeth Heckendorn Cook, John Hollander, Anne Mellor, Sara Melzer, Maria Menocal, Helene Moglen, David Quint, Annabel Patterson, Linda Peterson, Leah Price, Martin and Mary Price, Claude Rawson, Robert Smith, and Georgeann Witt. I am delighted to record such debts here.

Representations of the harem can crop up in the most unexpected places. For alerting me to passages I might otherwise have overlooked and for generously responding to my queries, I am grateful to Paula Backscheider, Martha Banta, Marlies Danzinger, Ina Ferris, Richard Howard, Lynne Hueffer, Claudia Johnson, Frank Kermode, Steven Marcus, Mitzi Myers, Ronald Paulson, Abby Rischin, Katherine Rowe, David Southward, Joan Sussler, Gordon Turnbull, and Bryan Wolf. I owe a debt to Andrew Dimock for the energy with which he tracked down sources at the beginning of this project and to Natalka Freeland and Jessica Leiman for their efficient help at later stages. Joan DelPlato is known to me only through her 1987 dissertation on John Frederick Lewis, and Billie Melman through her 1992 book on women's travel writing, but I would like to record my appreciation here as well as in the notes for the numerous leads their work provided me.

It is difficult to imagine writing this book without the combined resources of the Beinecke, the British Art Center, the Lewis Walpole Library, and the Sterling Memorial Library at Yale. I thank the staff of these institutions, as well as those of the British Library, the Bibliothèque Nationale, the Kinsey Institute, the Musée Ingres in Montauban, and

the Service d'étude et de documentation at the Musée du Louvre in Paris for assistance at various stages of this project. I am also grateful to Yale for its financial support of my research and for the generous leave time which made that research and writing possible.

Parts of *Harems of the Mind* were delivered as talks at Bard College, the Eighteenth-Century Seminar in New York, SUNY Binghamton, Wellesley College, and the Whitney Humanities Center at Yale. I wish to thank Deirdre d'Albertis, Marlies Danzinger, Nancy Henry, Susan Meyer and David Bromwich for the invitations to speak, and the audiences whose intelligent responses made these occasions so invigorating. Portions of chapters thirteen and fifteen first appeared as "Harems for Mozart and Rossini" in *Raritan* (1997); and some pages of chapters two, three and twenty-two were published in earlier form in the *Yale Journal of Criticism* (1994). I thank both journals for permission to include them here.

John Nicoll at Yale University Press helped immensely in the final shaping of this book. I am very grateful for his editorial wisdom as well as for the tact and judgment with which Adam Freudenheim went over the manuscript. Emily Weeks gave unselfishly of her time and knowledge in a scrupulous reading of the chapter on John Frederick Lewis. As always, Alexander Welsh has served as reader and patient interlocutor at every stage. I could not ask for a better critic or friend. This book is dedicated to him with love and pleasure.

List of Illustrations

All oil on canvas unless otherwise specified

A Note on Sources

For the convenience of the reader, extended quotations from works in other languages are given here in English. Unless otherwise indicated, all translations are my own, though I have gratefully consulted other English versions whenever possible. I am especially thankful to David Quint for assisting me with Italian and to Leah Price for casting her discerning eye over some of the knottier passages of French. All quotations from English sources preserve the emphasis and spelling of the original.

Since this book is not a history of the East but of Western perceptions and fantasies, I have thought it clearer to allude to Constantinople rather than Istanbul whenever my subjects do likewise.

Full bibliographical information for each work cited is given at its first appearance in the notes. Readers in search of such information about a particular work should consult the index under the author's name.

Introduction

Any study of the West's relations with the harem must be in large part a study of the imagination. Though Europeans were long fascinated by what they could know of the harem, what they could only imagine excited them still more. "I am writing a chapter on the women's quarters," the French traveler Jean Tavernier began his account of the sultan's harem at Constantinople in 1678, "only to persuade the reader of the impossibility of really knowing them." As late as 1910, a German academic, authorized to produce a plan of the Ottoman palace that would subsequently appear in Baedeker and other guidebooks, was forced to leave the site of the imperial harem a blank. If distant places and peoples have always tempted human beings to fantastic projections of their own wishes and fears, then the blank space of the harem, sealed by definition from the eyes of Western men, only magnified the temptation. "Unless one wishes to compose a fiction," Tavernier wrote of the amorous secrets of the sultan's harem, "it is difficult to talk about them"; but for several hundred years, writers and artists managed to "talk" about the harem by doing just that.[1] This book is a history of the representations, both verbal and visual, that resulted.

Strictly speaking, in fact, there is no such place as "the" harem, though collective fantasizing often proceeds as if there were: there are only harems, as various as the individual households, of many different countries and times, in which separate quarters have been set aside for the seclusion of the women. The word "harem" derives from the Arabic for "forbidden" or "sacred," and has come to refer both to the women themselves, who remain inviolable by adopting the veil when they venture outside, and to the part of the dwelling reserved for their use. (The Turkish word for the latter is actually *harēmlik* — literally, the place,

lik, of the sanctuary, *harēm*.) While the West predominantly associated the institution with Islam, the custom of segregating women, like the practice of polygamy, antedated the coming of Mohammed. Not every harem, for that matter, belonged to a polygamist. Though the Koran permits up to four legal wives and an unlimited number of concubines, only a small elite could afford to maintain very extensive establishments, and even the Ottoman sultans did not always possess the vast numbers often attributed to them. Europeans had occasionally noted such distinctions, but it was not until the expansion of travel in the nineteenth century, when relatively large numbers of women began to visit more or less ordinary Eastern households, that commentators in the West began seriously to register the difference between one harem and another. Even then, many continued vaguely to associate all harems with the most mysterious and fabled of such institutions — that in the Ottoman palace — and to construct their fantasies from a loose compound of lore about the Grand Seraglio and atmospheric trappings freely borrowed from the *Arabian Nights*. Indeed, the very fact that nineteenth-century travelers repeatedly recorded their disenchantment with actual harems, announcing over and over again how little the reality of Eastern domestic life met their expectations, testifies to the continuing power of the imaginary harems they had inherited.

Linguistic confusion at once reflected and encouraged Western fantasizing. Thinking of women as literally locked up in the harem, Europeans mistakenly associated the Turco-Persian word for palace, *saray*, with the Italian *serrare*, to lock up or enclose — by which false etymology the English "seraglio" and the French *sérail* came to signify not only an entire building (as in "the Grand Seraglio" at Constantinople), but the apartments in which the women were confined and even the women themselves. Though the pages that follow will distinguish between the *sérail* or the "seraglio" and the women who inhabit it, European imaginations freely exploited the confusion. When the libertine heroine of Choderlos de Laclos' *Les Liaisons dangereuses* (1782), for example, writes to her former lover, "I may have sometimes presumed to replace an entire sérail by myself, but it has never suited me to belong to one," she turns the same figure into a boast of her erotic prowess and a defiant assertion of her freedom.[2] While to replace a *sérail* is to exhibit the infinite variety of her sex, to belong to one, the Marquise de Merteuil makes clear, is effectively to be enslaved. But if identifying the harem as a seraglio could intensify its associations with slavery and imprisonment, as I argue below, such verbal habits also contributed to

what we might call the upward mobility of its image — the tendency automatically to invest harems of the mind with an aura of luxury and magnificence. To fantasize oneself the master of a "seraglio" was imaginatively to command at once harem and palace — even, perhaps, something very like the Grand Seraglio of the Ottomans.

Whether or not they identified with the sultan, most of the writers and artists in this book did place their harems somewhere in his empire: in addition to what is now modern Turkey, favorite sites include Egypt, Algeria, and Arabia — all more or less directly under the sway of the Ottomans. The principal exception to the rule is Persia, where women were by some accounts yet more closely guarded than in Turkey, and where Montesquieu located the imaginary "sérail" of his *Lettres persanes* (1721), one of the most influential harem narratives to circulate in the West. Though other cultures have also secluded women or permitted polygamy, I have confined this study to representations associated, however fantastically, with Islam: there are no Mormon "harems" here, nor accounts of Hindu *purdah*, even if there are occasional glances — some of them quite wistful — toward the polygamous example set by Old Testament patriarchs. At the same time, of course, harems of the mind do not always occupy a very fixed place on the map, and an imaginary passage East can reverse direction almost as swiftly as it gets under way. When the narrator of Thackeray's *Vanity Fair* (1847–48), for example, remarks, "We are Turks with the affections of our women," he briefly invokes a stereotype of Oriental jealousy only to locate a more insidious type of oppression in the households of his fellow Victorians. "We let their bodies go abroad liberally enough," he continues, "with smiles and ringlets and pink bonnets to disguise them instead of veils and yakmaks. But their souls must be seen by only one man, and they obey not unwillingly, and consent to remain at home as our slaves."³ This is still the harem as the locus of slavery, but it is the harem come home to nineteenth-century England.

Most of the representations in this book originated in England or France, the two nations with the richest tradition of Orientalist fantasizing, though I have felt free to draw on other sources, from operas by Mozart and Rossini to Edith Wharton's account of her travels in Morocco, as the occasion required. With a few significant exceptions, these imaginary harems were constructed sometime between the late seventeenth and the early twentieth centuries: I take as my approximate starting point the defeat of the Ottomans at Vienna in 1683 and conclude with the establishment of the Turkish Republic in 1923. (Though the imperial

harem had been dispersed in 1909, polygamy itself was not officially abolished in Turkey until 1926.) Of course both travelers' tales and more overt harem fantasies had long preceded the years in question: at the end of the sixteenth century, for example, the German *Faustbuch* (1587) told of how a demonically inspired Faust amused himself by causing the palace of the "great Turke" to be surrounded by an impenetrable fog, while he appeared in the guise of Mohammed and made love to several "Ladies" of the harem in turn.[4] Nor did such representations simply come to an end with the Ottoman Empire, though the disbanding of the harem in the Topkapi Palace, and the latter's gradual conversion into a museum, have removed one powerful stimulus to fantasizing. Many of the old stories and images still continue to circulate, especially on film; and there are even some signs that the twentieth century may have added to the repertoire, by viewing the harem through its own nostalgia for the extended family. At the same time, both the progressive globalization of culture and the growing body of writing by Islamic men and women available in the West have made some of the wilder fantasies increasingly difficult to sustain.

But if all dates have a measure of arbitrariness, there are a number of reasons why harems of the mind should have flourished so extensively in the two and half centuries studied here. Modern historians generally agree that the Ottomans' defeat by the Hapsburgs in 1683 and further losses in the years immediately following marked a major shift in the relations of East and West: with the threat of the "great Turk" significantly diminished, sheer awe and terror on the part of the Europeans could give way to a rather more complex view of the enemy.[5] Though crude stereotypes of Oriental lust and violence persisted well into the twentieth century, increasing diplomatic contacts in both directions helped to stimulate the curiosity and imagination of the West. Even before the siege of Vienna, popular excitement at the recent visit of an Ottoman official named Suleiman Aga to the court of Louis XIV inspired Molière to include a mock-Turkish ceremony in his *Bourgeois Gentilhomme* (1670); that same year, Antoine Galland, the future translator of the *Arabian Nights*, began service as secretary to the French ambassador in Constantinople. In 1672, Racine adopted an account of palace intrigue passed on by a former ambassador to the Ottoman court for the plot of his tragedy, *Bajazet* — the only Racinean tragedy not to be based on classical legend or the Bible. Anxious to represent his imaginary seraglio as accurately as possible, Racine turned to a recent study by yet another emissary to Turkey, Paul Rycaut's *The Present State of the*

Ottoman Empire (1668), which had just been translated from English into French. Among the inspirations for Montesquieu's imaginary travelers in the *Lettres persanes* of 1721 was a visit of Persia's ambassador to Paris in 1714, while an Ottoman embassy to France in the year Montesquieu published his work helped to create a vogue for *turquerie* that would continue throughout the century.[6] From 1716 to 1718, the wife of England's newly named ambassador to Constantinople, Lady Mary Wortley Montagu, accompanied her husband on his embassy to Turkey, where she composed the letters whose posthumous publication in 1763 would provide many in the West with their first inside glimpses of the harem. At the same time, readers on both sides of the Channel (Lady Mary included) were delighting in the fantastic adventures of Galland's *Mille et une Nuits* (1704–17), whose multiple volumes appeared in English almost as soon as they were published in France. Though the *Arabian Nights* themselves belong primarily to the literary tradition of the East rather than the West, several of the writers studied here were directly engaged in imitating or translating them; and there have been few fantasies of the harem after Galland that have not been touched by their influence.

Such widespread fascination with the matter of the East, however, does not by itself account for Europe's particular obsession with the harem. For men especially, both the lure of the unknown and the provocation of taboo no doubt remained fundamental; and the fact that the harem stayed hidden by definition, even as other bits of the East came tantalizingly into view, could only have intensified its appeal. The official sanction of polygamy had long made some Western men look enviously toward the East, and that prospect was likely to seem particularly tempting at a time when European culture itself was placing increasing stress on the monogamous couple — when persons of both sexes were being encouraged to concentrate all their emotional and erotic energies on a single partner. A largely Protestant and especially British phenomenon, the culture of affective monogamy took greatest hold among middle-class Britons from the later eighteenth through the nineteenth century, but its reach was not limited to one side of the Channel, as the impassioned rhetoric of perhaps its greatest prophet, Jean-Jacques Rousseau, clearly attests. And though the rhetoric of monogamous love was always more thoroughgoing than its practice, even those who regularly transgressed its ordinances could still find themselves dreaming of a better place elsewhere, a masculine paradise in which access to many women was not just tacitly overlooked but actively encouraged.

The compulsively unfaithful James Boswell was one such transgressor who repeatedly sought justification for his own promiscuity in fantasies of the harem. But the frequency with which far soberer men than he also contemplated what he liked to call "Asiatic satisfactions" may be suggested by an entry in his *Journal of a Tour to the Hebrides* (1773), which records how Samuel Johnson broke into a conversation about the comparative advantages of various fabrics (they had begun by remarking the lack of sheets in the Highlands) by casually observing, "I have often thought that if I kept a seraglio, the ladies should all wear linen gowns, or cotton; I mean stuffs made of vegetable substances. I would have no silk; you cannot tell when it is clean." As the startled Boswell commented in his journal, "To hear Mr. Johnson, while sitting solemn in arm-chair, talk of his keeping a seraglio and saying too, 'I have *often* thought,' was truly curious." The comedy of the scene notwithstanding, Boswell's surprise says more about his awe of Dr. Johnson than it does about the imaginative habits of his contemporaries. To judge by the evidence assembled in this book, the only really unusual aspect of this conversation is its earnest attention to the problem of the harem linen. Even the exchange of sexual insults with which the discussion concludes, whereby the hypothetical master of the seraglio assures his young admirer that "he'd make a very good eunuch," and a wounded Boswell responds in kind by casting doubts on the master's virility, hints at an anxious reversal of roles that I shall argue is itself very common in masculine fantasies of the harem.[7] If the arrangements of the harem are no longer such a familiar subject of contemplation today as they were at the end of the eighteenth century, one reason for the change may well be that Western culture no longer places such insistent pressure on the ideal of monogamy.

Not all fantasies of the harem were erotic, nor were men alone in contemplating the domestic arrangements of the East as an alternative to those at home. From a play about harem sisterhood and harem rivalry composed by Delarivier Manley in 1706, to a passing trope of the female literary tradition in an essay by Virginia Woolf more than two hundred years later, this book examines the imaginative uses of the harem both for women who never ventured East and for those who, like Lady Mary, actually saw some harems for themselves. Though significant numbers of European women did not follow Lady Mary eastward until the nineteenth century, they were of course free to enter where men could not; and their representations of harem life often emphasize their role as eyewitnesses, who self-consciously replace prior fantasy with fact. While some of their reports are clearly more reliable than others, this book

draws no hard lines between travelers' tales and the representations of those who stayed at home. I take for granted that all viewing is shaped by preconceptions, even — or especially — when the viewer sets out to overturn them. And where the harem in particular is concerned, I argue, Europeans were as apt to see their own wishes or fears (sometimes both at once) as any unmediated reality. The very fact that some Victorian travelers believed they had found in the harem an idealized version of home, while others — Harriet Martineau and Florence Nightingale, most notably — recoiled in horror, suggests how difficult it can be to distinguish the truth of the harem from the West's imagination of it, and how much the travelers themselves brought to the encounter.

Myths have a life of their own, and the history of Europe's myths about the harem is a history of persistence as much as change. For everyone who attempted to debunk a popular conception of the harem, it often seems, there were many more who continued to imagine what they wished. As early as the sixteenth century, learned Frenchmen were already reporting that polygamy in Turkey was largely confined to the rich and that Western writers had exaggerated its prevalence — a fact that did not prevent countless nineteenth-century travelers from solemnly repeating the same discovery.[8] The desire to believe in a place where a man could have as many women as he wanted was evidently stronger than any testimony to the contrary. Even minor bits of harem lore continued to circulate long after they had seemingly been laid to rest. Though this book argues that the nineteenth century witnessed a partial shift in Europe's representations of the harem, as rumors about the Grand Seraglio were increasingly replaced by accounts of visits to comparatively ordinary households, it also contends that the cycle of disenchantment and reenchantment was as old as Europe's imagination of the harem itself. In the nineteenth century, too, that cycle continued, and not only because travelers were apparently compelled to dispel the same enchantments again and again. If by one measure the period introduced a new realism into Western accounts of the harem, by another, it generated a new wave of fantasizing — as Orientalist painters on both sides of the Channel, but in France especially, produced the pictures that for many in the West still constitute our image of the harem. Though the evidence suggests that Eugène Delacroix actually saw the Algerian women who inspired his famous painting of *Les Femmes d'Alger dans leur appartement* (1834), while his great rival as a creator of harem images, Jean-Auguste-Dominique Ingres, never traveled to the East at all, what both men painted, I shall argue, are finally harems of the mind.

As imaginative projections, such harems tell us more about the Europeans who created them than they do about the domestic reality of the East. But by emphasizing the very heterogeneity of these projections, even in their cruder forms, this book also seeks to challenge some current clichés about Europe's relation to the Orient. Not all fantasies of the harem prove to be fantasies of mastery and power, nor do most of the representations examined here reveal a will to dominate the Orient imperially. Indeed, to the degree that Europeans based their fantasies of the harem on the great courts of Turkey and Persia, the empire of which they were dreaming was not in fact their own. Long after Ottoman power began to decline in the seventeenth century, this Eastern *imperium* continued its hold on the imagination of Europe. Turkey itself, of course, was never colonized during the years in question; but even when the British and French began to enforce their own imperial ambitions on the Middle East in the nineteenth century, Europe's obsession with the harem still owed more to the lure of the unknown and the forbidden than to the desire for political conquest. This is not to say that there are no vulgar stereotypes in the material examined here, or that many Europeans did not look to the harem simply to confirm a complacent belief in the superiority of the West. But it is to say that harems of the mind do not always take a predictable shape, and that they originate in impulses more various and internally divided than we have learned to expect. Rather than a systematic knowledge of the East that is coextensive with the wish to conquer it — as in Edward Said's immensely influential *Orientalism* (1978) — the representations in this book reveal the surprising range of uses to which men and women can put their imagination of difference.[9]

Harems of the mind are primarily structures of fantasy; and the greatest fantasists of the harem, I contend, self-consciously call attention to the imaginary status of their creations. Yet even as Europeans elaborated their tales and images, the mysteries of the harem inspired them with an avidity for facts scarcely less intense than the impulse to fantasize. Though the representations studied here differ greatly in their claims to authenticity — and, for that matter, in their makers' very concern for the truth — there is no such representation that does not display traces of a need to know as well as a desire to make believe. The more fantastic a harem the imagination builds, I argue, the stronger is the need to buttress the structure with fact. Part One of this book develops this paradox, from the repeated boasts of travelers to inside knowledge of the Ottoman palace, to a twentieth-century novel by Pierre Loti, whose claim to speak for the inhabitants of the modern Turkish harem is

considerably complicated, to say the least, by its origins in a hoax perpetrated by another writer from France. Here as throughout, I have tried to do justice both to the stubborn ahistoricity of many harem myths and to temporal differences by devoting the large part divisions to exploring different aspects of a central problem or theme, while keeping the organization of material within individual chapters roughly chronological whenever possible.

Parts Two through Six take up the most familiar scenarios of harem fantasy, from representations of confinement and erotic license, to the recurrent flight of the loving couple, the deadly plotting of harem rivals, and the persistent identification of the Orient with the past. Throughout this book, however, I am less interested in cataloguing *topoi* for their own sake than in exploring their often unexpected complications, whether in the internal divisions and mutual contradictions of popular myth-making or in the more deliberate ambiguities of sophisticated artists and writers. While the primary reference of my subtitle is to the passage eastward repeatedly imagined in this material, many of the representations studied here are also "passages" in another sense: not entire works, but only episodes or digressions, some as long as the harem cantos of Byron's *Don Juan* (1819–24), others as brief as an extended metaphor in a preface by Henry James. With a few significant exceptions — Racine among them — European novelists and dramatists have not lingered very long in the harem. There are a number of reasons for this, including the conventionally episodic structure of most travel literature, but a central one, I would suggest, is the eventlessness many Western imaginations associate with the harem. If fantasies of the harem take the form of scenes or images more often than of novel or drama, that is partly because Europeans imagine it as a place in which time and action are suspended. On the other hand, some aspects of harem fantasy lend themselves more readily to stories than pictures: there are no pictures in Part Four of this book, "The Couple versus the Harem," not only because "love" is difficult to represent visually, but because the loving couple, as the West imagines them, are almost always engaged in trying to escape.

While the following pages draw on a wide range of texts and images, both celebrated and obscure, certain key works and figures appear repeatedly: Racine's *Bajazet* (1672); Montesquieu's *Lettres persanes* (1721); the Turkish embassy letters of Lady Mary Wortley Montagu (1763); Byron's Eastern poems and the harem cantos of *Don Juan* (1819–24); the Eastern interiors of Delacroix, Ingres, and their nearest Victorian

equivalent, John Frederick Lewis, especially the various versions of Delacroix's *Femmes d'Alger* (1834) and Ingres's *Bain turc* (1862–63); and the two harem novels that frame the career of Pierre Loti, *Aziyadé* (1879) and *Les Désenchantées* (1906). Readers especially interested in these artists or works are encouraged to consult the index. Though Loti and Lewis remain in my view relatively minor artists and Racine and Ingres, for example, indisputably major ones, I take all these works as fundamental to understanding Europe's collective imagination of the harem.

Part One
Inside Stories

1
Some Travelers' Tales

I n the fifth canto of Byron's *Don Juan* (1819–24), the poem's hero, sold into slavery at Constantinople, finds himself disguised as a woman and smuggled into the Grand Seraglio of the sultan. In the sixth, he is about to retire for the night with the more orthodox members of the harem, when the narrator briefly pauses to boast of his inside knowledge of the scene:

It was a spacious chamber (Oda is
 The Turkish title) and ranged round the wall
Were couches, toilets — and much more than this
 I might describe, as I have seen it all,
But it suffices — little was amiss.
 'Twas on the whole a nobly furnished hall. (6.51)[1]

Though the author of *Childe Harold* often turned his own restless tourism to the uses of poetry, no evidence exists that he ever managed to include the sultan's harem on his itinerary. In fact, his modern editors find the narrator's claim to "have seen it all" anomalous enough to warrant the solemn note that "Byron usually did not claim to have been in places where he never had been."[2] But if the poet had never directly seen the interior of a harem, he had encountered many representations of one, and he was hardly the first to pretend to a familiarity in excess of his experience. While most male travelers stopped short of asserting that they themselves had actually entered forbidden ground, few could resist describing at length what they had not seen. And few could resist claiming to be more in the know than their predecessors. The blank walls of the harem have long constituted an imaginative provocation to the European mind, and the poet merely exaggerates a typical response to their challenge.

That Byron necessarily drew on other representations for his hero's adventures does not distinguish his imaginary harem from the more sober reports of those who had preceded him. The poet's boast of having seen it all might even be read not as a claim to direct experience but as a joke about the abundance of such images already in circulation. Among the many accounts of the East that Byron himself had read as a youth, Paul Rycaut's *Present State of the Ottoman Empire* (1668) openly acknowledged the challenge posed by writing of the harem.[3] After detailing the ranks of eunuchs, both white and black, who serve in the Grand Seraglio, Rycaut proceeded to a section on "The Apartments of the Women":

> And since I have brought my Reader into the quarters of these Eunuchs, which are the Black guard of the sequestered Ladies of the *Seraglio*, he may chance to take it unkindly, should I leave him at the door, and not introduce him into those apartments, where the Grand Signors Mistresses are lodged: And though I ingenuously confess my acquaintance there (as all other my conversation with Women in *Turky*) is but strange and unfamiliar; yet not to be guilty of this discourtesie, I shall to the best of my information write a short account of these Captivated Ladies, how they are treated, immured, educated and prepared for the great atchivements of the *Sultans* affection; and as in other stories the Knight consumes himself with combats, watching and penance to acquire the love of one fair Damsel; here an army of Virgins make it the only study and business of their life to obtain the single nod of invitation to the Bed of their great Master.

By suggesting that his own exclusion from the women's apartments would not stop him from helping others through the door, Rycaut called attention to how readers' presumed desire for inside knowledge governed his narrative. And even as he tried "to the best of [his] information" to give a faithful report of what he had learned, he immediately began to associate it with romance—as if the imagined rivalries of the sultan's harem were the polygynous Eastern version of those "other stories." As Rycaut likewise suggested when he came to describe how "the Grand Signior resolves to choose himself a Bed-fellow," the prohibited observer can only reproduce the tales he has been told: his account of how the sultan has all the "Damsels" gathered before him so that he may throw a handkerchief "where his eye and fancy best directs" proceeds, in his words, "according to the story in every place reported, when the Turkish *Seraglio* falls into discourse."[4] The story of the nightly handkerchief was one of the more

persistent tales to circulate around the mysteries of the sultan's harem; to this day, some uncertainty remains as to whether or not it corresponded to imperial practice.[5] But the more such stories were passed on from one traveler to another, the more each new visitor also insisted on distinguishing his knowledge from his predecessors'.[6]

Aaron Hill began his own *Present State of the Ottoman Empire* of 1709 by boasting of how the temporary absence of the sultan and "*his* Ladies" at Adrianople had enabled him and some other English travelers to "*snatch . . . the* Lucky *Opportunity of* Seeing . . . *the Great* Seraglio *at* Constantinople, *so much* farther, *than had been* before *permitted*" — an opportunity that he exploited to the full when it came time to describe the palace itself and "*particularly*" the apartments of the women. Like Rycaut, he appeared to have little doubt that this was the account his reader had been waiting for. "Chiefly bending my design'd description," as he put it, towards those "*Paths of Love,* and *Labyrinths of Pleasure . . .* where the amorous *Sultan* toys away his Minutes in the wanton Raptures of his *Ladies Conversation,*" he effectively offered himself as guide for a voyeur's tour of the harem.[7]

Having engaged to lead the reader "with a gradual Curiosity, through every *inmost* Part of its discover'd Glories," Hill proceeds through the rest of the chapter with a similar mixture of coyness and titillation, as he repeatedly anticipates and defers the promised climax of the tour. "But now appears a *SECRET* worth the hearing," he characteristically announces at one point, as if finally about to arrive at the "inmost" part of the narrative:

> I will not only trace the *Sultan* to his amorous Pastimes with the *Virgins* of his *Pleasure*, but admit the Reader to the close Apartments of the fair *SERAGLIO LADIES*, nay and into the retir'd Magnificence of their *Bed-chambers*, but shew him all the various Scenes of Love and Courtship, which are practis'd daily by *their Lord* and *them*, even to the Consummation of their utmost Wishes; and if the *British Ladies* are desirous of a further Information, still advance a step or two beyond it.[8]

Despite the note of imminent disclosure, however, Hill's eager readers would have had to traverse more than fifteen folio pages of architectural description before they approached anything like the amorous pastimes promised by this passage. If there is no end to the possibility of inside knowledge about the harem — since beyond the "utmost" one can "still advance a step or two" toward "further Information" — there is also no end, it would seem, to the lure of a "*SECRET*" not yet articulated.

A reader whose curiosity had been genuinely aroused by all this teasing

might well have complained of a certain anticlimax when the tour finally arrived at the threshold of the sultan's bedchamber. For as in many such accounts, Hill primarily achieved an effect of truth by dismissing previous reports as fictions. After once more teasing "the natural Curiosity" of his *"Female Readers"* by promising that they were about "to look a little" into the *"Amours"* of the sultan, he paused to urge that they first "lay aside those vulgar Errors and *Romantick* Notions, former *Authors*, or perhaps, their *travelling Lovers* have possess'd their Minds with." Hill's immediate target in this case was the familiar business of the sultan's handkerchief. Even "the Learned and Judicious Sir *Paul Ricaut*," he complained, "has not blush'd" to credit the "erroneous Story." Typically, however, he himself went on to retail another problematic bit of palace lore — that the evening's favorite entered the imperial bed by creeping up from its foot.[9] Assuming we believe Hill's repeated boasts of privileged access to the seraglio, we may still wonder just how a tour of the empty palace guaranteed this European visitor's superior knowledge of the sultan's private habits.[10]

Whatever his own reliability, Hill saw clearly enough why others, at least, might be tempted to fabricate evidence about the secrets of the harem. "Common Fame is both a *Lyar*, and a *Magnifier* of the falsities of all Mankind," he sensibly observed, and "where Truth is doubtful, or the Fact obscure, she strait contrives to fill *deficiencies* with a productive train of illegitimate Assertions." Though Hill believed no subject could "more entirely prove the certainty of this Opinion, than the Great *Seraglio* of the *Turkish Sultan*,"[11] the seventeenth-century French traveler, Jean Chardin, thought the harems of Persia more mysterious still. So closely did the Persians guard their women, according to Chardin, that the "sérails" of the Turks and even of their sultan could be called public spaces in comparison. The great difficulty of learning anything at all about the women's quarters, especially those in the royal palace, led Chardin to term the Persian harem "un monde inconnu" — after which, predictably, he declared himself better informed on the subject than any other European before him. What he had to say, he assured his readers, was nearly all that one could know, because even the "grands seigneurs" did not know any more. Soon he was pronouncing the royal harem of Persia "incomparable" in regard to the beauty of the women it enclosed.[12] The habit of filling epistemological "*deficiencies* with a productive train of illegitimate Assertions," in Hill's words, was clearly not limited to accounts of the Ottomans.

For all these travelers, of course, the way to any harem was barred not so much by differences of nationality and religion as by the distinction of sex. When Chardin alluded to those "grands seigneurs" who knew no more

of the royal harem than he did, he does not seem to have meant Europeans of higher rank than his own but the great lords of Persia themselves. Even his local informants, in other words, would have had no more access to its secrets than he did. And while the royal harem was always a special case, ordinary households posed scarcely less of an obstacle to the masculine visitor. If the mysteries of the harem had such a long hold on the imagination of the West, one reason, no doubt, was that the vast majority of travel reports — until the nineteenth century, at least — were written by those firmly excluded from its precincts. But less than a decade after Hill published his *Present State of the Ottoman Empire*, Lady Mary Wortley Montagu was already availing herself of the privileges afforded her sex, not to mention her position as the wife of England's ambassador to the Porte, to pronounce "the falsehood of a great part of what you find in authors" including "the admirable Mr. Hill . . . and all his Brethren Voyage-writers." Cheerfully indulging what she termed "a true female spirit of Contradiction," Lady Mary gave new force to the travelers' *topos* by which each writer routinely dismissed the accounts of his predecessors.[13]

Though Lady Mary clearly had no wish to confine her "spirit of Contradiction" to matters conventionally associated with her sex, she also took evident pleasure in her ability to venture where no man was permitted. "I am sure I have now entertaind you with an Account of such a sight as you never saw in your Life and what no book of travells could inform you of," she boasted to the female correspondent who received her famous description of the women's bath at Sofia. After all, she concluded pointedly: "'Tis no less than Death for a Man to be found in one of these places." In the midst of a detailed account of upper-class Turkish architecture, she paused to remind yet another woman friend of her privileged access to spaces — and to knowledge — ordinarily concealed from the authors of travel literature. "You will perhaps be surpriz'd at an Account so different from what you have been entertaind with by the common Voyage-writers who are very fond of speaking of what they don't know. It must be under a very particular character or on some Extrodinary Occassion when a Christian is admitted into the House of a Man of Quality, and their Harams are allways forbidden Ground."[14] Written in 1717–18, though not widely available until their posthumous publication in 1763, Lady Mary's letters from Turkey promised her readers the sort of inside knowledge only a woman "of Quality" in her own country could provide.

Like "common Voyage-writers," as she called them, Lady Mary prided herself on her capacity to surprise. Yet in the case of this cosmopolitan woman, the traveler's revelation often takes the ironic form of disclosing

that the secrets of the Other are not so novel after all. "As to their Morality or good Conduct," she wittily remarked to her sister on the inhabitants of the harem, "I can say like Arlequin, 'tis just as 'tis with you, and the Turkish Ladys don't commit one Sin the less for not being Christians."[15] Elsewhere in the same letter, she suggested that the polygamous character of the harem had been grossly exaggerated. "'Tis true their Law permits them 4 Wives, but there is no Instance of a Man of Quality that makes use of this Liberty, or of a Woman of Rank that would suffer it. When a Husband happens to be inconstant (as those things will happen) he keeps his mistrisse in a House apart and visits her as privately as he can, just as tis with you." She knows of but one exception, she reports, "and he is spoke of as a Libertine, or what we should call a Rake, and his Wife won't see him, thô she continues to live in his house." If the reality of the harem, by this account, proves all too familiar, the veracity of the teller is confirmed precisely by her refusal to exaggerate its difference. The letter's close drives home the point: "Thus you see, dear Sister, the manners of Mankind doe not differ so widely as our voyage Writers would make us beleive. Perhaps it would be more entertaining to add a few surprizing customs of my own Invention, but nothing seems to me so agreable as truth, and I beleive nothing so acceptable to you."[16]

When it came to the harem of the sultan, however, even Lady Mary never managed to get any closer than the apartments of a former "sultana."[17] "I did not omit this oppertunity of learning all that I possibly could of the Seraglio, which is so entirely unknown amongst us," she assured her sister, immediately adding that her informant had pronounced "the story of the Sultan's throwing a Handkercheif . . . altogether fabulous." Though in this respect at least Lady Mary evidently agreed with the objectionable Mr. Hill, she quickly followed it up by reporting that "neither is there any such thing as her creeping in at the bed's feet." Characteristically, the cosmopolitan traveler found the sultana's account of occasional jealousies among the imperial harem "neither better nor worse than the Circles in most Courts" where everyone waits upon the glance and smile of the monarch. Despite her demystifying impulses, however, the sheer opulence of the sultana's quarters prompted even Lady Mary partly to defend the authenticity of romance. "Now do I fancy that you imagine I have entertain'd you all this while with a relation that has (at least) receiv'd many Embellishments from my hand," she protested to her sister, after describing her hostess's elaborate jewelry, the "magnificence of her table" and the "rich habits," including "3 vests of fine Sables," casually strewn about her bed-chamber. "This is but too like (says you) the Arabian tales; these

embrodier'd Napkins, and a jewel as large as a Turkey's egg! — You forget, dear Sister, those very tales were writ by an Author of this Country and (excepting the Enchantments) are a real representation of the manners here." Its "Enchantments" duly excepted, the *Arabian Nights* briefly metamorphoses into a local informant more reliable than all those ignorant Europeans who have preceded her.[18]

Yet for Lady Mary, the habits of enlightened skepticism continued to outweigh the seductions of romance; and even today, she remains one of the more reliable witnesses for those wishing to reconstruct upper-class life among the eighteenth-century Ottomans. This is not quite to say, however, that she — or any female visitor to the harem, for that matter — could simply replace masculine fantasies with unmediated reality.[19] As we shall see, European women were not without their own preconceptions and wishful fantasies of life in the harem. Nor were those who followed Lady Mary to the East necessarily inclined to endorse her accounts of what she saw there. For subsequent women travelers intent on establishing their own claims to truth, her influential letters often furnished precisely the representations to be disputed. Embarking on another journey to Constantinople nearly seventy years after Lady Mary, Elizabeth Craven even refused to credit her predecessor's very existence as an author: "Whoever wrote L. M—'s Letters (for she never wrote a line of them) misrepresents things most terribly; I do really believe, in most things they wished to impose upon the credulity of their readers, and laugh at them."[20]

Few later writers approached this wholesale dismissiveness, but the impulse to correct the embassy letters persisted well into the nineteenth century. Reporting on the domestic life of the Turks in 1836, for example, one Victorian writer felt compelled to revise Lady Mary's famous account of the women's bath for contemporary audiences. Though the eighteenth-century aristocrat had described "200" bathers "all . . . in the state of nature, that is, in plain English, stark naked, without any Beauty or deffect conceal'd," Julia Pardoe happily announced that she had "witnessed none of that unnecessary and wanton exposure described by Lady M. W. Montague." As Pardoe diplomatically phrased it, "Either the fair Ambassadress was present at a peculiar ceremony, or the Turkish ladies have become more delicate and fastidious in their ideas of propriety."[21] In another account of *Harem Life in Egypt and Constantinople* three decades later, Emmeline Lott managed to contend that aristocratic privilege was precisely what kept the ambassador's wife from the inside knowledge accessible to a less fortunate person like herself. Lott's querulous record of her travails as a governess in Eastern harems opens with a fulsome

tribute to "that 'Princess of Female Writers,'" whose "rank and position" were the "talisman" which "drew back the massive double-bolted doors, and gave her access to those forbidden 'Abodes of Bliss'" — only to turn that rank and position firmly against her titled predecessor:

> Nevertheless, her handsome train, Lady Ambassadress as she was, swept but across the splendid carpeted floors of those noble Saloons of Audience, all of which had been, as is invariably the custom, well 'swept and garnished' for her reception. The interior of those Harems were to her Ladyship a *terra incognita*, and even although she passed through those gaudy halls like a beautiful meteor, all was *couleur de rose*, and not the slightest opportunity was permitted her to study the daily life of the Odalisques.

The harems of Constantinople may have opened their doors to Lady Mary, but only the long-suffering governess, it would seem, really managed to get inside. With a gesture of self-abasement almost worthy of Uriah Heep, Lott staked her claim:

> It was reserved to a humble individual like myself . . . to become the unheard-of instance in the annals of the Turkish Empire, of residing within those *foci* of intrigue, the Imperial and Viceregal Harems of Turkey and Egypt; and thus an opportunity has been afforded me of . . . uplifting that impenetrable veil, to accomplish which had hitherto baffled all the exertions of Eastern travellers.[22]

This boast of access without precedent met the usual fate. The English governess had no sooner published her account, in fact, than another Englishwoman in Egypt wrote of her own visit to a Turkish "Hareem" and pronounced it "not a bit like the description in Mrs. Lott's most extraordinary book."[23] Though she was a distant cousin of Harriet Martineau, Lucie Duff Gordon had no more patience for the "outrageous" representations of the harem that had appeared in her relative's *Eastern Life, Present and Past* (1848). As for the precedent of art and literature: "Fancy pictures of Eastern things are hopelessly absurd, and fancy poems too. I have got hold of a stray copy of Victor Hugo's '*Orientales*,' and I think I never laughed more in my life."[24]

Among the more open-minded and judicious of Eastern travel writers, Duff Gordon was more inclined to remark what she found "good and rational" about "hareem" than to celebrate its mysteries. But even she was not above mildly boasting of having penetrated further than others, as

when she announced after some months in Egypt that "I have contrived to see and know more of family life than many Europeans who have lived here for years." [25] By the time Duff Gordon first published her *Letters* (1865), however, the number of rival claimants to inside knowledge about the harem had grown quite crowded. Though artists and writers would continue to exploit its imagined secrets for at least another half-century, some travelers to the East were already beginning to lament the loss of mystery. As early as 1846, the author of an anonymous article for *Chambers' Edinburgh Journal* apparently felt the need to distinguish her own visit to the apartments of a Bulgarian "sultana" from run-of-the-mill accounts of the harems at Constantinople, which "so many travellers habitually visit . . . that they are half Europeanised." She was, in her words, "delighted with the prospect of inspecting an establishment which must be so very characteristic, so perfectly Eastern," for into *this* harem, of course, "no other stranger had ever been admitted." [26]

That the *Chambers'* correspondent may well have been the first foreigner to visit these apartments did not make her claim to novelty any less conventional. All travel literature implicitly holds out a similar promise: no one — at least no one like the writer — has ever seen this sight before, or those who claim to have done so have seen it all wrong. But as a space by definition sealed from alien eyes, the harem especially invited such claims, even as it rendered them more dubious than usual. For several centuries — Lady Mary in part excepted — most of what passed in the West for inside knowledge about any harem was little more than speculation and rumor, with one writer's dismissal of another's fiction often having to serve as fact. Yet even when a good number of European women began to visit Eastern homes in the nineteenth century, the thrill of getting inside did not altogether dissipate, nor did the impulse to claim that *this* traveler had really penetrated to the truth of the harem. Every household is different, after all, but the writer for *Chambers'* was not just making the trivial boast that no other European had happened to visit a particular set of Bulgarian apartments. What excited her, she made clear, was "the prospect of inspecting an establishment which must be so very characteristic, so perfectly Eastern" — the anticipation, in other words, of getting at that mysterious difference that she, like so many before and after, identified with the harem.

Seeing It All:
Ingres and Delacroix

I t is no wonder that Byron should have boasted of having "seen it all,"
since the first provocation posed by the harem was, of course, to the
eye. Travelers to the East never tired of reporting how even a single
look might be fatal, especially if it was directed at any of the female inhab-
itants of the Grand Turk's seraglio. "For there may none come neer, nor
be in sight of them, but himself and his black Eunuchs," one influential
commentator typically noted in 1650: "nay, if any other should but attempt
(by some trick in creeping into some private corner) to see the women,
and should be discovered; he should be put to death immediatly." Though
Robert Withers presented this account as his own, the evidence suggests
that he was merely translating a Venetian diplomatic report of several
decades earlier.[1] But the fatality of the look registered no less sharply with
the French. "The Grand Signor is ordinarily so jealous that a single glimpse
of one of his women would cost the life of the man who had looked at her,"
Jean Thévenot observed in his *Voyage du Levant* of 1665;[2] and Jean Chardin
recorded the same fate for anyone found in the streets of Persia on the rare
occasions when the women of the royal harem emerged from the palace.
Chardin told of how one old man, under the illusion that his great age
should make him pass as a eunuch, attempted to seize the occasion to
present a petition to the king, only to find himself instantly dispatched
by the ruler himself.[3] In Constantinople, Jean Dumont professed to have
himself encountered a Turk whose father had been strangled for attempt-
ing to look at the women of the sultan.[4]

Like the veil, the harem constituted a perpetual challenge to visual
desire. Forbidden to look upon Muslim women, Western men responded
by conceiving the harem as a place given over to obsessive exercise of the
eye. At least as early as the opening scene of Racine's *Bajazet* (1672), this
simultaneous not-seeing and all-seeing defines the *sérail*. The same speaker

who in the first exchange of the play evokes the swift death that ordinarily attends the forbidden gaze soon questions how illicit lovers can manage to evade all the jealous looks that police its interior. While the sultan is off at war, Roxane, his favorite, has fallen in love with his younger brother and potential rival, Bajazet. "La sultane éperdue / N'eut plus d'autre désir que celui de sa vue" [The impassioned sultana had no other desire than the sight of him], the grand vizier reports of her treacherous desire to see the imprisoned Bajazet, to which his companion immediately responds: "Mais pouvaient-ils tromper tant de jaloux regards / Qui semblent mettre entre eux d'invincibles remparts?" [But could they deceive so many jealous looks, which seem to place between them such invincible barriers?].[5] In Racine's imaginary harem, the lover's desire is first of all the desire to look, while others' looks figure as the internal walls of the *sérail*, as their watching is transformed into figurative barriers impeding the would-be lovers' sight of one another.

Dumont himself immediately followed up his account of the Turk strangled for his curiosity by reporting how the sultan in question not only made it "his daily Custom to walk in Disguise thro' the City, that he might be an Eye-witness of the Care that was taken to put the Laws in Execution," but engaged in a mortal ocular combat from the recesses of his seraglio:

> besides he frequently observ'd what was done in the City from his *Seraglio*, by the help of some excellent Prospective-Glasses, with which the *Venetians* had presented him. One day as he was making his usual Observations, he perceiv'd a Man in *Pera*, who had also a Prospective-Glass, and was viewing the *Sultanesses*, who were walking in the Garden. Immediately he call'd a *Capigi* [guard], and commanded him to go with four *Mutes* to such a House, and hang a Man, whom he describ'd, at the Window; which the *Capigi* executed, and [the sultan] saw him and was satisfy'd.[6]

Dumont's sultan appears to spend more time looking for others' looks than turning his gaze directly on his women themselves. But reports of how closely watched were the inhabitants of the harem were almost as routine as accounts of how no one could look upon them; and the idea of a place where women were constantly subject to internal surveillance had a powerful hold on the imagination of those who were themselves prevented from looking. "On les observe de fort près," Chardin wrote of the Persian harem, this close watching doubly motivated, as he told it, by a fear of the women's rivalrous intrigues and of their amorous passions for one another. Elsewhere, he compared the eunuchs to "des argus qui veillent sur toutes leurs actions," affirming in no uncertain terms that everywhere

in the Orient women mortally hated their argus-eyed guardians.[7] Aaron Hill claimed that the candles burned all night near the foot of each woman's bed in the Ottoman palace — "the only reason for it," being "that *by their Light*, the *Governante* may be able to Discover all immodest or indecent Pastimes, which the Wanton Inclinations of the Youthfull Ladies, kept from the Society or Sight of *Man*, might prompt 'em to the Practice of." With his customary mix of coyness and prurience, Hill declined to give "some Amazing Instances in that particular" lest it "offend the *Modesty* of my more *Chast* and *Vertuous Country-Women*."[8]

Such rhetoric of female curiosity is conventional enough, but Hill's apparent assumption that women are as eager to look as men is relatively rare in Western imaginations of the harem. So too is the prudent refusal of the gaze imagined by Joseph de Tournefort in his *Relation d'un voyage du Levant* of 1717. Tournefort sensibly declined to put much stock in what had been written about the harem of the sultan, for although means might be found of getting into the *sérail*, as he acknowledged, "who would be willing to die for a glance so unhappily employed?" Tournefort, who also served as the chief botanist to the French king, adopted an appropriately empirical stance toward the mysteries of the harem: "This would be the place to speak of the women of the sérail," he wrote, "but I must be excused from doing so, for they are no more available to the senses than so many pure spirits."[9]

Most of those who wrote about the women of the seraglio, needless to say, hardly felt themselves thus constrained. Nor did the countless visual artists whose odalisques and harem scenes formed so popular a theme of nineteenth-century painting. Any attempt at visual representation, of course, draws in large measure on what Tournefort called "the senses," but with a few partial exceptions — Delacroix most famous among them — Western painters of the harem "saw" their subject only with the eyes of the imagination. Delacroix had not yet embarked upon his formative visit to Morocco when he produced his *Odalisque allongée sur un divan* (fig. 1) sometime in 1827–28; while Jean-Auguste-Dominique Ingres, whose Oriental bathers and odalisques dominated French painting for more than half a century, never ventured further East than Rome. Though the Oriental tour had become fairly commonplace among French painters by the mid-nineteenth century, images of the harem, and especially of naked women in the harem, necessarily remained the constructions of fantasy. Even when artists employed live models and Oriental props so as to reproduce what appeared immediately before them, the designation of the scene as a "harem" required an act of imagination. Sometimes,

indeed, only the name of an image served to evoke the harem, as in the *Odalisque* painted by Jules Joseph Lefebvre in 1874 (fig. 2). While the crossed position of her feet recalls Ingres's *Grande Odalisque* of sixty years earlier (fig. 3), Lefebvre's nude lacks even the minimal turban and fan that associate her celebrated predecessor with the East. The pose of this "odalisque" more nearly resembles another famous prototype, the Venus whose study of herself in the mirror had been painted by Velásquez more than two centuries previously (fig. 4).

The male voyeurism implicit in representations of the female nude has by now become such a commonplace of writing on the visual arts that invoking it can tell us very little about the particular force and effects of an individual painting.[10] But the question of voyeurism has a special resonance for Western images of the harem, images which so obviously violate a taboo that carries the force of sacred authority as well as long-established custom. Though the degree to which women were in fact secluded seems to have varied widely with time, place, and class, even those far removed from the imperial palaces of Turkey and Persia were still subject, after all, to the revelation of the *hijab* (separation or veil) that had purportedly descended in seventh-century Medina.[11] "The first thing the foreign eye catches about Algerian women is that they are concealed from sight," remarks a critic of the "colonial" postcards staged by French photographers in the first decades of this century.[12] No doubt it was just such concealment, among so much else that caught Delacroix's eye as it discovered the light and colors of North Africa, that had prompted his attempt to see behind the veil on a visit to Algiers in 1832 — an adventure that resulted, most famously, in his *Femmes d'Alger dans leur appartement* of 1834 (fig. 5). Though he did not reconstruct this harem until more than a year after he had returned to Paris, the painting grew from quick sketches apparently produced on the scene, the French engineer of the port having persuaded one of his native employees to permit the artist a view of his women. By one account, the man in question was a renegade Christian, and thus presumably more willing than one born to the faith to invite the unbelieving foreigner into his harem. The same source nonetheless describes the painter as responding with an "exaltation" so feverish that it was "scarcely assuaged by sorbets and fruits." Indeed, so strong is the taboo Delacroix appears to have violated that some have wondered whether he was not in fact the victim of a deception — whether Jewish women, for example, were not passed off as Muslims.[13]

I shall return to the question of the painting's status as an ethnographic document shortly. Yet if the evidence suggests that the women Delacroix saw were genuine enough, their authenticity did not necessarily prevent a

certain staginess in their reception of their visitor. In the words of a friend who later described the event: "The woman, alerted by her husband, prepared the pipes and the coffee, put on her most sumptuous costume, and waited, seated on a divan."[14] And something of this theatricality persists in the final composition—not only in the frontal poses of several of the women, but in the shallow, proscenium-like space, the dramatic lighting, and the suggestion of a heavy curtain that has been pulled aside to disclose the scene. The last suggestion is intensified in the second and smaller version of the painting that Delacroix executed in 1849 (fig. 6), where the puzzling gesture of the black slave to the right, which appears to serve no evident purpose in 1834, has been clearly rationalized by her activity in drawing the curtain. Like the slave who similarly draws back the curtain in yet another *Femmes d'Alger* of the same period (fig. 7) — a painting sometimes known, mistakenly, as *L'Intérieur de harem à Oran* — the figure in the later harem calls dramatic attention to what would otherwise be hidden from sight.[15]

Yet Delacroix frustrates the voyeur's gaze even as he invites it, and the same image that self-consciously opens the harem to view also manages to preserve its mystery. Ever since Baudelaire wrote briefly but provocatively of "ce petit poème de l'intérieur, plein de repos et de silence,"[16] viewers have commented on the peculiar inwardness of Delacroix's *algériennes*, the sense of privacy and reserve they somehow convey at the very moment the painter exposes them to our view. The effect derives in part from the notable isolation of the individual figures, an impression perhaps traceable to the painting's origins in separate sketches that were only later combined into a single image of women in the harem.[17] Even the pair to the right display no evident awareness of one another's presence, despite the fact that they derive from figures who appeared together in a single sketch (fig. 8). Though the woman seated in the center appears to look toward her kneeling companion, neither the dreamy expression of the one nor the calm profile of the other registers any consciousness of the fact — their apparent self-containment no doubt intensified when Delacroix altered both faces between the original sketch and the final painting. So, too, though a diagonal would directly link the eyes of the seated woman to the profile of the black slave who turns in her direction, their gazes never actually meet in the painting. To adopt a term first advanced in a slightly different context, it is the marked "absorption" of the inhabitants that preserves the mystery of this harem, an absorption all the more striking because it cannot be accounted for by any obvious activity like reading or sleeping.[18] Though such images have been contrasted with the "theatricality" of those that directly acknowledge the beholder's presence, the *Femmes d'Alger* tends

to confound such distinctions — its double effect perhaps most evident in the woman on the left, whose frontal pose and gaze appear to confront us directly, even as her preoccupied expression suggests a person wholly absorbed in reverie. "À la fois présentes et lointaines, énigmatiques au plus haut point" — as the contemporary Algerian writer Assia Djebar puts it in her evocative meditation on the painting — Delacroix's women are at once theatrically exposed and withheld from view, as if still concealed behind the invisible wall of the harem. "Placing us in front of these women in the position of the viewer, [Delacroix] reminds us that ordinarily we do not have that right. The painting itself is a stolen look."[19]

Delacroix's arch-rival stole his looks at the harem only in fantasy, but he, too, liked to call attention to the imaginary disclosure his art had effected. From the early nude of 1808 known as the *Baigneuse Valpinçon* (fig. 9) to the first version of the *Bain turc* that he completed a half century later — a painting that now survives only in a photograph of the time (fig. 10) — Ingres repeatedly places his "Oriental" women near the folds of a curtain, as if to suggest that we are privileged to see what would otherwise be screened from our view. Of course, Western painters had long taken advantage of the visual effects made possible by posing the female nude against drapery of some sort: just as Velásquez delighted in such echoing curves and contrasting textures in the *"Rokeby Venus,"* for example (fig. 4), so Ingres accentuates the posture of the *Baigneuse Valpinçon* by the vertical folds of the curtain to the left, or continues the extended curves of his *Grande Odalisque* (fig. 3) in the more languorous draping of the patterned fabric to the right. But such formal relations need not preclude the simultaneous suggestion of hidden mysteries disclosed to view — a suggestion still more theatrically conveyed, perhaps, in the paired curtains that frame the oddly distant figures in the *Petite Baigneuse: Intérieur de harem* of 1828 (fig. 11). Making one of her many reappearances in Ingres's oeuvre, the Valpinçon bather here poses in the plane before the curtain, rather than behind it, as if she had become the viewer's surrogate or familiar as much as the continued object of his gaze. In the *Odalisque à l'esclave* of a decade later (fig. 12), the placement of the curtain encourages yet further intimacy, since the viewer now apparently belongs, together with the voluptuous odalisque, to the private space it would screen — a privilege effectively identical to the fantasized position of the sultan.[20] By the time the series first culminates in the teeming interior of 1859 (fig. 10), the Valpinçon bather has been joined by a collection of nudes whose truncated forms spill over into the space of the viewer, and only a vestigial curtain remains to evoke the privacy the image appears to have violated.

By comparison with the ethnographic sobriety of a *Femmes d'Alger,* the erotic invitation of Ingres's Orient can seem surprisingly blatant.[21] Yet Delacroix's principal rival had his own ways of preserving the mysteries of the harem. Indeed, it would not be too much to say that all of Ingres's erotic paintings, whether or not they are set in the Orient, produce something of a harem-effect, at once inviting and withholding themselves from the viewer.[22] And if the eroticism of his images is always bound up with their inaccessibility, their simultaneous evocation and frustration of desire, what we know about the history of his last and most extravagant vision of Oriental women suggests a particular attempt to intensify this tantalizing remoteness. In 1859, according to contemporary accounts, Ingres delivered a commission from the prince Napoléon for the painting of a "harem," only to have the work returned to him in the early weeks of 1860, ostensibly because the prince's wife, the princess Clotilde, had been shocked by its collection of nudes.[23] The prince's painting, described as rectangular in shape, is probably that which appears, signed and dated 1859, in the photograph we have already seen (fig. 10); and the evidence strongly suggests that Ingres took the opportunity of its return to his studio to transform the rejected rectangle into the familiar *tondo* which now hangs in the Louvre (fig. 13).[24] Legend has it that Ingres responded to the princess's objection to his bathers by observing, "C'est drôle! Elles sont pourtant si propres!"[25] — a remark whose own confidence as to their cleanliness nicely equivocates with their propriety. Though we cannot know with any certainty why Ingres decided to alter the shape of the painting after it was returned to him by Prince Napoléon, it may well be that the circular form of the final version represents still a further attempt to distance the image, to counter the illusion of reality so closely associated in Western art with the rectangular "slice of life."[26] That he chose to reshape the painting after the princess objected to its nudes tends to confirm this hypothesis, as if the artist were determined to remove his bathers from the realm of such naively illusionistic readings. Like the rounded forms of the still life, which were also added in the final version, the circular shape of the whole heightens the abstractness of its design, makes the women seem not so much bodies in space as curvilinear forms the painter has assembled on canvas. At the same time, the transformation of the original rectangle into the *tondo* as we know it paradoxically increases the effect of voyeurism. Unlike the rectangular slice of life, whose space we conventionally take as continuous with our own, the circle draws attention to itself as an artificial boundary of our vision, as if we were seeing the bodies before us only by means of an intervening aperture or instrument. Arbitrarily

framed by that aperture and seemingly oblivious of the viewer, Ingres's bathers appear to be glimpsed unawares through a spyglass or keyhole — an impression intensified by the knowledge that such sights would have been ordinarily forbidden to masculine eyes. The vestigial curtain has disappeared, to be replaced by the more radically voyeuristic structure of the entire image.

Though Western imaginations sometimes identified the voyeur's vision with the privileges of the sultan, such a viewpoint, it seems clear, was principally adapted for harems of the mind. In 1768 an English-woman who characterized herself as a "discarded sultana" published her *Memoirs of the Seraglio of the Bashaw of Merryland* — a pamphlet purporting to offer an inside account of an "English SERAGLIO" run on lines strictly adopted from the Eastern model. According to the *Memoirs,* no new recruits were admitted into the "seraglio" until they had been secretly examined by the "bashaw" himself. "To this end," she wrote, "there is an apartment allotted for the survey of the candidate-sultana; which the bashaw makes unperceived, through a lattice, from an adjoining room." But despite her assurances that the gentleman in question had recently returned from the East, where he had carefully studied "the regulations, laws, and customs of the seraglio, with all the ceremonies and methods of treating the sultanas," the voyeuristic ritual he enjoyed would appear to have been invented back home.[27] The Ottoman sultan did, indeed, often conceal himself from view; but though numerous travelers described the latticed aperture that enabled him to watch the proceedings of the Divan, or court of justice, unobserved, no comparable post seems to have existed for the inspection of the women. It is those prohibited from looking, after all, who primarily imagine the pleasure of peering through lattices.

The eyes at the lattices, in fact, were far more likely to look the other way — not in at the harem itself, but out at the world. Not surprisingly, perhaps, Western men did not typically adopt this viewpoint in painting, though like the English artist, Thomas Allom, they might occasionally represent the peering women themselves (fig. 14). Even this image, reproduced here from an engraving known as *The Favourite Odalique* (1838), gives pride of place not to the women who peer through the lattices but to the sumptuously dressed "favourite" who gestures to restrain them — an odalisque who herself appears to gaze directly, and without any intervening barrier, at the viewer.[28] Like so many painters of the harem, in other words, Allom himself indulges the fantasy of an inside look.

That the eyes of the harem appear primarily in language rather than paint is a fact less paradoxical than it might seem. For apart from the

difficulty of seeing and visually depicting those hidden eyes, it is the consciousness of being secretly observed — or the illusion of that consciousness — that would most have haunted those denied access to the observers themselves. The fantastic harem that appears in the first tale of Thomas Moore's popular Oriental poem, *Lalla Rookh* (1817), seems to be screened by curtains rather than lattices, but "through the silken network, glancing eyes, /From time to time, like sudden gleams that glow / Through autumn clouds, shine o'er the pomp below." That "pomp" belongs to an assembly of warriors ritually massed outside the harem walls; and Moore writes, vaguely, from a collective viewpoint which takes these "half-caught glances" as tantalizing synecdoches for the women within.[29] The awareness of being silently watched from behind lattices similarly figures as a passing *topos* in many accounts of the harem. But it would take a Pierre Loti fully to exploit the narcissistic pleasures of such a glance — to follow up the possibilities for the "egotistic-erotic" (I borrow the phrase from Henry James's account of his fellow-novelist) that await a man who fancies himself the secret object of harem eyes.[30]

In the opening pages of Loti's first novel, *Aziyadé* (1879), the autobiographical hero, himself called "Loti," records in his diary the strange sensation he experienced while wandering through the old Muslim quarters of Salonica, "in perceiving near me, behind thick bars of iron . . . two large green eyes fixed on mine." Between the challenge of those green eyes, which regard him fixedly, he believes, because "a giaour is not a man," and his immediate reflection on all the "impossibilities" that divide him from their possessor, the whole history of his doomed affair with this inmate of a Turkish harem inevitably follows.[31] Indeed, it would require only a slight exaggeration to argue that the self-pitying mood of Loti's entire canon derives from his initial experience (or imagination) of that glance, as subsequent novels compulsively seek to fulfill its promise of love and loss with a succession of exotic women. More than a quarter century was to separate *Aziyadé* from Loti's last harem novel, also set in Turkey, but in the concluding chapters of *Les Désenchantées* (1906), another version of the same hero glides at sunset along the shores of the Bosphorus, "where the invisible beauties are always seated . . . to await the return of the boats," while both he and his comrade beguile themselves with the consciousness of the fair spectacle their passage must make for the veiled figures seated on the "quais interdits" that line the banks.[32] As always, the barriers of the harem furnish a powerful stimulus for the imaginations of those compelled to remain outside.

Documenting the Harem from Bajazet *to the* Bain turc

Harems of the mind reveal an urge to document almost as intense as the urge to fantasize. The same barriers that compelled Europeans to imagine so much about the harem made them eager for whatever data they could gather. Though some harems of the mind are evidently more constrained by the facts than others, there is no such representation that does not display traces of a need to know as well as of a desire to make believe. Just as an element of wishfulness or fear shapes even the harem of the would-be ethnographer, so every fantasy of the harem requires some information to ground it. Indeed, in many harems of the mind, as we shall see, the pulls of fantasy and of fact are nearly inseparable — and not only because it is so difficult to distinguish epistemological drives from erotic ones. The more fantastic a harem the imagination builds, it often seems, the greater is the need to buttress the structure with fact.

The shifting positions Racine adopted toward his imaginary *sérail* in *Bajazet* already testify to these conflicting impulses. In his brief preface to the first edition of 1672, Racine devoted himself entirely to certifying the truth of the events represented in the play — a truth particularly important to affirm, it would appear, in the absence of published evidence. "Although the subject of this tragedy is not yet to be found in any printed history," he began, "it is nonetheless very true. It is an adventure that took place in the sérail not more than thirty years ago." Though no printed book yet records the history of Bajazet, Racine gives his immediate source as a friend at court, the chevalier de Nantouillet, who in turn heard it from the lips of the comte de Cézy, the man who had been France's ambassador to Constantinople at the time. While he has been obliged to alter some details, Racine reports, these have little significance for the reader — the principal rule to which he has adhered being "de ne rien changer ni aux

moeurs ni aux coutumes de la nation." After insisting that he has added nothing that does not conform to the new account of the Ottoman empire just translated from the English — by which he evidently alludes to Rycaut's recent work, first published in England a mere four years earlier — Racine ends with the assurance that he has referred all questions that have arisen to the current ambassador to the Porte, M. de La Haye.[1] Like the contemporaneous author of *Le Secrétaire turc* (1688), a compendium of lore and fables about the *sérail* that includes a set of "Testimonials" to its truth, purporting to be dated and signed by persons in Constantinople, Racine counts on names to help authorize the chain by which this oral history has been transmitted.[2] Having abandoned the classical settings of his previous tragedies for the mysterious world of the *sérail*, he appears all the more intent on certifying how up-to-the-minute is the state of his knowledge.

But by the time Racine came to rewrite the preface for the collected edition of 1676, the need to document the harem seems to have given way to the need to distance it. Worried lest his readers think he had dramatized events too recent for tragedy, Racine now argued that the spatial and cultural remoteness of the Ottoman court compensated for the temporal proximity of the action. If his protagonists had lived thirty years ago in France, he conceded, they would not yet have acquired the requisite dignity. But just as the ancient Athenians invested contemporary Persia with an aura of tragic remoteness, so ordinary Frenchmen now view the modern history of Constantinople:

> The distance of place makes up in some sort for the too great proximity of time: for people scarcely note any difference between that which is, if I may dare to put it thus, a thousand years away from them and that which is a thousand leagues. . . These are altogether different manners and customs. We have so little commerce with the princes and other persons who live in the sérail, that we consider them, so to speak, like people who lived in another age from our own.

Though the revised preface still invokes the authority of the French ambassador, the solemn recitation of sources otherwise disappears from its text — to be replaced by this insistence on the mysterious difference of "the sérail."[3]

Racine's two approaches to the problem of representation are less contradictory than they might seem. The very "moeurs" and "coutumes" whose authenticity he had first attested reappear in the second preface as the "moeurs et coutumes toutes différentes" that preserve the tragic aura

of the action. If he were to convince French spectators that Bajazet dwelled in a world truly remote from their own, the dramatist had need, after all, of just those particulars he had so assiduously collected. The rule that Byron once casually propounded — "there should always be some foundation of fact for the most airy fabric" — held with particular force for the construction of imaginary harems. Precisely because so little could be known about the place directly, harems of the mind inspired in their makers an unusual hunger for authenticating details — for "*costume . . .* and *. . . correctness,*" as Byron elsewhere half-seriously termed them.[4]

No writers and artists testified to this rule more than the Romantics, including Byron himself. By the time the little-known Mrs. Pickersgill concluded her poetic *Tales of the Harem* in 1827 with a set of scholarly citations on matters ranging from the behavior of Eastern fire-flies to the cosmetic use of henna and the ritual of suttee, the genre of the Orientalist footnote, as it might be termed, had been widely established in the literature of the period. Just as Byron had supplied early poems like *The Giaour* (1813) and *The Corsair* (1814) with notes to travel writers and other authorities on the East, so Thomas Moore had supplemented the writing of *Lalla Rookh* with detailed evidence of "the pains [he] took," as he later put it, "in long and laboriously *reading* for it." Looking back on all this homework in a preface to the twentieth edition of his poem (1845), Moore predictably emphasized the dependence of his "Fancy" on "fact":

> To form a storehouse, as it were, of illustration purely Oriental, and so familiarize myself with its various treasures, that, as quick as Fancy required the aid of fact, in her spiritings, the memory was ready . . . to furnish materials for the spell-work, — such was, for a long while, the sole object of my studies.[5]

Having taken "the whole range of all such Oriental reading as was accessible" to him, Moore even boasted that he had become "for the time, indeed, far more conversant with all relating to that distant region, than I have ever been with the scenery, productions, or modes of life of any of those countries lying most within my reach." As if all this were not enough to persuade the reader of his claims to "truthfulness," he followed with a bookish variation on the local witnesses rounded up for *Le Secrétaire turc* — a series of testimonials from "distinguished" authorities, each of whom certified, as one put it, "to the extraordinary accuracy of Mr. Moore."[6]

The desire to document exotic fact did not confine itself, of course, to representations of the harem. The mysteries of William Beckford's

Vathek (1786) extend well beyond the walls of the seraglio, but the obsessively detailed notes prepared by Samuel Henley for the English translation of the work provided one of the most notorious — and most imitated — examples of the genre.[7] (A correspondent to the *Gentleman's Magazine* went so far as to speculate that the tale itself had been composed "for the purpose of giving to the publick the information contained in the notes.")[8] Nor did the harem as such figure significantly in Robert Southey's *Thalaba the Destroyer* (1801) and *The Curse of Kehama* (1810), for instance, though both poems made lavish displays of their Eastern learning. Especially in the nineteenth century, what I have called the Orientalist footnote also played its part in a wider impulse of historicism — the urge to document distant times and places that resulted, for example, in the notes Sir Walter Scott appended to the "Magnum" edition of his novels in 1829–33. Yet it is not by chance that the most fantastic representations of the East are often the most weighted with documentary apparatus, or that even a late-twentieth-century fiction partly set in the Ottoman seraglio continues the convention of authenticating the narrative by reference to a scholarly source — though no such reference appears to be needed for the scenes set in nineteenth-century Italy.[9] For Western men, especially, the sealed space of the harem has long constituted at once the type and locus of Oriental mystery, and the very difficulty of getting at the facts has proved a particular stimulant to the appetite for knowledge.

Though visual artists were not in the habit of footnoting their sources, they too sought to ground their fantasies of the harem in some version of the facts. The feverish exaltation that reportedly seized Delacroix in the women's quarters at Algiers appears to have originated not in erotic excitement but in the zeal to document. Conscious of how rare an opportunity he had been afforded, he engaged in an eager flurry of visual note-taking, to be followed by an equally agitated attempt to pump the master of the house for information. According to the friend who later described the visit, "Delacroix voulait tout connaître de cette vie mystérieuse et nouvelle pour lui."[10] Still more literally than Beckford or Byron, the painter strove, in the words of the former, to be "exact" in his "costume";[11] and he duly annotated his watercolors with written memoranda as to shades and tones, as if to compensate for the potential imprecision of the medium (fig. 8).[12] There even exists a pastel where, "with his habitual care for documentary truth," as one scholar has put it, Delacroix meticulously noted the pair of babouches that would later appear in the foreground of the *Femmes d'Alger* (fig. 15).[13] The same man who had once declared external objects "nothing to the soul" now transcribed objects with such

fidelity that a modern historian of Algerian costume regards Delacroix's work as an invaluable piece of ethnographic evidence.[14]

Unlike so many Western representations of the harem, both verbal and visual, the *Femmes d'Alger* thus had its origins in a record of immediate experience. Yet the painting of 1834 did not so much represent what Delacroix saw in Algiers as what he chose to remember in Paris, and for all the ethnographic accuracy of certain details, this harem was finally constructed in the mind of the artist. Delacroix may have carefully noted the names of those whose likenesses he took on the spot, but he freely altered their portraits when he assembled them on canvas. A seminal study of the painting has shown how the finished work combines and recomposes the artist's original studies — so that the woman identified in two of the sketches as Môunî Bensoltane, for example, appears both in the figure stretched out to the left and in her closest neighbor, who at the same time owes something to an anonymous figure in another sketch that also served to inspire the black woman on the right.[15] Yet while the pose of the *algérienne* on the left evidently derives from a sketch of Môunî Bensoltane (fig. 16), her face more nearly belongs to someone Delacroix had only discovered on returning to France: the beautiful Parisienne, Élise Boulanger, for a number of years thereafter his favorite model and mistress.[16] And if to a casual eye the half-kneeling woman who holds the *narghile* adheres more or less faithfully to her Algerian prototype (fig. 8), a closer look reveals that she shares her profile with such disparate predecessors in Delacroix's canon as a dying Greek in the *Massacres de Scio* (1824) and the allegorized figure of a triumphant Liberty from the famous painting of 1830 (fig. 17).[17] As for the black slave to the right, she has no obvious origin in the images recorded at Algiers, though she vaguely resembles a sketch of a white woman also produced at the time, and her curious pose may owe something to paintings by Titian and Orazio Gentileschi.[18]

As most commentators have observed, the second version of Delacroix's painting suggests still a further remove from the initial experience — not only because the women appear at a greater distance from the viewer, but because their individual portraits have been blurred and generalized, the details of interior decoration radically simplified, the lighting and tonal contrasts of the whole softened. "It is as though Delacroix were recalling the scene," in one critic's words, "through a tinted veil of memory."[19] In 1853 Delacroix himself contended that he had only begun to make something "passable" of his African journey when he had "sufficiently forgotten the trivial details so as to recall . . . just the striking and poetic aspect" of the subject. Until then, he announced dismissively, "I had been haunted

by the passion for accuracy [l'amour de l'exactitude] that most people mistake for the truth."[20] Yet even by 1834 he had long begun this creative "forgetting," as he adapted and transformed his original sketches in the interests of his larger composition. Just as the first painting already reimagines the women, it dramatically shifts the original direction of the light, while the final arrangement of the entire harem probably owes more to a *Concert champêtre* by Giorgione than to the relative positions of the women of Algiers.[21] Even the signs of a "passion for accuracy" in this version are not always what they seem: by freely transposing pieces of the women's clothing so as to arrange them in a hierarchy of descending sumptuousness from left to right, for example, Delacroix provided not so much a literal record of local costume as an idealized schema.[22] And though a small tablet inscribed from the Koran may well have appeared on a wall of the apartment he saw in Algiers, what hangs in this harem is not a piece of Arabic at all but a fanciful bit of calligraphy that records no language but that of the artist.[23]

Understood generally enough, no doubt, some such tension between the "passion for accuracy" and the demands of the imagination characterizes any work of art that makes an attempt at representation — that tries, in other words, to present some recognizable image of the world, however faint or attenuated. Even as he insisted that it was "only a slave" to the imagination, the later Delacroix still grudgingly conceded the necessity of the model: "One borrows from it certain characteristic details that neither the most privileged imagination nor the most faithful memory could reproduce, and which give a sort of sanction to the imagined part."[24] Having recovered from the documentary fever to which he had succumbed in Algiers, Delacroix increasingly treated his own hasty sketches of the harem as just such humble bearers of the characteristic details. But precisely because most paintings of the harem, even in the nineteenth century, began and ended in fantasy, the need for something to "give a sort of sanction to the imagined part" could acquire extraordinary force. And few such images illustrate this need better than the dream vision of the *Bain turc* — all the more so, as we shall see, because illustration as such had so little to do with the artist's tenacious hold on his documents.

If we are to trust the evidence left by Ingres himself, the *Bain turc* commemorates his decades-long obsession with some eyewitness records — descriptions of Turkish women at their bath that he had first encountered in the letters of Lady Mary Wortley Montagu. Sometime in the late 1830s, if not earlier, he copied out several lengthy extracts from them into his notebooks — going so far as to write over a sheet originally consecrated

to episodes in the life of his adored Raphael. More than twenty years later, passages from the letters appear again on the back of several preparatory sketches for his painting of the *Bain turc.*[25] Strictly speaking, Ingres's pen was not so much engaged in transcribing Lady Mary's letters as freely adapting them, since the wording and order of his notes correspond to no known French edition of the work,[26] and extracts from two separate (and widely separated) letters are silently woven together as if they were one. Such evidence has even prompted speculation that the painter never actually read the text, but only recorded what he wished to remember from a loosely translated dictation.[27] Yet what seems most salient is not the manner in which Ingres encountered Lady Mary's work but his repeated impulse to appropriate and transform it — an impulse that culminated, apparently, in the familiar *tondo* that now hangs in the Louvre.

The first of the extracts that Ingres transcribed into his notebook comes from a letter by Lady Mary to an unnamed countess, written in Constantinople in the spring of 1718. As so often in the letters, Lady Mary authorizes her account by debunking some of the travelers' tales that have preceded her. Having already amused herself with the report of a miraculously sweating pillar allegedly witnessed by "the admirable Mr. Hill," she goes on to mock his pious lamentation for the "miserable confinement of the Turkish Ladys," who are, she instead affirms, "(perhaps) freer than any Ladys in the universe . . . They go abroad when and where they please. Tis true," she adds, "they have no public places but the Bagnios, and there can only be seen by their own Sex; however, that is a Diversion they take great pleasure in." The scene that caught the painter's attention immediately follows:

> I was 3 days ago at one of the finest in the Town and had the oppertunity of seeing a Turkish Bride receiv'd there and all the ceremonys us'd on that Occasion, which made me recollect the Epithilamium of Helen by Theocritus, and it seems to me that the same Customs have continu'd ever since. All the she-freinds, Relations and acquaintances of the 2 familys newly ally'd meet at the Bagnio. Several others go out of Curiosity, and I beleive there was that day at least 200 Women. Those that were or had been marry'd, place'd themselves round the room on the marble Sofas, but the Virgins very hastily threw off their cloaths and appear'd without other Ornament or covering than their own long hair braided with pearl or Riband. 2 of them met the bride at the door, conducted by her Mother and another grave relation. She was a Beautifull Maid of about 17, very richly drest and shineing with Jewells, but was

presently reduce'd by them to the state of nature. 2 others fill'd silver gilt pots with perfume and begun the procession, the rest following in pairs to the number of 30. The Leaders sung an Epithilamium answer'd by the others in chorus, and the 2 last led the fair Bride, her Eyes fix'd on the ground with a charming affectation of Modesty. In this order they march'd round the 3 large rooms of the bagnio. Tis not easy to represent to you the Beauty of this sight, most of them being well proportion'd and white skin'd, all of them perfectly smooth and polish'd by the frequent use of Bathing. After having made their tour, the bride was again led to every Matron round the rooms, who saluted her with a compliment and a present, some of Jewells, others pieces of stuff, Handkercheifs, or little Galantrys of that nature, which she thank'd them for by kissing their hands.[28]

Apart from the bathhouse setting and the crowd of naked virgins, with their good proportions and white skin, this decorous wedding reception would appear to have almost nothing in common with the *Bain turc*, few of whose lounging beauties seem likely to conjure up thoughts of an epithalamium by Theocritus.

For an artist of Ingres's sensibilities, nonetheless, the very decorum of the wedding scene is not without its relevance — nor, for that matter, is the allusion to a classical text. Here and in the other passages that he recorded, Lady Mary's eye for the formal poise exhibited by exposed flesh effectively made her representations of female beauty available to the painter. To adopt Kenneth Clark's famous distinction, she saw not naked women but nudes — a distinction that holds despite her use of the phrase "stark naked" in the extract that follows.[29] And these nudes called to mind the poetry of Theocritus because she also imagined herself to be looking upon the origins of Western civilization. Sharing the common belief of the period that in traveling East she had traveled back in time as well, Lady Mary thus provided one of the following century's classicists with a license which would justify his imaginative appropriation of her letters. Like Delacroix, who is famously said to have exclaimed upon his sight of the women of Algiers, "C'est beau! C'est comme au temps d'Homère!"[30] Ingres could believe himself to see the ancient world through a vision of the Orient — though in his case, significantly, both acts of seeing were equally filtered through books.

But before speculating any further on the pretexts Lady Mary provided him, let us look at the second and more famous of the scenes that Ingres recorded in his notebooks — a scene that superficially, at least, appears

closer to that represented in his painting.[31] This one comes from a letter to an unknown woman, dated 1 April [1717], in which Lady Mary describes her visit to the hot baths at Sofia. Ingres's notes correspond, very roughly, to the passage that follows:

> I was in my travelling Habit, which is a rideing dress, and certainly appear'd very extrodinary to them, yet there was not one of 'em that shew'd the least surprize or impertinent Curiosity, but receiv'd me with all the obliging civillity possible. I know no European Court where the Ladys would have behav'd them selves in so polite a manner to a stranger. I beleive in the whole there were 200 Women and yet none of those disdainfull smiles or satyric whispers that never fail in our assemblys when any body appears that is not dress'd exactly in fashion. They repeated over and over to me, Uzelle, pek uzelle, which is nothing but, charming, very charming. The first sofas were cover'd with Cushions and rich Carpets, on which sat the Ladys, and on the 2nd their slaves behind 'em, but without any distinction of rank by their dress, all being in the state of nature, that is, in plain English, stark naked, without any Beauty or deffect conceal'd, yet there was not the least wanton smile or immodest Gesture amongst 'em. They Walk'd and mov'd with the same majestic Grace which Milton describes of our General Mother. There were many amongst them as exactly proportion'd as ever any Goddess was drawn by the pencil of Guido or Titian, and most of their skins shineingly white, only adorn'd by their Beautifull Hair divided into many tresses hanging on their shoulders, braided either with pearl or riband, perfectly representing the figures of the Graces. I was here convinc'd of the Truth of a Refflexion that I had often made, that if twas the fashion to go naked, the face would be hardly observ'd. . . . To tell you the truth, I had wickedness enough to wish secretly that Mr. Gervase could have been there invisible. I fancy it would have very much improv'd his art to see so many fine Women naked in different postures, some in conversation, some working, others drinking Coffee or sherbet, and many negligently lying on their Cushions while their slaves (generally pritty Girls of 17 or 18) were employ'd in braiding their hair in several pritty manners. In short, tis the Women's coffée house, where all the news of the Town is told, Scandal invented, etc.[32]

Ingres's notes on this passage make no mention of Guido, Titian, or "Mr. Gervase," but he evidently rose to the implicit challenge Lady Mary issued with her representation — as if to demonstrate that he could reproduce

those "many fine Women naked in different postures" without benefit of the life-drawing class she hypothesized for the improvement of her contemporary, the London portrait painter, Charles Jervas (1675?–1739). Though dancing and playing music appear to have replaced conversation and working, the painting clearly represents white-skinned nudes drinking coffee or sherbet, one having her hair done, and, above all, "many negligently lying on their Cushions." Lady Mary does not seem to have registered the presence of any black women, but since both passages characterize "most" of the skins as shiningly white, even the blacks in the painting might be seen as simply filling in the visual cues left implicit by writing. (She specifically remarks that the women were "without any distinction of rank by their dress," but says nothing of skin color, though many such slaves would in fact have been white.) True, Lady Mary speaks of "200 Women," while Ingres contents himself with a mere twenty-five; but insofar as her number primarily signifies a crowd (a round "200" also happen to have attended the wedding reception), the painter responds by conveying his own impression of a densely populated space. In fact, the overlapping of the women's figures, the abrupt perspective, and the dramatic truncation of the bodies at the edges of the painting so effectively suggest a crowd that commentators on the *Bain turc* have had some difficulty in arriving at an accurate count of the company.[33]

Yet the more one looks at this teeming interior, the less it resembles the scenes recorded by Lady Mary. As both her letters make very clear, what she saw in the baths were not private retreats but public institutions — civic spaces in which women from different households could come temporarily together. Strictly segregated by sex, the baths nonetheless offer primarily communal pleasures, whether in formal rituals like the bridal reception or the more casual experiences of seeing and being seen, exchanging information and gossip. And this is a public life marked, as Lady Mary saw it, by an admirable decorum: recall, for example, not only the elegant ceremonies of the wedding reception, but the "obliging civillity" of the Sofia bathers, who politely decline to notice their visitor's unfashionable habit of dressing. Indeed, it is the very "state of nature" in which the women appear that gives their civilized control of themselves such piquancy: at Sofia, the women managed to greet their visitor without showing "the least surprize or impertinent Curiosity," and despite their utter nakedness, "there was not the least wanton smile or immodest Gesture amongst 'em."

Why is it that so much commentary on Ingres's painting speaks of the "harem," effectively assimilating his women to the private quarters of

an individual household? Perhaps this change of venue should partly be attributed to the wishful ignorance of the commentators, with any representation of more than one woman in a vaguely Oriental setting constituting a harem for the purposes of some long-lived masculine fantasies in the West. That Ingres's first biographer could refer to the passages from Lady Mary as themselves describing "les moeurs intérieures du harem" suggests just how easily such a fantasy may override the evidence.[34] But while Ingres's own records of the painting refer merely to Turkish women at the bath, the effect of his image is radically to privatize what the eighteenth-century Englishwoman saw. By placing the musician and the woman to her right so prominently in the foreground of the picture, arbitrarily compressing the distance that separates them from the frieze of figures in the rear, and keeping the viewer's perspective sufficiently low to cut off any view of the ceiling, he manages to produce an impression of striking intimacy — an impression all the more striking because this intimacy is maintained, as in the fantasized relations of the harem, with such a multiplicity of women. Rather than the polite distances of a public space, the *Bain turc* evokes the crowded familiarity of a private interior, whose inhabitants touch and intertwine with careless abandon.

Lady Mary did not say what "immodest" gestures from the Sofia bathers she might have expected, but, given the postures of some of the women in the *Bain turc*, it is worth noting here that tales of lesbianism among the harem were already well established in the travel literature of the period. "Les femmes orientales ont toujours passé pour tribades," Chardin had confidently announced in his *Voyages* of 1711, and he went on to report that he had heard such accounts so often and from so many people that he was convinced of their truth.[35] Since Ingres in turn had included the *Voyages* on a list of books he intended to consult and to "know," bits of Chardin's Persia may well have made their way into the painter's version of Lady Mary's Turkey.[36] No doubt the familiarity with which a number of the bodies in the *Bain turc* touch one another contributes powerfully to the harem-effect of the painting, though like other erotic signals in Ingres's work, the intimations of homoeroticism in the scene are at once strong and elusive. What may at first seem the most salient gesture in this regard proves, strictly speaking, an illusion: while to some eyes the hand cupping the breast of the woman in the foreground appears to belong to her companion with the diadem, preliminary sketches for the painting identify it as her own (fig. 18).[37] Yet the ambiguity of the final version remains, and the rapt intensify with which both women gaze at the averted face of the musician only increases the mysteriousness of the image — as does the

fact that the diademed head attaches itself to no possible body (apart, that is, from the single hand that rests upon the other woman's shoulder). In the appropriately equivocal words of Richard Frost's poetic meditation on the painting:

> Over on the right, wearing a ruby necklace,
> is a sleepy redhead with her forearms behind her neck
> in that timeless pose, and she partly obscures
> two others so that you can't tell whether one of them
> is fondling her own breast or the other is doing it.
> Except that when you look at their faces, you know which one.[38]

Whether one identifies the hand at the breast as homoerotic, autoerotic, or simply as the tantalizing half-concealment of modesty, it evokes a sensuous intimacy with the flesh that seems far removed from the public gestures recorded by Lady Mary.

The effect of Ingres's choices in the *Bain turc* may be brought into focus by comparison with another representation inspired by Lady Mary's visit—this one a 1781 engraving by the Berlin artist, Daniel Chodowiecki (1726–1801), that appeared as a frontispiece to several editions of the letters (fig. 19). Ingres may well have seen Chodowiecki's work,[39] but the image is less instructive as a possible influence on the *Bain turc* than as an alternative. Despite the fact that the population of the engraving is less than half that of the painting, the public scale of this scene is unmistakable. Having faithfully reproduced the dome and skylight as Lady Mary described them, Chodowiecki evokes something of the vast dimensions of the space in the empty expanse of wall and ceiling that occupies virtually the top half of the engraving, as well as in the bare floor that divides the figures standing in the foreground from those lounging in the rear. Here too are the naked women "negligently lying on their Cushions," but they are kept, one might say, in a proper perspective — politely distanced from the viewer. Nor do they lie with anything like the abandon of the more relaxed inhabitants of the *Bain turc*: these are still the postures of women conscious of their neighbors. The attitude of the pair to the right even hints at interrupted conversation, while some of the "obliging civillity" in Lady Mary's account may perhaps be translated by the tactful bearing of the slave who seems to hesitate before offering further drink to her mistress. Many of Ingres's women appear so absorbed in sensuous experience or private reverie as to be oblivious to their surroundings, but here no one sleeps, and only the attendant who carries off the urn detaches herself from the others.

Chodowiecki's image also underscores Ingres's most fundamental transformation of Lady Mary's text — the decision to eliminate her presence. A modern critic has suggested that the absence of Western observers is "one of the defining features of Orientalist painting," another of which is the absence of a sense of history.[40] Certainly the timeless dream-world of the *Bain turc* would find it difficult to accommodate the presence of Chodowiecki's fashionable Englishwoman in her riding habit. Like the letters it illustrates, the engraving records a confrontation of cultures, a particular episode in history. Equally to the point, from Lady Mary's perspective, is the reciprocity with which Chodowiecki's nudes look at the woman who has come to view them. For as she describes her visit to the bathers at Sofia, her own wonder at the strangeness of the scene is matched by her awareness that she must have "appear'd very extrodinary to them" — a relativity of viewpoint all the more pleasingly ironic because the rules of undress governing the occasion so thoroughly reverse the customary standards of propriety. In fact, at the moment illustrated by the engraving, the play of curiosity in the exchange is about to turn on the English woman. After recording her surprise at the women's ability to remain four or five hours at the baths without getting cold, the letter quoted earlier continues:

> The Lady that seem'd the most considerable amongst them entreated me to sit by her and would fain have undress'd me for the bath. I excus'd my selfe with some difficulty, they being all so earnest in perswading me. I was at last forc'd to open my skirt and shew them my stays, which satisfy'd 'em very well, for I saw they beleiv'd I was so lock'd up in that machine that it was not in my own power to open it, which contrivance they attributed to my Husband.[41]

Though modern readers have found this perhaps the most resonant moment in the embassy letters,[42] its ironies have no place in the dream-world of the *Bain turc.* Having removed the observer from the scene and assimilated her gaze to the privileged viewpoint of the painter, Ingres converts a social encounter into a private vision, a dream in which the dreamer himself remains invulnerable to observation. As Chodowiecki's example makes clear, in fact, the presence of a visitor on the scene would have considerably diminished its eroticism. To share in the artist's fantasy, the viewer must remain strictly outside the frame, gazing upon a collection of nudes who are themselves oblivious of his presence. Preserving the illusion of an inviolable space even while inviting us to violate it, Ingres transforms Lady Mary's public baths into the haremlike enclosure of his fantasy.

Ever since the existence of the notebook extracts was first reported by
Ingres's pupil and biographer in 1870, few commentators on the *Bain
turc* have failed to invoke Lady Mary in their turn. One solemnly calls the
painting "une illustration parfaite" of Lady Mary's letters; another "la plus
magistrale illustration des nudités décrites par Lady Montagu." Others
allude vaguely to the painting's inspiration, source, or — a term that come
closest to the truth — its "prétexte."[43] For it is not just the theoretical im-
possibility of "illustration parfaite" that makes the relation of word and
image in this case so problematic. Every painting inspired by a verbal
representation necessarily departs from its origins, but no viewer of the
Bain turc would recognize the connection to Lady Mary without the
evidence of the notebooks. Nor is this a matter of the relative obscurity
of the source — the Turkish embassy letters, for all their fame, hardly
prompting the sense of familiarity evoked by scenes from the Bible, say,
or the plays of Shakespeare. Indeed, while Ingres evidently did expect
his renditions of *Roger et Angélique*, for example, to recall Ariosto, or
his *Oedipe et le Sphinx* to evoke the mythical encounter it represented,
we have no reason to believe that he wanted the *Bain turc* to elicit any such
recognition from the viewer. The relation to Lady Mary remained for
the artist alone.

Yet the real question is why he needed her at all, so remote is his dream
of a harem from her accounts of civic dignity at the baths. Lady Mary
offered the report of an eyewitness, but Ingres did not look to her for the
sort of public authentication a writer might include, for example, in an
Orientalist footnote. Nor, obviously, did he want from her a verbal des-
cription of something to paint, a scene to illustrate. On the contrary: what
he sought in her testimony can only have been the ground for fantasizing.
It is only against such a distinct ground, after all, that any fantasy can de-
fine itself — which is to say that the more deliberately Ingres set about
dreaming of his harem, the more he needed to hold on to the accounts of
the apparent reality with which Lady Mary had provided him. The very
persistence with which he returned to his extracts testifies to the force
of the requirement. Lacking a model, he turned to her documents for
"certain characteristic details," in Delacroix's words, "that neither the most
fertile imagination nor the most faithful memory could reproduce, and
which give a sort of sanction to the imagined part." When almost every-
thing depends upon the imagination, even one naked woman drinking
coffee or sherbet may not be as incidental as she may seem. Precisely
because the artist was dreaming about something he could never have
witnessed, he had all the more need for an inside report.

4
The Fantastic Facts of
Les Désenchantées

That Europeans craved authenticating details of harem life did not mean that they were necessarily in a position to recognize the truth when they saw it. Until the nineteenth century, few European women followed Lady Mary into the households of the East, and even in the nineteenth century, few European men had anything like Delacroix's face-to-face encounter with the Algerian women in their apartment. Most representations of the harem necessarily began not with direct experience but with prior representations, both visual and verbal.[1] Thomas Moore might earnestly seek to ground his "Fancy" in "fact," but the ease with which his "storehouse . . . of illustration purely Oriental" — the phrase itself is telling — could accommodate both Aaron Hill and Lady Mary, for example, suggests how little his own imagination finally worried the difference.[2] Some Orientalist footnotes themselves derived from other footnotes: by his own account, Byron drew the annotations for his first Eastern tale, *The Giaour* (1813), not only from such standard reference works as d'Herbelot's *Bibliothèque Orientale* (1697), but from the notes that Henley had already compiled for Beckford's *Vathek*; in the following year, the author of still another Eastern tale documented his work by simply plagiarizing Henley's notes almost verbatim.[3] And even direct experience, of course, never came unmediated. Lady Mary may have provided Ingres with the eyewitness he wanted, but what she saw had already been filtered through other works of art and literature — an epithalamium by Theocritus, for example, or the paintings of Guido and Titian.

Whatever the limitations of such inside stories, for most of the period in question there were simply no other accounts to be had. Between the strict privacy of the institution itself — especially of the imperial harem — and the absence of written records by women, modern historians in search

of the facts must still attempt to sift them from the words and images recorded by European visitors.[4] Only toward the end of the nineteenth century did Eastern women begin to publish their own accounts of life in the harem; and since virtually all such women came from upper-class households that had themselves been exposed to European culture and fashion, it is hardly surprising that their inside stories were also partly inflected by some fictions of the West. In 1890 "A Voice from the Harem" who signed herself "Adalet" reported in a British journal on the contemporary corruption of Turkish harems, whose young inhabitants, by her account, had been abruptly unsettled by too much reading in European novels. "The young girl, who before believed that the highest happiness for her was to be tyrannised over by a man she did not know, in common with five or six rivals, suddenly saw opened before her a long vista of unknown bliss which to her dazzled eyes seemed more beautiful than anything promised in Paradise." According to Adalet, who herself began by citing Thackeray's *Voyage* [sic] *from Cornhill to Cairo,* "the leap from ignorance to knowledge was too sudden for the Turkish woman," who was "dazzled by the bright glare which suddenly surrounded her," had "very dim ideas of what was right or what was wrong," and inevitably "missed her way."[5] In her rather lurid memoirs of life in the imperial harem of Persia at the turn of the century, the princess Taj al-Saltana interrupted a sentimental defense of the sultan's favorite to wish that she were "a competent writer like Victor Hugo or Monsieur Rousseau and could write this history in sweet and delightful language." Her modern editor suggests that she patterned her memoir on Rousseau's *Confessions.*[6]

And how to determine the relation of inside and outside, fact and fantasy, when the authors of such memoirs had themselves grown accustomed to dwelling imaginatively in harems of the mind? "We Turkish women read a great deal of foreign literature, and this does not tend to make us any more satisfied with our lot," Zeyneb Hanoum explained in her *Turkish Woman's Impressions* of 1913. Among her "favourite English books," she immediately went on to report, were the *Letters* of Lady Mary: "Over and over again, and always with fresh interest, I read those charming and clever letters." As Zeyneb saw it, there was "nothing in them to shock or surprise a Turkish woman of to-day in their criticism of our life," because almost nothing had changed in Turkey since their author had visited.[7] In an article billed as "A Romance of Real Life," her sister, Melek Hanoum, told the *Strand Magazine* in 1926 how she had "escaped from the harem" and become a dressmaker — an outcome that she traced partly to her "European blood" (her father was half-French) and partly to a sophisticated

education that had included three Oriental and five European languages. And just as their grandfather, by Melek's account, had been an ardent student of Rousseau, she and her sister eagerly consumed the novels of Pierre Loti. "We knew his works," she declared, "almost by heart."[8]

The author of *Aziyadé* did enjoy quite a following in Turkey,[9] but in the case of these sisters reading the fiction of Loti had long since become hopelessly entangled with writing and living it. Though neither woman was exactly the "heroine" of Loti's last novel, as each of them boasted, there is no question that they had helped to inspire it — which is to say that the author of *Les Désenchantées* (1906) had based his inside story of the harem on the testimony of those who already understood themselves through the representations of the West, his own prior fictions included. Like almost all Loti's writing, this immensely popular novel adhered very closely to the author's immediate experience.[10] Presenting itself as a "roman des harems turcs contemporains," in the words of its subtitle, Loti's vertiginously self-reflexive fiction professed to tell how a successful French novelist named André Lhéry had become emotionally involved with three restless inhabitants of the modern harem, who eventually persuaded him to write a novel — called *Les Désenchantées,* of course — that would convey their suffering to the world. Moved by their own reading in the literature of the West, the *désenchantées* chafe under their arranged marriages, resist polygamy, and long to meet and love men as equals. Yet while Zeyneb and Melek had evidently served not only as models for the novel but as partial collaborators in its making, the role of heroine clearly belongs to one the novel calls "Djénane": a mysterious figure who increasingly reminds the novelist of his first Turkish love (and first heroine), the green-eyed Circassian whom he had abandoned to die of grief in Constantinople many years ago. Unlike Loti's first alter ego in *Aziyadé* — unlike all his fictional surrogates, for that matter — the hero of this last novel never consummates his affair with the heroine. But when Djénane finally decides to kill herself rather than return to the harem of her former husband, she first writes an impassioned suicide letter in which she confesses her love for the novelist.

Almost two decades after that fictional suicide, however, and half a year after Loti's own death, there appeared in Paris a book entitled *Le Secret des "Désenchantées"* (1924) which also professed to have been written by the novel's heroine — a "Djénane" who the opening line baldly announced was not in fact dead.[11] The author of this book had a pseudonym, Marc Hélys, but her real name was Marie Léra; and as she made unmistakably clear, the original of Loti's suicidal Turk was not only alive but a

professional writer—and a Frenchwoman.[12] Though Loti had never seen the heroine of his last romantic adventure without her veil, the woman he imagined had begun life as a "petite princesse barbare" on the distant plains of Circassia was in reality a French turcophile like himself, a journalist whose own sketches of life in the modern harem, *Le Jardin fermé* (1908), had appeared in Paris just two years after *Les Désenchantées*.[13] Indeed, when an anecdote that she had passed on to Loti did not appear in his novel, Hélys had later "taken it back," she explained, and used it for her own work instead (*Le Secret*, 230n).

As Hélys told it, *Les Désenchantées* had its origins during her second extended visit to Constantinople in the spring of 1904, when she and the two sisters (whose real names were Zennour and Nouryé), decided to enliven "the monotony of their existence" by arranging a clandestine meeting with the novelist (11). The trio began, she acknowledged, in a spirit of idle game-playing, and it was only when they saw how deeply moved he was by their actual encounter — so moved, indeed, that they ironically wondered whether he was really in the habit of having "les aventures" or only imagining them — that they decided to "*arranger de jolis souvenirs pour Pierre Loti*" by making him "vivre un roman" (28, 29). The idea of helping him to write one came a little later, but for Loti, as they well knew, the distinction between living a novel and writing it had practically disappeared long ago. Ever since the young naval officer had adapted his journal of his affair with a woman from the harem into the autobiographical romance of *Aziyadé*, Loti had not so much invented his narratives as transcribed his experiences and written them up, slightly revised, in the form of fiction.[14] If Loti were now to write a novel about modern harem life — or at least the novel the Frenchwoman and her friends wished him to write — he would first need that "aventure *vraie*" with which they proposed to supply him (76). As Hélys summed up the logic of the deception in her preface to *Le Secret*:

> But in order for him to be able to write this book in which the Muslim women of Turkey placed their hopes, it was necessary that Pierre Loti be provided with the documentation [fût documenté]. And it was not enough that he be provided with the documentation: it was necessary that he be moved. To write the novel of the Turkish women, it was necessary that he live it. (viii)

Between a "real adventure" and the theatrical representation of one, "documenting" an experience and inventing it, the women preferred

not to distinguish too closely. Despite his amorous history in Constanti-
nople more than a quarter century earlier, Loti had never entered a harem:
Aziyadé (or rather Hatidjé, as she seems really to have been called) had
always come to him. Now the *désenchantées* invited him to a clandestine
meeting within the confines of a genuine harem, an address appropriately
hidden away in the heart of old Stamboul. The apartment belonged to a
poor Circassian friend, a woman who also suitably "adored" the hero of
Aziyadé, Hélys reported, the two sisters having translated for her its most
moving pages (58). The location had the further virtue, as the women saw
it, of lacking the European bric-a-brac that would have cluttered up the
interiors of wealthier owners. But if this "maison turque" was "authentique"
enough (66), it also appears to have struck the conspirators as somewhat
deficient in authenticating details. To assure that Loti's first experience
of a harem was sufficiently moving, they therefore decided to deck out
the apartment with what amounted to a collection of Oriental stage props:
by Hélys's reckoning, the "décor" they brought to the meeting included
embroidered silks and cushions, coffee cups filigreed with gold and sil-
ver, local sweets, perfumes, and flowers to strew about the rooms (64).
They hoped, Hélys suggested, to throw "un reflet de mystère" over the
scene; and in this they would appear to have succeeded (66). When
he came to record the episode in the novel, Loti registered both the
excitement of really penetrating the harem at last and the sensation of
inhabiting a fantasy, the "pleine invraisemblance" of an Oriental tale:

> For the first time in his life, he was *in a harem* — a thing which, with all
> his experience of the Orient, had always seemed to him impossibility
> itself; he was *behind* those lattices of the women's apartments, those
> lattices so jealous that no men, *other than the master, ever see except from
> outside*. And below, the door was bolted, and this was taking place in
> the heart of old Stamboul, and in what a mysterious dwelling! . . . He
> was here in the complete improbability of an Oriental tale; they could
> have said to him: "The fairy Carabossa will emerge from underneath
> the divan, touch the wall with a stroke of her wand, and this will be-
> come a palace," and he would have accepted it without any further
> comment.[15]

This was not the only harem that the women worked up for Loti's benefit.
Later, after Hélys herself had returned to Paris, the sisters managed to
arrange a visit to Zennour's own apartments — a feat less difficult than it
might seem, according to *Le Secret*, because the married Zennour lived
in a "ménage à la moderne," with no extended family or large retinue of

servants to inhibit her (206). Predictably, the women seem to have felt that a little Orientalizing was again advisable, lest this all too modern harem not look sufficiently harem-like to their Western visitor.[16]

Though exotic sexual adventures had long dominated Loti's fiction, only in *Les Désenchantées* did the novelist grant his surrogate an imaginary harem of his own. And he was able to do so, ironically, by virtue of the very distance at which the three women kept him. Whether Lhéry is conversing with "les trois petits fantômes de son harem" in the first apartment to which they have summoned him (180), or taking up the part of "Arif Bey et son harem," as he dons his fez and accompanies the veiled women on the streets of Stamboul (301), he tacitly accepts his exclusion from sexual intimacy as the price of entering into the fantasy. On an excursion to an old mosque on the shore of the Bosphorus, he stops with the three veiled women in a humble café: "And the old fellow with the white beard served them coffee in his old blue cups, there, outside, in front of the mournful Black Sea, never doubting at all that he was doing business with an authentic bey on a pilgrimage with the women of his harem" (259–60). Though this decorous tableau may seem far removed from the images customarily produced by male fantasies of the harem, it is not surprising that Lhéry projects the scene through another man's eyes, or that the evidence for his possession of several women remains essentially visual. Neither Loti nor his fictional surrogates were ordinarily shy of collecting sexual experiences. As we shall later see, however, there is a sense in which the eye is the only organ by which men realize their dreams of possessing more than one woman simultaneously.

While the conspirators deliberately evoked the memory of their beloved predecessor at every turn, they had no intention of imitating her actual affair with the novelist. What they wished instead was to move him with a narrative of their lives — a narrative that necessarily fell to the professional among them to write. Especially after Hélys found herself required to return to France, the effort to assure that Loti be "documenté" turned literally into an effort to provide him with documents — letters in which the Frenchwoman would spin out the imagined emotions and history of the woman he knew as "Leyla," while Zennour and Nouryé would in turn supply her by post with the authenticating details. From Paris and for a time from Scandinavia, Hélys set herself to inventing a narrative that would evoke for Loti the "atmosphère d'une maison turque" and familiarize him with the "détails intimes" of its life (209). Instead of Oriental cushions and perfumes, the Turkish sisters now carefully specified the itinerary of her pretended sojourn in Smyrna, passed on bits of local

gossip and customs, and scolded their absent friend when her narrative seemed to them still lacking in "précision" (208).

That Loti should have concentrated his Oriental nostalgia on his masquerading countrywoman is an irony that in retrospect, at least, seems conspicuously overdetermined. The most provocatively mysterious of the three — because, of course, she had the most to hide — Hélys was also the one most capable of providing him with the verbal stimulus he needed. Even as her consistent refusal to unveil herself allowed her to serve as the blank surface upon which he could project his fantasies of Eastern secrets, so her writing could mirror back to him the Orient he desired. For if she relied on her Turkish friends to help document her imaginary life in the harem, she also clearly drew inspiration from the prior representations already conjured up by the novelist. So she freely embroidered on his hints of Aziyadé's childhood among "les farouches Circassiens, à moitié sauvages,"[17] for example, to invent "Leyla's" own Circassian "enfance barbare et poétique" (240), or openly recalled his evocation of Oriental roses in the recently published *Vers Ispahan* (1904), as she settled down in Paris to conjure up the flowers then purportedly blooming behind the somber walls of her family's old-fashioned *conak* in Smyrna (92).[18] Indeed, for the supremely narcissistic Loti, one of Hélys's particular charms would have been her gift for sounding very much like himself. She produced texts "déjà si lotiennes" that they had only to be "surlotisées" — in the witty formulation of a recent critic — for the novelist to incorporate them, as he did, in his fiction.[19]

When Hélys first chose to publish the "secret" of Loti's novel, she rested much of her case, in fact, simply on the juxtaposition of the relevant documents: in an ironic reversal of the usual method for authenticating narratives of the harem, the body of her book reproduced the actual correspondence she and her friends exchanged with Loti, while the notes at the foot of the page supported the truth of her claims by quoting at length from the fiction.[20] Between the evidence of the manuscripts, which she later took the additional precaution of depositing in the Bibliothèque Nationale, and the fact that the narrative of *Le Secret* accords closely with the sequence of events recorded in Loti's journal, to which she had no access, even critics distinctly hostile to her motives in the affair have accepted the basic truth of her story.[21] But Hélys's revelations did not so much settle the question of *Les Désenchantées'* own truthfulness as exacerbate doubts already in the air. As early as 1907 a Turk named Lufti Bey Fikri had published an extended critique of the novel's authenticity, in which he accused it of misrepresenting everything from the prevalence of latticework on Turkish windows to the

aspirations of its heroines. Djénane and her cousins, he baldly announced, were simply not recognizable as his countrywomen: "Nous les prenons plutôt pour trois françaises déguisées en femmes turques!"[22] Two years later another writer who identified himself as "un Oriental" and "un compatriote des héroïnes de M. Loti" joined the attack. Sefer Bey took specific pleasure in remarking the extraordinary learning Loti attributed to his heroines — the familiarity with Kant and Nietzsche, the reading of Dante in Italian and of Shakespeare and Byron in English, the discussions in German of the music of Gluck and Wagner. "O Orient!" as he ironically summed up this catalogue, "que de fadaises [nonsense] on commet en ton nom." Singling out the more implausible aspects of Djénane's history in particular, Sefer noted how "ce prodige" had somehow managed to transform herself from a little barbarian princess at age eleven to a sophisticated mistress of five languages, not to mention *The Critique of Pure Reason* and *Thus Spake Zarathustra*, by the time she was seventeen. The details of her marriage, he suggested, were equally unbelievable. Dismissing her as a product of an overheated imagination, he addressed her directly only to deny that she had ever existed: "You do not exist, you will never exist, you are nothing but a myth, a phantom, a zephyr of the Bosphorus that will disappear as soon as the gentle fan that has produced it ceases to stir." Later characterizing all the *désenchantées* as nothing but dolls made for exportation and designed for the use of readers "mal informées," Sefer argued, reasonably enough, that the real aim of the novel was the "glorification" of its hero.[23]

But if Sefer's suspicions of Loti's novel were obviously not unfounded, his wholesale dismissal of it as an alien fantasy had some wishful distortions of its own. Despite the French writer's representation of the *désenchantées*, Sefer assured his readers happily, there was not a single Muslim family in which such giddy creatures existed. Far from feeling restless and dissatisfied as a consequence of her exposure to the West, "la femme turque authentique" had not heard of Kant and Nietzsche, nor did she suffer at all from "claustration" in the harem. Indeed, precisely because she was enclosed in the harem, she considered herself happier than other women, more entirely the mistress of her own "intérieur." And so far at least, Sefer contended, she had also managed to remain free of the "vices" that afflicted her sex in other countries — by which he meant, apparently, that she was neither worn out by factory-work, weakened by drink, nor degraded ("avilie") by the need to live at the expense of her "dignité morale." Sefer's critique of *Les Désenchantées* was also, in short, a tendentious defense of the purity of Oriental womanhood; and for all

his shrewdness in detecting a Western fiction masquerading as Turkish, he refused to recognize the possible existence of a Zennour or a Nouryé. "Non, M. Lhéry," he wrote at one point of the opening scene in which the hero receives his first message from *les désenchantées*, "la femme qui vous a écrit n'est pas la musulmane de l'an 1322 . . . Elle peut être le produit d'une très brillante imagination . . . elle peut être Française, Anglaise, Allemande ou Américaine, mais Turque, jamais!"[24] Though Hélys's subsequent revelations may make this triumphant bit of rhetoric seem particularly prescient, the text in question actually had its origins in the first fan letter composed by Zennour.

A few months before *Les Désenchantées* had begun to appear in the *Revue des deux mondes*, its two Turkish models had themselves shown up in France, having fled Constantinople in part to escape the scandal that would follow if they were recognized in its characters. The news of their flight attracted much attention, especially since they were the daughters of a prominent government official, and a lengthy account of their "escape from the harem" (heavily revised, it seems, by Loti) appeared in several numbers of *Figaro*.[25] Though the dramatic arrival of these genuine *désenchantées* in Paris lent "un intérêt d'actualité considérable," as Hélys later put it, to the imminent publication of the novel (271), it was not until Sefer had published his attack that the sisters retaliated by revealing their relation to Loti's principals. In an article entitled, with a certain redundant defensiveness, "La Vérité vraie sur les 'Désenchantées,'" Zennour not only insisted on the utter truthfulness of Loti's narrative (including the death of that pure Circassian, Djénane), but responded by accusing Sefer in his turn of not being authentically Turkish. He was, she had recently learned, "ni bey, ni Sefer, ni musulman, ni Turc" but merely a wealthy Levantine—and thus, of course, a man who had never set foot in a harem.[26]

It is perhaps just as well that Sefer did not respond by observing that Zennour's French grandfather only proved his point about "la femme turque authentique." But the very fact that "authenticity," in this elusive sense, had become a matter of dispute suggests that the changing expectations chronicled by *Les Désenchantées* were not altogether a fiction. Even the Turkish critic who had first questioned the nationality of the novel's heroines had nonetheless testified, after all, to "un malaise social" among the modern inhabitants of the harem.[27] And though both the number of *désenchantées* and the extent of their disenchantment were much debated, other contemporaries shared his perception.[28]

The same year in which Sefer Bey confidently proclaimed that "pas une seule famille musulmane" contained such creatures as Loti depicted,[29]

another dubiously authentic Turk, Demetra Vaka, published a rather
different account of modern attitudes in the harem. Born in Turkey, though
of Greek descent, Vaka had subsequently married an American, only to
return to her homeland six years later to study the condition of its women,
her own "mind full," in her words, "of Occidental questioning." Despite
her new identification with the West, however — or perhaps because of it
— she had no patience for those she contemptuously dubbed the "Suf-
fragettes of the Harem." A chapter of *Haremlik: Some Pages from the Life
of Turkish Women* (1909) describes a clandestine meeting of these would-
be agitators: beneath banners that proclaim *"Down with the Old Ideas!"*
in letters of "fiery red," the women give speeches that denounce "the
tyranny of man," admire the "courage" of Americans in "discarding their
husbands," and make high-minded allusions to George Sand and George
Eliot, Kant and Schopenhauer. More sympathetically, *Haremlik* elsewhere
tells the story of a young woman, taught by the literature of three Euro-
pean languages to yearn discontentedly for romantic love, who concludes
that "it is wrong for women to think . . . wrong, at least, for us women of
the East." Yet if both Vaka's sentimentality and her satire are heavy-handed,
there is no reason to think that her reports of such discontent did not ori-
ginate in some actual experience. Like other Western observers at the
time, including Loti himself, she felt profoundly ambivalent about the loss
of "the good old times" in modern Turkey.[30] Indeed, though Loti showed
every sign of wanting to believe, against his own suspicions, in the reality
of his last adventure with the women of the harem, it was scarcely his own
wishfulness that shaped his representation of their unhappiness.[31]

To judge by subsequent events, there was no question that in Zeyneb's
case, at least, a state of disenchantment was all too genuine. Though she
had initially fled to "the country of Liberté, Egalité and Fraternité," in the
hope that there she would at last be free, first France, then Switzerland
and England disappointed her. In a Swiss hotel, the gossip of the other
guests recalled "the degrading supervision of the Sultan's spies" and con-
vinced her that "there is no privacy inside or outside Turkey"; a ladies' club
in England seemed only "another kind of harem," but with "none of the
mystery and charm of the Harem of the East." The Liberal government's
treatment of the suffragettes — the discovery that "England not only impri-
sons but tortures women," as she put it — was the "cataclysm" of "all [her]
most cherished faiths," while the boredom of watching Parliament in ac-
tion from the Ladies' Gallery proved an all too familiar experience. "But,
my dear," she wrote to her English editor, "why have you never told me
that the Ladies' Gallery is a harem? A harem with its latticed windows!

The harem of the Government!" Acknowledging "what a disappointment the West has been," she returned to Turkey—once "again," in her words, "a *désenchantée*."[32] As for those who remained at home, one local observer, who thought the original number of *désenchantées* small, and not, as she said, "the most interesting" of her compatriots, professed to find their ranks dramatically increased by the publication of Loti's novel. "Yes," she told a writer for the *Revue des deux mondes,* "many women have learned that they are terribly unhappy. They were unaware of it, before they read the novel."[33]

The elaborate hoax behind *Les Désenchantées* may appear to make it a special case. But both the novelist's need for "documentation" and the conspirators' impulse to work up that documentation from prior fictions, including his own, only exaggerate tendencies long manifest in Europe's inside stories of the harem. While most such stories staked their claims to truth by dismissing previous reports as fiction, Loti openly presented his account as a novel; yet his lifelong reliance on direct experience to produce his works meant that *Les Désenchantées* would be taken as the thinly disguised record of an actual encounter — as indeed it was — with some women in Turkey. Though he did not classify his work as a traveler's report, in other words, it, too, implicitly promised to reveal the hitherto undisclosed truth behind the closed walls of the harem. And despite the charade that Hélys and her friends put on for his benefit, the work that resulted was not altogether a fiction — not only in the sense that Loti faithfully transcribed their conversations and letters, but in the sense that at least some of their contemporaries appear to have shared in the restlessness they wished to convey to him. While the harems he entered were decked out like stage sets, they were nonetheless apartments actually inhabited by Turkish women. Yet the very fact that he could get inside also meant, ironically, that the harem as he imagined it would continue to elude him — which was why, after all, the conspirators felt the need to supplement the scene with Orientalizing props and to provide him with a narrative that conformed to his own earlier fictions. As Loti half-acknowledged when he associated his presence in the scene with the unreality of a fairy tale, the prospect of getting inside the harem had long excited Europeans precisely because they imagined it as a place whose mysterious difference depended on keeping them forever excluded. Even as *Les Désenchantées* purported to speak for those who wished to break down the barriers, its makers continued to build such harems of the mind.

Part Two
Confinement and Liberation

A Prison for Slaves

Evropean longings for freedom were built into the seraglio from the
start. Strictly speaking, in fact, both the possibility of being impris-
oned in a seraglio and the chance of escape from one existed only in
the European imagination. As we have already seen, the English "sera-
glio," like the French *sérail*, comes from the Italian *serraglio*, a word born
of etymological confusion between the Turco-Persian for palace, *saray,*
and the Italian *serrare*, to lock up or enclose. Westerners imagined, in other
words, that to be locked up was part of the very definition of an Eastern
palace. By a related logic, the "seraglio" came especially to be identified
with that section of the palace in which the women were confined — the
word in this sense serving as a common synonym for "harem." Beginning
at least as early as the seventeenth century, travelers repeatedly attempted
to correct the false etymology, but the terrors of the seraglio had taken too
deep a hold on the collective imagination to be easily exorcised.[1]

Routine tropes for the harem testify to similar anxieties — none more
clearly, perhaps, than that of the prison. When in *The Bride of Abydos* (1813)
Byron alludes to "the Haram's grating key" (1.3.67) or compares the heroine's
"gorgeous room" to a gloomy "cell" (2.5.83–85), he draws on a figurative
tradition so familiar as virtually to pass without notice. Early in Montes-
quieu's *Lettres persanes* one of Usbek's wives refers to "this place where
I am locked up [enfermée] according to the requirement of my position";
in the very next letter from Persia the chief eunuch himself complains of
being "enfermé dans une prison affreuse."[2] Montesquieu in turn relied
heavily on the account of Jean Chardin, whose *Voyages en Perse* (1686–
1711) simply declared, "Le sérail du roi est communément une prison
perpétuelle."[3] Though Chardin claimed that the Persians guarded their
women far more closely than did the Turks (a fact which he attributed to

the heightened passions of a hotter climate),[4] two years after he first pub-
lished his *Voyages* another Frenchman seems to have twice
used the same idiom — "prison perpétuelle" — to characterize the Grand
Turk's *sérail*.[5] Given the tendency to confuse all harems with that of the
Ottoman sultan, and the sultan's harem with his entire seraglio, even
descriptions of a part of the palace called in Turkish the *Kafes*, or Cage,
may have obscurely contributed to the figure of the harem as prison. In
Le Sécretaire turc of 1688 the same prison metaphor characterizes both
the Grand Seraglio as a whole and this structure within it.[6] In fact, the
Kafes had nothing to do with the seclusion of women, its function being to
confine all princely rivals to the current inhabitant of the sultan's throne.[7]

Of course the prison was not the only institution evoked in Western ac-
counts of the harem. As we shall see, the association between the harem
and the brothel was so deeply engrained in the European imagination
that the only definition of "seraglio" in Johnson's *Dictionary* (1755) — "a
house of women kept for debauchery" — fails to distinguish between the
foreign institution and the British fashion of thus naming local whore
houses.[8] Not altogether paradoxically, several centuries of European
commentators also thought that harems looked remarkably like nunner-
ies. Typically, they spelled out the grounds of the likeness — noting, for
example, how the communal sleeping arrangements in a harem resem-
bled those of a convent, or remarking, as did Chardin himself, the way both
institutions provided all necessary services within their walls.[9] But while
commentators argue the resemblance to a nunnery, they take the prison
as a given, an automatic figure of speech rather than a subject of proto-
ethnographic investigation. Or rather, they treat their entire accounts as
tacit arguments for the metaphor, so overdetermined is the imagination
of a loss of liberty. When Mrs. Pickersgill adopted some familiar lines from
the fifth act of *King Lear* as an epigraph to her versified *Tales of the Harem*
in 1827 — "So we'll live / And pray and sing, and tell old tales, and laugh /
At gilded butterflies" — she could take for granted that her readers would
grasp their relevance.[10] ("Come let's away to prison," Lear says to Corde-
lia: "We two alone will sing like birds i' th' cage.")[11] The harem may be
like a nunnery, but in many Western representations it simply *is* a prison.

Even a Victorian woman inclined to discriminate one harem from an-
other — and determined to substitute the "matter-of-fact" for her readers'
expectations of "romance" — drew on the figure automatically as she
glimpsed the sultan's gardens through "the many latticed openings con-
trived for the gratification of the fair prisoners."[12] Despite her relative
sympathy for Turkish culture, Julia Pardoe could not allow her boat to pass

Seraglio Point without fervently congratulating herself that she was an Englishwoman:

> I looked around me on the sea-birds that were sporting upon the wave — above me, to the fleecy clouds that were sailing over the blue ether . . . and . . . breathed a silent thanksgiving that *I* too was free! Free to come and to go — to love or to reject — to gaze in turn upon every bright and beautiful scene of nature, untrammelled and unquestioned — that no Sultan could frown me into submission–no Kislar Agha frighten me into hypocrisy — in short, that I was not born a subject of his Sublime Highness, Mahmoud the Powerful.[13]

The sea-birds who freely sport, together with the sailing Englishwoman, outside this "painted prison" recall by contrast another standard trope for entrapment in the harem, the caged birds who figure so often in poetry and painting on the subject. Earlier in the volume, Pardoe herself has already made passing use of the image, when she accounts for the behavior of upper-class Turkish women who flirt on their shopping expeditions by speculating that "like caged birds occasionally set free, they do not know how to use their liberty."[14] Though the caged birds generally serve a more domestic and sentimental vision of the harem than does the prison, they do not often figure in contexts so mundane as this critique of foreign shopping. In *Childe Harold's Pilgrimage* (1812), for example, Byron makes passing use of the trope to represent the inhabitant of the harem as calmly acquiescent in her fate:

> Here woman's voice is never heard: apart,
> And scare permitted, guarded, veil'd, to move,
> She yields to one her person and her heart,
> Tam'd to her cage, nor feels a wish to rove. (2.61.541–44)

Moore's *Lalla Rookh* (1817) extravagantly multiplies both bird and woman, extending the figure into a sumptuous catalogue of exotic species. Just as the sinister prophet of Khorassan has gathered into his harem representatives "from every land where woman smiles or sighs," so in his aviary he has "latticed lightly in / . . . Each brilliant bird that wings the air . . .":

> Gay, sparkling loories, such as gleam between
> The crimson blossoms of the coral-tree
> In the warm isles of India's sunny sea;
> Mecca's blue sacred pigeon, and the thrush

Of Hindostan, whose holy warblings gush,
At evening, from the tall pagoda's top; —
Those golden birds that, in the spice-time, drop
About the gardens, drunk with that sweet food
Whose scent hath lured them o'er the summer flood;
And those that under Araby's soft sun
Build their high nests of budding cinnamon.

We hardly need the consciousness of the poem's hero to register the point: the "birds' fate — in bondage thrown / For their weak loveliness — is like her own!"[15] Though John Frederick Lewis's *Caged Doves* of 1864 (fig. 20) foregoes the lush exoticism of Moore's poem, it drives home the same moral. In the painting itself, significantly, no bird cage is visible: the walls of the harem presumably enclose both doves and woman.[16]

Since the Italian *serraglio* originally meant a "cage for wild animals," the figure of the harem-as-bird-cage came all too readily to Western minds. And no doubt the association gained in force from the scurrilous canard, frequently repeated over the centuries, that Muslim theology denied woman a soul. If "to him she is a mere animal," as the *Englishwoman's Review* confidently announced as late as 1877, then a Muslim believer might well keep his women caged up together with his other domestic creatures.[17] That birds were said to be actually kept as pets in the harem made the temptation to identify them with the human inhabitants even harder to resist, especially given the conventional associations of liberty with flight that Pardoe exploits in the passage quoted earlier. The rarer and more exotic the species, the better it could figure the fantasized remoteness and exoticism of the women themselves, as in Moore's lush catalogue, or Thackeray's brief observation about the Grand Seraglio in 1846: "Strangers are not allowed to see the interior of the cage in which these birds of Paradise are confined."[18] The practice of gilding bird cages only made them a yet more obvious trope for the imagined luxury of harem confinement.[19]

The presence of slavery in Islamic culture — and above all at the Ottoman court — obviously compounded fears of liberty lost in the harem. In the words of one widely circulated account early in the seventeenth century: "all they which are in the *Seraglio*, both men and women, are the *Grand Signors* slaves." Though Robert Withers went on to imply that he meant this more or less figuratively, in the extended sense in which all subjects of a despot are "slaves," his marginal notation — "One Lord, the rest slaves" — did succinctly sum up the relation of the sultan to his sexual

partners in the harem.[20] And between the existence of Eastern slavery generally, the institution of slave-concubinage in particular, and the unique conditions of the sultan's harem, Western imaginations did not always distinguish too closely. As Europeans often represented it, to be immured in the harem was perforce to be a slave, while to be a certain kind of slave was perforce to be immured in the harem.[21]

Among the more familiar images of Eastern slavery produced by European painters in the nineteenth century, Jean-Léon Gérôme's *Marché aux esclaves* (c. 1867; fig. 21) could take for granted that its viewers would know where its light-skinned victim was headed. Like Jean Lecomte du Nouÿ's more openly erotic *L'Esclave blanche* of 1888 (fig. 22), whose nude-with-cigarette simultaneously evokes the fantasized indolence of the Orient and the smoking habits associated with European prostitutes, Gérôme's slave is obviously intended as a harem concubine. By the time of the later painting, the Ottoman trade in white slaves from Georgia and Circassia had largely come to an end,[22] but so routine was the association between light skin, slavery, and sexuality in the harem that viewers would take for granted the racial division of labor conveyed by the lazy nude and the partly clothed workers in Lecomte du Nouÿ's painting. I shall return to the erotic effects of such images in later chapters, but it is worth noting here how Gérôme's slave market manages to appeal at once to the moral superiority of the viewer and to his prurience. The painting invites the European male, at least, to distance himself from the cool brutality with which his darker-skinned counterparts inspect the woman's teeth, even as he is titillated by her nudity and the dominion to which she is subjected.[23] Though she is hardly brought as close to the viewer as Lecomte du Nouÿ's inviting slave, Gérôme's slavewoman in this sense also conjures up a harem.

While the custom of taking slavewomen as concubines long antedated the coming of Islam, the Koran sanctioned, if it did not encourage, the practice: theoretically, at least, any Muslim man could possess an unlimited number of slave-concubines in addition to his four legitimate wives — provided, that is, he was rich enough to afford them. In fact, of course, not all harems contained slavewomen, and not all slavewomen were concubines. And even in the imperial harem not every woman was, strictly speaking, a slave, since the court also housed the sisters and daughters of the sultan. But ever since the middle of the fifteenth century, the Ottoman sultans had chosen to avoid marriage almost entirely, relying instead on the importation of foreign slaves for both sex and reproduction. (Since no free-born Muslim woman could be enslaved, all slaves had to be imported.) The few departures from this custom — the marriage of Süleyman I to the concu-

bine known in the West as Roxelana is the most notorious — scandalously proved the rule.

Though the reasons for the imperial avoidance of marriage remain somewhat obscure, Western observers tended to associate it, not surprisingly, with a despot's reluctance to diminish his absolute power.[24] As *Bajazet*'s Roxane — herself just such a slave — explains:

> Je sais que des sultans l'usage m'est contraire;
> Je sais qu'ils se sont fait une superbe loi
> De ne point à l'hymen assujettir leur foi.
> Parmi tant des beautés qui briguent leur tendresse,
> Ils daignent quelquefois choisir une maîtresse
> Mais, toujours inquiète avec tous ses appas,
> Esclave, elle reçoit son maître dans ses bras
> Et, sans sortir du joug où leur loi la condamne,
> Il faut qu'un fils naissant la déclare sultane. (1.3, 365)*

While this Roxane may owe her ambition as well as her name to the famous consort of Süleyman the Magnificent, her own wayward desires will finally defeat any attempt to emulate the spectacular rise of her predecessor.

A system by which a slave might thus find herself rapidly translated into a sultana did not, of course, look very much like slavery as ordinarily understood in the West. Though Withers reported that at the slave market in Constantinople people were "bought, and sold, as beasts, and cattle are ... as if they were so many horses in *Smithfield*,"[25] other European travelers would remark on how comparatively benign slavery appeared under Ottoman rule — even for those far removed from the fabulous conditions of the Grand Seraglio. But for many writers and artists, the idea of enslavement in the harem had a power of its own, well in excess of any particular details of the travelers' reports. So *Bajazet* itself faithfully acknowledges the slave unions of Ottoman royalty as Racine had seen them described in up-to-the-minute sources, even as it radically opposes the "purest blood" of the Ottomans (5.6, 406) to the "slavish marriage" that its heroine proposes (2.3, 374). As the brother of the sultan, Bajazet presumably also descends from a slave mother, as well as from a royal father who was himself the son of a slave. But Racine so arranges the terms of his drama that

* I know that the custom of the sultans is against me. I know that they made themselves a proud rule not to subject their honor to matrimony. Among so many beauties who aspire to their love, they sometimes deign to choose a mistress. But, always anxious despite her attractions, she remains a slave who receives her master in her arms; and, without escaping the yoke to which their law condemns her, she must give birth to a son to be declared a sultana.

Bajazet's loyalty to a youthful love is synonymous with the purported nobility of his royal blood, while Roxane's identity as a slave is tragically confirmed by her slavery to her passions.

Racine was well aware of the speed with which persons could be made and unmade at the Ottoman court, but he was more interested in the vicissitudes of desire than in the whims of the despot; and it is the "empire" of love rather than that of the sultan that *Bajazet* is most designed to illustrate (3.7, 389). Though the play begins with an imperious Roxane at the height of her power — the sultan's favorite, she has been placed in charge of the *sérail* while he is off at war — it also assures that erotic feeling has already rendered her vulnerable. Unaware that Bajazet has long secretly loved the princess Atalide, Roxane has fallen violently in love with him herself. When she suddenly receives the sultan's order to execute this brother as a potential rival, she proposes instead that he marry her (as "Soliman" famously did his "Roxelane") and usurp the throne. No sooner does she sense his hesitation, however, than she immediately threatens death if he refuses. In Racine's scripting of Bajazet's response, the noble disdain of the Ottoman prince simultaneously resonates with faith to Atalide, defiance of death, the sultans' proud refusal to lower themselves in marriage — and contempt for the slave who thus poses the alternatives. There is no hint of Bajazet's own slave mother in this scornful dismissal of Roxane, nor any sign of Atalide's necessarily mixed ancestry in his declaring her, by contrast, "most worthy" of the blood that bore her (2.5, 378). Having demonstrated that worth by her willingness to sacrifice her own claim on the prince in order to save him, Atalide is automatically enrolled in *Bajazet*'s aristocratic company.

Of course, the Ottomans themselves were inclined to efface the slave status of a sultan's mother, and there is a sense in which Racine was only following their lead.[26] But if the sudden transition from enslavement to royalty was a genuine feature of Ottoman culture, it is the seventeenth-century Frenchman who associates that royalty with aristocratic control of the passions and who repeatedly calls attention, by contrast, to the slave's subjection to feeling. As for that slave, her only talk of freedom comes, significantly, when her discovery of a love letter to her rival momentarily liberates her from the "cruel cares" by which she has felt herself bound (4.5, 396). Though Roxane is executed in the end by an agent of the sultan, the language of the play more often represents her as the victim of her own desires. Many Europeans identified the *sérail* with slavery, but it takes Racine's imagination to transform a matter of status into a state of mind.

Rebellion in the Sérail of Montesquieu's Persian

Loosely translated into *The Sultaness*, Racine's heroine arrived on the English stage in 1717.[1] But it was another fictive slave called Roxane, the heroine of Montesquieu's *Lettres persanes* (1721), who most directly influenced subsequent representations of liberty lost in the harem. Indeed, for Montesquieu, as we shall see, the degradations of slavery necessarily corrupt all aspects of life in the *sérail,* and even the master himself must prove a slave in the end. The paradox that that master formulates in his opening letter to his chief eunuch — "You command [the women], and you obey them" (ii. 13) — foreshadows the logic that will govern the entire fiction.

Especially in the light cast by the *Esprit des lois* (1748) more than a quarter century later, it has long seemed clear that Montesquieu partly intended his Persian letters as a veiled critique of despotic government at home. Though the correspondents are Persian, the perspective is primarily that of Paris, where Usbek and Rica have traveled in search of wisdom and to escape the political intrigue of Ispahan. Both the defamiliarizing effect of their commentary on French politics and customs, and the structure of the text as a whole, with its implicit parallels between Usbek's *sérail* and the court of Louis XIV, deliberately draw attention to conditions in contemporary France. Like other Europeans in the late seventeenth and eighteenth century, Montesquieu could no longer identify the monster of despotism only with a remote Asiatic figure known as the Grand Turk: between the perceived weakening of the Ottoman Empire and the growth of absolutist and centralized rule in Europe, the despot looked more and more like the monster within.[2] For the baron de Montesquieu, the increasing centralization of the court particularly threatened the traditional independence of the nobility, who in his view had hitherto offered a critical check

on the absolute power of the king. When Usbek begins by instructing his chief eunuch, "always remember the nothingness from which I lifted you, when you were the lowest of my slaves" (ii. 13), he thus presents a frightening image of a court in which all power emanates from a single source, and even the ruler's chief delegates abjectly depend on his authority. If Usbek stands in by this account for Louis XIV, then the eunuchs serve as bitter satires on ministers like Colbert or Louvois, while the concubine-slaves ironically evoke the remaining courtiers.[3]

But the women of the harem are, obviously, women before they are courtiers, and the slavery in Usbek's *sérail* does more than figure the despotic arrangements of Louis' court. As the master of the harem, Usbek is also a despot in the original sense of the term — not the tyrannical ruler of a state but the absolute authority in the family.[4] Indeed, precisely because the *sérail* is at once palace and home, it seems to offer an exemplary figure for the inevitable identity of oppressions public and private. When the chief eunuch boasts that "I feel myself in the sérail as if in a little empire, and my ambition, the only passion I have left, is a little satisfied" (ix. 24), he implies that only a difference of scale distinguishes the control of one man's women from the conquest of the globe. Framing as it does the *Lettres'* eclectic mix of political allegory, social satire, pseudo-ethnography and moral tale, Montesquieu's harem fiction anticipates the modern argument that "politics" concerns all the power relations of a culture.

When Usbek begins his only letter to his favorite, Roxane, by congratulating her on being shut up in the *sérail*, he unwittingly articulates the assumptions that will betray him:

> How fortunate you are, Roxane, to be in the sweet land of Persia, and not in these poisonous climates, where people know neither modesty [pudeur] nor virtue! . . . You live in my sérail as if in the abode of innocence, inaccessible to the indecent assaults of all mankind. You joyfully find yourself in the happy position of not being able to fall. (xxvi. 59)

The remainder of the text will make clear what Usbek cannot see: to be "in the happy position of not being able to fall" — his euphemism for being locked up in the harem — is to be in a position where a fall is inevitable. Only his resort to the contrafactual ("*as if* in the abode of innocence") ominously hints at events to come. By the close of the *Lettres*, rebellion will have broken out in the harem, and the abode of innocence will in fact reveal itself the locus of treachery and corruption. In rapid succession,

Usbek will learn that his women have doffed the veil, taken lovers, and abandoned all restraint — even that Roxane herself, the woman he thought most virtuous, has long hated and deceived him.

It is no accident that the harem serves as the central exhibit in the *Lettres'* running argument about the necessary relation between freedom and virtue, nor that Montesquieu situates his imaginary institution in Persia, where he assumes, on the authority of Chardin, that the men guard their women still more closely than do the Indians or the Turks.[5] Rather than preserve its inhabitants' innocence and chastity, the harem as Montesquieu conceives it makes true virtue impossible. For if only the free exercise of self-control offers any hope of keeping the passions in check, then depriving women of freedom will assure nothing but corruption and defiance. Like the male slaves who guard them — eunuchs whose "condition," as one says, "does not leave us the power to be virtuous"[6] — the women of the harem can exhibit only that simulacrum of "virtue" that is compelled by necessity. Earlier in the *Lettres* Usbek himself has come close to recognizing this logic when he scolds one of his women, Zachi, for having been found alone with a white eunuch. Anticipating her protest that she has nonetheless been faithful, he scornfully reminds her that she could not have been otherwise. How could she have evaded the vigilance of her guardians, or managed to burst the bolts and doors that lock her in? "You boast of a virtue," he tells her, "which is not free" (xx. 49).

Usbek has often been taken for a man enlightened about other cultures and tragically blind to his own,[7] but the rapidity with which the balance of blindness and insight can shift even on home matters suggests that we should probably not look to the *Lettres* for much novel-like consistency of character. Nor does Montesquieu ever resolve the question of what might have become of a Zachi — or a Roxane, for that matter — if she had not been incarcerated in the harem in the first place. Though so much of the text goes to show that true virtue belongs only to the free, Montesquieu seems never to have decided whether Persian women were licentious because they were locked up or locked up because they were licentious. In his history of the Troglodytes, Usbek tells of a people who began in a warring state of nature and evolved, via a saving remnant, into a free and self-disciplined community — only to be tempted to give up the "burden" of virtue by choosing a king to rule over them (xiv. 37). The idle and degrading life they seek, it is implied, would be very like that which the *Lettres* elsewhere associates with the harem. But if the parable of the Troglodytes assumes that people should choose to govern themselves, the *Esprit des lois* suggests that the government of women, at least, should

be determined not by choice but by climate. Like Chardin, Montesquieu takes for granted that the hotter the climate, the more inflamed the passions — from which it follows, apparently, that "in certain places of the Orient," the climate itself requires women's confinement. Only cool countries like his own can afford not to lock women up in the harem. Where passions are calm and manners "naturally" good, "what purpose would it serve?" Though the *Lettres* appears to have argued that little purpose is served by shutting up women in Persia either, Montesquieu now alludes blandly to the "innocence and purity" of women's manners in those Eastern countries that practice seclusion, by contrast to the horrible "crimes" perpetrated in hot countries that grant women their liberty.[8] Perhaps because he is no longer imaginatively identifying with the inhabitants of the harem, the character of the virtues with which he credits them does not appear to trouble him.

What does remain constant from the fictive letters to the formal treatise is the insecurity of the despot.[9] That every tyrant, as the *Esprit des lois* puts it, is "at the same a slave"[10] becomes dramatically evident in the history of Usbek's relations with his *sérail*. The very epistolary structure of the text calls heightened attention to a weakness that always threatens absolute power: by removing Usbek from Ispahan to Paris and making him reliant on letters for news of the harem, Montesquieu exaggerates the distance that even at home separates the despot from his subjects — a distance that paradoxically entails his dependence on his dependents. As the master's delegates in the *sérail*, the eunuchs are the crucial intermediaries in the chain: at once his despotic surrogates and his abject slaves, they are also the agents without whom he is utterly helpless to exert control over the harem.[11] The eunuchs may be "base instruments," as Usbek puts it, "that I can break at my whim" (xxi. 51), but the mounting hysteria with which he responds to their accounts of the rebellion makes clear how little difference obtains between them. "You would pity me," he writes to a friend at Ispahan, "if you knew my wretched state."

I sometimes wait six whole months for news of the sérail; I count all the moments that pass by; my impatience always stretches them out for me; and when the man who has been so awaited is about to arrive, a sudden revolution takes place in my heart: my hand trembles to open a fatal letter. That anxiety which tormented me seems to me the happiest state I could be in, and I fear to be driven out of it by a blow that would be crueler for me than a thousand deaths. (clv. 329)

Like the chief eunuch, whose first letter describes himself as "never sure of being in my master's favor for an instant" (ix. 26), Usbek now lives in a state of perpetual anxiety. Indeed throughout the *Lettres*, the figures of master and principal slave are increasingly assimilated to one another, a process of identification which culminates in the first-person plural of the new chief eunuch's final message from the *sérail*: "My soul and yours will be appeased. We shall exterminate crime, and innocence will be appalled" (clx. 333).[12]

And just as the master of Montesquieu's fictive harem is always in danger of being reduced to a eunuch, so he is also perpetually at risk of changing places with his women. Even before rebellion overtly breaks out in the harem, a letter from yet another of Usbek's seemingly inter-changeable wives calls mocking attention to the potential reversibility of jailer and jailed. "In the very prison in which you confine me," Zélis writes, "I am freer than you. You could not redouble your attention to guarding me without my reveling in your anxiety; and your suspicions, your jealousy, and your vexations are so many signs of your dependence" (lxii. 130). The very suspicions of women that first motivate men to construct the harem, in other words, leave them continually vulnerable. Though Montesquieu breaks off without informing the reader whether his protagonist will return to Persia, the only letter in which Usbek him-self projects his future suggests that such perpetual anxiety as Zélis describes is his only imaginable fate. Anticipating the endless suspicion and jealousy from which he will suffer if he returns to the *sérail*, Usbek foresees himself as thereby imprisoned yet more thoroughly than his slavewomen.

The *Lettres'* last word belongs, famously, not to the master but the slave, and its revelation of freedom within the harem appropriately mirrors his anxious projection of confinement. The letter follows quickly on the chief eunuch's agitated report of catching Roxane in bed with a young man and of struggling violently with the lover until he was subdued and killed. "Yes, I deceived you," Roxane defiantly announces to Usbek be-fore committing suicide:

> How could you have thought me credulous enough to imagine that I was in the world only in order to worship your caprices? that, while you permitted yourself everything, you had the right to mortify all my desires? No! I may have lived in servitude, but I have always been free: I have reformed your laws according to those of Nature, and my spirit [esprit] has always kept itself independent. (clxi. 333, 334)

Roxane's account of her revolt provides at once the final letter in the collection and its dramatic peripeteia—the crucial revelation that Usbek's claim to "unlimited power" has long been founded on illusion (cxlviii. 324).[13] No harem, she implies, can constrain the minds and hearts within it.

Between the emotional force of Roxane's gesture and the ease with which epistolary texts in particular lend themselves to appropriation and recycling, it is not difficult to understand how some readers could have turned her statement into a sort of touchstone for the imagination of liberty. "In the imminence of death," a distinguished critic says of this letter, "the perspective of a universally liberating justice discloses itself."[14] Yet for all the power of Roxane's statement, its political implications remain at best ambiguous. As feminist critics have been quick to remark, the slave's declaration of independence is also, after all, a suicide note; Montesquieu's imagination of her revolt does not extend beyond her act of self-destruction. (The very last words of the *Lettres* are not "I have always been free," but "I am dying"—clxi. 334).[15] And while "the laws of Nature" that Roxane has substituted for those of the harem may simply mean the freedom to love as she pleases — she kills herself, she says, because "the only man who kept me alive is no more" (334) — they may also signify something closer to the "natural" outbreak of female licentiousness. Especially when juxtaposed with Montesquieu's later account of domestic arrangements in the East, the acts of which Roxane boasts to Usbek — "I have seduced your eunuchs, sported with your jealousy, and I have known how to turn your frightful sérail into a place of delights and pleasures" (333) — sound suspiciously like the horrible "crimes" that are to be feared if women in the hot countries are not adequately guarded.

The history of Roxane's revolt did not end, however, with the suicide of Montesquieu's heroine. Whatever the ambiguities of her act, it seems clear that she helped to inaugurate an imaginative tradition of female defiance in the harem. Having presumably inherited her name — as did Racine's heroine before her — from the famous consort of Süleyman the Magnificent, she appears in turn to have bequeathed her fiery independence to later representations of her ancestor.[16] By an ironic turn of literary history, Montesquieu's fiction of a rebellious harem inmate called Roxane encouraged later writers to imagine how the actual slave could have succeeded in persuading the sultan to marry her. Beginning as the victorious heroine of "Soliman II," Jean-François Marmontel's wry *conte morale* of 1761, this newly aggressive "Roxelane" immediately took to the stage in Charles Favart's verse-comedy, *Les Trois Sultanes* (1761), only to cross the

Channel in the following decade as Roxalana, the spirited English hero-
ine of Isaac Bickerstaff's two-act farce, *The Sultan, or a Peep into the Seraglio*
(1775). Indeed by 1798, "Roxana" had become so familiar a type for
female rebellion that the oppressive husband in Mary Wollstonecraft's
Maria or the Wrongs of Woman has only to evoke her name when he mock-
ingly dismisses his wife's demands for freedom: "Very pretty, upon my soul!
very pretty, theatrical flourishes! Pray, fair Roxana, stoop from your alti-
tudes, and remember that you are acting a part in real life."[17]

While Montesquieu never specifies Roxane's country of origin,
vaguely leaving the impression that she too is Persian, subsequent writers
liked to claim the rebel's love of liberty as a peculiarly European virtue.
Not surprisingly, they also liked to claim her as one of their own. The slave-
woman who married Süleyman I probably came from a part of the
Ukraine then controlled by Poland,[18] but when she appears as "Roxelane"
in Marmontel's light tale she defends a native freedom that is unmistak-
ably French. "Que n'avez-vous fait quelque voyage dans ma patrie!" she
scolds the sultan at one point. "C'est-là que l'on connoit l'amour, c'est-là
qu'il est vif & tendre, & pourquoi? parce qu'il est libre."[19] Favart's Roxelane
speaks to the same effect, though in terms more explicitly political.[20]
Predictably, in Bickerstaff's farce it is now "that English slave" who proves
"quite ungovernable," driving the chief eunuch to talk of quitting. Deliv-
ering loose translations of both her predecessors' speeches, this Roxelana
boasts of an England where "every citizen is himself a king," and where
love is "all life and tenderness, because it is free."[21]

Of course, the patriotic uses of the formula were hardly limited to
England and France, as the wily heroine of Rossini's *L'italiana in Algeri*
(1813) would cheerfully demonstrate nearly a half-century later. Nor did
everyone who imagined such a rebel in the harem choose to make her his
own countrywoman. In his libretto for Mozart's *Die Entführung aus dem
Serail* (1782), for example, the Prussian-born Gottlieb Stephanie the Younger,
himself reworking a libretto by the Austrian dramatist Christoph Friedrich
Bretzner, exploited the stereotype of the spirited Englishwoman for
the feistier of his two female captives, the maidservant Blonde. Stephanie
added the duet between Blonde and the pasha's tyrannical overseer,
Osmin, in which she sings of "Ein Herz, so in Freiheit geboren," while her
would-be master counters with contempt for the Englishmen who are
such fools as to let women have their way.[22] And in England itself, espe-
cially in the first decades of the nineteenth century, philhellenic sentiment
could sometimes turn the liberty-loving slavewoman into a Greek. In her
letterpress for Thomas Allom's *Character and Costume in Turkey and Italy*

(1839), Emma Reeve pointedly contrasted the defiance of one such captive, taken "at the period of the late Greek revolutions," with the "spiritless" acquiescence of the Circassian woman, who "is often the voluntary yielder of her liberty."[23] Though Reeve's exemplary Greek, who begins by smashing every article of furniture in the harem, is quickly executed by her wealthy owner, the anonymous pornographer of *The Lustful Turk* (1828) had already imagined a more thoroughgoing resistance: his defiant Greek commits suicide, but not before she has put an end to the Dey's erotic career by severing "his pinnacle of strength" from his body.[24] Even those who liked to identify with the master could apparently entertain fantasies of harem rebellion.

Visions of Oppression from Wollstonecraft to Nightingale

Though we might expect that the harem-as-prison would appear very different depending on which sex did the looking, it may seem surprising that the "prison" as such tends to loom larger in the imaginations of men than of women. Yet the paradox is only superficial, for the harem was never so consistently meant to lock up one sex as to shut out the other: though the degree to which women actually ventured outside its walls seems to have varied considerably with time, place, and class — not to mention the eyes of the observer — restrictions on their movement were rarely as absolute as were the obstacles, at once physical and conventional, that kept unrelated men at a distance. Registering this with a subtlety rare for him, Gérôme's *Le Harem à le kiosque* (c. 1870) manages to turn even a harem outing into an image of prohibition, as it radically subordinates its distant glimpse of the veiled woman to the dark verticals and diagonals that bar them from the viewer (fig. 23). Like the two eunuchs on the left, the wall, railing and pillars of the kiosk echo the prominent figure of the guard on the right, while the very shadows that dominate the central foreground ominously reinforce the angle of his pike. If European men imaginatively fortified the walls of the "prison," in other words, they may well have been projecting onto the harem something of their own frustration at the rigidity of the barriers that excluded them.

A study of the French colonial postcard reproduces an early twentieth-century image that vividly illustrates the erotic logic of such projection (fig. 24). By juxtaposing the half-naked woman with the figure of the man clutching at the bars that divide them, the postcard effectively renders male sexual frustration and female incarceration equivalent. But even as the prison-like bars deliberately evoke the lattice windows of the harem, their spacing conforms to the demands of fantasy, since the real function

of such windows was precisely that the inhabitants could see out without being seen. Though the postcard purports to represent a young Moorish woman in Algeria, what it actually depicts is "an *imaginary scenario*," staged in the photographer's studio.[1]

Only in the eighteenth century did European women actually begin to visit their Eastern counterparts, and only in the nineteenth did such meetings take place in significant numbers. But the very fact that the harem was not absolutely closed to Western women meant that they were less likely to focus on the inviolability of its walls than on the character and condition of its inhabitants. Even those who called most attention to its oppressiveness — and, as we shall see, some women thought the institution far from oppressive — typically emphasized the spiritual and mental degradation they attributed to its lack of freedom. In an article for *Chambers' Edinburgh Journal* of 1846, one anonymous "lady" described her visit to the harem of a Bulgarian pasha by implying that the tedium of incarceration had reduced its occupant to one of the lower animals: "My whole existence was as incomprehensible to this poor princess, vegetating from day to day within her four walls, as that of a bird in the air must be to a mole burrowing in the earth," she reported complacently. As she saw it, the reputed soullessness of Muslim women was not a cause but a consequence of their being shut in:

> her life consisted, as she told me, of sleeping, eating, dressing, and bathing. She never walked farther than from one room to another, and I can answer for her not having an idea beyond the narrow limits of her prison. It is a strange and most unnatural state to which these poor women are brought, nor do I wonder that the Turks, whose own detestable egotism alone causes it, should declare that they have no souls.[2]

The *Chambers'* correspondent was hardly alone in thus yoking the old myth about the absence of a female soul in Muslim theology to the degraded state of women in the harem. For all its loftiness, of course, "a bird in the air" is finally no less animal than a burrowing mole — a bit of rhetorical evidence that might go to support the recent argument that Western women thought of themselves as "all powerful and free" in such comparisons in order to avoid confronting their own powerlessness at home.[3] Indeed, the strategy need not even be unconscious: in an article for *Bentley's Miscellany* a few years later, another anonymous "oriental traveller," who identified himself as male, concluded his grim picture of "sufferings" in the harem by explicitly urging the woman reader to "learn

resignation to her lot, as she compares it with the condition of the women of the East."[4] But if some European women consoled themselves by conjuring up images of oppression in the seraglio, others exploited just such images to advance feminist arguments in their own countries. Contending that "Wife and servant are the same, / But only differ in the name," Mary Chudleigh's "To the Ladies" (1703) encourages her readers to "shun that wretched state" by developing an extended parallel between "an eastern prince" and the ordinary Western husband:

When she the word *Obey* has said,
And man by law supreme has made,
Then all that's kind is laid aside,
And nothing left but state and pride.
Fierce as an eastern prince he grows,
And all his innate rigour shows:
Then but to look, or laugh, or speak,
Will the nuptial contract break.
Like mutes, she signs alone must make,
And never any freedom take,
But still be governed by a nod,
And fear her husband as her god:
Him still must serve, him still obey,
And nothing act, and nothing say,
But what her haughty lord thinks fit.[5]

Evoking the legendary silence of the Eastern palace as well as its despotism, Lady Chudleigh's vision of British marriage collapses the entire population of the seraglio, concubines and mutes alike, into the single figure of the tyrannized wife.

Nearly a century later, Mary Wollstonecraft's *Vindication of the Rights of Woman* (1792) would elaborate a similar rhetoric, repeatedly turning tropes of degradation and slavery in the harem into monitory images for Western women. For Wollstonecraft, to vindicate the rights of women meant above all to release them from their demeaning identification with sexuality and the body — an identification enforced, in her view, by a culture that directed all their energies toward the fleeting excitements of "love" and courtship. Insisting that women are rational creatures, with minds and souls equal to those of men, the *Vindication* sets out to contend with the "many . . . causes," in its words, "that, in the present corrupt state of society, contribute to enslave women by cramping their understandings

and sharpening their senses."[6] Though Wollstonecraft unquestionably aimed her attack at "the present corrupt state of society," she recurrently figured that corruption by conditions in the seraglio. Automatically identifying the East with despotism and tyranny, she took for granted that others would share her assumptions:[7] her contemptuous allusions to "the husband who lords it in his little haram" (73) or to those "weak beings" whose educations have rendered them "only fit for a seraglio!" (10) count on her readers' wish to put such disturbing resemblances behind them. "In a seraglio, I grant, that all these arts are necessary," she typically concedes at one point, thereby dismissing to that imagined elsewhere all those feminine wiles and servile tricks she finds so repugnant:

> the epicure must have his palate tickled, or he will sink into apathy; but have women so little ambition as to be satisfied with such a condition? Can they supinely dream life away in the lap of pleasure, or the languour of weariness, rather than assert their claim to pursue reasonable pleasures and render themselves conspicuous by practising the virtues which dignify mankind? Surely she has not an immortal soul who can loiter life away merely employed to adorn her person, that she may amuse the languid hours, and soften the care of a fellow-creature who is willing to be enlivened by her smiles and tricks, when the serious business of life is over. (29)

At once the home of despotism and the dreamlike space of sensual pleasure and lassitude, this imaginary seraglio provides Wollstonecraft with a concentrated figure for woman's simultaneous enslavement to men and to the body — the very antitype of the *Vindication*'s strenuous insistence on her "improvable soul" (124). Routinely subscribing to the belief that Muslims thought of their women as little more than animals, Wollstonecraft similarly consigned to "Mahometanism" those assumptions she was most engaged in fighting. Anticipating her subsequent criticisms of Rousseau, Fordyce, and the rest, her introduction sweepingly condemns "books of instruction, written by men of genius" that "in the true style of Mahometanism" treat women as "a kind of subordinate beings, and not as a part of the human species" (8). Even Milton is ironically suspected of writing "in the true Mahometan strain" when he represents Eve as a being designed "to gratify the senses of man" (19).[8]

Like Montesquieu, Wollstonecraft contended that only a conscious and active virtue was worthy of the name; and like Montesquieu, too, she saw the harem as an institution that must therefore travesty the virtue it was

designed to protect. "If women are to be made virtuous by authority, which is a contradiction in terms," she announces in her concluding chapter, "let them be immured in seraglios and watched with a jealous eye." Where the *Lettres persanes* predicted that revolution would inevitably follow, however, *The Rights of Woman* is distinctly more equivocal: "Fear not that the iron will enter their souls," Wollstonecraft continues, "for the souls that can bear such treatment are made of yielding materials, just animated enough to give life to the body" (188). As in her earlier allusion to the hypothetical inhabitant of the seraglio — "surely she has not an immortal soul who can loiter life away"(29) — the passage ironically appears to endorse the "Mahometan's" belief in the soullessness of his women: if only those souls "just animated enough to give life to the body" can bear such treatment for a moment, then any living inhabitant of a harem must indeed be little better than an animal. What has been termed Wollstonecraft's "feminist orientalism" — the practice of exploiting stereotypes of the East in order to argue a feminist case in the West — might be said to reach here its terrible conclusion.[9] Yet the hortatory force of both passages depends, of course, on compelling the reader to acknowledge how impossibly self-contradictory are the scenarios with which they conjure. It is not to deny the stereotypes that animate Wollstonecraft's rhetoric to suggest that they also betray just how phantasmic was her vision of the seraglio.

The author of *The Rights of Woman,* needless to say, never visited a harem. But even some of the female travelers who actually undertook the journey East in the century that followed saw something like the mental and spiritual torpor Wollstonecraft had imagined. Julia Pardoe thought Turkish women happy on the whole, but only because their sensibilities had never been sufficiently awakened to feel otherwise. Though Pardoe debunked the myth about Muslim women's souls and explicitly countered the belief "that the natives of the East are . . . plunged in profoundest ignorance" ("perhaps, with the single exception of Great Britain," she reported, "there exists not in the world a more reading nation than Turkey"),[10] she attributed the "careless" contentment of the harem to "the almost total absence of education among Turkish women, and the consequently limited range of their ideas." Characteristically, Pardoe appears unable to decide whether she feels mild contempt for this bovine happiness or the envy of the hyper-civilized: "their feelings and habits are comparatively unexacting; they have no factitious wants, growing out of excessive mental refinement; and they do not, therefore, torment themselves with the myriad anxieties, and doubts, and chimeras, which would darken and depress the spirits of

more highly-gifted females." As Pardoe saw it, however, harem life need not be altogether indolent: on a subsequent visit to the palace of a government official, she noted approvingly that "the supreme high breeding of the harem is no longer its perpetual idleness," and that "several of the ladies were engaged in needlework."[11]

Other Englishwomen in the East showed no such ambivalence. In 1871, Annie Harvey's *Turkish Harems and Circassian Homes,* for example, spoke flatly of "slavery of the mind" and announced firmly that "mental imprisonment is worse even than bodily imprisonment."[12] But it seems no accident that some of the most vehement denunciations of torpor in the harem came from Victorian women who were themselves actively chafing at restrictions on their liberty. The 44-year-old Harriet Martineau was already an established author when she visited the Middle East in 1846–47, while Florence Nightingale, still in her twenties, had yet to take up her vocation when she set off for her journey on the Nile a few years later. But despite their commitment to work — or because of it — the intensity with which both women recoiled from the harem suggests how strongly expectations of feminine idleness continued to haunt them. Martineau devotes only one chapter of her three-volume *Eastern Life* (1848) to the subject; so horrific was the entire business, she implies, that she had been tempted simply to expunge it from the record:

> I saw two Hareems in the east; and it would be wrong to pass them over in an account of my travels; though the subject is as little agreeable as any I can have to treat. I cannot now think of the two mornings thus employed without a heaviness of heart greater than I have ever brought away from Deaf and Dumb Schools, Lunatic Asylums, or even Prisons. As such are my impressions of hareems, of course I shall not say whose they were that I visited. Suffice it that one was at Cairo and the other at Damascus.

A similar *pudeur* governs the remainder of the narrative, as Martineau repeatedly consigns the "hareem" to the realm of the unspeakable: "I shall say but little of what I know. . . . I will only tell something of what I saw; and but little of what I thought and know. . . . But I will not dwell on these hopeless miseries. . . . I will tell that story now, that I may dismiss the subject of this chapter."[13]

Martineau was by this time an experienced institutional visitor, as the passage above suggests, and in her eyes the harem apparently compounded the effects of a deaf and dumb school and a lunatic asylum as well as a prison.

Indeed, a visit to a harem, for Martineau, entailed nothing less in the end than a journey to the underworld: "I declare that if we are to look for a hell upon earth, it is where polygamy exists: and that as polygamy runs riot in Egypt, Egypt is the lowest depth of this hell." Ironically, however — though she would no doubt have found the irony bitter — what she actually described resembles nothing so much as the familiar tedium of a London drawing-room:

> The difficulty is to get away, when one is visiting a hareem. The poor ladies cannot conceive of one's having anything to do; and the only reason they can understand for the interview coming to an end is the arrival of sunset, after which it would, they think, be improper for any woman to be abroad. And the amusement to them of such a visit is so great that they protract it to the utmost.... It is certainly very tiresome; and the only wonder is that the hostesses can like it. To sit hour after hour on the deewán, without any exchange of ideas, having our clothes examined, and being plied with successive cups of coffee and sherbet, and pipes, and being gazed at by a half-circle of girls in brocade and shawls, and made to sit down again as soon as one attempts to rise, is as wearisome an experience as one meets with in foreign lands.[14]

This is the harem at Cairo, but apart from the divan, the sherbet and the pipes, it would be hard to distinguish the scene from afternoon tea among a circle of leisured ladies in Kensington.

Complaining that with the exception of a single homely old lady, she saw "no trace of mind" in anyone present — "all the younger ones were dull, soulless, brutish, or peevish" — Martineau herself implicitly makes the comparison:

> How should it be otherwise, when the only idea of their whole lives is that which, with all our interests and engagements, we consider too prominent with us? There cannot be a woman of them all who is not dwarfed and withered in mind and soul by being kept engrossed with that one interest, — detained at that stage in existence which, though most important in its place, is so as a means to ulterior ends.

Even as she leaves the name for what absorbs these women as unspoken as other horrors of the harem, Martineau scarcely conceals how close to home her boredom and anxiety have come. Despite "all our interests and engagements," evidently, "we" continue to struggle with the idea of female life incarnated by the inhabitants of the harem.[15]

At Damascus "there was more mirth and nonsense" than at Cairo — even a childlike game in which everyone took turns shouting "Bo!" into Martineau's ear trumpet and provoking loud outbursts of laughter. But the effect on the impatient visitor was much the same: "There is nothing about which the inmates of hareems seem to be so utterly stupid as about women having anything to do. That time should be valuable to a woman, and that she should have any business on her hands, and any engagements to observe, are things quite beyond their comprehension." When the women appear to take her for a servant and to pity her solitary state, her fellow-visitor attempts to explain that Martineau has written "many books" — "but the information was thrown away," the prolific author reports grimly, "because they did not know what a book was."[16] The presence of an interpreter notwithstanding, communication between the parties was far from perfect.[17] But whatever the literal truth about the harem's ignorance of books, it is hard to imagine an image of collective femininity Martineau would more thoroughly wish to repudiate. "I am thankful to have seen a hareem under favorable circumstances," she recorded in her journal after that visit; "and I earnestly hope I may never see another."[18]

If for Martineau the harem recalled all that she had striven to overcome, for Nightingale it could still threaten a possible future. Her letters from Egypt (1849–50) conclude, in fact, as if self-consciously rehearsing the alternative lives that await her return to England. On her last day in the East, she reports — "perhaps the most curious day of my life" — she made a pair of visits, the first to a dispensary run by the Sisters of St. Vincent de Paul and the second to the harem of Said Pascha, the future viceroy of Egypt. Having already called several times on the nuns, Nightingale apparently felt quite at home when she now arrived to say good-bye: "I was like a tame cat there, I went in without ringing, and straight to the dispensary." To the harem, on the other hand, she went only once, and that reluctantly — the visit having been arranged without her knowledge by a European friend, the wife of the Tuscan consul. Though she thought Engeli Hanum, Said Pascha's only wife, the loveliest woman she had ever seen, Nightingale represented their encounter as if the deadliness of its boredom threatened to prove quite literal:

I felt that I could have died a martyr to give her one hour of such feelings as those Sisters have; but I was nearer the consummation of my kind wishes than you can have any idea of, for certainly a little more of such a place would have killed us. Luckily, we were obliged to hurry away

for the boat, though the first time we got up, she would not let us go, having no idea that there could be such a thing as necessity. Oh, the *ennui* of that magnificent palace, it will stand in my memory as a circle of hell!

"Hell," Nightingale makes clear, amounts to a place in which there is absolutely nothing for a woman to do — the very antitype, as we might expect, of the hospital run by the Sisters of St. Vincent. "If heaven and hell exist on this earth," her allegory concludes, "it is in the two worlds I saw on that one morning — the Dispensary and the Hareem."[19] Four years later, she would return to the East to organize her celebrated hospital at Scutari.

Like Martineau, Nightingale felt herself entrapped in the harem by a visit that could go on forever — an eternity of leisure in which woman's time had no value because it had no measure in obligations or commitments. And in their eagerness to get away, both women inadvertently testify to how travel itself could contribute to this vision of the harem, its fuss about schedules and appointments sharply counterpointed to the apparent stasis of those who remain so emphatically at home. Especially at a time and in a part of the world where female tourism had not yet become routine, even a woman traveler with no actual vocation might well feel that she had "business on her hands," to adopt Martineau's phrase, which appeared to render the inmates of the harem all the more inert by comparison. So desperate did the need for motion seem to Martineau, at least, that after her visit to Damascus she asked a physician who had access to the harem "whether he could not introduce skipping-ropes upon these spacious marble floors" — an impulse Nightingale duly echoed when she remarked of Engeli Hanum, "we almost longed to send her a cup and ball." The harem may be "hell," but there is a kind of grim comedy in the way both women respond to its horrors by contemplating exercise equipment. Or rather, like other domestic allusions that keep intruding on their accounts — Martineau speaks, for instance, of how she braced herself up for her second visit to a harem "as one does to an hour at the dentist's, or to an expedition into the city to prove a debt"[20] — the very disparity between jump ropes and the underworld only calls attention once again to how the desire to put this "hell" behind them conflicts with the recognition that it is altogether too close to home.

Of course, gender does not always make a critical difference in representation — even when what is represented literally divides the women from the men. In *Rasselas* (1759), for instance, Samuel Johnson briefly anticipates the feminist critique of the mental stunting produced by

confinement in the harem, when the Lady Pekuah, who has been abducted in an Arab raid, reports that she found it impossible to engage in sensible conversation with her fellow inmates: "They had no ideas but of the few things that were within their view, and had hardly names for anything but their clothes and their food."[21] According to James Morier's crudely Orientalist romance, *Ayesha* (1834), "every accomplishment soon falls a victim to the idleness and indolence incidental to their mode of life" — a law of the harem that Morier's own plot blithely proceeds to violate, when its English heroine, secretly abducted as an infant, manages to retain both her perfect refinement and her aptitude for Christianity throughout all her years of incarceration in Turkey. (No sooner has she been rescued than "her mind, as it were by instinct, threw off its errors, and became renewed by truths which were congenial to it.")[22]

In *Beppo* (1817), on the other hand, Byron wittily turned the *topos* of ignorance in the harem to the uses of misogynist satire. The way "they lock them up" in Turkey, the narrator suggests (71.561), produces the happy antithesis of English bluestockings:

> They cannot read, and so don't lisp in criticism;
> Nor write, and so they don't affect the muse;
> Were never caught in epigram or witticism,
> Have no romances, sermons, plays, reviews, —
> In harams learning soon would make a pretty schism!
> But luckily these beauties are no "blues." (72.569–74)

The catalogue of negatives continues, as the narrator eagerly embraces the very vision of intellectual emptiness that women since Wollstonecraft had repudiated so vigorously. Gleefully postulating a female world whose every definition is Not England, Byron's satire all but acknowledges the harem of no-mind as yet another harem of the Western mind.

Looking for Liberty:
Lady Mary Wortley Montagu
and the Victorians

Not everyone believed liberty lost in the harem. A few years before Montesquieu published his fictive letters from Persia, Lady Mary Wortley Montagu offered her correspondents a strikingly different representation of domestic arrangements in Turkey. "Upon the Whole," she announced to her sister, "I look upon the Turkish Women as the only free people in the Empire." Conscious that as a woman and an aristocrat she could venture in places strictly forbidden her predecessors, Lady Mary delighted, as always, in overturning prior accounts of the subject. "Now I am a little acquainted with their ways," she characteristically remarks to her sister, "I cannot forbear admiring either the exemplary discretion or extreme Stupidity of all the writers that have given accounts of 'em. Tis very easy to see they have more Liberty than we have."[1] A subsequent letter specifically directs her irony at Aaron Hill, whose recent account of the Ottoman empire had evoked the "awfull *Fear* and *Duty*" that kept Turkish women "shut up" at home, "never Stirring from their Houses"[2]:

> Tis . . . very pleasant to observe how tenderly he and all his Brethren Voyage-writers lament the miserable confinement of the Turkish Ladys, who are (perhaps) freer than any Ladys in the universe, and are the only Women in the world that lead a life of unintterupted pleasure, exempt from cares, their whole life being spent in visiting, bathing, or the agreable Amusement of spending Money and inventing new fashions. . . . They go abroad when and where they please.[3]

In Lady Mary's account, the barriers that Muslims design to screen one sex from the other undergo a curious transformation: far from imprison-

ing its inhabitants, the walls of the harem effectively disappear, while the coverings that hide women when they venture outside positively enable their freedom. If she found the liberty of Turkish women "easy to see," her language suggests, that was precisely because they themselves were so thoroughly camouflaged. Dressed in their heavy veils and shapeless garments, the women conceal their identities so effectively, she tells her sister, "that there is no distinguishing the great Lady from her Slave, and 'tis impossible for the most jealous Husband to know his Wife when he meets her"; even their lovers, she claims, generally have no idea who they are. "This perpetual Masquerade gives them entire Liberty of following their Inclinations without danger of Discovery," she continues, adding, "You may easily imagine the number of faithfull Wives very small."[4]

Yet the very ease with which Lady Mary professed to discover so much liberty suggests that at least some wishfulness went into all this seeing and imagining. Though several male travelers who had preceded her had also testified to the amorous convenience of the women's garments,[5] they had hardly been tempted to find "the Turkish Ladys . . . (perhaps) freer than any Ladys in the universe." Indeed, such a "perpetual Masquerade" — the metaphor is telling — might well be thought the aristocratic English-woman's counterpart to men's erotic fantasies of the harem.[6] Yet for all the wry amusement with which Lady Mary could speculate on Turkish love affairs, what she most wished to imagine, her letters suggest, was the women's freedom to "go abroad when and where they please[d]."

Certainly this was the freedom she seems to have most wished for herself. Judging from the letters she wrote during the protracted three-year courtship with Wortley, it would hardly be an exaggeration to say that she had married less from sexual desire than from the desire to travel. "If you realy intend to travel, as it is the thing upon Earth I should most wish, I should prefer that manner of living to any other; and with the utmost Sincerity I confesse I should chuse you before any Match could be offerd me," she announced in one early letter — adding in the next paragraph, "If you expect Passion I am utterly unacquainted with any." "My schemes are a little Romantic," she wrote in another. "Was I to follow entirely my own Inclinations it would be to travel, my first and cheifest wish." On the eve of their elopement, nearly two years later, she was still driving the point home: "I beleive to travell is the most likely way to make a Solitude agreable, and not tiresome. Remember you have promis'd it."[7] Not surprisingly, she appears to have leapt at the chance afforded by her husband's appointment to Constantinople. "Those embassies are generally an affair of twenty years, and so 'twas a sort of dying to her friends and country," she later

told Joseph Spence. "But 'twas travelling; 'twas going farther than most other people go; 'twas wandering; 'twas all whimsical, and charming; and so she set out with all the pleasure imaginable."[8]

And when she arrived in Turkey, what she thought she had found was a culture in which women's concealment freed them to continue wandering — a "perpetual Masquerade" that enabled the anonymous maskers to gaze at the sights without being gazed upon. At least this was the scenario into which she herself appears to have entered eagerly.[9] While sometimes reports of her traveling around the city "incognito" appear simply to mean that she has managed to pass without calling attention to her identity as ambassador's wife, at many other times she has clearly gone under the cover of Turkish costume. "The asmak, or Turkish vail, is become not only very easy but agreeable to me," she reports to one correspondent, "and if it was not, I would be content to endure some inconveniency to content a passion so powerfull with me as Curiosity." "I ramble every day," she writes to another, "wrap'd up in my ferigé and asmak, about Constantinople and amuse my selfe with seeing all that is curious in it." Even the Turkish coach that she hires to take her to Sofia becomes, in her telling, a vehicle ideally fit for her purposes, being covered by a scarlet cloth which "entirely hides the persons in [it], but may be thrown back at pleasure and the Ladys peep through the Lattices."[10]

In Lady Mary's eyes, the harem apparently poses no bar to the exercise of its inhabitants' "Curiosity" — its permeable walls allowing for the expansion of a woman's mind as readily as the circulation of her body. "You may beleive me," she sums up her impression after the wedding ceremony at Constantinople; "that the Turkish Ladys have at least as much wit and Civillity, nay, Liberty, as Ladys Amongst us." Of course, she manages to see all this wit and civility by looking only at the Turkey of an aristocrat: Lady Mary has little interest in anyone who is not "of Quality," in her repeated phrase, while her criticism of previous travelers frequently amounts to the complaint that they failed to see the right people. And not all her experiences, even in the best circles, prove equally enlivening: after dinner with the elderly and devout wife of the Grand Vizier, Lady Mary reports, "I had found so little diversion in this Haram that I had no mind to go into Another." But she was "extreme glad," as she puts it, that she was persuaded to try again, since on her very next visit she encountered a woman so lovely and gracious that "nobody would think her other than born and bred to be a Queen, thô educated in a Country we call barbarous." When Lady Mary left the harem of the young and beautiful Fatima, wife of a high official in Adrianople, she "could not help fancying

I had been some time in Mahomet's Paradice, so much I was charm'd with what I had seen." Though the record of her infatuation begins with ecstatic praise for the young woman's beauty and elegance of manner ("That surprizing Harmony of features! . . .the unutterable Enchantment of her Smile!"), by the time they meet again in Constantinople the following year, Lady Mary has sufficiently mastered the Turkish language to find her friend's "Wit as engaging as her Beauty." Indeed, despite the relative brevity of their acquaintance, Lady Mary turns her encounters with the beautiful Fatima into something like the epitome of female friendship — probably the most idealized relation with another woman, for that matter, in all her surviving letters. "She is very curious after the manners of other countrys," the letter from Constantinople continues, "and has not that partiality for her own, so common to little minds."[11] For the author of the embassy letters, this was clearly the highest form of praise.

So happily is the harem constructed in Lady Mary's telling that while it never appears to shut women in, it does work, as desired, to keep the other sex out. When she announces to her sister that she "look[s] upon the Turkish Women as the only free people in the Empire," she immediately follows up the remark by celebrating the inviolability of the harem:

> The very Divan pays a respect to 'em, and the Grand Signor himselfe, when a Bassa [man of high rank] is executed, never violates the priveleges of the Haram (or Women's apartment) which remains unsearch'd entire to the Widow. They are Queens of their slaves, which the Husband has no permission so much as to look upon, except it be an old Woman or 2 that his Lady chuses.

Such freedom from intrusion figures less often in Lady Mary's letters than the freedom to wander at will, but she pays tacit tribute to its effects whenever she pens one of her glowing representations of women alone together. Appropriately, if mistakenly, she believed that a separate paradise was reserved for Turkish women. As she wittily observed to the abbé Conti, "*Mahomet* . . .etoit trop galant homme & amoit trop le beau Sexe" to exclude them from all participation in a future life, as was commonly held in the West. "Au contraire, il promet un très-beau Paradis aux femmes Turques." True, she continued, this was to be a paradise separate from their husbands, "mais je crois que la pluspart n'en seront pas moins contentes pour cela."[12] The letter may be written in French, but its accent is unmistakably Lady Mary's.

Some women travelers are so determined to find abroad what they lack

at home, a recent study suggests, that their idealized accounts of life else-where should be termed "feminotopias."[13] And certainly there are signs of feminotopia in Lady Mary's Turkey, whether in her grand tableaux of civic harmony at the baths or in her rhapsodic accounts of the relative intimacy in Fatima's harem. (The "Scene of Beauty" in the latter place encompassed the languorous dancing of some twenty "fair Maids.")[14] That she had come abroad prepared for such visions was evident well before she had reached Constantinople: "I don't know what your Ladyship may think of this matter," she remarked to her correspondent on the fashion for mature women in Vienna, "but tis a considerable comfort to me to know there is upon Earth such a paradise for old Women." A similar penchant for constructing ideal communities for women may even be sensed in the adolescent Lady Mary's "favorite Scheme," as she later told her daughter, of founding a Protestant nunnery — a project, it should be added, that included electing herself Lady Abbess. No doubt Protestant nunneries are a long way from Turkish baths, yet in Lady Mary's imagination both institutions apparently lent themselves to utopian visions. "In short, tis the Women's coffée house," she says to sum up her account of the baths at Sofia;[15] but in fact there were no such things as women's coffee houses in England.[16] Later, on her voyage home through the Greek isles, she would briefly entertain a similar fantasy — imagining how thousands of years previously she might have been "drinking a dish of tea with Sapho."[17] In such a context, it should come as no surprise that the lovely Fatima herself may have been partly an imaginative construction.[18]

The ambassador's wife was not the only European who saw in the harem the possibilities of freedom. While the idea of imprisonment in the sera-glio continued to haunt the Western imagination well into the nineteenth century, there nonetheless began with Lady Mary something of a counter-tradition, a way of looking shaped more by restlessness and yearning, perhaps, than by fear. If none of the women who followed her to the East approached her as a verbal artist, a number did manage to share in her vision of liberty.[19] When Elizabeth Craven made her own journey to Constantinople some twenty years after the posthumous publication of the embassy letters, she too reported that she "never saw a country where women may enjoy so much liberty . . . as in Turkey" — and this despite the fact that she had earlier refused all belief in her predecessor. Lady Craven has very little of Lady Mary's cosmopolitan attraction to other cultures: she is more inclined to preen herself on the obvious superiority of the En-glish to the "idle and ignorant" Turks. But even she appears half-envious of a female "liberty" she associates with both the erotic adventures and

the dreamy autonomy she imagines possible in the harem. In Turkey, she writes, "women are perfectly safe from an idle, curious, impertinent public, and what is called the *world* can never disturb the ease and quiet of a Turkish wife." By her account, "the wife whose wretched husband earns subsistence by carrying water, or burthens, sits at home bedecked with jewels, or goes out as her fancy directs, and the fruits of his labour are appropriated to her use"[20] — a scenario that Wollstonecraft, one imagines, would have thought more convincing as a representation of Eastern women's indolence than of their "liberty." But the author of the account had reason to find it appealing: legally separated from her husband and children, deprived of her jointure, and traveling on the Continent to spare expense and escape the scandal of her own adultery, she might well fantasize about a place where a woman could be free to do as she liked, removed at once from the "curious, impertinent public" and from any demand for personal effort.

Having repeated Lady Mary's observations about the ease of concealment afforded by Turkish dress, Lady Craven went on to remark another custom she imagined conducive to female "liberty": "A Turkish husband that sees a pair of slippers at the door of his harem must not enter; his respect for the sex prevents him from intruding when a stranger is there upon a visit; how easy then is it for men to visit and pass for women!"[21] These useful slippers have a way of reappearing in subsequent accounts of liberty in the harem. After remarking the freedom with which Turkish women "expostulate" and talk back to their husbands, Julia Pardoe, for instance, reports that should such a husband "on passing to his apartment, see slippers at the foot of the stairs, he cannot, under any pretence, intrude himself in the harem: it is a liberty that every woman in the empire would resent."[22] Whereas Lady Craven imagined how easily one might put out the slippers in order to introduce a lover, a Victorian like Pardoe was more inclined to see in the custom the sign of a wife's power to refuse even her husband. Indeed, such monitory slippers are increasingly fetishized by later writers, who come to associate them not with sexual freedom but with a freedom from sex — or at least from sex-on-demand — conspicuously absent at home.[23] Recognizing how little either law or custom acknowledged an Englishwoman's right to marital privacy, nineteenth-century travelers tended to idealize the sanctity of the harem, celebrating its inviolable space as a realm of female autonomy and control.[24] "The Turks, in their gallantry, consider the person of a woman sacred," Anne Katharine Elwood announced firmly in 1830, "and the place of her retreat, her Haram, is always respected."[25]

The liberty that some Victorian women saw in the harem was not merely negative, however. If they no longer dwelled on the carnivalesque possibilities of Lady Mary's "perpetual Masquerade," they still emphasized the Turkish woman's ability to come and go as she wished. "A Turkish woman consults no pleasure save her own when she wishes to walk or drive, or even to pass a short time with a friend," Pardoe reported: "she adjusts her *yashmac* and *feridjhe,* summons her slave," and leaves her husband to learn from another member of the household that she "is gone to spend a week at the harem of so and so." Should her husband be suspicious, Pardoe claimed, he "takes steps to ascertain that she is really there; but the idea of controlling her in the fancy, or of making it subject of reproach on her return, is perfectly out of the question." Unconsciously echoing Lady Mary, she too pronounced Turkish women "the freest individuals in the Empire."[26] This is the same Pardoe, it may be recalled, who automatically reached for the figure of the "caged birds" when she wished to register her disapproval of Turkish women's tendency to flirt on shopping trips. But if Pardoe was not the most rigorously consistent of writers, she did tacitly correct herself when she published her sequel to *The City of the Sultan* the following year: "it is a great fallacy to imagine that Turkish females are like birds in a cage, or captives in a cell; — far from it."[27] And though she never repudiated her allusion to the Grand Seraglio as a "painted prison," several decades later *Bentley's Miscellany* would confidently dismiss that figure too: "At the present day, at any rate, there is no such thing as imprisonment in the seraï. When a Sultana or an Odalisque feels inclined — and this happens very often — to take an excursion to the Sweet Waters, or make purchases at a bazaar, she simply orders her carriage, drives off, and remains out as long as she likes."[28] Even in the face of such representations, of course, the old images persisted. But it is no wonder that by the time Annie Harvey set out a few years later to deplore the harem's "mental imprisonment," she felt compelled to begin by acknowledging that received wisdom appeared to argue quite the opposite: "We had often heard that Eastern women enjoyed in reality far more liberty than their Western sisters."[29]

That such contradictory representations could exist side by side testifies partly, of course, to the elements of projection and fantasy in both. But if the trope of the prison was increasingly contested in the nineteenth century, the monolithic figure of the harem was also giving way to a multiplicity of harems, as speculations about the hidden life of the Grand Seraglio were displaced by a growing number of travelers' reports on their visits to more or less ordinary households. For all their aristocratic biases, the

embassy letters anticipate the change: though Lady Mary confined her visits exclusively to harems "of Quality," their inhabitants still moved more freely through the city than did the royal concubines. And since the lower down the social scale one looked, the less restrictively the harem system operated, it is not surprising that representations of Eastern women's "liberty" should appear with increasing frequency the more that middle-class Western women began to visit among their Eastern counterparts.[30]

Acquaintance with the relative economic and legal power of Muslim women also contributed to these visions of liberty. "A Husband would be thought mad that exacted any degree of Oeconomy from his wife, whose expences are no way limited but by her own fancy," Lady Mary characteristically reported. "'Tis his busyness to get Money and hers to spend it, and this noble prerogative extends it selfe to the very meanest of the Sex." The female power of the purse, Lady Mary believed, left an erring wife little to fear from the resentment of her husband — "those Ladys that are rich having all their money in their own hands, which they take with 'em upon a divorce with an addition which he is oblig'd to give 'em."[31] Though Lady Mary may have been mistaken on the latter point, at least if the husband was thought to have repudiated his wife with good cause,[32] she was not alone in envying the comparative financial independence of women in the East. Nearly two hundred years later, an American traveler, Anna Bowman Dodd, likewise commended "the free and uncontrolled possession of her property" that a Turkish wife retained for the duration of the marriage, as well as the practice of reserving half the dowry for her in case of divorce. "The rights of women in Turkey were clearly defined some twelve centuries before Christian Europe or America had seen fit to grant either divorce to women or suitable alimony," Dodd announced firmly, while another passage declared these rights "so numerous, indeed, that . . . it is the European rather than the Osmanli women who seem to be still in bondage."[33] If such rights may have existed more often in theory than in practice,[34] the very eagerness with which some female travelers seized on the theory speaks to the wishfulness that always entered into such visions of liberty.

Given Europe's long obsession with enslavement in the seraglio, it hardly seems irrelevant, either, that many of those who saw freedom in the harem also found Eastern slavery a more benign and flexible institution than they had expected. Lady Mary, for one, thought the evils of the slave market at Constantinople grossly exaggerated. "You will Imagine me half a Turk when I don't speak of it with the same horror other Christians

have done before me," she wrote to an aristocratic woman of her acquaintance, "but I cannot forbear applauding the Humanity of the Turks to those Creatures. They are never ill us'd and their Slavery is in my Opinion no worse than Servitude all over the world."[35] Though some English abolitionists would campaign vigorously against slavery in the harem during the century that followed,[36] many travelers to the East agreed with Lady Mary and turned her comparison with domestic servitude into a commonplace of writing in the period. "Apart from the feeling of moral degradation which belongs to the idea of slavery," Emma Reeve observed typically in 1839, "that unhappy state is more tolerable in Turkey than domestic servitude among many nations."[37] Despite her skepticism about the mental liberty of Turkish women, Annie Harvey went even further, remarking that "the servants, or slaves, are treated with a kindness and consideration that many Christian households would do well to imitate."[38] Harriet Martineau might fulminate against "these two hellish practices, slavery and polygamy" and compare the Egyptian slave owner to the "Carolina planter," but those who looked more sympathetically at the harem drew firm distinctions between Eastern slavery and the institution as it existed in America and the European colonies.[39] Julia Pardoe regarded the sale of human beings as a "painful scene, bitter and revolting even under the most favourable aspect," yet she left the slave market at Constantinople with "an increased conviction of the great moral beauty of the Turkish character." Like other travelers, she noted that slavery was often a temporary condition, deliberately chosen by the slave, that it served as a means of social mobility for many people, and that those unhappy with their owners could negotiate for new ones. To illustrate the slave's power over her fate, Pardoe told of a woman who successfully demanded that her current mistress sell her to her lover, despite the fact that the young man had been outbid by a wealthier purchaser.[40] Others observed that slaves who bore their masters' children were often granted their freedom. Indeed, the remark that the slave was virtually a member of the family surfaced almost as regularly as the comparison with domestic service. If such analogies may prompt some modern readers to reflect cynically on how servants — or relatives, for that matter — were once treated in the West,[41] the writers themselves concentrated on how lightly and even impermanently the bonds of Eastern slavery seemed to be tied.

Women who wrote in this vein were more inclined to identify with the mistress, of course, than with the slave. But the less they thought of the harem as the locus of oppression, the readier they were to entertain such ironic reversals of comparative liberty as Lady Mary first registered when

the Sofia bathers mistook her corset for a cage in which she was locked up by her husband. Julia Pardoe may have gloried in her freedom as her boat sped past the sultan's "painted prison." Yet what looked like freedom, she could also acknowledge, depended on the perspective of the observer. When Turkish women contemplated the anxiety with which female travelers like herself rushed about — all the trouble and danger to which they exposed themselves as they hastily ran from one sight to another, all that busyness expended for "such slight ends" — they could "imagine," Pardoe duly reported, "no slavery comparable with our's."[42]

Part Three
Sex and Satiety

9

Pleasure in Numbers

Harems of the mind offer their makers the possibility of erotic choice without limit — a fantasized alternative, in other words, to the constraints of monogamy. Whether one thinks of European history generally or the sequence of a particular narrative, it should not be surprising that such harems tend to appear whenever Western men seriously contemplate the prospect of marriage. Like more respectable heroes, even the protagonist of *The Beggar's Opera* (1728) must finally settle for monogamy — but not before he first bids farewell to the fantasy of a harem. With his numerous "Wives" and his ready appropriation of other people's money, John Gay's hero appears to defy English laws of matrimony and property alike. Yet the final scenes of Gay's satire mock the artifice of comic closure not only by arranging for Macheath's last-minute reprieve from the gallows but by dismissing the multiple "Wives" as a fiction. The very plurality of these "Wives" may have encouraged the audience to take for granted that none is legitimate, but when four new claimants appear on stage — accompanied, the jailor announces, "with a Child a-peice!" — Macheath reveals that he and Polly were "really married" all along. Though he has repeatedly joked about the advantages — and disadvantages — of having more than one wife, Gay's hero openly compares himself to "the Turk" only at the moment when he publicly commits himself to a single partner "for Life":

> *Thus I stand like the Turk, with his Doxies around;*
> *From all Sides their Glances his Passion confound;*
> *For black, brown, and fair, his Inconstancy burns,*
> *And the different Beauties subdue him by turns:*
> *Each calls forth her Charms, to provoke his Desires:*
> *Though willing to all; with but one he retires.*[1]

While the fires of "Inconstancy" have not gone out, Macheath's ironic acknowledgment that even the Turk can manage "but one" at a time ruefully accepts the necessity of choice. As a sentimental husband — for the moment, at least — he relegates the pleasure of numbers to the realm of illusion.

Gay was not the only eighteenth-century writer to suggest how men's fantasies of the harem might appear to compensate for their anticipation of monogamy. Richardson's Lovelace occupies a rather more exalted place in society than does Macheath, but both are essentially male aristocrats, who conduct their amorous careers by codes that were coming into increasing conflict with a bourgeois and feminine morality.[2] The promiscuous antagonist of *Clarissa* (1747–48) is a far more serious and pathological case than Macheath, of course; but like Gay's hero, he knows that "once married…I am married for life,"[3] and he too responds to the threat by projecting himself — more than once, in fact — into an imaginary harem. While Macheath compares himself to the generic "Turk," Lovelace, as we might expect, identifies with the Grand Signor. But even when he casts his fantasy in the humble form of a barnyard parable, he clearly associates the harem with the power of erotic choice. Complaining to Belford that Clarissa has resisted his attempts to place her under obligation to him, he offers the rooster's management of his hens as a model for the giving and receiving of benefits between "lovers":

> A strutting rascal of a cock have I beheld chuck, chuck, chuck, chucking his mistress to him, when he has found a single barley-corn, taking it up with his bill, and letting it drop five or six times, still repeating his chucking invitation: and when two or three of his feathered ladies strive who shall be the first for't (Oh Jack! a cock is a Grand Signor of a bird!), he directs the bill of the foremost to it; and when she has got the dirty pearl, he struts over her with an erected crest, and an exulting chuck . . . while the obliged she, half-shy, half-willing . . . lets one see that she knows the barley-corn was not all he called her for. (449)

At once a sexual member and a Grand Signor, this "strutting rascal of a cock" acts out the barnyard equivalent of the fabled ritual at the Ottoman court — the bit of barley-corn substituting for the royal handkerchief with which that other master of the harem was reputed to single out his partner for the night.[4]

That Lovelace has this very ritual in mind is confirmed by the human harem he imagines for himself somewhat later in the novel, when he conjures up a "humble and tamed" Anna Howe sitting "arm in arm" with

an already broken and submissive Clarissa: "And I their emperor, their then *acknowledged* emperor, reclined on a sophee, in the same room, Grand Signor-like, uncertain to which I should first throw out my handkerchief." Like other fantasizers of the harem, as we shall see, Lovelace evidently derives sadistic pleasure from the imagined powers of the despot: in his harem, "the two lovely friends" are "weeping and sobbing for each other," while the anticipated thrill of choosing between them is intensified by his consciousness that both have been thoroughly humbled and broken (637). If a choice of two nonetheless appears to constitute a very modest fantasy of a harem, Lovelace will subsequently make clear that his ambitions in this regard are nothing short of global. Had he been born a prince, he tells Belford, he would have "added kingdom to kingdom" till he "had obtained the name of *Robert the Great*": "And I would have gone to war with the Great Turk, and the Persian, and the Mogul, for their seraglios; for not one of those Eastern monarchs should have had a pretty woman to bless himself with, till I had done with her" (762).

As if the alternative to monogamy were indeed gratification without limit, bodies and pleasures multiply endlessly in harems of the mind. An erotic print by Thomas Rowlandson entitled *Harem* (after 1812) wittily evokes the dream of infinite possibility that inspires so many masculine fantasies of the East (fig. 25). Seated cross-legged on a carpet and sporting a very conspicuous erection, a male in Oriental costume surveys a double frieze of naked women, whose various body-types and lascivious postures appear to extend indefinitely before him. Between the cropped bodies on the left and the unreadable curves that imply a crowd vanishing into the distance on the right, Rowlandson deliberately refuses to fix the numbers of this feminine company. At the same time, he clearly consigns their promise of endless pleasure to the realm of fantasy. Just as the second row of women floats on no visible support, so the implausible perspective and arbitrary lighting of the entire "harem" call attention to the flat surface from which the artist has conjured them. Only the excited observer fully exists in three dimensions, sharply divided from the space of the imaginary crowd. The eye alone, Rowlandson knows, is capable of possessing multitudes.

Not every dreamer of the harem was so clear-sighted. In a characteristic bit of anti-Islamic polemic, Aaron Hill's *Present State of the Ottoman Empire* (1709), heatedly conjured up a masculine population altogether given over to licentious indulgence— "*Wives, Slaves,* and *Concubines,* promiscuously granted them without controul, and every *Tenet* of their *Faith,* and *Practice* of their *Lives,* combining jointly to indulge their Wishes, in

the gross Enjoyment of a sensual Appetite." Though Hill went on to
acknowledge that "common Custom" limited the Turks to "four *lawful
Wives*," it was obviously the unlimited numbers that he found
irresistible — and the official permission to enjoy them. No sooner had
he mentioned the four wives than he immediately remarked how the Turks'
"wand'ring Inclinations" could meet no impediment to "a Pleasure *Heaven*
design'd 'em," since "they are freely suffer'd to enjoy the Persons of as many
Concubines, or *purchas'd Slaves*, as they may think agreable." Like other
wishful commentators, Hill hardly troubled to distinguish between the
agreeable and the practical, though a later passage on the subject at least
alludes, more soberly, to "as many *Slaves* as they can purchase."[5] While
Lady Mary would soon suggest that even wealthy Turks were no more
inconstant than the English with their mistresses,[6] most erotic fantasies
of the harem take little account of how few men could actually afford to
maintain large collections of concubines. Even the number of women in
the Ottoman palace was routinely exaggerated in Western reports,[7] and
harems of the mind expanded accordingly. In the fifth canto of *Don Juan*,
Byron extravagantly supplied his sultan with "four wives and twice five
hundred maids" (5.148); by the time the poet took up his tale again two
years later, the sultan had somehow acquired "a fifteen-hundredth con-
cubine" (6.8). Though Byron evidently delighted in his jokey numbers, it
is not clear that even he registered how his imaginary harem had swelled
by a third, while his hero still remained suspended in the "awkward"
seduction scene that had closed the previous canto (6.7).

As Lady Mary's worldly comparisons between masculine habits in
Turkey and England might remind us, men hardly needed a harem in
order to possess multiple partners. "But You'l object Men buy women
with an Eye to Evil," she had written to a female friend about the slave
market at Constantinople. "In my opinion they are bought and sold as
publickly and more infamously in all our Christian great Citys."[8] Though
Lady Mary clearly aimed her remark against the prostituting of women at
home, others exploited the analogy for the exotic coloring it lent Western
practices. By the middle of the century, when Cleland's Fanny Hill paid
affectionate tribute to the "founders, and patrons of this little Seraglio,"
she was recalling no visit to the East but a sojourn in a London brothel.[9]
That the English word "seraglio" came, in fact, simply to signify a "house
of women kept for debauchery," as Johnson's *Dictionary* (1755) records,
while the largest brothel in mid-nineteenth-century Paris called itself
the "Maison Orientale," suggests how thoroughly many Western imagi-
nations confounded the harem and the whorehouse.[10] Though some moral

arguments prompted by the analogy were serious enough — writing in 1778, Lord Kames, for example, protested that the lack of any "culture bestowed on the mind" effectively prevented the women of Asia from realizing that they had been "made prostitutes" — the identification of harems and brothels tended to obscure the fact that the sexual promiscuity in question was strictly that of the master. "There can be no mutual affection between a man and his instruments of sensual pleasure," Kames declared, only to follow it up by writing as if the sensual pleasure of the instruments accounted for the harem: "And if women be so little virtuous as not to be safely trusted with their own conduct, they ought to be lock'd up."[11] Rather than "twice five hundred maids," Byron himself had originally thought of populating his harem with "twelve hundred whores."[12]

Indeed, it was precisely the conviction that whoring and fornication were all too prevalent in eighteenth-century England that would inspire an extended debate in the 1780s over the comparative virtue of polygamy. In *Thelyphthora; or, A Treatise on Female Ruin* (1781), the most influential advocate of the practice, a hospital chaplain named Martin Madan, marshaled three volumes of scriptural and other evidence (including the very lines cited above from Lady Mary) in order to demonstrate the moral superiority of marrying several women rather than "ruining" them. Though Madan strenuously worked to distinguish his case from "the laws of the *seraglio*, or of the *haram*," he also freely drew on comparisons that operated to the evident disadvantage of his countrymen.[13] One note cites the "bitter *sarcasm*" that David Hume had attributed to the last Turkish ambassador in France: "We *Turks* are great simpletons, in comparison of the *Christians*. We are at the expence and trouble of keeping a *seraglio*, each in his own house; but you ease yourselves of this burden, and have your *seraglio* in your friends' houses." Yet if Madan was not exactly wrong to contend that "in this *Christian* country" a man "may have as great a variety of women as he pleases," many of his fellow Christians nonetheless continued to dream of a place where variety was not just possible but officially authorized and encouraged.[14]

When Boswell confided in his journal for 1775 that he "could not help indulging Asiatic ideas as I viewed such a number of pretty women," or assured himself in 1776 that "these are Asiatic satisfactions, quite consistent with devotion and with a fervent attachment to my valuable spouse," his repeated code for promiscuity also entailed a fantasy of moral permission and approval. Like his other favorite idiom for amorous experience with multiple women — being "patriarchal" or acting "upon

the Old Testament plan" — the idea of "Asiatic" satisfactions carried with it the idea of a culture in which divine authority had officially sanctioned such indulgence.[15] "If it was morally wrong, why was it permitted to the most pious men under the Old Testament?" he might ask himself one day; while on another he could record how he had "flattered" himself "that there were no certain divine precepts as to intercourse between the sexes" and immediately follow this up by confessing, "I was Asiatic in imagination."[16] Though Boswell had tried out both idioms on Rousseau more than a decade earlier, neither "the Oriental usage" nor "the example of the old Patriarchs" had won the desired approval for his hypothetical concubines. "You must not pick and choose one law here and another law there," Rousseau had sternly advised him; "you must take the laws of your own society." But Boswell evidently went on dreaming of a place where he might have "thirty" women — the number he had ventured to Rousseau — with impunity.[17]

Though Boswell devoted considerable energy to justifying his "Asiatic" imaginings, he does not seem to have speculated very much about why men should find themselves so attracted to such a numerical imbalance between the sexes. For his own part, he just took for granted that he was "*too many* for one woman," as he put it — especially when that woman (his wife) was herself "moderate and averse to much dalliance." Possessed of "an exuberance of amorous faculties," James Boswell simply tended to exhaust the available opportunities.[18] But many of those who did theorize about the harem were either less energetic or more cynical. The disproportionate numbers, they tended to suggest, had less to do with a natural overflow of male capacity than with a need to stimulate it. When Usbek's chief black eunuch describes his latest acquisition for the *sérail*, a young Circassian slave whose beauties he has just unveiled, he writes pointedly of the "pleasure" his returning master will find in seeing "reborn" such charms as "time and possession work to destroy" (lxxix. 169). What Boswell would call a "plurality" of women serves by this account more to reawaken male desire than to accommodate its excess.[19]

Not surprisingly, perhaps, the marquis de Sade elaborated a version of this argument at once more thoroughgoing and more brutal. Though Sade drew freely on the associations of the harem for pornographic fantasies like *Les Cent vingt Journées de Sodome*, his most extended harem fiction occurs as a subplot of his epistolary "roman philosophique," *Aline et Valcour* (1795). In pursuit of his beloved Léonore, who has been abducted from him, the hero Sainville is himself captured and taken to the *sérail* of a ferocious African cannibal named Ben Mâacoro. Deemed too thin to be eaten

and too old for the cannibal's sexual appetite, he is instead assigned to replace an aging Portuguese named Sarmiento in the business of selecting the members of the royal harem. A worldly relativist whose accommodation to native ways has even extended to his diet, Sarmiento instructs the new recruit on the duties of his office. To Sainville's wondering question — "But can you conceive . . . that there are beings for whom debauchery renders seven or eight hundred women necessary?" — Sarmiento replies, in effect, that nothing could be simpler. "Is it not natural to seek to multiply one's pleasures [jouissances]?" he demands.

> However beautiful a woman may be, however fascinated one is with her, it is impossible not to become accustomed, by the end of fifteen days, to the monotony of her features; and how can what one knows by heart inflame one's desires? . . . Isn't their irritation much more sure when the objects that excite them vary ceaselessly around you? Where you have only one sensation, the man who changes or who multiplies feels a thousand. Since desire is nothing but the effect of irritation caused by the shock of atoms of beauty on the animal spirits, since the vibration of these can only arise from the force or the multitude of these shocks, isn't it clear that the more you multiply the cause of these shocks, the more violent the irritation will be? Now, who doubts that ten women at the same time under our eyes will produce, by the emanation of the multitude of the shocks of their atoms on the animal spirits, a more violent inflammation than a single one could?

What begins as an argument from variety ends, it would seem, in sheer multiplication: the larger the harem, the more "atoms of beauty" to inflame the "animal spirits" of the observer. Though Sainville responds with predictable outrage to Sarmiento's theory — denouncing it as lacking all "principle" and "delicacy" — an author's note solemnly endorses its basis in science. Identifying the "animal spirits" as "this electric fluid that circulates in the cavities of our nerves" and causes all our sensations of pain and pleasure, the note defines it — "in a word" — as "the only soul admitted by our modern philosophers." Sainville's principle and delicacy may have some bearing on love, Sarmiento goes on to suggest, but this decidedly material soul is the only one necessary for the pleasures of the harem.[20]

When it came to bodies, the appetite for variety could apparently encompass the globe. Among the "two thousand women" in the king's *sérail*, Sainville later reports, were "black women, yellow ones, mulattos, and pale ones" — the brief racial taxonomy serving as a familiar shorthand

for a collection that knows no geographical boundaries.[21] Though Sade's cannibal king bears little resemblance to an Ottoman sultan, the actual practice of the Ottomans in this regard, duly exaggerated, would seem to have inspired many such fantasies of the harem's boundless variety. According to Paul Rycaut's *Present State of the Ottoman Empire* (1668), the Grand Seraglio housed an "Assembly of fair Women . . . composed almost of as many Nations as there are Countries of the World," who "make it the only study and business of their lives to obtain the nod of invitation to the Bed of their great Master" — a passage Byron may well have recalled when he mischievously described "this goodly row / Of ladies of all countries at the will / Of one good man" in the sixth canto of *Don Juan* (6.33).[22] Since their faith forbid the enslavement of free Muslims, the Ottomans did import many slave-concubines from lands outside Islamic rule, and the practice obviously tended to increase the international character of their harems.[23] But if it seems doubtful that even the Grand Signor had quite the choice of partners Rycaut imagined, a harem of the mind could allow a man to entertain such possibilities without limit. Fantasies of the harem enable any man to imagine himself an erotic imperialist.

In "The Veiled Prophet of Khorassan," the first tale of *Lalla Rookh* (1817), Thomas Moore luxuriantly catalogued the female charms that "every beauteous race beneath the sun" had contributed to the harem of his sinister prophet:

> From those who kneel at BRAHMA's burning founts,
> To the fresh nymphs bounding o'er YEHMEN's mounts;
> From PERSIA's eyes of full and fawn-like ray,
> To the small, half-shut glances of KATHAY:
> And GEORGIA's bloom and AZAB's darker smiles,
> And the gold ringlets of the Western Isles;
> All, all are there . . .

A subsequent episode in which the prophet sets his women to seduce the hero makes the fantasy of erotic choice in such taxonomies more explicit:

> Woman's bright eyes, a dazzling host of eyes
> From every land where woman smiles or sighs;
> Of every hue, as Love may chance to raise
> His black or azure banner in their blaze;

And each sweet mode of warfare, from the flash
That lightens boldly through the shadowy lash,
To the sly, stealing splendours, almost hid,
Like swords half-sheathed, beneath the downcast lid; —
Such, AZIM, is the lovely, luminous host
Now led against thee . . .[24]

Azim steadfastly resists his temptation, but not before the poet himself has indulged in several more pages of his sensuous catalogue. Perhaps as a consequence, Byron's version a few years later was distinctly more impatient:

> in short,
> (To save description) fair as fair can be
> Were they, according to the best report,
> Though differing in stature and degree,
> And clime and time, and country and complexion. (6.40)

Though most visual representations of the harem approach something like Moore's luxuriance, their methods of cataloging come closer to Byron. Rather than attempt to reproduce "every beauteous race beneath the sun," in the words of *Lalla Rookh*, they typically choose to evoke such fantasies by providing only a schematic indication of imagined plenitude. In his pastel of *Trois Odalisques* (1820s), for example, Jules-Robert Auguste transposes the dream of infinite variety into a seductive contrast of black and white (fig. 26). While Auguste seems primarily interested in titillating the viewer with a choice of races and positions — and a hint of lesbianism — others manipulate such contrasts to distinctly more racist effect. Like so many of his Oriental bathing scenes, Gérôme's *Bain maure* [Moorish bath] of 1870 (fig. 27), gestures at the racial diversity of the harem, even as it points up the superior attractions of the lighter-skinned figure. A luscious nude who deliberately recalls the pose of Ingres's *Baigneuse Valpinçon* (fig. 9), Gérôme's bather not only stakes out his own claim to the status of art but makes the erotic focus of his attention unmistakable.[25] While the half-nudity of the black figure duly contributes to the viewer's seduction, there is no question that she is designed, in every sense of the word, to serve her fairer companion.

The routine racism with which Gérard de Nerval speculated on such contrasts in the account of his Egyptian travels that first began to appear in the 1840s may serve to gloss the many images of Oriental women that

operate to similar effect. Having reluctantly been persuaded that a single man in Cairo was in need of a female slave, Nerval (or at least his fictional substitute) rejected the idea of purchasing one of several Nubians exhibited to him at the market.[26] But while he could not "catch fire for these pretty monsters," as he put it, he had no doubt that "the beautiful women of Cairo" must like to surround themselves with such creatures:

> It is possible to produce charming oppositions of color and form; these Nubians are not at all ugly in the absolute sense of the word, but form a perfect contrast with beauty such as we understand it. A white woman must stand out admirably in the middle of these young women of the night [filles de la nuit], whose slender forms seem destined to braid hair, lay out cloth, and carry bottles and vases, as in the antique frescos.

As if he were recalling the black slaves in Delacroix's Algerian interiors or anticipating the uses to which Ingres would similarly put such figures in the *Bain turc,* Nerval conjures up a vision of subservience at once social and aesthetic — even as he attributes it, of course, to the vanity of women. Intending to buy only a single slave, he inevitably looks for a lighter-skinned purchase. But just as the price scale of the Cairo slave market suggests that his relative preferences were shared by many Egyptians, so the Frenchman's own fantasies do not altogether dismiss the pleasure of numbers. If he had been able to lead "la vie orientale" on a large scale, Nerval adds revealingly, he would not have deprived himself of these "pittoresques créatures."[27]

A Climate for Pornography

F or many imaginations, the erotic heat of the harem was scarcely to be distinguished from the prevailing warmth of the climate. The fifth canto of *Don Juan* elaborates the connection with Byron's usual flippancy:

> The Turks do well to shut — at least, sometimes —
> The women up — because in sad reality
> Their chastity in these unhappy climes
> Is not a thing of that astringent quality,
> Which in the north prevents precocious crimes,
> And makes our snow less pure than our morality;
> The sun, which yearly melts the polar ice,
> Has quite the contrary effect on vice. (5. 157)

Despite the final allusion to an ungendered "vice," the Turkish sun, in Byron's account, appears primarily to heat up the passions of the women — men's libidos presumably requiring little assistance from heightened temperatures. If his hero's subsequent adventures in the harem suggest that shutting women up does more to arouse female appetite than to curb it, Byron was hardly alone in thus contradicting himself. Whether they concentrated on the heat outside or the atmosphere within, erotic fantasists of the harem had more than one way of generating their desired climate.

What might be called the climatological theory of the harem's origins had a long history, though not every commentator agreed on just whose hot passions rendered it necessary.[1] Both Chardin and Montesquieu, as we have seen, thought the confinement of women followed naturally from the inflamed passions of Eastern climates. In so hot and dry a country as Persia, Chardin wrote, "one feels the movements of love more

strongly and . . . is more capable of responding to them" — a rule he immediately glossed by asserting that "the passion for women is extremely violent there and as a consequence jealousy too is much stronger." Though Chardin also refers generally to "lust" as "natural to the Persian climate," the climatological laws in his account seem chiefly to govern the male.[2] According to the *Esprit des lois* (1748), on the other hand, the principal casualty of high temperatures is the "natural" modesty of the female. As Montesquieu blandly inquires in book 16: "What purpose would it serve to lock up women in our northern countries, where their manners [moeurs] are naturally good; where all their passions are calm . . . where love exerts over the heart so regulated an empire that the least government suffices to rule them?"[3] Though this picture of northern womanhood seems hardly consistent with the collective portrait of Frenchwomen limned by the satirist of the *Lettres persanes* (1721), it presumably does serve to explain why harems arise where both climates and women are hotter.

Which sex is actually the aggressor by Montesquieu's account is not always easy to determine. While at one point he speaks of "attack" and "resistance" in conventional terms — the problem being, it would seem, that women in the hot countries fail to present men with any natural check to their passions — at another he appears to suggest that men build harems less to exclude other men than to protect themselves from being worn out by the sexual demands of their women. Comparing the master of the harem to "an insolvent debtor [who] seeks to conceal himself from the pursuit of his creditors," Montesquieu conjures up the image of a man energetically pursued by claimants who have exhausted his capacity to satisfy them.[4] But whether women actively chase men or simply lack all restraint, the lesson appears much the same: a man possessed of many women whose erotic temperatures are high has every reason to build the walls of a harem.

The threat of sexual exhaustion, as we shall see, often haunted the dream of the harem's limitless pleasures. But for a man accustomed to the conventional order of attack and resistance, there was also something powerfully attractive in the idea of a prodigious number of women all hotly competing for his attention. And no one inspired such fantasies more, of course, than the Ottoman sultan. In notably similar accounts, both Rycaut and Hill placed the scene of competitive seduction in the seraglio gardens. "Here the Women strive with their Dances, Songs and Discourse to make themselves Mistresses of the Grand Signiors affection," Rycaut reported, "and then let themselves loose to all kind of lasciviousness and wanton carriage, acquitting themselves as much of all respect to Majesty as they do to modesty." As if his predecessor's brief remarks had served to kindle

his own heated fantasies, Hill generated an entire narrative of erotic desire and satisfaction:

> It is not seldom that the *Sultan* does in Person grace their Exercises, and then they all contrive with eager Emulation, who shall most engage his fancy by the Artifice of her Behaviour; now *Modesty* takes leave of these Licentious *Ladies*, and the Warmer Arguments of loose desire incline them to the Practice of the most *Lascivious Dances, Postures,* and *Performances*, which serve to raise a Lustfull Fire, and may excite the *Passion* of the Amorous *Sultan* to a Cooling satisfaction of his Heated Wishes, in a full Possession of her happy charms, who more than any other moves his Inclinations.[5]

Though Hill never openly identifies with "the Amorous *Sultan*," his imaginary monarch would appear not to be the only man carried away by this scene of female abandonment.

Tales of ordinary men pursued by women in the hot countries offer perhaps a more obvious route for masculine fantasizing, especially when the hero of such wishful tales happens, as he often does, to be a traveler from the West. Such tales were a regular feature of harem literature, though whether the women in question were locked up because they were lascivious or lascivious because they were locked up, not all commentators managed to agree. While the evidence of the *Lettres persanes* is rather equivocal on this score, the *Esprit des lois* seems to take for granted that the heat of the women normally preceded their experience of confinement. In several cautionary reports that he attaches to his discussion, Montesquieu conjures up the spectacle of men in the hot countries apparently unprotected by the harem — as in Patan, where "the lechery of the women is so great, that the men are obliged to make use of certain garments to shelter them from their attempts," or in Guinea, where the women "slip into a man's bed, and wake him; and if he refuses, threaten to suffer themselves to be caught in the act."[6] For Aaron Hill, on the other hand, the harem was itself the cause of such licentious behavior. Though Hill told similar tales about "the Lewdness of the *Turkish* Ladies, when they can convey some Stranger into their Appartments," he firmly attributed their "warm Desires" to "the effects of their unnatural Confinement." As a "fair Example" of such "*Levity*," he offered a lengthy anecdote about a harem of "no less a Number than *a quarter of an Hundred*," whose restless inhabitants cheerfully draw lots for their turns with "a brisk *English Sailor.*" Though an accidental discovery prompts his escape before he has

completed his rounds, the protagonist of this fabulous narrative nonetheless departs "Ten or Twelve" large diamonds the richer — "every *Lady* gratefully bestowing *One*, the Night she Bedded him."[7]

Introducing his own tales of amorous Turkish women and willing strangers in his *Voyage du Levant* of 1717, Joseph de Tournefort offered a temporal variant on Hill's theory: "the extreme constraint with which they are guarded makes them go a great way [faire trop de chemin] in a little time." Tournefort claimed that the more ardent among them sometimes ordered their slaves to stop the best looking men who passed in the streets, and that "they usually address themselves to Christians" — the naturalist in him no doubt prompting him to add, "it is easy to believe that they do not choose those who appear the least vigorous."[8] Several decades later, Lord Kames endorsed the climatological theory of erotic heat in both sexes, while painting a picture of the streets of Constantinople as yet more hazardous to the chastity of a passing stranger. According to Kames, a male traveler walking through the city was accosted en masse by a group of wives and concubines on an outing, one of whom even attempted to "expose his nakedness." Neither the objections of the victim nor the loud protests of "an old Janizary" who happened to observe the scene, Kames reported, had any effect.[9]

Such tales persisted well into the nineteenth century, as did speculation about whether the harem was the cause or the consequence of female amorousness.[10] But if some men imagined being overwhelmed by women in the hot countries, others fantasized a place where beautiful slaves surrendered utterly to the will of the master. This is what we might call the fantasy of erotic despotism, and it had its most relentless exponent, not surprisingly, in the marquis de Sade. In Sade's African kingdom, "moral corruption" is predictably induced by "the extreme heat of the climate," but all that corruption concentrates, as Sarmiento tells it, in the "lascivious debauchery" of the patriarch. Women in Butua, Sarmiento reports, are raised with only one virtue: "the most entire resignation, the most profound submission to the will of men."[11] Indeed, so thoroughgoing is the sexual slavery of the royal harem that a woman who attempts to share in the *jouissance* of her master is severely punished. Yet even such extravagant fantasies of male domination may not so much oppose dreams of female aggressiveness, one could argue, as derive additional excitement from their existence. Nor do erotic dreamers necessarily occupy fixed positions in their fantasies, especially when these involve scenarios of absolute control and surrender. The desire to be utterly overwhelmed and the desire to dominate totally could well inspire the same harem of the mind.

The only climate in *Les Cent vingt Journées de Sodome* is that of the French countryside in winter, but the readiness with which Sade drew on figures of the harem for his exercise in pornographic violence suggests how closely Oriental despotism was already identified with erotic domination. "We libertines take wives to be our slaves," the duc de Blangis announces to the assembled company, "and you know what value we place upon despotism in the pleasures we enjoy." In a château appropriately furnished with "very fine Turkish beds," the libertines gather not only those slave-wives but two parallel collections of young persons — a "sérail des jeunes filles" and a "sérail des jeunes garçons" — on whom they proceed to perform their experiments in debauchery and torture. Just as the figure of the *sérail* attaches itself indifferently to erotic victims of either sex, so the young girls themselves are incongruously termed "sultanes" — despite the fact that the word actually refers not to the sultan's sexual partners but to his sisters and daughters.[12] While the libertines' methodical insistence on incestuous couplings of every kind might give the term a certain ironic appropriateness, there is no evidence that Sade had any such intention in mind. (In fact, it is the libertines' "wives" who are variously related by blood to other members of the company.) Unlike the *Memoirs of the Seraglio of the Bashaw of Merryland* (1768), which similarly imagines that "sultanas" are women collected for sexual use in a "seraglio," *Les Cent vingt Journées* makes no pretense of modeling its elaborate rules on the actual organization of an Eastern palace.[13] Its repeated allusions to the *sérail* are verbal tokens in a work of pornography rather than attempts at mimesis, however fantastic, and they serve primarily an emotive function, conjuring up vague associations of Oriental cruelty and license.[14] Like the African cannibal of *Aline et Valcour*, the libertines of *Les Cent vingt Journées* exercise an absolute despotism over the bodies of their victims; and like the cannibal king, they recognize no difference between the erotic use of those bodies and the power to torture and mutilate them. Instead of the business of the sultan's handkerchief, Sarmiento reports, Ben Mâacoro signals his choice of a partner for the evening by ordering that she receive "one hundred strokes with the belt." Such a custom may seem rather mild by comparison with the slow dismemberments coolly detailed in the later portions of *Les Cent vingt Journées*, but it follows from the same theory of erotic despotism.[15]

Though Sarmiento focuses on the proscription of reciprocal pleasure rather than the direct infliction of pain, his account of despotic *jouissance* in Butua provides an explicit articulation of the logic that governs any Sadean *sérail*. "A sultan commands his pleasures, without caring for others to partake

of them," he explains; and if Sainville were to inquire why Ben Mâacoro punishes any woman who tries to share in his pleasure, the king would respond, Sarmiento says, like the inhabitants of three quarters of the earth,

> that the woman who takes as much pleasure as [jouit autant que] the man, occupies herself with something other than the pleasures of that man . . . that he who wishes to take his pleasures completely [jouir complètement] should draw them all to himself . . . and that, in a word, pleasure tasted with an inert being can in no way be less than total, since the agent is the only one who feels it, and at this moment, it is thus all the more intense.

Despite the allusion to an "inert being," Sade makes clear that it is not merely the solitariness of his orgasm that excites the despot but the thrill of exerting power over another living person. When Sainville protests that by this account a man should prefer to have sex with a statue, Sarmiento responds that he has failed to understand: "the voluptuous pleasure imagined by these people consists in what the passive partner [le succube] *is able to do* and *doesn't do,* in the fact that the faculties she has and that it is necessary she have are only employed in doubling the sensation of the active partner [l'incube], without dreaming of feeling it herself." As he demands rhetorically a few lines later: "Who says that tyranny doesn't add to voluptuous pleasure?"[16]

It was Byron rather than Sade who provided the immediate inspiration for Delacroix's *Mort de Sardanapale* of 1827–28 (fig. 28), but the painter's fantasy of orgiastic violence more nearly resembles the erotics of the Sadean *sérail* than it does the pacific sensuality of the poet's *Sardanapalus* (1821). Indeed, for all his licentiousness, no monarch could sound less like a Sadean despot than the Sardanapalus who rules over Assyria in the opening acts of Byron's closet drama. "I hate all pain, / Given or received," this gentle voluptuary announces, arguing that human beings of every rank should rather seek to alleviate one another's suffering than do anything to add to the "natural burthen / Of mortal misery" (1.2.348–52). Though Byron's hero begins as an effeminate "king of concubines" (2.1.59), who wishes to leave his people in peace while he indulges himself with wine and women, he reluctantly ends as a noble warrior, choosing to destroy himself and his palace rather than surrender to his enemies. But compared to the murderous orgy by which Delacroix's monarch anticipates his imminent suicide, the funeral pyre which consumes this Sardanapalus is a dignified and private affair: seeking "no partners," as he says, "but in pleasure"

(4.1.484), Byron's king frees all his slaves, vacates the palace, and even tries to dissuade his courageous Greek favorite, Myrrha, from her loving determination to join him in death. The dramatis personae of Byron's play may include an entire harem, but the action and poetry of *Sardanapalus* produce something closer to an anti-harem fantasy: the only two women with speaking parts are the Queen and this intrepid Greek, both of whom testify movingly to their love for the king; while the solitary pair who finally mount the funeral pyre offer their end as a lesson to "voluptuous princes," even as they welcome the purifying flame in which their ashes will be "purged from the dross of earth, and earthly passion" (5.1.442, 473–74).

According to ancient legend, many of his human possessions did in fact go up in flames with the king. But if the sources that both poet and painter consulted provided some warrant for a more wholesale destruction than Byron represented, the fantasy of sexual murder in the *Mort de Sardanapale* is wholly Delacroix's own.[17] Or rather, the painter responded to the vaguely Byronic aura that now surrounded the Assyrian king with a daring improvisation upon a collective fantasy of lust and violence — of lust *as* violence — in the Eastern seraglio. Between the orgasmic contortion of the nude about to receive a dagger in the foreground — a posture that manages to identify murder with rape, and rape with a consummation avidly desired by the victim — and the intimation of sexual exhaustion in the woman who lies with her arms spread out at the foot of the bed, Delacroix turns the destruction of Sardanapalus's harem into an orgy of pleasurable pain, whose victims ambiguously welcome their own annihilation. If this is not quite the same masculine fantasy as the solitary *jouissance* practiced by the Sadean cannibal — Sade, after all, makes no pretense that the women of the harem enjoy being dominated — it speaks to a related desire for absolute mastery.

Painted five years before Delacroix's journey to Africa, the *Mort de Sardanapale* belongs to a wholly fantasized Orient, an imaginary place far removed from the apartment of the *Femmes d'Alger.* Rather than the interior of a seraglio, the extravagant form of the king's mysteriously isolated bed appears to dominate a fiery wasteland, whose irrationally crowded spaces, theatrical lighting, and cloudlike billows of smoke intensify the dreamlike effect. Though the hallucinatory violence of Delacroix's image could scarcely be further in tone and intent from the genial pornography of Rowlandson's *Harem* (fig. 25), the romantic painting resembles the satiric print in the deliberate theatricality and spatial distortions by which both works self-consciously call attention to their own status as

fantasies. Unlike Rowlandson's all too excited observer, however, Sarda-napalus "holds himself aloof," in the words of one critic, "from the sensual tumult that surrounds him." Comparing the posture of Delacroix's king to the "pose of the philosopher," she has even suggested that this philo-sophic detachment may have helped the painter to "justify to himself his own erotic extremism."[18] But like the similarly posed figure who occupies the shadows of Benjamin Constant's *Les Chérifas* (1884; fig. 29), Sardana-palus shares his bed with one evidently exhausted nude, while he looks, however ambiguously, toward the concupiscently arched form of another;[19] and like that shadowy figure, his pose suggests not so much the aloofness of "the philosopher" as the conventional satiety of the master of the harem. Such an Oriental potentate may appear partly removed from the action, in other words, but he continues to dominate it; and even our knowledge of Sardanapalus's imminent suicide need not cancel out the effect, as in *Les Chérifas,* of his past and future implication in the action.

However freely Delacroix adapted his sources, his image of sexual murder in the Orient could also pretend to the distance of history. Lack-ing such a filter, the violence in most nineteenth-century paintings of the harem is considerably more oblique, even among the highly eroticized tradition of the French Orientalists. As we have seen, a work like Gérôme's *Marché aux esclaves* (fig. 21) manages to evoke the sexual domination of the harem, even as it permits the European viewer to distance himself from the brutality of those who openly traffic in slaves. And while in cer-tain respects the erotic relations of *Les Chérifas* suggest a drastically muted version of the Delacroix, it is one in which any possibility of latent violence would seem to be altogether canceled out by the eager posture of the central nude. Only the bracelets around her arm and leg may faintly hint at what the chain-linked jewelry of Paul-Désiré Trouillebert's *Servante du harem* (1874; fig. 30) implies more boldly — the identification of sexual availability with the condition of a slave. If "shackles worn like ornaments no less / Are chains," to quote the enslaved Greek heroine of Byron's *Sardanapalus* (3.1.195–96), Trouillebert's *Servante* suggests how ornamental "shackles" could themselves be the signs of erotic domination in the harem.

Such associations of slavery and sex have long made the harem an obvious location for pornographic fantasizing. But despite the logic with which Sade argued for the solitary *jouissance* of the sultan, not every erotic fantasist took so rigorously unsentimental a view of the pleasures of despotism.[20] For all the notorious sameness of its products, even the por-nographic imagination responds to shifting beliefs about the nature of the sexes; and if the anonymous author of *The Lustful Turk* (1828) indulged

in a rather different fantasy of domination in the harem, it was at least in part because he had quite different assumptions about the sexuality of women. Sarmiento's account of the voluptuous pleasure to be derived from what a woman "*is able to do* and *doesn't do*" takes for granted, one might say, that she is able to do it; the master of the harem exercises his power by denying, or at least ignoring, her own capacity for pleasure.[21] For the nineteenth-century English pornographer, in contrast, erotic domination means forcibly awakening desire in women otherwise too modest to feel it. Though the titular hero of *The Lustful Turk* begins each conquest by a violent rape, he proves his power by the rapidity with which he can turn a proper Western virgin into an eager, if submissive slave, who "blest the happy chance that had thrown [her] into his powerful arms."[22]

The Lustful Turk in question is Ali, the Dey of Algiers, and the account of his prowess takes the form of an epistolary novel that often reads like a pornographer's variation on Richardson's *Clarissa* (1747–48), translated into a style obviously indebted to Cleland's *Memoirs of a Woman of Pleasure* (1748–49).[23] Though the Dey has inevitably exercised his powers on the women of many nations — in the course of the narrative, we hear of at least two Italians, two Greeks, one Frenchwoman, and an unspecified number of Corsicans — the novel concentrates on the adventures of two respectable Englishwomen, Emily Barlow and Silvia Carey, whose letters to one another alternate, *Clarissa*-like, with the correspondence of the Dey and a fellow despot, the Bey of Tunis. In practice, most of the female side of the story is carried by Emily (who in turn passes on the narratives of several other members of the harem), Sylvia's principal role as a correspondent being to spur her own abduction and rape by writing an indignant letter — intercepted, of course, by the Dey — denouncing Emily's warm account of "the libidinous scenes" in which she has participated. (Once Sylvia joins her friend in the harem, Emily conveniently acquires a new female correspondent, whose sole function is to prompt the remainder of the novel.) While the Bey writes to the Dey only to offer a more brutal version of the latter's standard narrative, their correspondence is further supplemented by a pair of lustful monks, one of whom admiringly calls the other "as bad as the Dey himself." Like most pornography, *The Lustful Turk* has relatively little interest in distinguishing one character from another, though the Dey is by far the most genial and articulate of these assorted rapists, and his "wonderful instrument" proves the dominant force in the narrative.[24]

In a fantasy that would have been familiar to Richardson's Lovelace, *The Lustful Turk* imagines rape as the necessary prelude to sexual awak-

ening, as if a proper woman must literally be forced to discover how "desires to which she ha[s] hitherto been a stranger thrill . . . in her veins." Having reduced Emily's chastity "to a bleeding ruin," the Dey characteristically follows up the "first lesson" by urging his weeping victim to "reason a little . . . consider the great end that Nature has created you for," and "give over these unavailing tears, which only delay your tasting of the sweetest joys." And just as characteristically, the new member of the harem proves an apt pupil, who quickly exchanges her tears for "unutterable rapture." While his particular methods vary with the individual case, none of the Dey's women begins by willingly surrendering her virginity — and none fails to adore him when the ritual is over. When it comes Sylvia's turn, "the couch which was the field of battle trembled under the shock." Scarcely has the couch finished trembling, however, before Sylvia is covered with "burning blushes"; and "long before morn," as the Dey later tells Emily, "she became (if anything) more submissive to my wishes than you were on your education."[25]

As an influential study of the genre has shown, pornography readily converts the language of sensibility to its uses: the "nature, too powerful nature" that in Emily's first encounter with the Dey immediately "assist[s] his lascivious proceedings," repeatedly triumphs over all the "indignation" that she and the other members of the harem can summon to resist it.[26] Yet if *The Lustful Turk* obviously looks back to eighteenth-century precedents, it was written a few years before Victoria came to the throne; and like many other works of its time, it manages to negotiate between two contradictory views of women's "nature." Even as the pornographer imagines women naturally all too eager to yield, in other words, he also imagines a resistance so ingrained that only force can break through it.[27] All the "herculean strength" the Dey is said to deploy when he conquers a virgin, the couches which tremble with the shock of battle, become the almost comically extravagant signs of this ingrained resistance, as the pornographic imagination turns the erotic despotism of the harem into a kind of benign discipline necessary to instruct Western virgins in "the mysteries of love."[28]

And though there is more than a little male sadism in all these violent episodes,[29] the novel itself nonetheless goes out of its way to distinguish its favorite domination fantasy from sadism *tout court*. While the Dey enjoys himself with Emily, he sends her servant, Eliza, to the harem of the Bey, where her spirited resistance to his advances ends in a brutal rape that never pretends to erotic awakening. In pointed contrast to the Dey, the Bey approaches his pleasures with the single-mindedness of a Sadean

despot: "There is nothing on earth so much enhances the joy with me," he writes of the attack on Eliza, "as to know the object that affords me pleasure detests me, but cannot help satisfying my desires." Unlike "the dear wicked Dey," as the adoring Sylvia calls him after her awakening,[30] this unequivocal sadist inspires no "love" in his victim: having pretended acquiescence, Eliza merely waits till he falls asleep and stabs him repeatedly.

From one perspective, the difference between Emily's experience of the harem and Eliza's amounts to little more than a variation on the conventional difference between mistress and servant. Though the defiant Eliza has been called "a regular pornographic Susan Nipper,"[31] a still apter comparison might be with the feisty Blonde of Mozart's *Die Entführung aus dem Serail* (1782), another English maidservant whose struggles in the harem provide a more openly aggressive version of the conflicts that confront her refined mistress. But the punishment meted out to the Bey also suggests that *The Lustful Turk* has a certain stake in preserving its central fantasy of an erotic despot who deserves to rule because he succeeds in arousing the latent responsiveness of women. While some readers might well characterize this as a more insidious fantasy than the outright sadism of the Bey, it should at least be remarked that *The Lustful Turk* exhibits none of that deep ambivalence about female sexuality that characterizes even so proto-feminist a work as Richardson's *Clarissa*. Unlike Lovelace, that is, the Dey betrays no signs of secret disappointment or contempt when yet another resistant virgin proves a yielding woman after all. On the contrary, both partners are typically "lost in an ecstasy," as they sink "insensible in each other's arms."[32]

The Lustful Turk stops well short of the murderousness with which Sade — or Delacroix, for that matter — associates the absolute power of the despot. In this pleasantly sadistic novel, even the sadist finally acts like a gentleman: when the Bey is stabbed by Eliza, he thoughtfully returns her to the Dey, lest his people insist on executing vengeance if he should not recover from his wounds. And though the eventual comeuppance of the Dey primarily suggests that the author had at least the wit not to take himself too seriously, the novel's ending also testifies to the limits of its fantasy of domination. Like many a more respectable English fiction, *The Lustful Turk* enlists a passionate foreigner to serve as the agent of its heroine's revenge: when an anonymous Greek slave defends her "second maidenhead" by briskly severing the Dey's "pinnacle of strength" from his body, she punishes him for an act that Emily herself has persistently regarded with "disgust and horror" — sodomy being the one sexual practice, it would seem, to which experience does not cheerfully reconcile her. While the

helpful Greek immediately plunges the knife in her own heart, the Dey determines to finish what she has begun: observing that "life would be a very hell if he retained the desire after the power was dead," he calmly orders his physician "to relieve him from those now useless appendages" and affectionately dismisses the two heroines, having first presented each with a glass vase in which a portion of "the lost members" are preserved in alcohol. The former concubines return to England, where they appear well on their way at the end to successful marriages. Meanwhile, their friends "hushed up matters," Emily writes, "and reported that we had been at a boarding school in France, instead of the boarding school of the Dey of Algiers."[33]

With its jokey conclusion, in other words, *The Lustful Turk* turns a harem fantasy into a sort of erotic bildungsroman, as if training as a concubine were a necessary stage in the developing of what the Dey calls a "finished woman." Indeed, the comic conceit of the harem as a kind of Eastern finishing school in the arts of love has run through the narrative, both in the repeated allusions to the "lessons" which the multilingual Dey delivers with the "authority of a master," and in the amusing notion that each new member of the harem apparently receives a large collection of books in her own language ("I found them to consist of our choicest authors," an Italian reports of her set), as well as a pianoforte, lutes, and prints with which to complete her education. It goes without saying that having provided these articles, both the Lustful Turk and his author devote all their attention to other matters. The erotic *Bildung* in this novel may be female, but the fantasy that shapes it remains unmistakably male. If there is any doubt on the subject, it should be settled by the fate accorded the Dey's parting presents. The women have donated the precious vases to a friend's "fashionable boarding school in London," Emily reports, where they are exhibited to "the little lady scholars" as a "reward for good behavior."[34]

Multiplying Effects:
Lesbians and Eunuchs

rotic possibilities multiply in harems of the mind almost as extrava-
gantly as the number of their women, and not all these fantasized
scenarios incorporate the figure of the master. The very sexual
imbalance that constitutes so powerful a seduction for the male dreamer
continually threatens to subvert his fantasy of erotic dominance: rumors
of lesbianism among the women of the harem and even of sex with eunuchs
haunt Western accounts of the institution from the start.[1] Chardin was not
wrong to imply that the reputation of Oriental women as "tribades" was
already an old story by the time he published the full text of his *Voyages* in
1711.[2] At least as early as 1567, another French traveler, Nicolas de Nicolay,
reported that Turkish women could be "as ardently amorous towards one
another as if they were men," and described how they frequently resorted
to the baths "in order to carry out their voluptuous pleasures."[3] George
Sandys was more censorious, but no less emphatic when he wrote nearly
a half century later of the "unnaturall and filthie lust . . . said to be commit-
ted daily in the remote closets of these darkesome *Bannias*: yea women with
women" — "a thing uncredible," he added, "if former times had not given
thereunto both detection and punishment."[4]

Well into the nineteenth century, travelers to the East passed on similar
gossip. The author of *Three Years in Constantinople; or Domestic Man-
ners of the Turks in 1844* was scarcely a lurid writer, yet Charles White not
only remarked the prevalence of "sentimental attachments" among the
women of Turkey but implied that he had access to the code by which they
communicated with one another. Lady Mary had famously described the
conventional system of flowers and other objects that enabled the Turks
to compose "letters" without writing a word; but according to White, she
had either ignored or concealed the fact that this "love language" was more

commonly used "within the harems, that is among the ladies themselves, than between the two sexes." Though a Turkish acquaintance had furnished him with a glossary, White coyly declined to reproduce it: "personal experience," he explained, did not permit him to vouch for its accuracy, while if it were correct, "the application might entail consequences no wise to be coveted."[5] Richard Burton himself acknowledged that "this feminine perversion is only glanced at" in the vast collection of tales he translated as *The Thousand Nights and A Night* (1885), but that did not prevent him from using a single character in one tale who is amorously attracted to her own sex as a pretext for a note on the harem as "a great school" for lesbianism. In another tale, a man falsely accuses his beloved of betraying him with a slavegirl who kisses her on the cheek — a representation that Burton shamelessly glossed by explaining that "wealthy harims . . . are hot-beds of sapphism and tribadism" and "every woman past her first youth has a girl."[6] At the century's close, such sweeping pronouncements even passed for science, when Havelock Ellis included almost the identical formula in the first volume of his *Studies in the Psychology of Sex* (1897). Ellis did not cite Burton when he maintained that in Egypt "every woman in the harem has a 'friend,'" but his own brief survey of female homosexuality in the East freely drew on sources dating back to the sixteenth century.[7]

As factual reports, such claims about the hidden life of the harem were still less reliable than usual, since those engaged in homoerotic affairs would have had reason to conceal their attachments from persons within as well as outside the walls. But something of the mixture of anxiety and prurience that no doubt contributed to their circulation is subtly conveyed in a very early passage of the *Lettres persanes*, when one of Usbek's wives, Zéphis, indignantly complains to the absent master that the black eunuch has insisted on separating her from her devoted slavegirl, Zélide. "It is not enough for him that this separation should be painful," Zéphis writes; "he wants it to be dishonorable as well. The traitor wants to regard as criminal my trustworthy motives, and, because he grows bored behind the door, where I always find him, he dares to suppose that he has heard or seen things that I do not even know how to imagine." Protesting that neither her retiring habits nor her virtue can guard her from these "wild suspicions," Zéphis refuses to "descend to explanations" (iv. 16). Usbek never responds to this letter, though he later alludes to a report that another wife, Zachi, has been taking improper "familiarities" with the same slave (xx. 50); and it is Zachi whom the chief eunuch claims to have found in bed with an unnamed slave in his final catalogue of the "horrible events" that

have been increasingly disrupting the *sérail* (cxlvii. 323). Since it is also Zachi who boastfully recalls to Usbek how she once triumphed over the other wives in a memorable "contest" of love, one way of explaining this sequence is to argue that the rivalrous Zachi falsely accuses Zéphis of improprieties with Zélide in order to acquire the slave for herself.[8]

But the reader struggles to make sense of these events at the risk of dispelling ambiguities and confusions that appear very much to the point. Usbek has scarcely left home before his emasculated surrogate, also shut out from the scene, entertains suspicions we have no way of verifying. That Zéphis refuses even to name the acts of which she is accused, much less to defend herself, compels us to share in the frustrated imaginings of both master and eunuch. And though the evidence may finally suggest that Zachi is engaged in homoerotic liaisons and Zéphis is not, the very tendency of these women to blur into one another contributes to our difficulty in distinguishing between the representation of fantasy and of actual event.[9] While Roxane's final letter defiantly refers to her affair with a man, no such document ever directly confirms the accusations of lesbianism. The homoerotic narrative of the *Lettres persanes* remains a story told by eunuchs.[10]

A modern reader might expect to find women themselves fantasizing about the homoerotic possibilities of the harem, but until the twentieth century, at least, any recorded evidence of such fantasies is elusive indeed.[11] Even "Sappho," as Pope later maliciously dubbed Lady Mary,[12] offers at most a partial exception, despite the obvious pleasure with which she gazed on the naked women at Adrianople and Sofia. Perhaps she came closest to such a vision in the letter that recorded her first visit to the harem of "the beauteous Fatima," especially when she followed up her ardent tribute to the attractions of Fatima herself by describing the sensual motions of a dance performed by twenty "fair Maids" of the household. "Nothing could be more artfull or more proper to raise certain Ideas," Lady Mary wrote to her sister, "the Tunes so soft, the motions so Languishing, accompany'd with pauses and dying Eyes, halfe falling back and then recovering themselves in so artfull a Manner that I am very possitive the coldest and most rigid Prude upon Earth could not have look'd upon them without thinking of something not to be spoke of." Yet what is "not to be spoke of" here is not necessarily women's desire for other women, so much as a labile eroticism that chooses not to specify itself further. Like her concluding remark that she "could not help fancying [she] had been some time in Mahomet's Paradice," Lady Mary's account of the dance focuses her gaze on the bodies of women, even as it manages not to distinguish

between a homoerotic way of looking and the fluid identifications of
heterosexual desire. Nor is it altogether possible to isolate the erotics of
her gaze from her sophisticated assumption of the aesthetic viewpoint
of her culture — as when she "had wickedness enough to wish secretly"
that Charles Jervas could have improved his art by his invisible presence
at Sofia. The letter that ends in "Mahomet's Paradise" also goes out of its
way to insist that she has looked on the scene with the same disinterested-
ness that others bring to the contemplation of art. "I think I have read
somewhere that Women allways speak in rapture when they speak of
Beauty, but I can't imagine why they should not be allow'd to do so," she
protests, as she defends her enthusiastic description of Fatima by com-
paring it to "the great warmth" with which "the Gravest Writers have spoke
. . . of some celebrated Pictures and Statues": "I am not asham'd to own I
took more pleasure in looking on the beauteous Fatima than the finest
piece of Sculpture could have given me." Rather than condemn women
for such extravagance, she writes, "I rather think it Virtue to be able to
admire without any Mixture of desire or Envy."[13]

Even if one thinks that at such moments the lady protests too much, the
fact remains that it was not the female writer but the male painter who
introduced the homoerotic gesture into the representation of Turkish
women at their bath (fig. 13). Together with Auguste's *Les Amies* (1820s;
fig. 31), which renders more explicit what his *Trois Odalisques* (fig. 26) only
insinuated, Ingres's painting may serve to remind us how readily some
male imaginations could assimilate the fantasy of sexual relations among
women, especially when these were distanced by the exoticism of the
East. The anxious accusations in the *Lettres persanes* notwithstanding, most
male fantasies of lesbian activity in the harem appear to have their origins
in desire rather than fear. If what worries Montesquieu's outsiders is
precisely that they are excluded from the scene, harems of the mind can
easily turn woman's embrace of woman into a mere prelude to woman's
embrace of the man.[14]

Just how cheerfully a man could imagine himself replacing a woman
in such a setting is suggested in the sixth canto of *Don Juan*, when the
hero, still disguised as a slavegirl, slips into bed with another member
of the harem named Dudù — one of those who "had most genius," as the
narrator slyly puts it, "for this sort / Of sentimental friendship" (6.40).
The episode is preceded by a teasing comparison of the harem to a nun-
nery, a comparison that depends for its effect on familiar stories about
the sexual proclivities of nuns.[15] Of the "Mother of the Maids," we're
told,

Her office, was to keep aloof or smother
All bad propensities in fifteen hundred
Young women, and correct them when they blundered.

A goodly sinecure no doubt! but made
 More easy by the absence of all men
Except his Majesty, who, with her aid,
 And guards, and bolts, and walls, and now and then
A slight example, just to cast a shade
 Along the rest, contrived to keep this den
Of beauties cool as an Italian convent,
Where all the passions have, alas! but one vent. (6.31–2)

Even as the joke equivocates between auto- and homoeroticism — the anatomical suggestiveness of "one vent" doing service for either — the narrator archly points up his innuendo by pretending to deny it: "And what is that? Devotion, doubtless — how / Could you ask such a question? — but we will / Continue" (6.33).

In the scene that follows, the harem prepares for bed. As the narrator explains how all the women somehow feel a particular affinity for the latest addition to their number, a similar, if more understated turn manages to raise a doubt about the nature of this "sentimental friendship":

But certain 'tis they all felt for their new
 Companion something newer still, as 'twere
A sentimental friendship through and through,
 Extremely pure … (6.39)

Of the three "who had most genius for this sort / Of sentimental friendship" (6.40), the two others eagerly dispute the privilege of sharing a bed with "Juanna," while Dudù, who merely sighs as she plays with the newcomer's veil ("her talents were of the more silent class") is awarded the prize (6.49). Before retiring for the night, Dudù gives Juanna a "chaste kiss," whose chastity is once again coyly put in question by the narrator:

Dudù was fond of kissing — which I'm sure
That nobody can ever take amiss,
 Because 'tis pleasant, so that it be pure,
And between females means no more than this —
 That they have nothing better near, or newer. (6.59)

In fact, of course, Dudù has something "better" near, her discovery of which prompts a startled scream in the middle of the night and a confused account of dreaming that she has been stung by a bee. Though the narrator professes himself unable to explain either her awakening or her blushes, "sentimental friendship" has obviously dissolved into heterosexual pleasure — what has been called "the only unqualifiedly happy expression of sexuality in the poem."[16] Far from proving a threat, the women's vaguely amorous interest in one another has only disguised, quite literally, their attraction to the hero. Indeed, the very fact that all the erotic charge in this episode can be explained away by the harem's unconscious awareness that "Juanna" is really Juan assures that the sex in "sentimental friendship" remains nothing but a titillating illusion — an amusing possibility no sooner conjured up than it is once again relegated to the realm of fantasy.

Though Byron does not tease the reader with any suggestion that what he calls "the third sex" had its own erotic pleasures in the seraglio (5.26), rumors about liaisons between women and their eunuchs also contributed to the aura of sexual perversity that surrounded the harem. In his account of his travels in Persia, Chardin managed to introduce such rumors by modestly refusing to mention them. After remarking that the white eunuchs in the royal palace were forbidden access to the harem lest the women see men more handsome than their master, he added: "I pass over what they say about the eunuchs, that although they are entirely cut, they still do not lose the ability to give and receive pleasure in commerce with women, because modesty [la pudeur] does not permit one even to recall what one has understood about such a subject."[17] Despite this coyness, Montesquieu presumably understood enough to elaborate at some length on the subject in two of his *Lettres persanes*.[18] In the first of these, a jealous Usbek accuses the irrepressible Zachi of having been found alone with a white eunuch, a thing expressly "forbidden," as he says, "by the laws of the sérail"; in the second, another of the wives, Zélis, takes up the history of the circulating slavegirl, Zélide, whom a different white eunuch reportedly wishes to marry. While Usbek torments himself by conjuring up nameless "crimes" by which an impotent man may somehow "defile" a woman (xx. 49), Zélis devotes most of her letter to imagining the frustration of being married to a eunuch. Much of the erotic suggestiveness of both letters depends on negation, as Zélis speculates on what it would be like "to find oneself always close to pleasures, and never have them" (liii. 112), and Usbek dwells on a teasing scenario that he chooses to imagine has never occurred. Yet even if it were true, he tells Zachi, that

she allowed the eunuch neither to touch her nor to look at her, the very fact that she was thus ready to violate the laws of the harem without fulfilling her "unrestrained desires" only makes him worry the more what she would do to satisfy them (xx. 49). But while Usbek returns, understandably, to the imagined appetite of the woman, Zélis's letter ends by insinuating that the eunuch himself has erotic resources unknown to the other sexes — that his very loss is somehow translated into voluptuous gain. After elaborating on the presumed frustration of a woman wedded to the eunuch's impotence, her letter abruptly changes course. "I have heard you say a thousand times," the next paragraph begins somewhat incongruously,

> that eunuchs taste with women a kind of pleasure unknown to us [une sorte de volupté qui nous est inconnue]; that nature makes up for their losses; that she has resources which repair the disadvantage of their condition; that one may very well cease being a man without ceasing to feel; and that, in this condition, it is as if they are in a third state [un troisième sens], in which they do nothing, so to speak, but change pleasures. (liii. 113)

In language apparently borrowed from the French translator of Rycaut, who had already evoked "une sorte de volupté brutale et inconnue" that eunuchs practiced with women, Montesquieu hints at this unknown pleasure even as he continues to render it hypothetical: "if" this were the case, Zélis concludes, then she would have less reason to pity the eunuch's bride.[19]

Some of the confusion about the erotic capabilities of "the third sex" may be explained by a certain ambiguity as to what constituted a eunuch. Despite the often repeated tale of the Ottoman sultan who responded to the sight of a gelded horse mounted by a mare by ordering that henceforth all eunuchs in the palace should be completely deprived of their organs, the evidence suggests that not every eunuch was fully castrated, and that some may have retained both the appetite and the capacity for sexual pleasure.[20] Human desire, after all, depends as much on the mind as on other organs, though tales of eunuchs who not only married but fathered children presumably belied either the physical condition of the husband or the faithfulness of the wife. Emmeline Lott's *Harem Life in Egypt and Constantinople* (1866) passed on one such scurrilous story, whose punchline — "They have a numerous family, and that fact speaks volumes with regard to all eunuchs" — manages simultaneously to impugn all eunuchs as sexually voracious and to declare them all frauds. Earlier, however, the

storyteller associates the jealous passion that gossip attributed to this particular eunuch with a desire at once boundless and obscurely hidden in the recesses of the harem. "An Asiatic's love stops at nothing, and he spares no cost to attain his ends," Lott's European informant remarks helpfully, immediately adding, "The mysterious doings in the Harems are generally enveloped in impenetrable darkness."[21] Even in this debased form, the eunuch evokes something of the "volupté...inconnue" that identifies him with the deepest secrets of the harem. Incongruous as it may seem, the man deprived of his sex serves as the very figure of the harem's erotic mystery.

Anti-Erotics: Frustration and Ennui

Harems of the mind were haunted by the figure of the eunuch in more ways than one. As the official guardian of the women, he was, of course, the designated blocking agent of erotic pleasure: frustrating others by virtue of being frustrated himself, the eunuch assured, at least theoretically, that no man but the master would have access to the harem. Like the figure who bars the way in Gérôme's *Harem à le kiosque* (fig. 23), he served as a dark reminder of the dreamer's perpetual exclusion from the women. But the eunuch was himself, after all, a denizen of the harem as well as its guardian; and those who remained outside were free to see in him more than the cause of their own baffled yearning. Even as Europeans fantasized the harem's infinite pleasures, in other words, they were ready to imagine that frustration and boredom were its truest inhabitants. The very numbers that appeared to promise erotic gratification without limits kept threatening not to compute as pleasure at all.

For the countless women of the place — so the story went — erotic frustration followed inevitably from the fantastic disproportion of the sexes. The same arrangements that guaranteed endless variety for the master, Europeans liked to think, required that each woman long languish for a partner. Many in the Grand Seraglio, according to Robert Withers, simply waited in vain. "Now, the other women which are not so fortunate as to be beloved of the King," he reported, "must still live together, and diet with the rest of the young virgins; wasting their youthfull dayes amongst themselves in evil thoughts: (for they are too strictly lookt unto, to offend in act)." A subsequent passage recounted in more detail the extravagant precautions allegedly taken to frustrate the women's appetite:

Now it is not lawfull for any one to bring ought in unto them, with

which they may commit the deeds of beastly, and unnaturall unclean-
nesse; so that if they have a will to eat, radishes, cucumbers, gourds, or
such like meats; they are sent in unto them sliced, to deprive them of
the means of playing the wantons: for they all being young, lusty,
and lascivious wenches, and wanting the society of men (which would
better instruct them, and questionlesse far better employ them) are
doubtless of themselves inclined to that which is naught, and will often
be possest with unchast thoughts.[1]

Despite the fact that a French traveler would soon dismiss this as a "fable"
— remarking that it was the general custom in the Levant to serve fruits
cut up into slices — these castrated cucumbers continued to catch the
imagination of subsequent commentators.[2] As Alexander Pope teasingly
reminded Lady Mary on her journey to Constantinople in 1716, she would
soon find herself in "the Land of Jealousy, where the unhappy Women
converse with none but Eunuchs, and where the very Cucumbers are
brought to them Cutt."[3]

Whether the exercise of the kitchen knife was intended to thwart
lesbian pleasures or solitary ones, Withers did not say, though rumors of
both kinds of eroticism continued to circulate around the harem. But even
those who liked to speculate about such activity were all too ready to
imagine, as we have seen, that it was just a poor substitute for themselves.
Tales of Eastern women who eagerly pursue Western men attributed this
ardor not only to the fact of confinement and the heat of the climate but
to the sheer frustration of life in the harem. The English translation (1696)
of Jean Dumont's *Nouveau Voyage du Levant*, for example, told of a
European traveler who attempted to leave after he had been seduced
and "exhausted" by the beautiful wife of a Turkish official, only to learn
that she had preserved her reputation through many such episodes by
immediately doing away with her victims. A female slave offered to assist
him — but not until he had first made love to her in turn, since she had
been "*shut up*" in the place "*these Twenty Years, and in all that time . . . not
seen the Face of a Man.*" The "Terms were somewhat hard for a Man in his
Condition," Dumont wryly observes; "but since his Life was at stake, he
made a Vertue of Necessity, and *perform'd* as well as he cou'd." From the
perspective of "the poor Woman," needless to say, the performance ap-
pears more than adequate: having been "a Stranger so long to the Pleasure
of Love," she is "ravish'd with the unaccustom'd Delight" and gratefully
manages his escape.[4]

Aaron Hill preferred to imagine the frustration of all those women

compelled to divide up one man among them. His tale about the collective seduction of the English sailor began by explaining the system of nightly rotation that obtained in that "very large *Haramm*" — a group that numbered, by Hill's account, "no less . . . than *a quarter of an Hundred.*" Though the master of the house would "chuse some one among them *every Night*, to carry to his *Bed*, and favour with the Duty of his kind Embraces," his many wives and concubines remained unsatisfied. "Whether *Nature* had not qualified him for the *Womens Favourite*, or whether *every Lady* thought her turn too long in coming, is not known," Hill remarks coyly,

> but this is certain, that the whole Society of Beauties, were extreamly Melancholy, and wou'd pensively retire to a large Window, which look'd out upon a *Garden* on the backside of their Apartment, and by throwing up the *Lettice*, let in *Air*, which *fan'd* not *cool'd* the warmth of their Desires.

It is through this window, of course, that they catch sight of the sailor and contrive to hoist him up to their apartment — at which point "a sort of *War*" for scarce resources breaks out among them, until they agree to draw lots for yet another rotation.[5]

By cheerfully refashioning its elements, Hill elsewhere adopted such a scenario for the mock-instruction of his countrywomen. In an epilogue composed for Eliza Haywood's seraglio tragedy, *The Fair Captive* (1721), he pretended to speak as an Englishwoman "broke loose, from a *Seraglio Life*," who warns her sisters of the risk to "*Petticoat Dominion*" should their husbands discover the Turkish model. Since the point is now to mock the excessive liberties of contemporary Englishwomen by comparison, this particular harem fantasy simply suppresses the possibility of amorous interludes with accommodating sailors:

> *No Visits* there — *no* Plays — *no* Cards — *no* Wooing;
> *Dull, downright* Duty *makes up all* their *doing.*
> *Jealous of genial* Air, *even* that's *deny'd 'em!*
> *And their* grim Dears *in Drawers and Mufflers* hide *'em.*

Another image has them "*stew'd up like Ponds of Fish*," who "*feed, and fatten, for* one *Glutton's Dish!*" But the final joke is, of course, the tedious chastity of harem life — a chastity enforced by the sheer limitation of one man struggling to satisfy so many available partners:

> *But, when* Night *comes, how* pure, *how* pious *they!*
> *Who go to Bed — to* sleep! *— and rise — to* pray!
> *Blest in* full *Chastity, and* unbroke Slumber,
> *They owe a spotless Purity — to* Number.
> Slow *must five hundred Womens* Virtue *fall,*
> *Who have but* one poor Man *t'undoe 'em all!*
> *Like the warm* Sun, *he daily does* appear;
> *But his* grand Round *is made, scarce* once *a* Year!
> *Dreadful Reflection! — Call they* this a Wife?
> *'Tis an unwholesom, dull, —* unactive *Life!* [6]

Hill was hardly alone in enjoying this joke. A century later, Byron would make very much the same point in *Don Juan*, when Dudù introduces the new arrival to "the customs of the East / With all their chaste integrity of laws" — a chaste integrity that once again proves wholly a matter of numbers. "The more a Harem is encreased," we are told, "The stricter doubtless grow the vestal duties / Of any supernumerary beauties" (6.58). Like Hill, Byron makes clear that lack of opportunity alone preserves the sexual virtue of the harem, as the "chaste kiss" with which Dudù immediately follows up her brief instruction leads quickly to the so-called dream that inspires her blushes (6.59).

Byron may not be inclined to keep very precise count of his fantastic seraglio, but whether he evokes "a thousand bosoms there / Beating for love as the caged birds for air" (6.26), or adds five hundred more in order to explain why even the sultan's favorite should attempt to seduce Don Juan, he never loses track of the sexual arithmetic at issue. His ironic defense of the favorite obligingly compounds her frustration by adding the sultan's growing years to the increasing size of his harem:

> I know Gulbeyaz was extremely wrong;
> I own it, I deplore it, I condemn it;
> But I detest all fiction even in song,
> And so must tell the truth, howe'er you blame it.
> Her reason being weak, her passions strong,
> She thought that her lord's heart (even could she claim it)
> Was scarce enough; for he had fifty-nine
> Years, and a fifteen-hundredth concubine. (6.8)

Just as Hill puts a masculine joke about the thwarting of female appetite in the voice of a woman, so Byron attributes this reckoning of sexual

opportunity in the seraglio to the "feminine precision" of the sultana:

> I am not, like Cassio, "an arithmetician,"
> But by "the bookish theoric" it appears,
> If 'tis summed up with feminine precision,
> That, adding to the account his Highness' years,
> The fair Sultana erred from inanition;
> For were the Sultan just to all his dears,
> She could but claim the fifteenth hundred part
> Of what should be monopoly — the heart. (6.9)

The teasing punchline manages to suggest that it is really another organ the imperious sultana wishes to monopolize. Though elsewhere the poem is hardly at a loss to account for its hero's attractiveness to women, the harem episode playfully identifies Gulbeyaz's appetite with the "inanition" of one who must settle for a mere "fifteenth hundred part" of the only male member available to her. To the great fury of the proud sultana, Juan will nonetheless end up in Dudù's bed rather than her own. But if Byron determines to frustrate the hungry Gulbeyaz once more, his hero's adventures still make clear how such scenarios of thwarted desire tend to flatter the wishes of those who construct them.[7] By imagining all those women in want of his own sex, in other words, a European man can easily imagine them eager to welcome himself in their midst. Even when it serves primarily as a joke, the sexual frustration of the harem resolves itself all too readily in the erotic fantasy of the male intruder.

Montesquieu offers a partial exception: though the *Lettres persanes* exiles Usbek from the *sérail* altogether, it never directly records the experience of the man who briefly succeeds in supplanting him. Articulating instead the frustration of those left behind, Montesquieu uses his protagonist's absence to intensify the unsatisfied longings that Western imaginations often associated with the harem. As if an extended sojourn abroad only exaggerated the distance customarily maintained between the master and his women, one of the "wives," Fatmé, writes to Usbek in heated terms of the desires that consume her. Fatmé ostensibly complains about Usbek's absence in Paris, yet even had he never left the *sérail*, her letter suggests, she would still perpetually suffer from unsatisfied desire — the constant *soupirs* and erotic *fureur* that necessarily follow from the unequal numbers of the harem. She is, in her words, a woman who "must habitually live in a state of longing and the frenzy of an inflamed passion" (vii. 20).

But it is not only the women who suffer erotically in Montesquieu's harem. The master suffers, too, by the *Lettres'* accounting — and from those very same numbers. For if the women of the place are perpetually frustrated by their competing desires for a single man, the capacities of that man are soon overwhelmed by his struggle to assuage their inordinate demands. There is "nothing so contradictory," Usbek complains, than "this plurality of wives permitted by the holy Koran, and the order to satisfy them, given in the same book" — a contradiction that inevitably results, he makes clear, in the sexual exhaustion of the male. In his self-pitying trope, the "good Muslim" resembles "an athlete doomed to combat without respite; but who, soon weakened and overwhelmed by his initial efforts, languishes on the very field of his victory and finds himself, so to speak, buried under his own triumphs... It is to this state of debility," he continues, "that we are always reduced by our large number of women, who are better suited to exhaust us than to satisfy us (cxiv. 239, 240)."

Like Chardin before him, Montesquieu was partly seeking to explain the fact that Muslim countries appeared to be losing population by comparison with their Christian neighbors: just as Chardin had attributed the discrepancy between the Persians' large number of wives and their small families to their habit of making love too early and too often, so Usbek claims that "it is very common with us to see a man with a vast sérail and a very small number of children" — a phenomenon he ascribes to the father's "lethargy."[8] But more than the fruitfulness of the male troubled Montesquieu's imagination of the harem. Elsewhere, he suggests that what kills the master's desire is not so much exhaustion as the ease with which that desire may be fulfilled. Though Usbek suffers from constant anxiety and jealousy, his torment does not arise from any love for his women. "I find myself in this regard in a state of insensibility that leaves me no desires at all," he writes to a friend. "In the numerous sérail in which I lived, I anticipated and destroyed love by love itself; but, from my very indifference there arises a sort of secret jealousy, which devours me" (vi. 18). Only a few letters separate this account from the chief eunuch's report of his own endless torment in the *sérail*, where he is continually "devoured" by anxiety, and where everything "inspires" him, as he puts it, with the regret of what he has lost. But while the eunuch feels his misery intensified because he has always before his eyes "a happy man," the ironic resemblance of their positions is clear.[9] Between the state of the eunuch, who continually desires what he cannot have, and that of the master, who feels no desires at all, there is apparently little to choose.

In an unpublished *conte philosophique* composed sometime after the *Lettres persanes*, Montesquieu drove home the point. The narrator, a transmigrating soul who undergoes numerous metamorphoses in the course of his adventures, at one point finds himself in the body of a eunuch—in which condition, as Montesquieu characteristically imagines it, he suffers all the torments of "an impotent love." Determined to teach him a lesson, his "Génie" exchanges his body with that of his master. But while he now has "everything" where he once had "nothing," the narrator quickly discovers that he is no happier: "I felt oppressed with illness, with lassitude and with disgusts. The presence of a woman promised me no more than a greater feebleness. What can I tell you of these loves begun and finished by impotence?"[10] As in the *Lettres persanes*, "impuissance" appears to characterize all the erotic relations in Montesquieu's harem.

Few subsequent writers entered so thoroughly into the psychology of the eunuch as Montesquieu, but he was not alone in imagining that impotence was the necessary consequence of possessing a harem. Indeed, the exhausted male, reduced to artificial stimulants even to feign desire, became something of a cliché in harem literature, as available for moralizing reflection as for pornography. "I regarded this state of insensibility, this privation of desires, as a punishment for having wished to excite them too much," writes the daughter of one such master of the *sérail* in Pouillan Saint-Foix's *Lettres turques* (1731), though she duly goes on to suggest de that even the most virtuous lovers find themselves similarly afflicted.[11] On the other side of the Channel, the anonymous author of the *Memoirs of the Seraglio of the Bashaw of Merryland* (1768) claimed that despite the relative youth of her would-be master, he left her "as good a virgin" as he found her—this particular bashaw making "a violent fit of the cholic his apology."[12] The English heroine of Robert Bage's *The Fair Syrian* (1787) likewise escapes from an Eastern harem with her virginity intact, when her master opportunely succumbs to fatal convulsions brought on by an overdose of "provocatives." Though still a young man, this wealthy Syrian already bears the tell-tale "marks of debility and disease." Reflecting on his "sickly appetite," the heroine predictably traces it to the abundance of his women: "I have been told, the love of wine increases with the use; the love of woman, not."[13] Nearly a century later, an anonymous contributor to an issue of the *Pearl* (1880) could still exploit the convention to begin a piece of sadistic pornography, by introducing a sultan "worn out with the amorous exertions in the well-filled seraglio," who "determines to seek some fresh excitement; everything seems so insipid and blasé to him."[14]

The boredom of this sultan is even more conventional than his exhaustion — and both were routinely associated with the arrangements of the harem. Ennui need not, of course, always entail sexual exhaustion; but whether he was thought to be worn out by the appetite of others or bored by the sheer ease with which his own desires could be gratified, the effect on the imaginary sultan himself was much the same. By the time of Crébillon's *Le Sopha* (1742) and Diderot's *Bijoux indiscrets* (1748), a writer could take for granted that to introduce such a figure was to represent him yawning. "Despite such great occupations and ... varied pleasures, it was impossible for the sultan to avoid ennui," says the narrator in the opening pages of *Le Sopha*, while *Les Bijoux indiscrets* permits the imperial favorite to deliver virtually the same observation: "Your Highness is bored to death," she says to her consort. "The variety of amusements that attend you have not been able to keep you from disgust."[15] A century later, "un coeur blasé" and "son ennui sans trêve" [without respite] were still afflicting an imaginary sultan in a poem of Gautier,[16] just as they continue to do in a recent novel by David Slavitt entitled *Turkish Delights* (1993), whose sultan "struggles with his ennui as much as any humble householder in Constantinople — or probably more, for while the householder can dream of change and believe in his dream, the Sultan can barely dream of dreaming, knowing there are no dreams left."[17] Fantastically reversing the dream of pleasure without limits, this nightmare of erotic torpor also originates in harems of the mind.

Part Four
The Couple versus the Harem

13

Free Hearts in Montesquieu, Mozart, and Byron

L ove is at once everywhere and nowhere in harems of the mind. Understood as the random force of erotic desire, love dominates the place. "The *Turkish* Women . . . seem to be made for Love," the English version of Jean Dumont's *Noveau Voyage du Levant* observed in 1696; "their Actions, Gestures, Discourse, and Looks are all Amorous."[1] Yet even as Europeans imaginatively dedicated the harem to eros, they also imagined that "true" love had no home there. The more that "love," whether in French or in English, meant the freely chosen attachment to a single partner, the more it was thought to oppose the very structures of the harem. As the West liked to tell it, a harem love story almost always meant the end of the harem or the flight of the lovers.

Both Racine's *Bajazet* (1672) and Montesquieu's *Lettres persanes* (1721) end with the death of a slavewoman named Roxane, but the difference between the erotic obsessions of the one and the suicidal defiance of the other may begin to clarify what is at stake for European representations of love in the harem. In plotting *Bajazet*, Racine took for granted that the *sérail* was the locus of amorous passion. When some critics protested that its heroines knew too much about love ("étaient trop savantes en amour"), he responded that he thought it "enough to say" that the action took place in the *sérail*. Indeed, he continued,

> is there any court in the world where jealousy and love should be so well known as in a place where so many rivals are closed up together, and where all these women have no other object of study, in an eternal idleness, than to learn to please and to make themselves loved?[2]

I shall return later to the other passion that Racine routinely associates

with the harem, but it is worth noting here how "jealousy and love" appear inseparable in his *sérail*, and how both passions are automatically identified with its multiplicity of women. Suggestively, "la jalousie" even takes precedence over "l'amour" in this formula, as if the structure of female rivalry in the harem were as much the cause as the consequence of the women's love for their master. Though *Bajazet*'s principal triangle does not in fact begin with what we have learned to call triangular desire — neither Roxane nor Atalide (the princess who actually commands Bajazet's affections) is aware of her rival when she first falls in love with the protagonist — female jealousy does drive the play to its tragic conclusion.[3] More immediately to the point is the way in which Racine conceives of both jealousy and love — of all passion, for that matter — as overwhelming the sufferer. Throughout *Bajazet*, Roxane is represented as "une amante en furie" (2.1, 372) and whether she is demanding that Bajazet love her in return or threatening his death, such terrible "fureurs" as she repeatedly experiences have nothing to do with freedom or with choice.[4] Like the jealous rage into which it mutates so abruptly, love in Racine's world is all too compatible, in other words, with the despotic environment of the *sérail*.

What Montesquieu understands by love, on the other hand, is fundamentally opposed to the compulsory regime of the harem. Though his Roxane too is a slave, her history shows that one cannot be made to love on command, and that the devotion her master thought he had won from her was merely an illusion. In the same letter in which he congratulates her for being "in the happy position of being unable to fall," Usbek praises the *sérail* as a place where she can find "innocence" and be "sure of herself" — "where, finally, you can love me without the fear of ever losing the love that you owe me" (xxvi. 59, 60). As for himself, he continues, he cannot doubt what Roxane feels for him: everything from her use of cosmetics and perfumes to her modest blushes and flattering words goes to prove it. But having defined "love" as a duty and enclosed it in a *sérail*, Usbek will discover that what he has commanded was only a series of empty gestures. When Roxane's only letter announces that her "spirit" has always remained independent and alludes to the "heart" in which she has kept the truth secret, she calls on a conception of interiority utterly divorced from the signs of the body. "How could you have thought me credulous enough to imagine that I existed in the world only to worship your caprices?" she demands contemptuously. "If you had known me well," she taunts him, "you would have found there all the violence of hate" (clxi. 334). Most imaginary rebels in the harem dwell less on how they hate than on how they love, but they share her insistence that the heart cannot be commanded.

Though Montesquieu does not dwell upon the point, Usbek's relations with his harem suggest not only a general concern about the problem of knowing other people but a peculiarly masculine anxiety about the erotic secrets of women. Lacking even the crude evidence of desire his own erection affords her, the male is especially vulnerable to such shocks as Roxane delivers. She may declare that if Usbek had known her better he would have discovered the truth, but exactly how this intimate knowledge could have been assured remains uncertain, since both by gesture and by speech she proved capable of deceiving him. Perhaps the most that can be said — and this Montesquieu implies repeatedly — is that a regime of love-on-demand virtually guarantees deception. In one of the many letters in which Usbek shows himself more clear-eyed about the vicissitudes of the West than about his troubles at home, he argues that the Christian prohibition of divorce only ended by weakening marriage rather than strengthening it — that "instead of uniting hearts, as they pretended, they separated them forever."

> On an act so free, and in which the heart should have so much concern, they imposed constraint, necessity, and the fatality of Destiny itself. They took no account of the repulsions, the whims and the incompatibility of temperaments; they wanted to fix the heart, that is to say, the most variable and inconstant thing in nature; they joined without recourse and without hope people burdened by one another and almost always ill-sorted; and they acted like those tyrants who had living men tied to dead bodies. (cxvi. 243–44)

Apart from his final comparison of the marital bond to a mode of torture practiced by tyrants, whereby what is already dead slowly kills any vitality that remains, Usbek never seems to recognize the analogy which is nonetheless everywhere implicit: like the indissoluble ties of Christian marriage, the constraints of the harem only succeed in destroying the love they attempt to enforce. If Usbek were a more thoroughly psychologized character, in fact, one would be tempted to argue that it is not only his distance from the West that enables him to see its failures so clearly, but the fact that the burdens of Western marriage as he describes them weigh on both sexes equally. Though the *Lettres* will elsewhere imply that Usbek too suffers from the amorous arrangements of the *sérail*, the requirement to love on command oppresses only his women.

Such a requirement operates in a very different register, of course, from the compulsion with which Racine associates the passions. The tragic poet

imagines how desire itself overpowers the sufferer, while the social philosopher examines the attempt of one individual to compel desire in another. This is not to say that the inhabitants of Racine's imaginary *sérail*, any more than of Montesquieu's, can simply love on command. Indeed, the case of Bajazet himself clearly proves otherwise, since despite Roxane's threats he remains loyal to Atalide. In a reversal of the gender relations customarily associated with the seraglio, Roxane plays the despot to Bajazet's effeminized slave, as she attempts to translate her absolute power over life and death into the power to force desire from the other.[5] Yet if Bajazet ends by dying rather than marry the sultana, it is not primarily in the name of freedom that he perishes. Significantly, he responds to Roxane's belated discovery of his love for Atalide not by defending the liberty of his heart but by explaining that it has long been already occupied: "Déjà plein d'un amour dès l'enfance formé, / A tout autre désir mon coeur était fermé" [Already filled with a love formed since childhood, my heart was closed to all other desire — 5.4, 403]. He may refuse one woman because he loves the other, but Racine does not even represent the choice between them *as* a choice, so much as a necessary adherence to the already given. Though Bajazet's attachment to Atalide never reaches the passionate "fureurs" attributed to both the women, in this sense he too is subject to love's empire. In Racine's imaginary *sérail*, the despotism of the passions proves still move powerful than the despot.

Pornography excepted, however, most subsequent fictions of love in the harem owe more to Montesquieu's account of desire than to Racine's. The more specifically they speak of "love" — rather than erotic obsession — the more routinely they oppose the freedom of the heart to the imagined despotism of the harem. By the time Mozart's spirited Blonde first sang of "Ein Herz, so in Freiheit geboren" in *Die Entführung aus dem Serail* (1782), the trials of such a heart had become a staple of harem fictions.[6] There is no necessary reason, of course, why those who love as they choose should choose fidelity to a single partner. But the more that Europeans struggled to reconcile marriages made for love with the demand for female chastity,[7] the more they also needed to imagine that the free heart would remain a monogamous one — at least if that heart was a woman's. It is not for nothing that the principal heroine of Mozart's opera is named Konstanze.

Unlike Racine and even Montesquieu, of course, the opera approaches its imaginary seraglio in the spirit of comedy, and in scripting Blonde's confrontation with her would-be master, the tyrannical Osmin, the librettist cheerfully points up the absurdity of the despot's "love" by

command. "Ich befehle dir augenblicklich, mich zu lieben" [I order you to love me, immediately], Osmin tells Blonde — to which her first response is to laugh (2.1, #9). Together with her mistress, Konstanze, and her lover and fellow servant, Pedrillo, Blonde has been captured by pirates and sold to the pasha Selim, who in turn has given her as a slave to the bullying Osmin; and while the English servant repels the attacks of her stereo-typically crude and lustful Turk, her Spanish mistress is engaged in a somewhat more high-minded struggle with the pasha himself. When Selim opens the third scene of act 2 by warning Konstanze, "Der Tag ist bald verstrichen, morgen musst du mich lieben, oder — " [The day is almost over, tomorrow you must love me, or else —], the text seems to measure his difference from his overseer primarily by the clock: where Osmin demands an instantaneous return of his feelings, Selim graciously affords his victim twenty-four hours. As a good European, and one who is already in love with another, Konstanze replies true to form: "Muss! Welch albernes Begehren! Als ob man die Liebe befehlen könnte, wie eine Tracht Schläge!" [Must! What an absurd demand! As if one could order up love, like a sound beating!]. When she declares herself ready to die rather than yield, Selim counters by threatening all kinds of torture, and the scene concludes with the celebrated aria in which she defies these as well ("Martern aller Arten," #11).

But as the audience already knows, another idea of love also animates Mozart's pasha, who has thus far had too much "Delikatesse" to force himself on Konstanze (1.4). In his own words, "auch Selim hat ein Herz, auch Selim kennt Liebe" [Selim also has a heart, Selim also knows love]; and he has in fact waited an indefinite period of time for his captive to give herself voluntarily (1.8). As he points out to her, he demonstrates his love precisely by granting her more freedom than his other women and by treasuring her as if he had no other ("meine einzige Schätze") — an emotional monogamy that the libretto effectively confirms by seeing to it that no other members of the harem appear on stage (1.7).[8] The master of this seraglio, in other words, falls in love as they do in the West. And though he temporarily reverts to the cruelty of the East when his overseer thwarts the attempted abduction of the women by their lovers, he finally proves both his deli-cacy and his magnanimity by setting both couples free. The role of bad Turk is clearly reserved for the brutish, if comical Osmin, who exits from the final reconciliation scene still singing of the assorted tortures he would like to perform on the lovers.[9]

Like many harem fictions, *Die Entführung* repeatedly evokes the imagined dangers of its setting in order to represent its lovers' readiness

to sacrifice all to their devotion. Yet despite Konstanze's defiant "Marten aller Arten" and the moving recitative and duet in which she and Belmonte ecstatically welcome the chance to die for each other (3.7, #20), only Pasha Selim actually sacrifices in the end. In fact, by transforming the denouement of Bretzner's original libretto, Stephanie further ennobled the character of this noble Turk: instead of breaking off his vengeance because he discovers that Belmonte is his long-lost son, Stephanie's pasha ends by forgiving the son of a man who destroyed his own happiness.[10] In the revised libretto, Selim reports that "dieser Barbar" deprived him not just of wealth and social standing but of his "eine Geliebte," the one woman he cherished more than life, a passing revelation that merely heightens the poignancy of his loss of Konstanze (3.6). If only Mozart had written some music for him — of the six principals, Selim alone does not sing — he might well have run away with the show.

Yet even such a pasha, it seems safe to say, would never have run away with the heroine. The regretful exclamation with which Konstanze at one point responds to his wooing — "O dass ich es könnte" [If only I could!] — both pays tribute to the genuine choice that he offers her and takes for granted that her choosing him is impossible (1.7). Though Selim notably proves more "Christian" than the Christians — "I detested your father far too much," as he says to Belmonte, "ever to follow in his footsteps" (3.8) — the nobility of this particular Turk is somewhat compromised by the fact that the libretto makes him a renegade, thus potentially returning both his knowledge of how to love and his capacity for forgiveness to their supposed origins in the West. But all the conventions assure that the heroine of such a drama would never love the master of a seraglio in any case. Indeed, precisely because Konstanze is a Konstanze, her faithful attachment will necessarily resist the imagined variety of the harem. And she will resist it all the more, one might add, because Selim's style of wooing begins to reveal just how fragile is that fiction of love that attempts to reconcile freedom of choice with the principle of monogamy.

That the imaginary seraglio threatens the constancy of the heart as well as its freedom is dramatized most vividly in the midst of the famous quartet that concludes the second act (#16), when Belmonte and Pedrillo suddenly decide to mistrust the women they have come to rescue. The ensemble begins with Konstanze's rapturous "Ach, Belmonte! ach, mein Leben!" as the lovers joyfully anticipate their planned escape, only to darken in mood abruptly when the men begin to hint at their jealousy. From Belmonte's stuttering "Man sagt — man sagt, du seist — " [They say, they say, you were —] and Pedrillo's hesitant "Doch Herr Osmin — " [But

Mister Osmin —], they finally arrive at direct questions. Tellingly, Belmonte asks whether Konstanze actually loves the pasha ("Ob du den Bassa liebst?"), while Pedrillo wants to know whether Osmin has exercised "sein Recht als Herr" — his rights as master — with Blonde; but both questions are met with predictable outrage from the women, before the quartet closes in Mozartian harmonies of forgiveness and reconciliation.

If anxieties about female inconstancy in such a setting obviously entail considerable projection on the part of men, Belmonte and his servant are hardly alone, as we have seen, in thus confusing the polygamy of the harem with the promiscuity of its women. It may even be relevant here that in his own first allusion to the projected opera Mozart absent-mindedly substituted "seduction" (verführung) for the abduction (entführung) of its title.[11] Of course, it hardly requires a harem to inspire masculine jealousy in Mozartian opera: one need only think of the cynical experiment in *Così fan tutte* (1790), or the unfounded suspicions for which the Count must beg his wife's pardon in the final act of *Le nozze di Figaro* (1786). Indeed, the latter especially might suggest that the deepest motive for Belmonte's doubts was in fact musical: another departure from Bretzner's original libretto, the quartet that closes the second act of *Die Entführung* poignantly anticipates the sublime modulations from tension to harmony in the finale of *Figaro*.[12] There is no question, in any case, that Mozart's resolution of the conflict proves more satisfying than Stephanie's. No sooner do the women deny their guilt — Blonde characteristically follows up with a slap — than the lovers retract their suspicions with a bit of reasoning that can at best be termed perfunctory: "Sobald sich Weiber kränken, / Wenn wir sie untreu denken, / Dann sind sie wahrhaft treu, / Von allem Vorwurf frei" [As soon as women feel themselves aggrieved when we think them untrue, then they are truly faithful, free from all reproach — 2.9, #16].

The anxieties provoked by the harem, in other words, are not so much settled as sung away. And though the audience knows that both women have indeed proved faithful, it also knows that female love does not always take such idealized forms as Konstanze's. Blonde's opening aria may dismiss the use of force as a method of love-making, but it also explains how easily women can be won with a little tenderness and flattery (2.1, #8). A typical soubrette, Blonde stands up for her rights more aggressively than her mistress, but the very cheekiness with which she responds to Osmin has its counterpart in the distinctly more practical view of love the theater often attributes to the lower orders. Konstanze has scarcely sung her last line in defiance of torture when Blonde arrives on stage to observe that her mistress is "too sensitive" (zu empfindsam) for her situation:

Indeed, if I didn't have my Pedrillo by my side, who knows how it would go with me! At least I wouldn't be as tender-hearted as she. Men really don't deserve that we should fret ourselves to death on their account. Perhaps I would think like a Muslim. (2.5)

For a woman to think "muselmännisch" in this sense is not to deny the freedom of her heart but to give it full play. Luckily for Pedrillo, at least, the plot assures that Blonde's joke will remain at the expense of the Muslims.

Despite the masculine prowess evoked by the name of Don Juan, the amorous difficulties that Byron's hero confronts in the harem bear a striking resemblance to the tribulations of Mozart's Blonde and Konstanze. Throughout the episode, of course, he actually appears in the guise of a woman, since the imperial eunuch who purchased him for the sultana only managed to slip him into the harem by disguising him as a slavegirl. But while the motif of a man thus smuggled into the harem is at least as old as the *Arabian Nights*,[13] Byron's hero retains the feminine position far longer than we might anticipate. Rather than a notorious seducer let loose among the concubines — a Don Juan who would quickly doff his female disguise to indulge the fantasized pleasures of a sultan — Byron gives us a handsome young man who bursts into tears when an imperious woman summons him to love on demand. Still dressed as a slavegirl, Juan confronts the beautiful and despotic Gulbeyaz, the sultana who has ordered this "latest of her whims" procured for the seraglio (5.114):

> She now conceived all difficulties past,
> And deem'd herself extremely condescending
> When, being made her property at last,
> Without more preface, in her blue eyes blending
> Passion and power, a glance on him she cast,
> And merely saying, "Christian, canst thou love?"
> Conceived that phrase was quite enough to move.
>
> And so it was, in proper time and place;
> But Juan, who had still his mind o'erflowing
> With Haidée's isle and soft Ionian face,
> Felt the warm blood, which in his face was glowing,
> Rush back upon his heart, which fill'd apace,
> And left his cheeks as pale as snowdrops blowing:
> These words went through his soul like Arab-spears,
> So that he spoke not, but burst into tears. (5.116–17)

For a brief moment, the fifth canto of *Don Juan* threatens to replay Racine's harem tragedy in the costume of farce. Like Bajazet, Juan finds himself in the position usually reserved for the female slave, and like Bajazet, too, he resists a sultana's advances because he has already committed his heart to another. But no sooner does Byron's hero recover his voice in this episode than he talks of "love" more nearly in the spirit of Montesquieu's Roxane:

> Thou ask'st, if I can love? be this the proof
> How much I *have* loved — that I love not *thee*!
> In this vile garb, the distaff, web, and woof,
> Were fitter for me: Love is for the free!
> I am not dazzled by this splendid roof.
> Whate'er thy power, and great it seems to be,
> Heads bow, knees bend, eyes watch around a throne,
> And hands obey — our hearts are still our own. (5.127)

Like Roxane, Don Juan distinguishes between the external signs of submission to the tyrant — the heads that bow, the knees that bend — and the inward resistance of hearts. If Byron's gender reversals momentarily resemble Racine's, in other words, his fiction of love belongs rather to the tradition of Montesquieu and Mozart. And this despite his immediately acknowledging how such talk of free hearts is already a cliché, since what is all too familiar to "us" is apparently not so to tyrants:

> This was a truth to us extremely trite;
> Not so to her, who ne'er had heard such things;
> She deem'd her least command must yield delight,
> Earth being only made for queens and kings. (5.128)

"Ce langage, sans doute, te paraît nouveau," Roxane concludes her final letter to Usbek, and it would seem that "ce langage," duly translated, still sounds new to the despot a century later (clxi. 334). Only in this imaginary seraglio, the woman makes love "as if she rather ordered than was granting" (5.109), and the man duly registers the expected protest: "Love is for the free! ... our hearts are still our own."

Don Juan is not without its passing fantasies of playing the sultan as well. After reporting how the still innocent hero of the first canto, "Tormented with a wound he could not know", responds to Julia's advances by plunging his "deep grief" in "solitude," the narrator amuses himself with a brief digression:

I'm fond myself of solitude or so,
 But then, I beg it may be understood,
By solitude I mean a sultan's, not
A hermit's, with a harem for a grot. (1.87)

"With a harem for a grot" fleetingly mocks not only Juan's self-induced loneliness but the amorous illusion that has prompted it. The narrator's imaginative polygamy opposes both his hero's solitude, in other words, and the romantic premise of a solitary love. If Byron nonetheless later arranges for his hero to join a harem rather than enjoy one, his temporary feminizing of Juan thrusts this joke aside and emphasizes instead his unwillingness to identify with the despot. For all his celebrated "mobility,"[14] the poet of *Don Juan* will not so forswear his "downright detestation / Of every despotism in every nation" (9.24) as to permit his hero to take the place of the sultan. Indeed, even the sultan himself seems scarcely up to the part, appearing more like a parody of imperial power when he arrives, "Shawl'd to the nose, and bearded to the eyes," to put an inopportune end to Gulbeyaz's tête-a-tête with her latest purchase (5.147). At this fantastic Eastern court, the role of principal despot obviously belongs to the woman. Though Byron probably knew enough about the Ottoman sultans to realize that they had no wives, only slave-born concubines, he cannot resist making Gulbeyaz "the last wife of the emperor" and "of course the favourite of the four" (5.146).[15] And he cannot resist pretending that she has always been a despot. "'To hear and to obey,'" he implausibly tells us, "had been from birth / The law of all around her" (5.112) — a law that necessarily clashes with the doctrine of love articulated by both narrator and hero. Though for a moment Byron hints at the Racine-like paradox that the despot is herself enslaved to her passions, the primary weight of Gulbeyaz's figurative chain falls on the neck of her attractive male victim.[16]

Of course, the harem is hardly the only place in which the poem deliberately reverses the conventional roles of pursued and pursuer: from his original affair with Donna Julia to his ghostly stalking by the Duchess Fitz-Fulke, this Don Juan does not so much actively seduce women as willingly submit to his own seduction. Nor does Byron indulge in a bit of imaginative cross-dressing merely to assure that his hero makes his way into the harem. Juan may indignantly disclaim "this vile garb" (5.127), but his notoriously bisexual author took obvious pleasure in a hero whose "youth and features favour'd the disguise" (5.115). When the sultan later makes his untimely appearance on the scene, Byron mischievously turns His Majesty's "great black eyes" on the ambiguous charms of his hero:

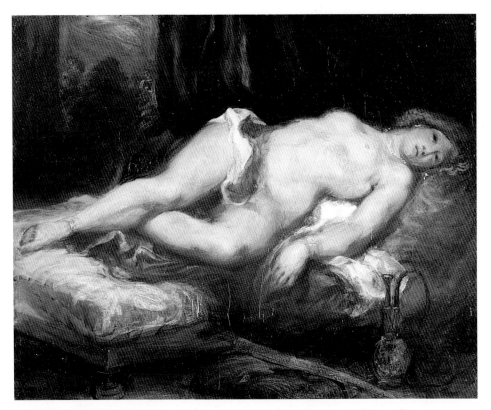

1. Eugène Delacroix, *Odalisque allongée sur un divan* (1827–28). Fitzwilliam Museum, University of Cambridge.

2. Jules Joseph Lefebvre, *Odalisque* (1874). Art Institute of Chicago.

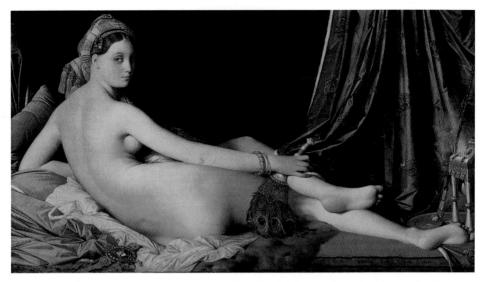

3. Jean-Auguste-Dominique Ingres, *La Grande Odalisque* (1814). Musée du Louvre, Paris.

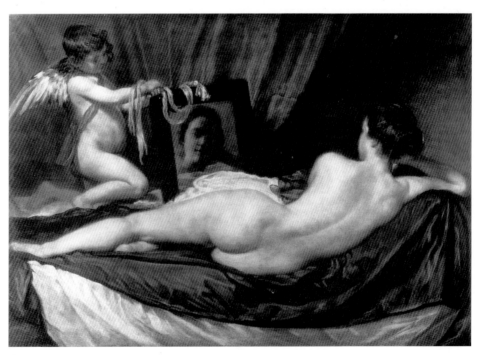

4. Diego Velásquez, *The Toilet of Venus* (*"The Rokeby Venus"*) (c. 1649–51). National Gallery, London.

6. Eugène Delacroix, *Femmes d'Alger dans leur appartement* (c. 1834). Musée Fabre, Montpellier.

5. Eugène Delacroix, *Femmes d'Alger dans leur appartement* (1834). Musée du Louvre, Paris.

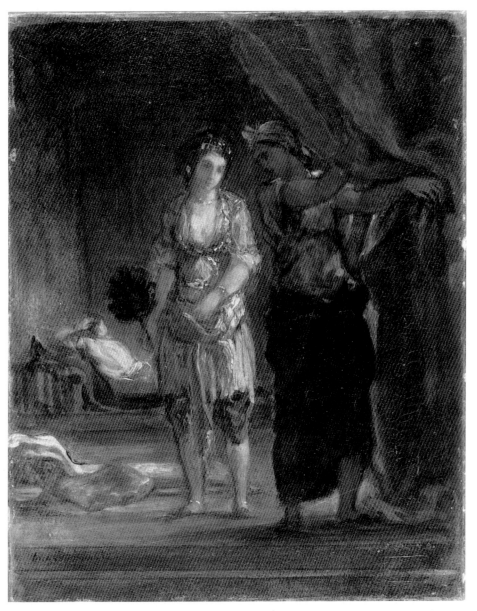

7. Eugène Delacroix, *Femmes d'Alger dans un intérieur* (1847?). Musée des Beaux-Arts, Rouen.

8. Eugène Delacroix, Study for *Femmes d'Alger* (1832). Musée du Louvre, Paris.

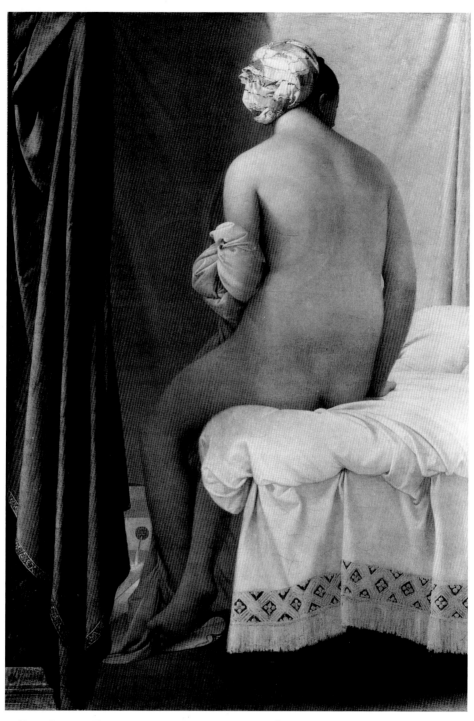

9. Jean-Auguste-Dominque Ingres, *Baigneuse Valpinçon* (1808). Musée du Louvre, Paris.

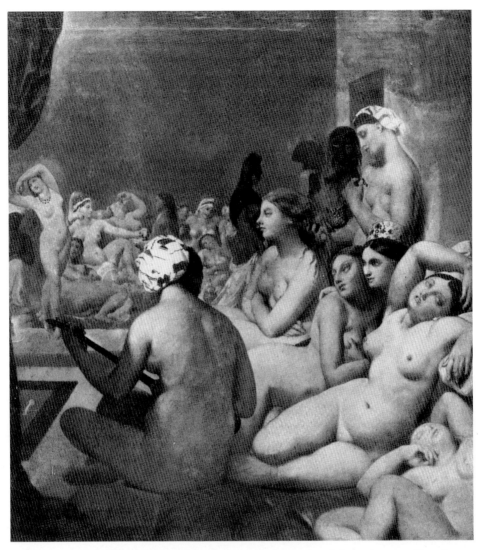

10. Charles Marville, photograph of the 1859 version of Jean-Auguste-Dominque Ingres, *Bain turc*. Bibliothèque Nationale, Paris.

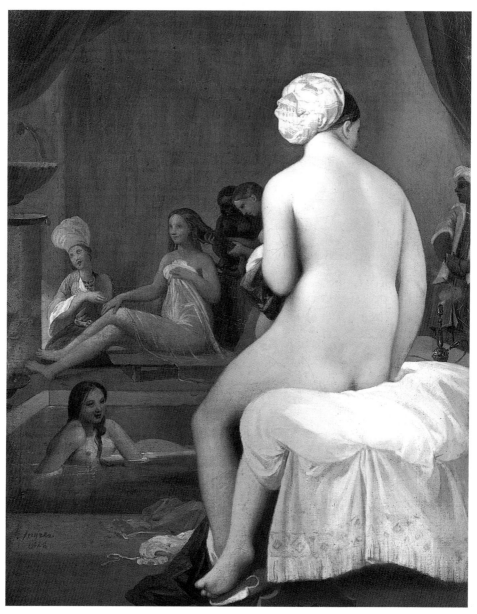

11. Jean-Auguste-Dominque Ingres, *La Petite Baigneuse: Intérieur de harem* (1828). Musée du Louvre, Paris.

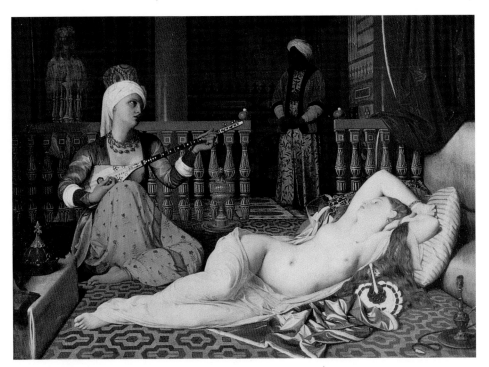

12. Jean-Auguste-Dominque Ingres, *Odalisque à l'esclave* (1839). Fogg Art Museum, Harvard University, Cambridge, Massachusetts.

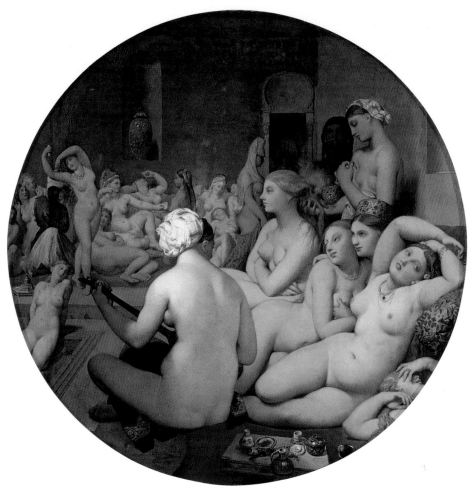

13. Jean-Auguste-Dominique Ingres, *Le Bain turc* (1862–63). Musée du Louvre, Paris.

14. Thomas Allom, *The Favourite Odalique*. From Thomas Allom and Robert Walsh, *Constantinople and the Scenery of the Seven Churches* (1838).

15. Eugène Delacroix, *Deux Babouches* (1832?). Collection Jean-Louis Vaudoyer, Paris.

16. Eugène Delacroix, Sketch for the *Femmes d'Alger* (1832). Musée du Louvre, Paris.

17. Eugène Delacroix, Details from *Les Massacres de Scio* (1824) and *La Liberté guidant le peuple* (1830). Musée du Louvre, Paris.

18. (below) Jean-Auguste-Dominque Ingres, Preparatory sketch for the *Bain turc*: woman with a hand on her breast (n.d.). Private collection, London.

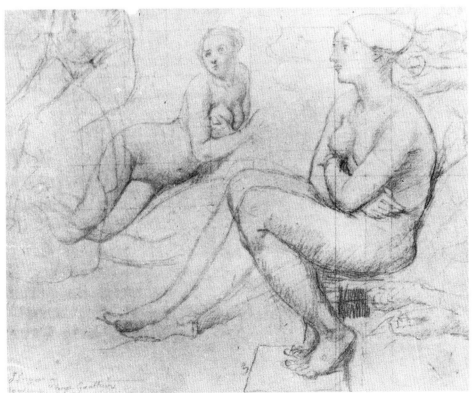

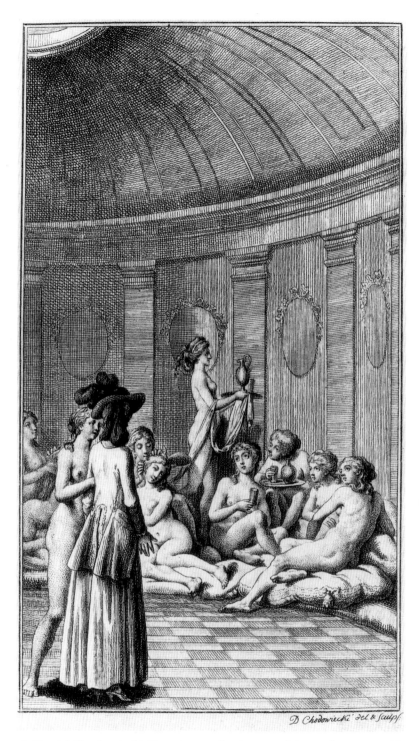

19. Daniel Chodowiecki, Frontispiece for *Letters of the Right Honourable Lady M—W—y M—e* (Berlin, 1781).

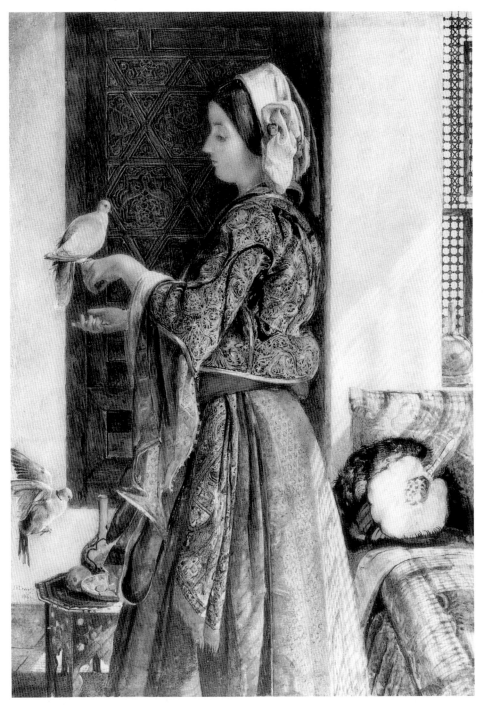

20. John Frederick Lewis, Caged Doves (1864). Fitzwilliam Museum, University of Cambridge.

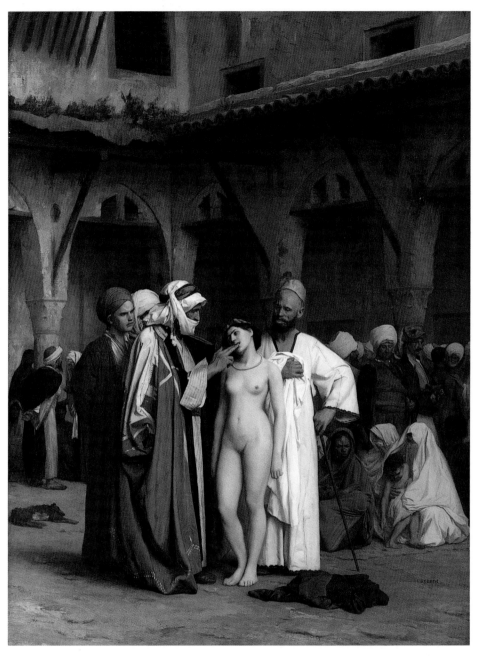

21. Jean-Léon Gérôme, *Marché aux esclaves* (c. 1867). Sterling and Francine Clark Art Institute, Williamstown, Massachusetts.

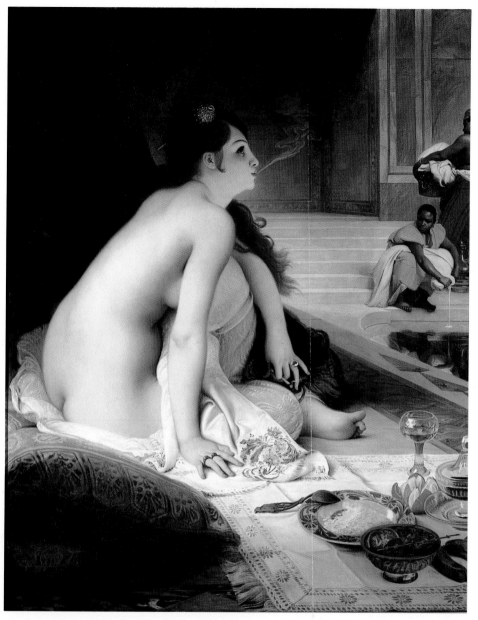

22. Jean Lecome de Nouÿ, *L'Esclave blanche* (1888). Musée des Beaux-Arts, Nantes.

23. Jean-Léon Gérôme, *Le Harem à le kiosque* (c. 1870). Najd Collection, Mathaf Gallery, London.

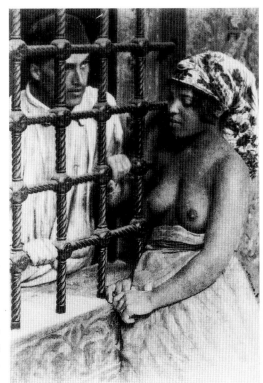

24. *Young Moorish Woman* (photo graphic postcard, first quarter of the 20th century). From Malek Alloula, *The Colonial Harem* (1986).

25. Thomas Rowlandson, *Harem* (after 1812).

26. Jules-Robert Auguste, *Trois Odalisques* (1820s). Musée des Beaux-Arts, Orléans.

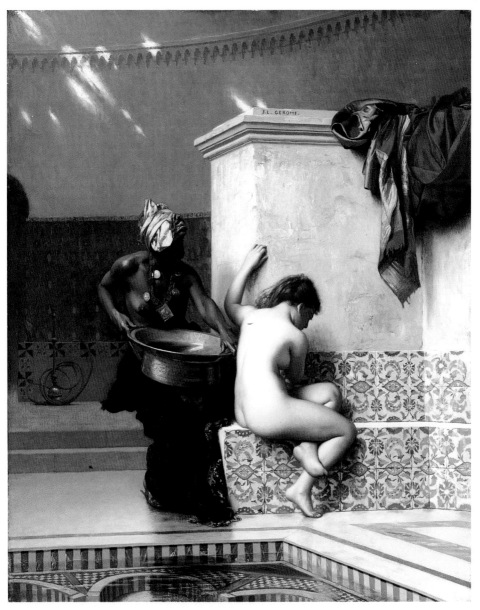

27. Jean-Léon Gérôme, *Le Bain maure* (1870). Museum of Fine Arts, Boston.

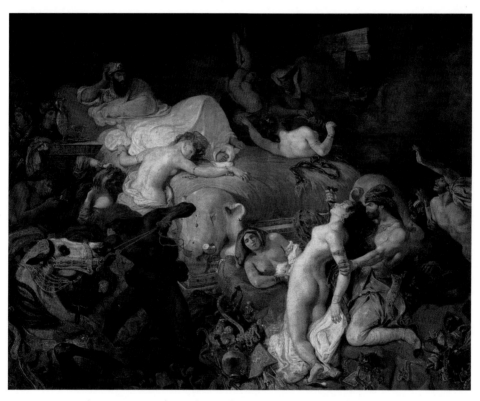

28. Eugène Delacroix, *Mort de Sardanapale* (1827–28). Musée du Louvre, Paris.

29. Benjamin Constant, *Les Chérifas* (1884). Musée des Beaux-Arts, Pau.

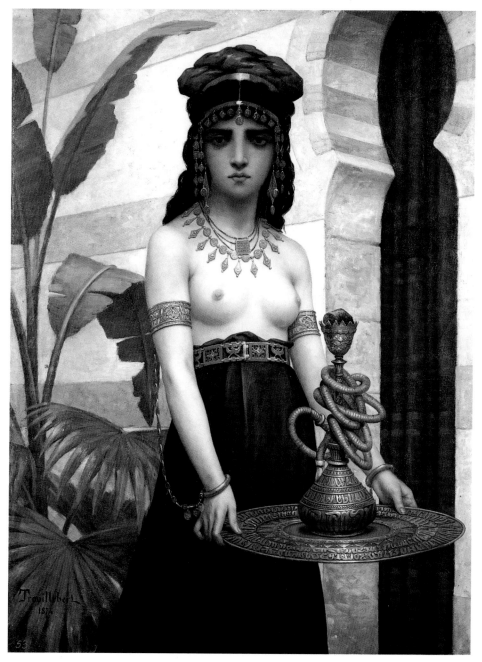

30. Paul-Désiré Trouillebert, *Servante du harem* (1874). Musée des Beaux-Arts Jules Chéret, Nice.

31. Jules-Robert Auguste, *Les Amies* (1820s). Cabinet des Dessins, Musée du Louvre, Paris.

32. Fernand Cormon, *Jalousie au sérail* (1874). Musée des Beaux-Arts et d'Archéologie, Besançon.

33. Two harem women? (unlabeled illustration for Sophia Lane Poole, *The Englishwoman in Egypt*, 1844).

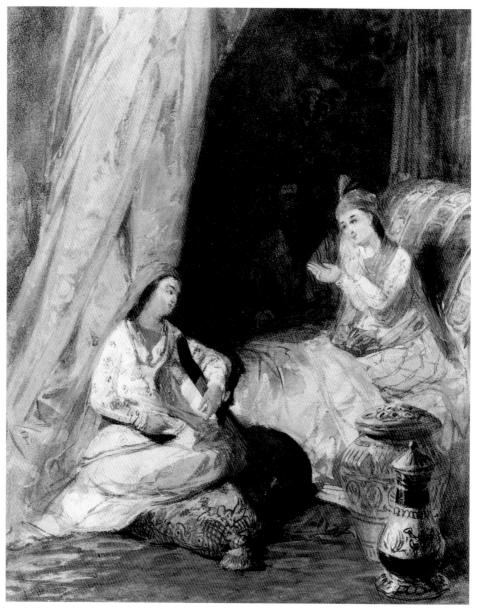

34. Richard Parkes Bonington, *Eastern Scene* (1825). Wallace Collection, London.

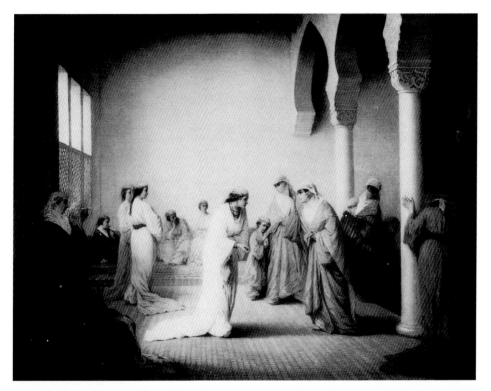

35. Henriette Browne, *Une Visite: Intérieur de harem, Constantinople, 1860* (1861). Private Collection.

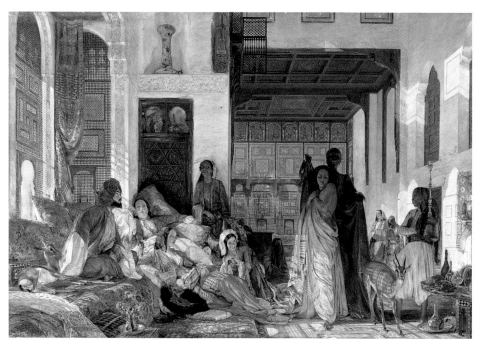

36. John Frederick Lewis, *The Hhareem* (1849). Private collection.

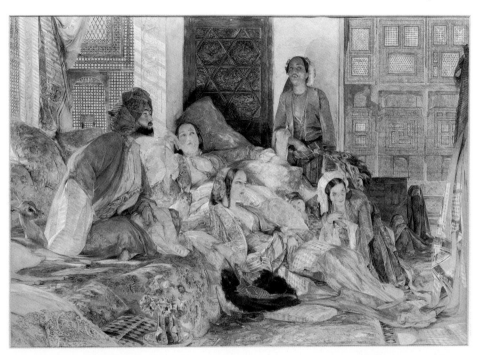

37. John Frederick Lewis, *The Hhareem* (n.d.). Victoria & Albert Museum, London.

38. John Frederick Lewis, *Recess in the Chamber of a House, Cairo* (1840s?). Victoria & Albert Museum, London.

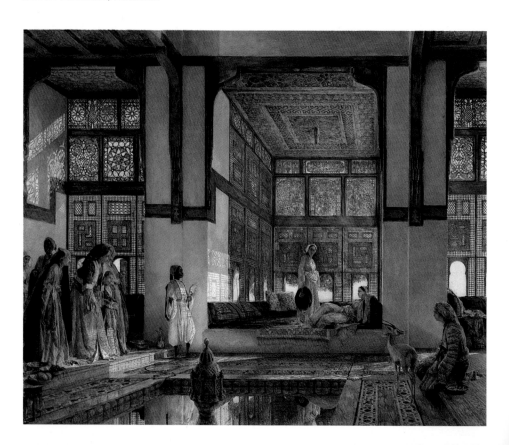

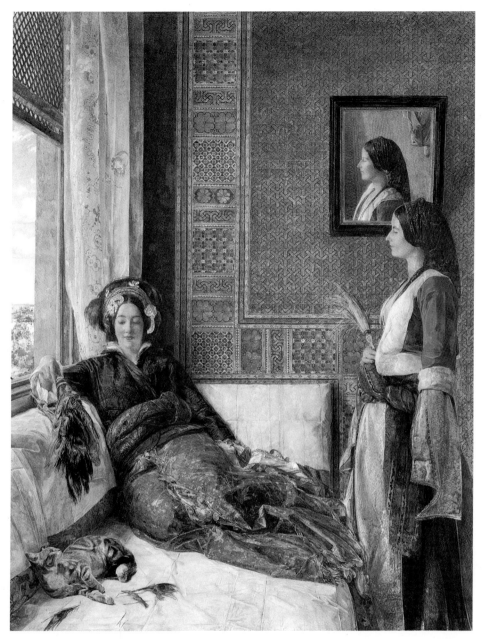

40. John Frederick Lewis, *Hhareem Life, Constantinople* (1857). Laing Art Gallery, Newcastle upon Tyne.

39. John Frederick Lewis, *The Reception* (1873). Yale Center for British Art, New Haven.

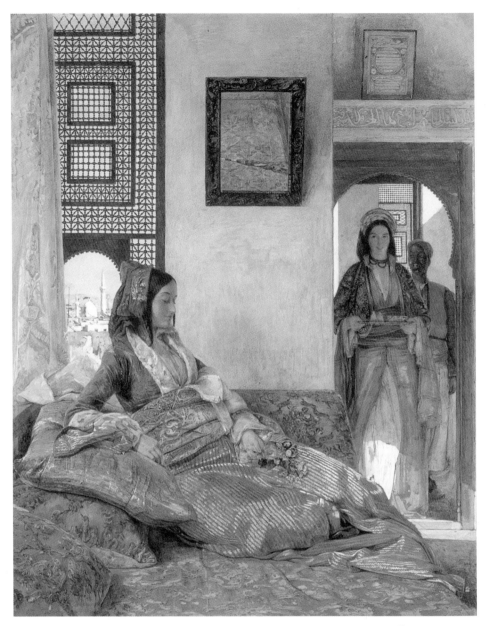

41. John Frederick Lewis, *Life in the Harem, Cairo* (1858). Victoria & Albert Museum, London.

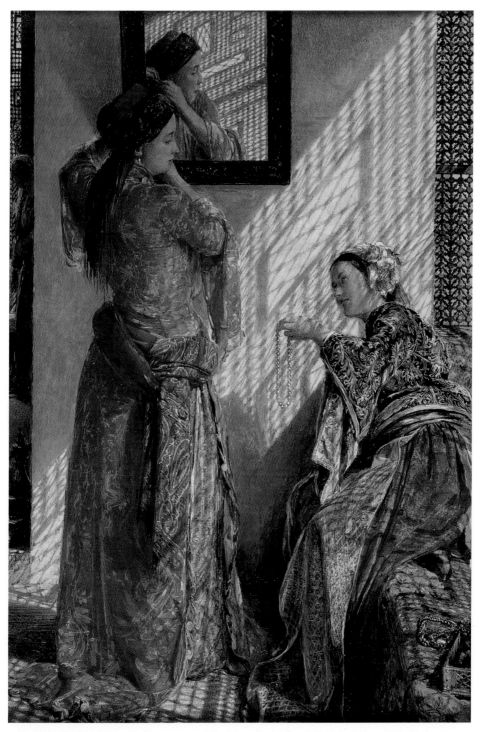

42. John Frederick Lewis, *Indoor Gossip (Hareem), Cairo* (1873). Whitworth Art Gallery. The University of Manchester.

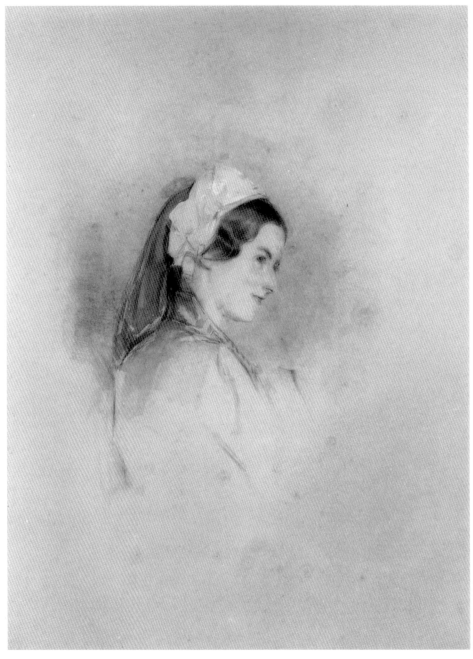

43. John Frederick Lewis, *Marian Lewis, the Artist's Wife* (n.d.). Private Collection.

44. John Frederick Lewis, *The Bouquet* (1857). Dunedin Art Gallery, New Zealand.

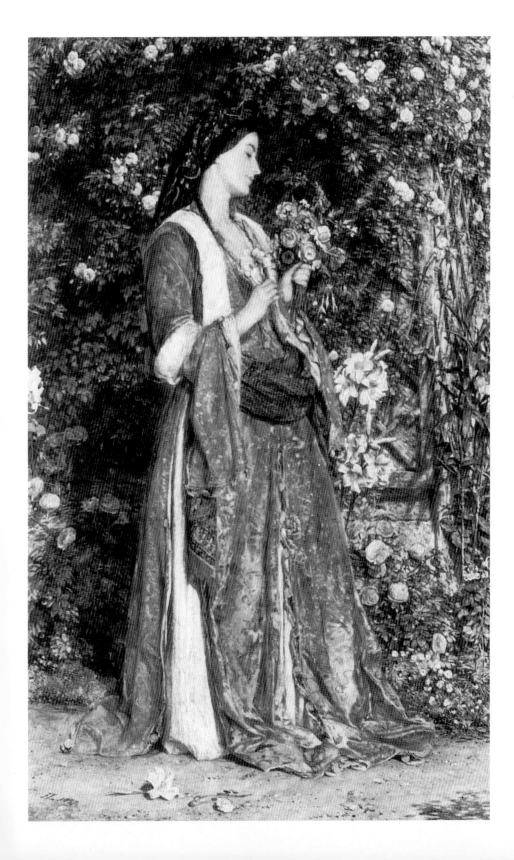

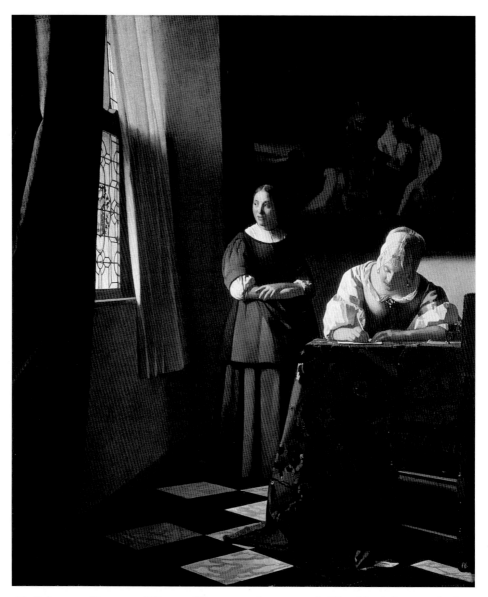

45. Johannes Vermeer, *Woman Writing a Letter, with Her Maid* (c. 1671). Beit Collection, Ireland.

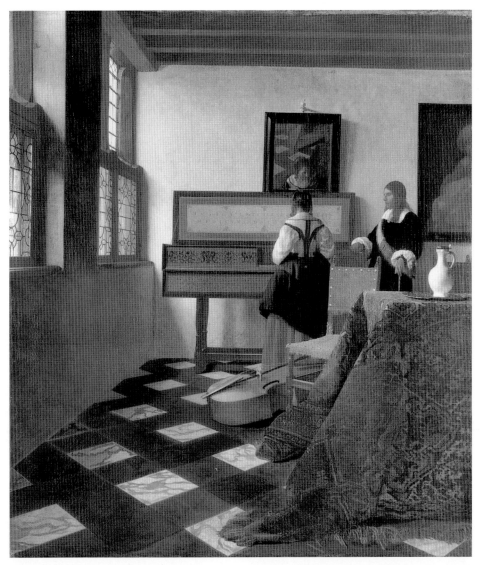

46. Johannes Vermeer, *A Lady at the Virginals with a Gentleman* (c. 1664). The Royal Collection.

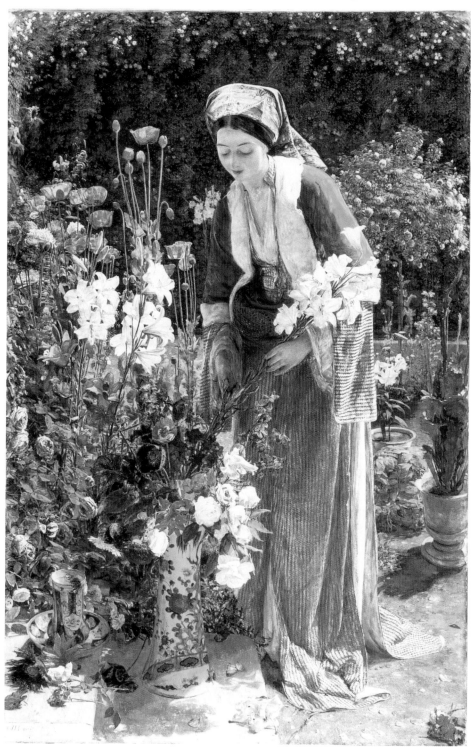

47. John Frederick Lewis, *In the Bey's Garden, Asia Minor* (1865). Harris Museum and Art Gallery, Preston.

48. (left) *Moorish Ornament*, plate xliii from Owen Jones, *The Grammar of Ornament* (1856).

49. (above) John Frederick Lewis, Detail from *Hhareem Life, Constantinople* (fig. 40).

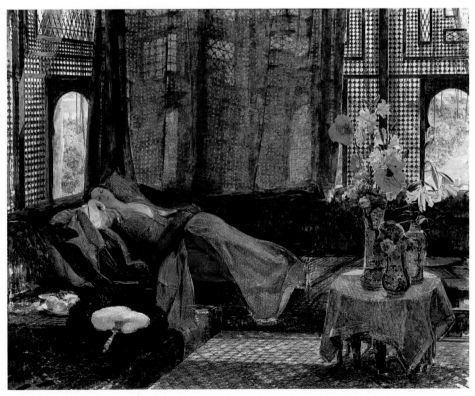

50. John Frederick Lewis, *The Siesta* (1876). Tate Gallery, London.

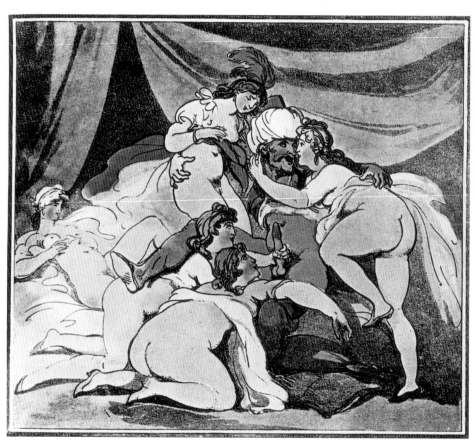

51. Thomas Rowlandson, *The Pasha* (after 1812).

52. Jean-Auguste-Dominque Ingres, Study of a woman with three arms (1815–18?).
Musée Ingres, Montauban.

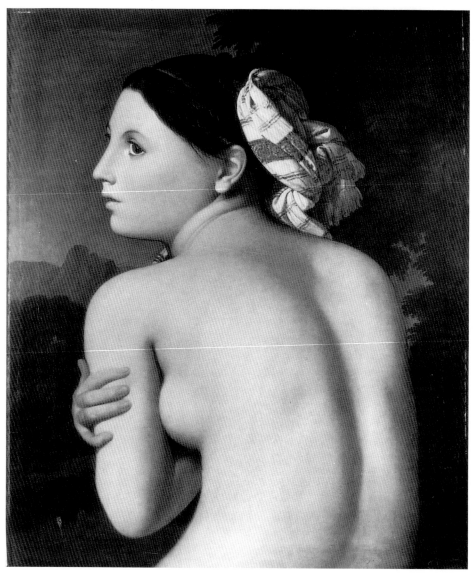

53. Jean-Auguste-Dominique Ingres, *Baigneuse* (1807). Musée Bonnat, Bayonne.

54. Jean-Auguste-Dominque Ingres, Detail from *Le Voeu de Louis XIII* (1824). Cathedral, Montauban.

55. Detail from *Hercules and Telephus*, fresco from Pompeii. Museo Nazionale, Naples.

56. Jean-Auguste-Dominque Ingres, Detail from *Madame Moitessier* (1856). National Gallery, London.

57. Jean-Auguste-Dominique Ingres, *Madeleine Ingres neé Chapelle* (1815). From Henri Lapauze, *Ingres* (1911).

58. Jean-Auguste-Dominique Ingres, *Profile de Madame de Lauréal* (1814). Musée du Louvre, Paris.

59. Sylvia Sleigh, *The Turkish Bath* (1973). Private collection, New York.

"I see you've bought another girl; 'tis pity / That a mere christian should be half so pretty" (5.155).[17] When the same disguise subsequently enables Juan to pass as a suitable bedmate for Dudù, it also enables his author to indulge, as we have seen, in a familiar masculine fantasy of lesbian eroticism in the harem. The poet of *Don Juan* famously delights in contradictions, not the least of which are the contradictions of gender itself.[18] The first effect of the hero's temporary sex change, however, is to identify him with all those other Byronic slavewomen whose hearts insist on remaining free. Despite the jokiness of his harem drag, Juan bears a serious resemblance to his predecessors: defying Gulbeyaz, he recalls Leila in *The Giaour* (1813), who "gave her heart, that all/ Which tyranny can ne'er enthrall" (1068–69) to the unnamed hero rather than Hassan, her master; or Gulnare in *The Corsair* (1814), who stammers out her account of how she never loved the pasha—"I felt—I feel—love dwells with—with the free" (2.14.502), even as she volunteers to help the imprisoned Conrad escape from the seraglio.

Yet Don Juan remains at heart a man, and the freedom of that heart entails liberties not permitted the corresponding organs of his sisters in Byron's graver Oriental poems. Leila may choose to love the Giaour rather than Hassan, but the latter sees to it that she pays for that choice with her life. Remarking that her killer did "but what I had done / Had she been false to more than one" (1062–63), the Giaour makes ominously clear how the female heart that freely challenges the tyranny of the harem nonetheless exercises that freedom within very narrow limits. As for Gulnare, her spectacular treachery to one man obviously disqualifies her for the love of the other: by murdering the pasha in his sleep, a deed that even the Corsair shrinks from, she simultaneously proves herself "at once above — beneath her sex" (3.16.514) and assures that she will disappear from the text after begging a single kiss from its hero.[19] Admittedly, gender alone does not seem to determine the sternness with which these poems treat the chance that the heroine might love more than once, since both poems apparently require that the hero too remain loyal to a single love: the Giaour lives and dies still mourning Leila, and the Corsair resists Gulnare in part because he is still committed to the faithful Medora. Indeed, so strenuously do these poems adhere to the convention that opposes the harem to the monogamous couple that they even risk a certain unintentional comedy — as in the Corsair's solemn exhortation to his pirate crew when they storm the pasha's court: "Oh! burst the Haram — wrong not on your lives / One female form — remember — *we* have wives" (2.5.202–203). Still more incongruously, the grim hero of *The Giaour* explains how he dutifully follows the example of the birds: "But this was taught me by

the dove — / To die — and know no second love. . . . The swan that swims upon the lake, / One mate, and one alone, will take" (1165–71).

But the young man who weeps for Haidée is already mourning a "second love"; and while his tears are genuine, no idealized fidelity to her shade will keep him from responding flexibly to the possibilities of the moment. "Love bears within its breast the very germ / Of change," the narrator observes elsewhere in the poem, as he argues from nature to a very different effect than the Giaour:

> That violent things more quickly find a term
> Is shown through nature's whole analogies;
> And how should the most fierce of all be firm?
> Would you have endless lightning in the skies? (14.94)

Arguments from nature are notoriously convenient, as the author of *Don Juan* surely recognizes, but where love is concerned, "nature" in this poem happily conspires with the improvisational spirit of the whole. It also, of course, happens to accord with some conventional assumptions about the differences between the sexes. Though Gulbeyaz is a despot, the poem argues, she is also a woman, and no sooner does she begin to behave like one by bursting into tears in her turn than Juan too begins to melt, as "all his great preparatives for dying / Dissolved like snow before a woman crying" (5.141). Of Gulbeyaz, the narrator remarks that "her sex's shame broke in at last" (5.137); and that return of her sex, apparently, helps to restore Juan to his.[20] Between the "real" gender of the despot and that of the protagonist, in other words, the heart of this slave in the harem is free to love again. "So Juan's virtue ebb'd, I know not how; / And first he wonder'd why he had refused; / And then, if matters could be made up now" (5.142).

Since the sultan unexpectedly arrives just as Juan is beginning to succeed in his peace-making, his affair with Gulbeyaz remains only slightly less theoretical than Blonde's speculations on how she would behave in the seraglio were it not for Pedrillo. But in the following canto, Juan, as Blonde might say, begins to think "muselmännisch." Still disguised as a woman, he joins "the lovely Odalisques," and "though he certainly ran many risks," the narrator tells us, "Yet he could not at times keep, by the way / . . . From ogling all their charms from breasts to backs" (6.29). And when "Juanna" is put to bed with Dudù, no exalted memories of Haidée appear to prevent "her" from taking full advantage of the opportunity. With the question of compulsion no longer at issue, Don Juan is free to enjoy a night in the harem.

14
Taming Soliman and Other Great Ones

I t is not only the slave who is thought to suffer from the absence of love in the harem. Lovelessness often afflicts the master of the imaginary seraglio as well — and afflicts him all the more, paradoxically, because he is free to choose from such a large number of partners. If the slave cannot love because her heart is compelled, the master cannot love because he meets no resistance, and because one woman in turn easily replaces another. Byron playfully grants his sultan "four wives and twice five hundred maids" (5.148), but even those less prodigal with their numbers often dwell on the imagined interchangeability of the women in the harem. It is no accident, for example, that with the notable exception of Roxane, readers of the *Lettres persanes* have found themselves unable to distinguish one of Usbek's women from the other.[1] As for Usbek's own feelings, he early on denies that they have anything to do with "love": "I find myself in this regard in a state of insensibility which leaves me with no desires at all." Exactly how he "anticipated and destroyed love by love itself" is far from transparent, but he appears to mean that the availability of so many women in his "crowded sérail" gave his desire almost no time to establish itself before it was immediately satisfied (vi. 18). In a letter that Montesquieu finally decided not to include in the collection, the chief eunuch recommends something very like this means of destroying love by exhausting it in order to prevent the master of a harem from permanently succumbing to the attractions of a single woman. When you wish to break such an attachment, he advises another eunuch, you have only to open the *sérail* to "great crowds of new rivals," and "you will wear out his heart so well that he will feel nothing."[2]

If such inability to love seems impossible to distinguish from the state of erotic boredom often attributed to imaginary sultans, Montesquieu

has little interest in worrying the difference. Until the last letter, it has been argued, "l'amour véritable" is "le grand absent des *Lettres Persanes*."[3] But the idea of a "true" love somehow to be discriminated from other kinds hardly arises in Montesquieu's text. Apart from her passing allusion to her dead lover as "le seul homme qui me retenait à la vie," Roxane draws no distinction between "l'amour" and "mes désirs," but simply defends her freedom to give herself where she pleases (clxi. 334). Nor do the letters particularly concern themselves with marriage-for-love, though Usbek's parable of the virtuous Troglodytes tells of a people who "loved their wives, and were tenderly cherished by them in turn" (xii. 32).[4] It would remain for later writers to imagine how a Roxane with marriage on her mind could successfully deploy such an ideal to undo the very structure of the harem. A still more wishful version of the female captive with the free heart, this Roxane became a culture heroine who not only conquers the sultan but overturns the laws of his empire.

Though the fame of the historical Hurrem Sultan, known to Europe as "Roxelana," obviously inspired these writers, the plots they attributed to her owe more to Western literary conventions than to the customs of the harem. First a concubine and later the only acknowledged wife of Süleyman I (r. 1520–66), Hurrem achieved her fame by making herself the exception to the rule that the Ottoman sultans took no wives. What little we know about how she persuaded Süleyman to marry her comes primarily from the accounts of the Venetian ambassadors, who were themselves, of course, viewing the Ottoman court through European eyes. Yet while successive reports do trace the apparent transformation of a hitherto "lustful" sultan into a faithful consort who forswore all other women, the stories they tell bear little resemblance to the fiction first circulated in Jean-François Marmontel's *Contes moraux* (1761) some two centuries later.[5] In 1553, roughly two decades after the marriage appears to have taken place, one ambassador passed on a revealing anecdote about how "the Russian" (i.e., Hurrem) had "entered into the favor of the sultan" by defeating her principal rival, the Circassian mother of his first born son. The account begins with the jealousy of the other woman, who "scratched her all over her face and mussed up her clothing, saying, 'Traitor, sold meat, you want to compete with me?'" Hurrem takes her revenge when the sultan next summons her:

She did not let this opportunity pass, and angrily told the eunuch agha who had come to fetch her that she was not worthy to come into the presence of the sultan because, being sold meat and with her face so

spoiled and some of her hair pulled out, she recognized that she would offend the majesty of such a sultan by coming before him.

As she has presumably foreseen, Hurrem's words have the effect of making the sultan even more eager to see her. This time he summons her to explain why she has sent him such a message, and she tells her story — "accompanying her words with tears and showing the sultan her face, which still bore the scratches, and how her hair had been pulled out." The Circassian defiantly confirms the story, but her words only "inflamed the sultan even more," according to the ambassador, "for the reason that he no longer wanted her, and all his love was given to this other."[6]

Whatever the truth of such gossip — and one modern historian argues that the Venetians had reason to be accurate at least in spirit, if not in details[7] — the woman who emerges victorious from this hair-pulling match is hardly the heroine of a love story. Except for the hint that she deliberately exploits her injuries to refuse the sultan and thus increase his desire for her, "the Russian" succeeds primarily by abasing herself, flattering him, and shrewdly discrediting her rival. Süleyman's original attraction to Hurrem presumably antedated this episode, which explains rather how she managed to consolidate her power. But his persistent loyalty to a single woman was so anomalous, according to the Venetians, that his subjects concluded she had bewitched him. The ambassadors claimed, in fact, that everyone else at court roundly hated her; and well into the next century European dramatists followed their lead and duly represented her as a murderous political schemer.[8]

By the time she showed up as a heroine of the *Contes moraux,* however, she appears to have acquired such an exalted reputation in the West that Marmontel could entice his readers by offering to debunk her. Mocking "the solemn historians" who have racked their brains to attach "great causes to great events," the tale begins by promising to tell the real story behind the legend of the glorious Roxelane.[9] Rather than an accomplished beauty with a great soul and a genius for statecraft, Marmontel's heroine proves an impudent European with a "nez retroussé" and a habit of laughing immoderately at the customs of the *sérail.* Alone among the "five hundred" women in this imaginary harem, she teaches Soliman to love by mocking and resisting him (34). The sultan who routinely begins by lamenting his boredom ends by determining to share in the "bonheur" that all his subjects enjoy, as "transporté de joie & d'amour" he leads his bride to their nuptials (44, 45).

Though it takes Roxelane to persuade Soliman that what he wants is

"une épouse légitime," Marmontel's sultan seems familiar enough with the literary tradition he inhabits to realize from the start that only a free heart will liven up his harem (43). Finding "the varied, but easy pleasures" of his *sérail* "inspid," and his slaves nothing but "caressing machines," he orders up a trio of European newcomers in the hope of diverting himself by making "hearts nourished in the bosom of liberty" learn to love their slavery (19, 20). The first of these, the beautiful and sensitive Elmire, initially resists his advances, but the month that follows gradually accomplishes the seduction. Elmire fails to perceive the "pétites négligences" that escape her "pudeur," while the sultan knows — "& c'étoit beaucoup savoir pour un Sultan," as the narrator dryly remarks — that one conquers by gently taming such *pudeur* rather than clumsily alerting it to its danger (23). Such gradual seduction, we are given to understand, is love-making of the European rather than the Oriental kind, and the sultan newly savors the pleasure of thus prolonging the experience: "the roads to happiness where he had only passed rapidly with his Asiatic slaves, had seemed to him so delightful with Elmire, that he had found an inexpressible charm in traversing them step by step." But no sooner have the obstacles disappeared than so does the satisfaction of overcoming them, and the sultan finds himself as bored as ever by the "too easy" pleasures of the victor (25). Much to the distress of Elmire, Soliman briefly attempts to revive his languor with the charms of her countrywoman, the musician, Délia, who appropriately sings ravishing songs in praise of inconstancy. His infatuation with Délia, however, quickly fades in its turn, and "habit" has already weakened the illusion produced by her enchanting voice when Roxelane's impudent laughter dissipates it forever (29).

Roxelane, we are told, is no beauty, but she has "cette singularité piquante" which is more expressive than beauty; and between the "fire of her looks and the play of her features" — not to mention her upturned nose and flippant manner of speaking — Soliman finds her captivating (31). Her opening gambit when they come face-to-face in the presence of his eunuch is characteristic. "Thank heavens," she says, "here is a human figure. You are, no doubt, the sublime Sultan of whom I have the honor to be a slave? Do me the favor to dismiss this old rascal who offends my sight." Mildly advised by Soliman that the customs of the *sérail* require that she obey him and respect "the Minister" of his "wishes," she continues in the same vein:

> *Obey!* And is that Turkish gallantry? ... *Respect the Minister of my wishes!* You have then wishes? & what wishes, just heavens, if they resemble

their Minister! An old amphibious monster who keeps us locked up as in a sheepfold, & who prowls around with terrible eyes, ever ready to devour us! Here is the confidant of your pleasures and the guardian of your wisdom? It's necessary to do him justice: if you pay him to make yourself hated, he doesn't steal his wages. (29–30)

The sultan's more ingratiating approaches meet with equal defiance: when the eunuch announces that he has come on behalf of his master to "kiss the dust of her feet" and invite her to tea, for example, she announces that her feet have not a bit of dust and that she is not taking tea that morning (32). Later, Roxelane invites Délia to make a third at an intimate supper, asks her to sing, and then presents her with the legendary handkerchief of the favorite that she has herself softly requested from the sultan. When Soliman inquires how she has enjoyed the daily festivals he has arranged in her honor, she coolly responds that she likes them well enough, but something is missing. "Et quoi!" he demands. "Des hommes & de la liberté," says Roxelane — at which utter negation of the harem, the sultan, understandably, lapses into despair (40).

Roxelane expressly designs her campaign to teach Soliman how to love — which means, she makes clear, to love her liberty as a European.[10] In her own country, she explains, "they know love, there it is lively and tender; and why? because it is free." As her master, Soliman may possess "the rights of rapine and violence" — the same rights, she observes, as the "brigand" who sold her — but "love" by definition must elude him. Reminded that she is only a slave, Marmontel's comic heroine even momentarily threatens to imitate the fatal solution of her predecessor: "But I am no longer your slave, if I know how to scorn life; and frankly, the life that one leads here little deserves saving" (34). This Roxelane is distinctly more inclined to prove her liberty by laughter than by suicide, however; and with her persistent mockery and defiance, she not only cures Soliman of his boredom but thoroughly enraptures him.

Yet if the sultan ends by replacing his harem with a marriage for love, the motives of the would-be bride are considerably more equivocal. Though she goes so far as to say that she would have had "some weakness" for Soliman had he merely been an ordinary fellow in her own country — "you even have something of a Frenchman," she adds, flatteringly (35) — Marmontel's Roxelane holds out for marriage because she holds out for "glory." "Les femmes de son pays aiment la gloire," Délia explains, as she suggests to the desperate Soliman that he try to win over his recalcitrant slave by permitting her to watch, suitably veiled, while he receives some

foreign ambassadors (40–41). But rather than accomplish the seduction, the ceremony only convinces Roxelane that she too should receive "des ambassades" (42) — which is to say that the sultan must marry her: "If my lover had only a cottage, I would share his cottage, and I would be content; he has a throne; I want to share his throne, or he is not my lover" (41). Refusing all distractions, she announces that she "will dream of nothing but scepter, crown, embassy" (42) until Soliman does as she wishes. The sultan tries to talk of "amour," but the slave only wants to talk "politique" (43). And while he burns with love, she busily plans to introduce vineyards, build opera houses and do away with the eunuchs — effectively turning the Ottoman empire into an Eastern image of France. "Est-il possible qu'un petit nez retroussé renverse des loix d'un Empire?" Soliman inquires as he leads her to their nuptials, but both sultan and author obviously regard the question as rhetorical (45). Marmontel's cheerfully ironic tale does not so much abandon the old figure of the scheming Roxelane, in other words, as imagine how a Western courtship plot might be adapted to serve her ends.

"Soliman II" never asks why the boredom that afflicted the sultan once he had his way with Elmire will not return when he has consummated his marriage with Roxelane — as Lessing, for one, ironically speculated[11] — but whether we think of him as trapped in perpetual ennui with one woman or saved from that fate by her endless mockery and resistance, Marmontel makes clear that whoever loves surrenders power to the other. Except for Soliman's momentary transport with Elmire, "l'amour" in this imaginary harem is never reciprocal. The sultan learns how to love, but only by exchanging his erotic dominion over his slaves for the slavish uxoriousness of the husband; the slave exercises her free heart not to choose a mate but to compel his choice of her and thus acquire a throne.

The Roxelane who would charm Europe over the following century was the heroine of a more orthodox love story. Charles-Simon Favart adhered closely to many details of Marmontel's text when he versified it for the stage as *Les Trois Sultanes* in 1761, from the banter with which Roxelane first greets the sultan to Soliman's concluding question, now spoken by the chief eunuch, about the "petit nez retroussé" that changed the laws of an empire.[12] While Marmontel only hints at the Frenchness of his heroine, Favart seizes the opportunity of the harem setting to offer up a small taxonomy of national types for the sultan: Elmire, we now learn, is a Spaniard, and the sensuous singer, Délia, has turned into a Circassian. Indeed, by calling attention to the female trio it inherited from its predecessor, *Les Trois Sultanes* helps to make clear the numerical rule that governs so many

Western representations of the harem: according to the rule of three, as it might be called, two women who compete for the same man are merely rivals, while the addition of a third produces a convenient synecdoche for multitudes.

In keeping with the temporal conventions of the stage, *Les Trois Sultanes* opens with Elmire's month-long seduction nearly concluded, though ‧ Favart heightens the dramatic potential of his source by elaborating her subsequent role as Roxelane's principal rival in the harem. Marmontel's Soliman ships Elmire back home as soon as he becomes infatuated with Délia, but on stage she remains the official favorite well after he finds himself captivated by Roxelane, so that Favart may contrast the Spanish woman's sentimental idea of love and her humiliating jealousy with the Frenchwoman's mocking laughter and her cheerful efforts to advance the fortunes of her rivals. Elsewhere Favart indulges his audience by imagining how Roxelane might set about Europeanizing the *sérail* — throwing Soliman's pipe "into the back of the theater," for example, in order to enforce her point that it is not polite to smoke in a woman's presence (2.3), or insisting that "les coutumes françaises" require tables and chairs rather than hassocks and carpets at the intimate supper to which she has invited both rivals as well as the sultan. Commanding that the shutters be closed and candles lighted, the Frenchwoman further scandalizes the assembled slaves by ordering up wine from the mufti (the leading religious official at court), and consolidates her victory by persuading both the chief eunuch and Soliman himself to drink the forbidden liquid. ("He condemns the use of wine, yet he drinks it like the others, in secret," an author's note says of the mufti, by way of solemnly explaining this routine Western joke about Islamic hypocrisy on the subject of alcohol — 2.8.)

But the principal difference between the popular stage comedy and the tale that inspired it concerns the representation of the marriage that in both versions replaces the harem.[13] In *Les Trois Sultanes*, unlike "Soliman II," the love that joins the sultan to his only wife is clearly reciprocal. When Favart's Soliman delights in "Cet amour pur, né de l'égalité, / Que réciproquement l'un à l'autre on s'inspire," he is no uxorious fool but an Oriental emperor who has been happily converted to a Western faith in the loving couple (3.6).[14] "You have a good heart, and that interests me," Roxelane tells him at one point, and when he subsequently liberates her from slavery, the stage directions require her to address him with "most tender sentiment" (3.5). By the end of the play, Roxelane is praising the greatness of his soul and announcing that "so many virtues ravish me," adding a bit less extravagantly, "I love you, Soliman; but you have deserved it" (3.10).

And so many virtues newly discovered in the sultan, the play suggests, are the mirror image of his bride's.

Like her predecessor, Favart's heroine insists on sharing the throne, but rather than dream of the scepter and the crown, this Roxelane dwells on a marriage of equals. Love requires both "liberté" and "égalité," she explains, but the sultan's vast power distorts the balance; and without marriage, she adds, she would have no recourse against the arbitrary withdrawal of his favor. Though she too talks of "gloire," the context makes clear that for her the word signifies personal honor rather than the thrill of receiving ambassadors. "Vos grandeurs ne sont rien," she tells the sultan; "mais ma gloire m'est chère. / Vous aimer en esclave est un affront pour moi" (3.9). Indeed, she has earlier anticipated this proud internal-ization of "gloire" by announcing that "my happiness is never in what surrounds me; it is in myself" (3.5). Where Marmontel represented a charming wit with a lively sense of what was due her, Favart substitutes an enlightened heroine who conquers the sultan by force of reason and merit as well as the genuine dignity of her feelings.

And though she now makes clear that she will only surrender to Soliman if she can share his power, her vision of the future has less to do with impe-rial magnificence than with virtuous domesticity writ large. The words "époux" and "épouse" echo repeatedly through the last scenes of the comedy, as the harem gives way to the promise of a domestic ideal. Amplifying on the speech from Marmontel in which Roxelane claims that she would happily have shared a cottage if that were all her husband had to offer, Favart's heroine not only draws out the egalitarian implications of the argument but conjures up an image of marital virtue in which the loving wife comforts, consoles and supports her humble partner. If she were to marry Soliman, she later suggests, just such "tender humanity," suitably magnified, would sit "beside majesty," as the benevolent wife gave a help-ing hand to adversity, softened the rigor of the laws, protected the innocent, and above all, told him the truth— "the foremost need of a monarch" (3.9). While Marmontel's heroine dreams of vineyards, opera houses, and ridding herself of eunuchs, the first and only act of "absolute power" this Roxelane undertakes is, significantly, to free the women of the *sérail* (3.10).

Despite all the talk of reciprocity and equality which brings the play to a close, those inclined to a more skeptical view of marital relations might find cause for alarm in the submissive rhetoric with which Favart's hero-ine finally accepts her fate. "Take back your rights," she suddenly instructs her future husband; "take back my liberty. Be my sultan, my hero, and my master." Urging that he do nothing his laws and customs do not authorize,

she concludes by declaring herself, in her words, "une esclave soumise" (3.10). Since Soliman immediately announces that such sentiments only prove her the more worthy of the throne, Roxelane's speech is presumably to be read as one more gesture of reciprocity, a generous sacrifice for the other that testifies to the reality of her love. Yet the evidence also suggests that Favart felt something like this momentary abasement was wanted before the hitherto feisty Frenchwoman was rendered altogether fit for marriage. Marmontel's tale, needless to say, records no such self-abasing gesture on the part of its heroine. Indeed, one of the instances of Roxelane's wit that Favart did not adapt for the stage suggests that even marriage French-style may not differ as radically from the relations of sultan and slave as *Les Trois Sultanes* pretends. "Our marriage is nothing like servitude," Marmontel's heroine says, "yet a beloved husband is a prodigy. . . . Now, if it is so hard to love a husband, how much more difficult it is to love a master, above all if he doesn't have the cleverness to hide the chains he gives us!" (33). Having comically transformed the harem into a model Western marriage, Favart chooses not to ask if it will still be hard to love the sultan when he has hidden the chains and become merely a husband.

By the time the heroine with the "cock'd-up nose" arrived in England in the following decade, the champion of affectionate marriage had virtually effaced the ambitious schemer.[15] In an advertisement to *The Sultan, or a Peep into the Seraglio* (1775), Isaac Bickerstaff described his piece as "taken from Marmontel," but the brief farce that follows is closer in spirit to the romantic comedy scripted by Favart (3). Though Bickerstaff could not resist the heroine's crack about the difficulty of loving a husband — "even" in England, it appears, "a husband belov'd is next to a prodigy" — his Roxalana still acts for love rather than political ambition when she persuades "Solyman" to marry her (12). *A Peep into the Seraglio* is in every sense a slighter work than *Les Trois Sultanes*, and for the most part Bickerstaff contented himself with translating highlights from the work of his predecessor. He retained small parts for Roxalana's rivals, but as if impatient with fine distinctions among national types — or convinced that the English alone among Europeans had claims to freedom — he vaguely Orientalized both women, making one a Circassian and the other a Persian. Roxalana still protests that she has no dust on her feet, but instead of rejecting an offer of tea, the good Englishwoman now refuses sherbet. Bickerstaff preserved much of the dinner scene, including the wine from the "Mufty," though dining "like Christians" (15) rather than "à la française" as in Favart (2.14) seems not to have required candlelight.

Most revealingly, however, when the sultan's future wife becomes an Englishwoman she apparently loses all her sexual experience. In both Marmontel and Favart, Roxelane at once point professed to tell Soliman "without flattery" that she had had lovers in her own country who were not his equals. When both sultans reacted with outrage, the Frenchwomen merely laughed at them. "Pourquoi non, je vous prie?" demanded Favart's heroine:

> Croyez-vous que, vive, jolie,
> Et dans l'âge de plaire, on a jusqu' à présent
> Gardé son coeur, ce fardeau si pesant,
> Pour qui? Pour le Grand Turc? Mais quelle extravagance!
> Je devais prendre patience. (3.5)* [16]

Nothing like this appears in the English farce, which for all its light-heartedness seems to take for granted that the harem is properly replaced by marriage to a virgin. Like Favart's heroine, Bickerstaff's marries for "love," but a love still more monogamously domesticated by its translation to English. When Roxalana argues the case for marriage, she speaks "on the side of reason and virtue" (20). And though the play's final scene duly includes the eunuch's wonder at the nose that "overturn'd the customs of a mighty empire," it reserves the last line for Solyman's praise of the perfection of her mind (21).

Whether in French or in English, the story of the slave who married the sultan was a predictable success with Western audiences, a gratifying triumph of European wit and European virtue over the polygamous temptations of the harem. Variations on the theme sounded everywhere, from Haydn's Symphony No. 63, popularly called *La Roxelane*, to Rossini's Italian girl, who craftily imitates her predecessors, as we shall see, though with a very different end in view.[17] Indeed, whatever the truth about Süleyman's bride, by the middle of the nineteenth century Europe's imaginary heroine had so thoroughly swallowed up her historical proto-type that Gérard de Nerval could refer casually to "cette Roxelane française au nez retroussé, qui a existé ailleurs qu'au théâtre" and whose tomb one might actually visit at Constantinople.[18]

Faint echoes of the English Roxalana's voice may even sound in Don Juan's flippant promise to his fellow-captive before he undertakes his

* Why not, I ask you? Do you believe that young, pretty, and at the age for pleasing, one has until now preserved one's heart, that burden so heavy? For whom? For the Grand Turk? But what folly! I must be patient.

brief career as a slavegirl: "the Sultan's self shan't carry me, / Unless his highness promises to marry me" (5.84). And they sound as well, more seriously, in Jane Eyre's struggle toward the same end with a "master" she herself compares to a sultan.[19] Brontë's heroine is already burning with "a sense of annoyance and degradation" at the silks and jewels Rochester has insisted on purchasing for her in the days before their marriage, when she first reaches for the Oriental analogy. "He smiled," she reports; "and I thought his smile was such as a sultan might, in a blissful and fond moment, bestow on a slave his gold and gems had enriched."[20] Jane has not yet learned that Rochester is literally polygamist enough already to possess another wife, but she does know something of his habits where the keeping of women is concerned; and she feels all too keenly the gestures of despotic munificence that she associates with the master of a harem. So much does the Oriental analogy saturate the air between them that she has no need to make explicit her silent comparison for Rochester to take up his identification with a sultan.[21] "Oh, it is rich to see and hear her!" he exclaims, when she spiritedly rejects his gifts: "Is she original? Is she piquant? I would not exchange this one little English girl for the grand Turk's whole seraglio; gazelle-eyes, houri forms and all!" (339).

Later, in the aftermath of the discovery of the first Mrs. Rochester, he will offer a full taxonomy of his Continental mistresses — the French Céline, the Italian Giacinta and the German Clara — implicitly contrasting their assorted national types with the witty banter and stubborn virtue of the plain English governess. Of this sequential harem he will remark, significantly, that "hiring a mistress is the next worst thing to buying a slave: both are often by nature, and always by position, inferior; and to live familiarly with inferiors is degrading" (397–98). But Brontë's nouvelle Roxelane has no need to hear this confession before she undertakes to liberate the harem:

> The eastern allusion bit me again: "I'll not stand you an inch in the stead of a seraglio," I said; "so don't consider me an equivalent for one: if you have a fancy for anything in that line, away with you, sir, to the bazars of Stamboul without delay; and lay out in extensive slave-purchases some of that spare cash you seem at a loss to spend satisfactorily here."

To Rochester's query as to what she will do, while he is "bargaining for so many tons of flesh and such an assortment of black eyes," Jane responds, famously, by threatening to "go out as a missionary to preach liberty to them that are enslaved — your Harem inmates amongst the rest. I'll get

admitted there," she says, "and I'll stir up mutiny; and you, three-tailed bashaw as you are, sir, shall in a trice find yourself fettered amongst our hands: nor will I, for one, consent to cut your bonds till you have signed a charter, the most liberal that despot ever yet conferred" (339). Like Bickerstaff's Roxalana, who at once infuriates and charms the sultan by addressing him "with the sincerity of a friend" (19), the candid English heroine teases the master, speaks truthfully to him, and insists that he take her as an equal when he marries her for love. Whether Rochester would have thought his "little English girl" quite so original had he recalled a similarly "piquant" heroine from France, his own choice of her over "the whole seraglio" obviously resembles Soliman's. The wedding that closes *Jane Eyre* belongs to the same tradition that requires the marrying of the sultan.

15
Leaving the Harem Behind

üleyman's marriage is a famous exception, however, and not just in the annals of Ottoman history. In most Western representations, the loving couple do not reform the harem but flee from it, confirming themselves *as* a couple precisely by running away from the temptations and dangers of polygamy.[1] And with predictable regularity, such "Haremsmäuse" (harem mice), as Osmin wonderfully calls the European intruders in *Die Entführung* (3.5, #19), thereby also confirm their identity as Westerners. Indeed, for all the ambiguous superiority of Pasha Selim, the two pairs of lovers in *Die Entführung* are a case in point, as are their many predecessors in the fashionable abduction operas that anticipated Mozart's in the 1760s and 70s.[2] And so too are the proto-nationalists of Rossini's *L'italiana in Algeri* (1813), a work which seems to adhere yet more firmly to the convention, even as it mischievously reverses the usual sex of the rescuer. Though Byron's Turkish lovers in *The Bride of Abydos* (1813) may appear to violate the rule, neither of them escapes the harem alive. As in *The Giaour* (1813), whose Circassian heroine similarly perishes in her attempt to join the unbelieving hero, Byron plots the romance of loss rather than the triumph of the couple.

In some fictions a woman who successfully flees the harem does come from the Orient, but convention usually requires that she be thoroughly Westernized before she is united with her lover. The veil has no sooner managed to fall from the eponymous heroine in James Morier's popular novel *Ayesha* (1834) than the English hero is planning to possess "this gem of human perfection, improve its lustre, efface any flaws which it might contain, and polish it so effectually that he might produce it as something unequalled in the estimation of his own countrymen." Though Ayesha "appeared so alive to any words of instruction which casually fell from

[him] . . . and seemed to cling to him as an oracle . . . who would dissipate that mist of ignorance in which she seemed aware that she had hitherto lived," Osmond's powers as an instructor are somewhat compromised by the last-minute discovery that she is not really a Turk after all but the kidnapped daughter of an English aristocrat, who has retained from infancy her instincts as a Christian.[3] In *The Turkish Slave: or, the Mahometan and His Harem* (1850), Lieutenant Murray goes so far as to make his heroine the real daughter of the sultan, but since she falls in love with her father's Greek slave when they are both still children, her future husband has a long time in which to instruct her in his own religion and "the respect in which her sex was held by Christian nations," before he escapes to freedom, discovers that he is really the long-lost heir to the throne of Greece, and returns to negotiate for her hand in marriage.[4]

Despite the automatic recourse of his erotic imagination to confinement and compulsion, even the marquis de Sade arranged a faithful couple's escape from the *sérail*. Indeed, *Aline et Valcour* (1795) represents the Western idea of such lovers as both a motive and a method for fleeing the harem. Before being reunited with her beloved Sainville, the long-suffering Léonore endures a series of assaults on her chastity and hair-breadth escapes that includes periods of captivity in two different African harems. She manages to flee the first of these with the aid of a loyal male friend and a guard whom he has suborned, but in the second she relies primarily on her own wits to preserve herself unviolated for her husband. This is the harem of Ben Mâacoro, the cannibal king whose appetite for women, we are told, is exceeded only by his particular taste for white ones. Léonore has scarcely arrived at his *sérail* before she watches with disgust as he attacks her fellow captive, a beautiful Spaniard named Clémentine, in a scene that barely distinguishes the act of rape from the cannibalism he also practices. In the eyes of the horrified onlooker, Clémentine appears "a pitiful lamb in the claws of a tiger in a rage"; but she is also, significantly, a woman "born to the class of courtesans," who has already made clear to her friend that she would far rather serve "the pleasures of this monster" than as a dish for his table. Léonore, of course, has responded that she would rather die than thus betray the one she loves, and when Ben Mâacoro accosts her in turn, she manages to confound the would-be rapist with familiar lessons in the superiority of European love-making. "Tyrant," she exclaims, "you little know my country, if you imagine that women born there can find themselves happy in the caresses of a monster like you." By contrasting his brutal methods with courtship in her own country, she succeeds in persuading him that only patient wooing yields the

rewards of true love and that he has yet to taste the superior pleasures of the soul. Later, she contrives to spare Clémentine any further outrages by insisting that the master of the harem reserve his heart for one woman alone. When Ben Mâacoro accedes to this demand as well, even that libertine Spanish woman is compelled to acknowledge the "empire" of French delicacy, and to admit that "there is no man whom a woman cannot captivate by the art of expediently resisting him."[5]

Unlike some of her predecessors in this line of argument, however, Ben Mâacoro's "fière esclave" has no intention of satisfying the amorous passions of her master. Converting the cannibal king to monogamy is not a prelude to marrying him but a ruse to preserve her own monogamous union with Sainville. Yet even as the will of this heroine consistently opposes the harem, she manages to preserve the fiction of the couple with a typically Sadean offer to violate it. Agreeing at last to satisfy Mâacoro's desires, she invites him to a rendezvous where he may enjoy both herself and Clémentine simultaneously. As she rather superfluously proposes to this man who rules a harem of two thousand, "O great emperor! you will see of what powerful effect is a second woman in the singular pleasures I have promised you!" The invitation is, of course, a stratagem by which to effect the two friends' escape, and a scene which begins with one woman seductively displayed on the parapet "so as to excite [his] desires, while the other will satisfy them" quickly ends with both women leaping over the wall and successfully fleeing the country.[6]

Léonore escapes the harem by her own efforts, as she does virtually all the menaces to life and honor that constitute the three-year history of her adventures. But even as she acts alone, she is emphatically part of a couple — and not merely in the incredible persistence of her loyalty. As in so many such fictions, the lovers are in fact fellow captives, though by keeping them ignorant of one another's presence in the *sérail*, Sade manages not only to heighten the thrills of the episode but to narrate it twice, giving both his and her perspectives on the adventure. Since Sainville's function in the harem is to inspect the virginity and other physical attributes of the latest arrivals, who appear before him heavily veiled and with bandaged eyes, the episode also offers a non-recognition scene whose erotic frissons are countered only by its potential for comedy. Every bit as implausibly faithful as Léonore, Sainville remains coolly indifferent to his new occupation, until circumstances permit him to feel both excited and disturbed by his unwitting examination of the very body he has been seeking. Though he thus manages unknowingly to hand over his own wife to the brutal king, she herself proves more resourceful; and they finally return

to France to enjoy both their marriage and a fortune.

Whether the fantastic persistence of this couple's devotion to one another should be understood as an exemplary instance of marital fidelity or as just another obsession in the Sadean catalogue is far from obvious, however. The novel does not reunite the lovers until Léonore has participated in a last, farcical adventure, a genially *Tom Jones*-like business of crossed purposes and wrong beds at an inn; and though once again she just manages to preserve her own chastity, the inadvertent sexual union of another couple prompts an extended disquisition on the arbitrariness of female honor and the absurdity of men's obsession with it. Real love, it is suggested, should rather encourage the other's sexual opportunities than discourage them — a principle which would seem to cast a certain questionable light over Léonore and Sainville's three-year exercise in sublimation. Nor does Sade suggest that the harem has any monopoly on the licentiousness that opposes the couple. For all the crude racism in the fantasy of the African cannibal with his taste for white women, Ben Mâacoro comes to seem positively mild-mannered by comparison with the Grand Inquisitor. And that is not to mention all the other Europeans whose lusts Léonore just manages to elude in the course of her journey, from the Venetian libertine who first spirits her away to the French brigand who nearly succeeds in raping her on her return through the Pyrénées. As she observes of the French consul in Tripoli who liberates her from the Barbary pirates in order to take her for himself:

> I soon recognized . . . that if I had changed masters, if from the sérail of a Turk which I had been on the verge of entering I had passed into the house of a Frenchman, it would not be on a very different footing, and that in general, in whatever hands a woman of my age happened to fall, there were always pretty much the same risks.[7]

There is very little chance that either the young Rossini or his librettist, Angelo Anelli, had encountered Sade's novel when they composed their *Italiana in Algeri*, but the aria in which Isabella works up her courage on the way to the harem by reminding herself of how all men are alike, more or less, might serve as a cheerful gloss on Léonore's adventures.[8] "Son tutti simili / A presso a poco," she sings, as she reassures herself that she already knows from experience how to handle them.[9] As in *Aline et Valcour*, the heroine's lover has preceded her into captivity, though unlike Léonore, Isabella does not long remain ignorant of her beloved's presence in the harem. Though the opera affords its couple a rather more orthodox

recognition scene than does the novel, Isabella's delighted discovery of Lindoro hardly alters the assumption that coping with the harem is work for a woman. Like Léonore, Isabella is the wily strategist of the pair, a resourceful heroine who exploits her knowledge of men to trick and elude her would-be master; and like Léonore, she partly effects her escape by pretending to imitate Roxelane. Even before she issues her instructions, however, Rossini's imaginary harem is well on its way to Western domesticity.

L'italiana begins with yet another bored despot, as Mustafà, the Bey of Algiers, registers his weariness with his current wife, Elvira, and expresses his wish for an Italian girl to liven up the harem. Determined to repudiate his wife and marry her off to Lindoro, he orders her Italian replacement from the local pirates, though like the similarly named Elmire in the several redactions of the Soliman story, Elvira continues to love her rejecting master. In a variation on the praise of inconstancy sung by the beautiful slavewoman in Soliman's harem, all those on stage join Mustafà himself in singing of how his heart flits from one desire to another. But while he too complains briefly that, with all their caresses, not one of his slaves pleases him, only Isabella ever figures as a serious rival to Elvira: none of Mustafà's other women has any individualized role in the opera. Though his harem twice appears on the stage collectively, Rossini's Bey seems more like a straying husband with easy access to divorce than like the despotic master of a seraglio. Indeed, the rivals for Isabella's favor effectively outnumber the competition for Mustafà, since the active contenders in her case include not only the Bey and Lindoro but also Taddeo, the infatuated suitor who has followed her to Algiers.

When Isabella delivers Roxelane-like lessons on the right way to love, then, she is not so much reforming a harem as restoring a marriage. Rather than welcome the Bey's plans for ridding himself of his first wife, the *italiana* announces that she intends to change such "barbarous" customs and insists his "sposa" remain. The new arrival gets her way, of course, by obliquely holding out the promise that she herself will be the reward of his obedience, but from the moment Mustafà haplessly acquiesces in her demand, the entire seraglio agrees, she has made an "ass" of him (1.4) — which is to say, according to the logic of the comedy, that she will end by making him "a good husband" (2.1). In a scene that clearly recalls the similar episode in the career of Roxelane, Isabella invites the Bey to coffee and then arranges for his wife to join the party, having first offered the latter some friendly advice on how to resemble an *italiana*. "Don't act like a sheep," Isabella instructs Elvira, "for if you do the wolf will eat you up.

In my country it's the wives who whip our husbands into shape." When Mustafà later protests his wife's presence at the assignation, Isabella tries to coax him into attitudes more becoming a proper husband, as her sweetly domestic admonitions — "Colla sposa sia gentile" [Be nice to your wife] and "È sì cara!" [She's so dear!] — replace the business of the switched handkerchiefs in the *sérail* of the sultan (2.2). In Roxelane's case, such promotion of her rivals was at once a form of coy resistance and evidence of high-mindedness, but between Isabella's comic revulsion when she first catches sight of Mustafà — "Oh! che muso, che figura!" [Oh! what a mug, what a figure!] — and her ecstatic encounter with Lindoro, the audience has no reason to doubt her sincerity (1.4). Whatever she has inherited from her predecessor, it is obviously not the wish to marry the master herself. Though even the dim-witted Bey proves canny enough to recognize that he is being manipulated, only two more scenes will elapse before she has transformed this petty tyrant into the most dutifully complaisant of spouses.

The final ruse by which the lovers manage both to flee the harem and restore the marriage owes more to the comedy of *Le Bourgeois Gentilhomme* (1670), however, than to the fictive histories of Süleyman. In a mock ritual that clearly recalls the "Turkish" ceremony by which Molière's would-be gentleman is tricked into fancying himself an honorary "Mamamouchi," Isabella arranges for the assembled Italian slaves to award Mustafà the pseudo-rank of "Pappataci." The honor accorded M. Jourdan is so much mumbo jumbo — both the word and the office of "Mamamouchi" are wholly Molière's invention[10] — but "Pappataci" is nonsense that signifies, being good Italian for a cuckold (literally, "take your food and shut up"). Solemnly explaining that the title is bestowed on a man who never loses his temper with the fair sex, and that the principal duties of the office are eating, drinking, and sleeping, Lindoro and Taddeo prepare the Bey for an induction ceremony in which he is officially enrolled in the ranks of complaisant husbands. Accompanied by the sound of horns, which "in our rites," as the chorus pointedly sings, "are preferred to the drums," Mustafà swears "to see and not see. . . to hear and not hear," and "to let people do and say what they like" — a commitment that is immediately tested as the dutiful "Pappataci" eats and drinks while Isabella and Lindoro first embrace before his eyes and then, together with the other enslaved Italians, head for their ship. Though at the last minute the Bey realizes he has been duped, the flight of his *italiana* teaches him the lesson that duly returns him to his *sposa*. Mustafà begs pardon from Elvira, and the opera closes as the chorus celebrates the powers of a woman to do what she likes (2.4).

L'italiana also famously closes with a rousing call to patriotism — a nationalist fervor rather crudely worked up at the expense of the Muslims. Isabella fires Lindoro's courage by exhorting him to "think of our fatherland," the orchestra briefly launches into the *Marseillaise,* and the assembled Italians repeatedly boast of how much stuff they can show when put to the test ("Quanto vaglian gl'Italiani / Al cimento si vedrà"), as they demonstrate their cleverness and valor by leaving behind not only the duped Mustafà but an entire collection of drunken subordinates — alcohol having been put to its conventional uses in such imaginary escapes from the seraglio. For all the celebrated charm of Rossini's opera, there is no question that its libretto cheerfully exploits some vulgar stereotypes of the Orient. Yet the farcical plot of *L'italiana* has finally more to do with the war of the sexes than with the conflict of East and West, and Isabella triumphs over men still more thoroughly than she does over Muslims. The fact that the final trick turns against her foolish Italian suitor as well as her Oriental master only reinforces the point: though Taddeo has enjoyed the joke on Mustafà, he has not recognized the identity of Lindoro, nor anticipated that the lovers will take advantage of the "Pappataci's" vow of blindness to escape the harem together. Even as the gullible Mustafà has sworn that he will henceforth play "lampione" — literally, a lamppost, but figuratively, one who watches, willingly or not, two lovers in action — so Taddeo recognizes that this will be his role too if he returns to Italy ("Se parto, il lampione"). Like the Eastern fool, the Western one haplessly acquiesces in his fate: "Gabbati, burlati / Noi siamo, o signor" [We've both been swindled, made to look like fools, my lord], he protests to the Bey, as he desperately scrambles to catch the parting ship (2.4).

With Taddeo the odd man out, *L'italiana* neatly sorts its principals once more into couples. But Isabella is a sexually knowing contralto rather than an innocent soprano, and the lesson she delivers has more to do with the power of a woman than with the superiority of true love to the customs of the harem. "Qua le femmine son nate / Solamente per soffrir" [Here women are born only to suffer], the eunuchs sing in the opening chorus, but by the close of the opera she has demonstrated that there need be no such place, since men all the world over "son tutti simili." Without quite suggesting that Lindoro himself is on his way to be cuckolded, the opera makes quite clear that the function of a good Italian husband, like that of an Algerian bey, is to see and say nothing. The rank of "Pappataci" may be imaginary, after all, but the anxiety about which it jokes would have been all too familiar to contemporary audiences. As Byron ruefully remarked of Italian marital arrangements in 1819, when he found

himself half-willingly playing *cavaliere servente* to Teresa Guiccioli: "I like women — God he knows — but the more their system here developes upon me — the worse it seems — after Turkey too — here the *polygamy* is all on the female side."[11] Like other sophisticated fictions, Rossini's opera acknowledges that the difference between inside and outside the harem is not nearly as great as it pretends.

Part Five
Rivalry, Community, Domesticity

16

Plotting Jealousy from Racine to the Victorians

The plot of the harem, as the West likes to tell it, is driven by jealousy. Jealousy builds the place and jealousy populates it: locking rivals of one sex out, the harem locks rivals of the other sex in, the very intensity of their struggle heightened by the fact of their collective confinement. Though European travelers routinely attested to the jealousies of Eastern men, most stories of the harem focus on the rivalry of the women. If the locks hold, after all, the jealousy of the master has no story. Only when the seclusion of the harem is breached does the jealous male become an active agent in the plot, his fury aroused just long enough, usually, to effect the swift execution of the offending party.

As always, rumors about the Grand Seraglio helped to color other fictions of the harem: reports of strangulation by mutes and of trap-doors through which a body might be instantly dispatched to the Bosphorus contributed to the impression that masculine jealousy in the East operated swiftly and silently.[1] She who "sleeps beneath the wave" in Byron's *Giaour* (1813) appears to have been the victim of such quietly efficient passion (675), though her outraged master does not rest until he has been slaughtered in turn.[2] In *Don Juan* (1819–24) the poet approaches the same *topos* with characteristic flippancy, as he conjures up a story that is almost over before it happens:

> If now and then there happen'd a slight slip,
> Little was heard of criminal or crime;
> The story scarcely pass'd a single lip —
> The sack and sea had settled all in time. (5. 149)

Whereas the plot of male jealousy always threatens to end too soon, however, the plot of female jealousy promises to continue so long as the harem exists, or the West can imagine it. And in harems of the mind, as we shall see, the anxieties of one sex were not always very far from the anxieties of the other. Even when there was no story, Europeans could find reasons for identifying uneasy passions of many kinds with the arrangements of the harem.

Racine took the harem as his theater of jealousy. Recall the terms in which his second preface to *Bajazet* defended his representation of amorous passion in the *sérail*: "Is there any court in the world where jealousy and love should be so well known as in a place where so many rivals are closed up together, and where all these women have no other object of study, in an eternal idleness, than to learn to please and to make themselves loved?"[3] In practice, of course, the relentless pacing of Racinian tragedy leaves no margin for the depiction of "eternal idleness," and the play turns aside from these "many rivals . . . closed up together" to concentrate rigorously on a single pair: it is the heightened pressure of erotic obsession and jealousy that *Bajazet* identifies with the harem, not its multitudes of idle inhabitants. Strictly speaking, in fact, private desire rather than official position generates the rivalry in this harem, since Roxane and Atalide compete not for the favor of the sultan but for the love of his younger brother, Bajazet. In this sense, the passions of *Bajazet* are not so distant from those of *Phèdre* (1677), whose heroine likewise succumbs to "jealous rage" at her fourth-act discovery of Hippolyte's love for Aricie.[4] But if Racine hardly requires the harem in order to imagine female rivalry, only in *Bajazet* does such rivalry so saturate the atmosphere. The words "rivale" and "jaloux" echo through the tragedy, as Atalide's "mille soins jaloux" conspire with Roxane's "soupçons jaloux" to determine the action (2.5, 377; 379). From the moment at which Roxane unwittingly employs Atalide to woo Bajazet in her stead, the rivals ironically speak with one voice, as they join forces in a relentless sequence of destruction. Roxane's discovery of Bajazet's pledge of love to Atalide may precipitate the order to kill him, but as Atalide herself later argues, it was her own "fatal blindness" and "perfidious jealousy" that prompted the pledge in the first place (4.1, 391). One rival issued the order of execution; the other, by her own account, wove the fatal cords in whose "hateful knots" he strangled (5.12, 411).

And even as the jealousy of the two women drives the action, another jealousy, off stage, constantly shadows it. Roxane has initially engaged Atalide as her surrogate, after all, in order to screen her desire for Bajazet from the "jaloux regards" of the *sérail* — a formula that does not distin-

guish between the prying eyes of her rivals and those of her guards, whose jealousy officially substitutes for that of the absent sultan. Like the preface's allusion to "tant de rivales . . . enfermées ensemble," Osmin's figurative identification of those jealous looks with the walls of the *sérail* ("tant de jaloux regards . . . semblement mettre entre eux d'invincible remparts" — 1.1, 361) implicitly associates the jealousy within the harem with the jealousy that constructs it. While Racine's tragedy focuses on the conflict of the women, there is of course a second triangle in *Bajazet*, at whose apex stands the figure of the sultan's favorite. Indeed, by basing this second erotic triangle on the struggle between the absent sultan and his brother, Racine deliberately compounds an already existing rivalry, since Amurat has long had reason to fear the prince as a contender for the throne. When Bajazet himself alludes to the "jaloux sultan" (2.5, 378), he apparently has this anxiety about power rather than the favorite in mind. Yet Roxane's offer to the prince includes herself as well as the throne, and by the final scene of the play, rumors of their potential treachery have apparently reached the absent ruler. She alone survives long enough to be executed by Amurat's agent, but had her own jealousy not anticipated his, brother and favorite would have died together on the order of the sultan.

Few harems of the mind are constructed as tightly as Racine's, but the very compactness of his language and plot help to make clear how deeply the jealousies of both sexes were associated with the place, and how many kinds of rivalrous relation might thus be imaginatively confounded. Fratricidal struggles for the Ottoman throne had no immediate connection, in fact, to such sexual jealousies as Racine represented: the women of the royal harem did compete, sometimes murderously, for power and influence, but they were more apt to do so as mothers of future sultans than as consorts of the present one.[5] While Racine based the execution of Bajazet on contemporary reports, the passionate rivalry of his heroines appears to have been his own invention.[6] Nor did the masculine jealousy that confined women and veiled them have any necessary relation to the female rivalries of a polygamous household, though some political theorists, as we shall see, did try to argue that one form of anxiety engendered the other. But the "Land of Jealousy," as Pope called it, was a place whose passionate excesses were long overdetermined in the European imagination.[7]

When Pope conjured up that place in a flirtatious letter to Lady Mary, it was a fantastic projection of his own sex's insecurity that he amused himself by imagining. For Victor Hugo, over a century later, the jealousies of the East were associated instead with female competition in the *sérail*: "Ah! jalouse entre les jalouses!" an imaginary sultan exclaims in *Les*

Orientales (1829), as he pleads in vain with his favorite "sultane" to spare the lives of her rivals.[8] Others, like Racine, identified the jealousy of both sexes with the arrangements of the harem. Chardin, who characteristically insisted that the passion was even stronger in Persia than in neighboring countries, invoked the "furieuse jalousie" of the men to explain not only the exceptional height of their harem walls but the practice of sometimes doubling and tripling them. The jealousy of Persian men went farther yet, Chardin reported: in burying a woman they pitched a tent around the grave, lest witnesses glimpse the shrouded body as it descended. Later, he again cited "the jealousy that men feel toward women, in the Orient," to account for "this cruel and unnatural invention of making eunuchs." Elsewhere, however, Chardin elaborated at some length on the jealous passions of the women within the *sérail* — passions fomented both by their desire for one another, in his telling, and by their competition for the favor of the king.[9]

Indeed, the origin of all these "hatreds" and "treacheries" apparently signifies less than their consequences, since harem jealousies of one sort or another generate a narrative sequence whose inevitable close is torture and death:

> These jealousies produce the most cruel effects in the world; because the king, who finds, among all these perfidious women, neither love nor sincere attachment, debases one group, changing these favorites into slaves who are sent to serve in the lowest posts and in remote quarters of the sérail: he has the others flogged with blows of the rod or of the staff; he has them killed; he even has some burned and others buried wholly alive.

The king may punish his women and kill them, but the root of his disaffection, as Chardin tells it, is the perfidiousness of the women themselves. Even the arbitrary impulses of the master's own desire appear to have their origins in the malign activity of his women. After describing the "witchcraft" by which the inhabitants of the harem reputedly punish their rivals or draw favor to themselves, Chardin blandly concludes: "It is certain that in many sérails the master, during some periods, finds himself as if bewitched by love for a slave who is black or deformed, in the midst of several admirably beautiful ones." The jealousy of one sex may explain the architecture of the harem, but the jealousies of the other drive its plot.[10]

The thrill of such a plot was intensified by the imagination of violence — an imagination that could operate all the more freely because the harem

itself was impenetrable. Like the imperial punishments meted out in Chardin's Persian *sérail*, rumors of strangulation and poisoning at the Ottoman court could be readily confounded with quotidian bickering in ordinary households. Not every such narrative, of course, proceeded inexorably to the torture and death of the participants. For some story-tellers, the threat of violence sufficed to enliven a comic treatment of jealousy. In Aaron Hill's tale of the English sailor eagerly set upon by the Turkish harem, a quarrel that erupts over the nightly rotation of his favors ends in farce rather than tragedy. "Words were multiplied to noisy Disputations, and *from thence* they fell to downright Blows about the matter"; but their lover succeeds in escaping the eunuch who has been summoned by the disturbance, while the "Ingenious *Ladies*" manage to salvage "their *Reputations*, and perhaps their *Lives*" by producing "an Amazing Story" of having been frightened by an intruder. Elsewhere, Hill suggests that the "thousand Jealousies" of the harem make the domestic life of the sultan himself rather less than enviable: "the Quarrels of his Women so distract his Temper" that he often escapes "in *Hunting* or some other Pastime" in order to avoid adjudicating them.[11]

Several decades after Hill's *Present State of the Ottoman Empire*, a Frenchman who had already published some "Turkish" imitations of Montesquieu's *Lettres persanes* produced a brief comedy about harem rivalry for the amusement of the sultan's ambassador. If Pouillan de Saint-Foix himself is to be believed, the ambassador was so delighted with the play that he requested a copy, and the ambassador's son began to exercise his new-found skill with French by translating it into Turkish. This was, so far as the author knew, a singular honor; and in his preface to the published text, he happily speculated on the possibility that his little piece had already been performed several times in the "Serrail" of the Grand Turk himself. But despite his claim to have produced "une Comédie qui fût absolument dans les moeurs Turques," Saint-Foix's play was more likely to have entertained the sultan by its imaginative distance from the harem than by its sociological accuracy.[12]

Les Veuves turques (1742; pub. 1748) turns on the efforts of a Turkish widow to persuade her new lover to marry her former co-wife as well, so that she can continue to enjoy the pleasure of rivalry. In the first marriage, Fatime explains, she was compelled to suffer as the other reveled in the position of their late husband's favorite; now she refuses to be content unless she can see Zaïde in her turn humiliated. "I intend that she should again become my rival," Fatime announces to the startled Osmin, "to pay back to her with a new husband all the troubles that she made me endure

with Assan." When Osmin responds with a bewildered allusion to the pleasure of monogamy — "What, Madame, when you can enjoy the tenderness of a husband who will adore you?" — Fatime counters with the "double pleasure" she will obtain from the vexations and griefs of her counterpart. Female rivalry, she goes on to suggest, is at once a way of compounding the satisfactions of marriage and of compensating for the notable frustrations of the harem. While men "have a thousand resources to escape ennui," those confined to the harem must make do with rivalry:

> Hatred of a rival sustains love for a husband; this hatred, like tenderness, has its motions, its intrigues, its sweetnesses. At the least reverse of an enemy, one represents, one exaggerates to oneself her difficulty; one sustains oneself on her anxieties; one strives to augment them; one speaks about them; one laughs about them; this amuses; the days pass insensibly; the spirit occupied by the quarrels of the sérail is less sensible of the constraint of living there, and finally accustoms itself, little by little, to run no more after the vain chimeras of independence and liberty.[13]

Once male jealousy has locked women into the harem, only female jealousy, by this account, can serve to animate it — sustaining at once the women's love for their husband and the vitality of the women themselves. Nothing so dispels the ennui of the harem, in other words, as a little rivalry among its inhabitants.

Whether many women would actually have shared Fatime's preference for continued battle may well be doubted. But Saint-Foix's heroine surely does speak for the imaginative needs of the writer, who looks to the "motions" of rivalry to provide his harem with a plot. Though his own play finally derives most of its energy from the intrigues of the go-between who arranges the double marriage, rather than from the direct conflicts of the "aimables rivales,"[14] Saint-Foix's witty synopsis helps to make clear why so many writers resort to tales of jealousy and intrigue in the harem to enliven their accounts.

Not every writer wanted to tell stories, however. Though most representations of jealousy in the harem took dramatic or narrative form, some Enlightenment thinkers chose to approach the subject more abstractly, as they contemplated the destructive passions of a hypothetical "seraglio." Both David Hume's brief essay "Of Polygamy and Divorces" (1742) and Adam Smith's more extended treatment of the question in his *Lectures on Jurisprudence* (1762–63) present themselves as dispassionate investigations

into the comparative merits of human marital arrangements, though both also clearly intend to demonstrate the superior virtue of Western, and even Scottish, monogamy. "It is mere superstition," Hume announces at the outset, "to imagine, that marriage can be entirely uniform, and will admit only of one mode or form." But if he is ready to concede that "the laws may allow of polygamy, as among the *Eastern* nations," he can scarcely contemplate the possibility before his calm assessment of "advantages and disadvantages" has turned to vehement denunciation of "ASIATIC manners."[15] Like Smith after him, Hume automatically identifies the practice of marrying many women with the practice of secluding them: while neither actually speaks of the harem, both take for granted that polygamy belongs in a "seraglio." And both set out to demonstrate that such a place must be altogether dominated by the passion of jealousy.

The jealousies of the "seraglio," in fact, provide the one argument in favor of polygamy that Hume considers — that men can only retain domestic power by following the maxim, "*to divide and to govern.*" Were it not for man's capacity to exploit the rivalries of multiple partners, say some imaginary "advocates for polygamy," his own desire for the other sex would inevitably enslave him. As Hume sums up their reasoning: "Man, like a weak sovereign, being unable to support himself against the wiles and intrigues of his subjects, must play one faction against another, and become absolute by the mutual jealousy of the females."[16] Though Hume only hypothesizes these "advocates for polygamy," he might well have been recalling some apposite remarks of the chief eunuch in Montesquieu's *Lettres persanes* (1721). "The more women we have under our surveillance," the eunuch observes, "the less trouble they give us. A greater need to please, less capacity to unite, more examples of submission: all this forms their chains. Some ceaselessly spy on the proceedings of the others; it seems as if, in concert with us, they work to render themselves more dependent; they do part of our work for us, and open our eyes when we close them" (xcvi. 199). The more women, by this account, the more rivals to betray one another, and the more power accrues to the master.

Hume never explicitly dismisses this theory as unworkable, though he might have remembered that no system of mutual spying prevents rebellion from breaking out in the imaginary *sérail* of the *Lettres persanes*. But like Montesquieu before him, he does argue that such domestic authority proves devastating for the master. Just as Usbek complains that his *sérail* has destroyed love and left him only the torment of "une jalousie secrète" (vi. 18), so Hume contends that in the tyranny of such a household "the *lover*, is totally annihilated," while "the *husband* is as little a gainer,

having found the admirable secret of extinguishing every part of love, except its jealousy."[17] Not only does this jealousy poison a man's relations with the other sex, in Hume's telling, but it destroys his bonds with his own. Here, too, the essay perhaps elaborates on a hint from the *Lettres*: according to Usbek, friendship is "almost unknown" in Asiatic countries, since "men retire into their houses . . . and each family is, so to speak, isolated" (xxxiv. 74). It is Hume, however, who specifically attributes this purported state of affairs to jealousy:

> the ASIATIC manners are as destructive to friendship as to love. Jealousy excludes men from all intimacies and familiarities with each other. No one dares bring his friend to his house or table, lest he bring a lover to his numerous wives. Hence all over the east, each family is as much separate from another, as if they were so many distinct kingdoms.[18]

Hume's seraglio is, so to speak, all harem; no separate quarters have apparently been provided for the social life of the men. Though many travelers, then and since, have remarked the masculine conviviality of the Middle East,[19] these households have been wholly constructed by the imagination of jealousy.

Having thus demonstrated that the owner of a "seraglio" can obtain no possible pleasure from the establishment, Hume turns with like insistence to the other inhabitants. If the discussion began by hypothesizing how the women's own jealousies might serve to keep them in check, it now returns to the constraint that they suffer from the jealousy of their master. By this point Hume scarcely troubles to disguise the polemical thrust of the argument: "To render polygamy more odious," as he says, "I need not recount the frightful effects of jealousy, and the constraint in which it holds the fair-sex all over the east." In fact, the only example he offers seems more comic than terrifying — an anecdote freely adapted from Tournefort's *Voyage du Levant* (1717), in which the French physician told how he was called to attend some women in the Grand Seraglio, only to discover that he could examine nothing but "a great number of naked arms."[20] But if Tournefort's medical report proves somewhat anticlimactic, the essay's representations of the seraglio have nonetheless served their purpose. "Having rejected polygamy, and matched one man with one woman," as Hume puts it — almost as if he were in fact writing a novel — he can now turn his attention to the problem of "divorces." And only once he has done so, apparently, can he acknowledge the attraction of the model he has

repudiated. "If the public interest will not allow us to enjoy in polygamy that *variety*, which is so agreeable in love," he imagines the advocates of divorce wistfully pleading, "at least, deprive us not of that liberty" to escape an unhappy marriage to one.[21]

Adam Smith's *Lectures on Jurisprudence* have more to say about political and legal arrangements than about the passions of domestic life, but they too seek to demonstrate the superiority of British monogamy by focusing their attention on the jealousies of the "seraglio." Just as Hume moves automatically from the mutual jealousies within the household to the isolating jealousy of its master, so Smith begins by pronouncing it "evident" that the women of the family "must look upon one another with the greatest jealousy," only to attribute the same passion — and the same misery — to the man who possesses them. If "the condition of the female part of these families is then without question most wretched, and exposed to the greatest envy, malice, hatred, and disorder, confusion, etc., etc., etc., etc., etc. imaginable," as the lecturer (or his note-taker) wearily sums up the picture, then "we will find that that of the male part is not much more desirable.... He can ... have but very little conjugall affection, but a greater share of jealousy than any other man has." Again, the only example offered in support of this claim proves to be the familiar anecdote of Tournefort's baffled medical attendance in the harem — only this time transferred to the household of a "great man" in Ispahan.[22]

Despite its obvious debt to "Of Polygamy and Divorces," however, the lecture added its own weight to this Enlightenment construction of the harem. While Hume evoked the jealousies of its inhabitants primarily to consider how a man might exploit them, Smith returns repeatedly to the imagined conflicts among the women themselves — describing how "continuall discord and enmity, the naturall consequences of rivallship, must prevail amongst them," for example, or asserting that "the jealousy of love and that of interest both conspire to raise the discord, enmity, confusion, and disorder of such a family to the highest pitch." Far from suggesting that women's mutual spying might serve to keep them in check, Smith argues that only "severity and hard usage" can account for the "apparent tranquillity" that reportedly obtains in the seraglios of the great. And while Hume never ventured to explain why polygamists should suffer more jealousy than other men, Smith locates the cause in their own consciousness of divided affection: the greater the numbers they possess, the more "they are sensible that ... the women can not have great reason to be faithfull to them." Indeed, one form of jealousy, Smith goes on to suggest, inexorably produces the other: the more unevenly the

polygamist's affections are bestowed, in this scenario, the more those he neglects have reason to be jealous — and the more grounds he has, in turn, to be jealous of them.[23] By this time, presumably, Smith is conjuring with an anxiety born of masculine honor rather than erotic love, since his imaginary polygamist has ceased to care for those who nonetheless excite his "jealousy." But here as elsewhere, the lecture works less to distinguish human miseries than to compound them — the more thoroughly, it would appear, to place them at a distance from the speaker.

Even the tyranny of the state, in Smith's telling, can be traced to the passion of "jealousy." Like Hume, Smith contends that every household in the East keeps anxiously to itself, each man fearing lest other men gain access to his women. But where "Of Polygamy and Divorces" merely conjured up the imagined loneliness of Eastern men, the *Lectures on Jurisprudence* manages to identify that loneliness with the origins of despotism. As Smith put its, "all the countries where polygamy is received are under the most despotic and arbitrary government," because men, jealously isolated in their seraglios, are "altogether incapacitated to enter into any associations or alliances to revenge themselves on their oppressors." Lacking any political institutions to interpose between themselves and the state, the men of the East, by this account, inevitably surrender to tyranny — their only reward, it would seem, the power to tyrannize over their own households in turn.[24]

How the "absolute and arbitrary authority" that Smith attributes to the master of the household nonetheless tolerates the "continuall discord" that prevails there, he does not say. But if it is not altogether clear how such a place would function in practice, what is clear is how this harem of the mind gathers unto itself all the characteristics of home and state that Smith wishes to reject — and how many functions "jealousy" serves in his relentless accounting. Like Hume, it should be said, he does not confine his assault to the culture of the East: though both men direct their most impassioned attacks at the practice of polygamy, both also seek to repudiate the custom of easy divorce they associate with the ancient Greeks and Romans. Just as Hume ended by announcing that "the exclusion of polygamy and divorces sufficiently recommends our present EUROPEAN practice with regard to marriage," so Smith affirms the benefits of marital law in Scotland only by representing the "inconveniencies" of every conceivable alternative. Despite his evocations of Oriental discord and despotism, it is less the East as such he aims to repudiate than the arrangements of the "seraglio" — a seraglio conceived as the utter negation of monogamous union. So intent is he on this end, in fact, that a certain wishfulness creeps

into his otherwise relentlessly hostile construction of Eastern difference. "In those countries one who keeps only one wife," he blandly remarks in passing, "has never the least suspicion of her nor the least jealousy."[25]

Such tranquilly monogamous households may have their own fictiveness, but it is not the sort that lends itself very well to narrative. Though one might think that the picaresque hero of James Morier's *Adventures of Hajji Baba, of Ispahan* (1824) keeps that tale sufficiently supplied with narratable incident, harems appear in Morier's popular fiction only to contribute their own store of conflict and treachery. From an early scene in which Hajji gains access to the women's tent of some Turcoman robbers, where the inhabitants are ignorantly quarreling over a turban, to a late episode in which he flees from a harem "amid the groans, the revilings, and the clapping of hands of the beings within it, who . . . looked more like maniacs than those fair creatures in paradise, promised by our Prophet," Morier's novel regularly associates the harem with acrimony and discord. In the last instance, admittedly, it is Hajji himself who is the object of the harem's collective anger, since he has deceived the woman of the house by marrying her under false pretenses. She is another Turkish widow — a solitary one in this case — but Morier makes sure to inform us that her first husband "scrupulously refrained from having more than one wife at a time, because from experience he knew that he could have no peace at home" if he exercised his right of "multiplying to himself his female companions."[26]

Hajji's most extended entanglement in the jealous plotting of the harem follows from his infatuation with a slavegirl named Zeenab. Zeenab belongs to the royal physician, who also possesses several other slaves and one jealous wife — herself a former slave in the royal harem, where she was once "the terror of all [her] rivals." Only when a new woman cast a spell and managed to get her ejected from the palace — so we later learn — did the erstwhile terror of the shah's harem settle for terrorizing the physician's. Life in the lesser harem consists of nothing but "intrigue and espionage." The wife is "so jealous, that there is no slave in her harem who does not excite her suspicions," while the slaves pass their days in "peevish disputes," the strife constantly renewed by the participants' shifting allegiances and enmities. Hajji is quickly enamored of the beautiful slave, and their brief affair proceeds far enough, we are meant to understand, that Zeenab later discovers she is pregnant. But in Morier's harems, rivalrous passions rather than amorous ones drive the plot. Jealousy enables the affair and jealousy ends it: just as the lovers' only assignation depends on Zeenab's being left behind through the

maneuvers of her rivals, while the others attend the funeral of a woman who has inevitably been poisoned by another rival in the royal harem, so the mistress returns to mistake the signs of Hajji's visit for an assignation with her husband, falls on Zeenab in a jealous rage, and punishes her own imagined rival with solitary confinement. Hajji fleetingly imagines going to the rescue of his beloved, but he quickly concludes that he would only have been "impaled . . . on the spot: and what good would that have done to Zeenab? She would have been even more cruelly treated than before, and the doctor's wife would not have been the less jealous."[27]

Harem rivalry, of course, was not merely a fiction. The deadly struggles for power in the Ottoman palace could be all too real, and so, the evidence suggests, were some jealous conflicts among women in ordinary households. It is no accident that the word for "co-wive" among the medieval Mamluks has its root in a verb meaning "to harm."[28] But the avidity with which Europeans recounted tales of harem intrigue, from backbiting to murder, cannot be explained simply as an attempt at ethnographic accuracy. For some masculine imaginations, the scenario of many women jealously competing for a single man appears to have constituted an irresistible fantasy — a fantasy whose *frissons* were no doubt intensified by the rumors of bloody violence associated with the imperial seraglio. To imagine a collection of women all ready to kill for oneself was to indulge in a dream obviously flattering to the dreamer. The sultan who pleads with his jealous "sultane" in Hugo's *Orientales*, for example, repeatedly evokes the murderous impulses she harbors toward her rivals, even as he emphasizes the desperate jealousy of the other beauties whose desire she shares. She is, after all, "jalouse entre les jalouses!" and the very extent of her violent ambition — she would not, it appears, leave a single other woman alive — bespeaks the strength of her passion. So too does her refusal to be satisfied by the hopeless envy of her rivals:

Ne suis-je pas à toi? qu'importe,
Quand sur toi mes bras sont fermés,
Que cent femmes qu'un feu transporte
Consument en vain à ma porte
Leur souffle en soupirs enflammés?*

Like these hundred women desperately consumed by a single flame, the implacable jealousy of the favorite only confirms the supreme importance of their object — the sultan in whose voice the poet here chooses to speak.[29]

* Am I not yours? What does it matter, when my arms close around you, that a hundred women, whom one flame transports, consume in vain at my door, their breath in blazing sighs?

While Hugo obviously luxuriates in this fantasy of jealous women, others seem to have been more eager to persuade themselves that owning a harem was not worth the trouble. *Hajji Baba*'s insistent plotting of harem rivalry seems most explicable as a defensive fantasy of this sort — a fantasy that depends, of course, on the attraction of the very idea it seeks to repudiate. Aaron Hill came close to making such motives explicit when he introduced his comments on female witchcraft in Turkey by remarking, "And now, since I am treating of the Lover's fond *Elyzium,* 'twill not be improper to observe, that those bewitching Joys are sometimes frustrated, and lessen'd very commonly, by the Jealousy or Malice of *some other Wife* . . . at the appearance of a Rival in her Lord's Affections." For Hill, who elsewhere reveled in the vision of numerous women all competing for one man's favors, it was evidently necessary to keep reminding himself that "*the Envy of the Women make[s] Mens Houses downright Bedlams.*"[30] Though the nineteenth-century novelist gives less evidence of openly indulging in erotic fantasy than the eighteenth-century travel writer, the very relentlessness of Morier's representations suggests that he also wanted to convince himself — or his readers — that a harem-full of women was a recipe for disaster.

Indeed, there is no reason to assume that Morier was actually tempted by a harem fantasy of his own in order to understand why a nineteenth-century British writer might have some stake in dismissing polygamous arrangements as unworkable. Women, too, could evoke the horrors of female jealousy in order to vindicate the superior domestic arrangements of Europe. Presumably it was not a secret desire to identify with the Egyptian viceroy or the Turkish sultan that prompted Emmeline Lott, for instance, to sum up her *Harem Life in Egypt and Constantinople* (1866) by pronouncing harems "the very hotbeds of every wicked quality, the seeds of which are already slumbering in the heart of woman." The "inmates" of the harem, according to Lott, "are surrounded by rivals," and "being always without any profitable or suitable occupation, jealousy, envy, asperity, hatred, an innate love of intrigue, a boundless desire to please, inflamed with sensual passion, must blaze up like flames." Especially in the wealthier harems, Lott reported, "many a Lucretia Borgia abides her time to turn to account her intuitive knowledge of poisons and acts of cruelty" — an allusion that says less for the author's cosmopolitanism than for her assumptions about Italians.[31]

Even a comparative feminist like Harriet Martineau seems to have been determined to see the harem as inevitably corrupted by female jealousy. Her view is all the more striking, in fact, because it appears to originate

in its opposite, a fleeting vision of the community's shared feelings and sympathies. As she was about to conclude the first of the two harem visits recounted in her *Eastern Life: Present and Past* (1848), Martineau discovered that a woman who had been observed mourning the death of a baby was not actually grieving for her own offspring, but for the child of another inmate in the harem. The fact struck her, she reported, as a "curious illustration of the feelings and manners of the place!" Yet no sooner had she transcribed this equivocal phrase than the glimpse of shared maternity shifted, with startling abruptness, into an evocation of jealous murder, while the Egyptian harem itself swiftly gave way to an English brothel:

> The children born in large hareems are extremely few: and they are usually idolized, and sometimes murdered. It is known that in the houses at home which morally most resemble these hareems (though little enough externally) when the rare event of the birth of a child happens, a passionate joy extends over the wretched household: —jars are quieted, drunkenness is moderated, and there is no self-denial which the poor creatures will not undergo during this gratification of their feminine instincts. They will nurse the child all night in illness, and pamper it all day with sweetmeats and toys; they will fight for the possession of it, and be almost heart-broken at its loss: and lose it they must; for the child always dies, — killed with kindness, even if born healthy. This natural outbreak of feminine instinct takes place in the too populous hareem, when a child is given to any one of the many who are longing for the gift: and if it dies naturally, it is mourned as we saw, through a wonderful conquest of personal jealousy by this general instinct. But when the jealousy is uppermost, — what happens then? — why, the strangling the innocent in its sleep, — or the letting it slip from the window into the river below, — or the mixing poison with its food; — the mother and the murderess, always rivals and now fiends, being shut up together for life.[32]

Prostitutes at least manage to kill their children with "kindness," but death in the harem proceeds inevitably from the passions of rivals. One way or another, it would seem, such children are fated to die—though Martineau did go on to speculate on the "hopeless miseries" awaiting those in the harem who happen to survive the poison and strangling.

In her second harem, at Damascus, it was not motherhood but sisterhood that immediately conjured up the specter of jealousy. Among "the seven wives of three gentlemen" collected here, Martineau reported, "three were sisters," or rather, as she corrected herself, "half-sisters; — children

of different mothers in the same hareem." For the visiting Englishwoman, this appears to have been another of those curious illustrations of harem life that could only yield one scene. "It is evident at a glance," as she put it, "what a tragedy lies under this; what the horrors of jealousy must be among sisters thus connected for life: — three of them between two husbands in the same house."[33] By Martineau's own arithmetic, one of these women had not married the same man as the others, but sisters in the harem were apparently destined for "the horrors of jealousy" whether or not they shared a husband. As in the previous harem, where she imagined the murderess and her rival "shut up together," the final horror is to be "thus connected for life." Shared households were hardly unknown among sisters in England, but by fantasizing those horrors and recoiling from them, Martineau evidently sought to distance herself from the very aspects of woman's life that she found most troubling at home. The sheer ease with which an Egyptian harem could give way in her mind to an English brothel suggests the continuous comparisons she was making, as does her apparently unconscious effort to find home-grown methods of child-murder less appalling than Eastern ones.

A painting by a minor French Orientalist, Fernand Cormon, gives visual form to some of these lurid imaginings. His *Jalousie au sérail* (1874) depicts the murderous glee of one member of the harem, as the eunuch who has apparently acted on her wishes bares the fatal wound of her victim (fig. 32). By representing both women — rather implausibly — as naked, and by arranging for the body of the murderess to coil with snaky lasciviousness as she clutches the divan, Cormon blatantly eroticizes his image of female rivalry: as in Hugo's *Orientales* earlier, the violence and sensuality of this fantastic harem are inseparable. While the pallor of the victim may partly be attributed to the condition of the corpse, Cormon also takes advantage of the occasion to provide the usual juxtaposition of harem races, as the tawny-colored killer exults over the bleeding body of the fair-skinned favorite. Underscoring one of the victim's breasts and soaking into the pillow below, that blood itself is largely a function of the medium: most written accounts of harem murder tend to favor poison and strangling, but the painter presumably settles for a method that will offer visible evidence of the killing. Despite the crude vividness of Cormon's image, he still counts on his title to name the motive for murder — an act which might otherwise pass, after all, as a deed of vengeance, or even, perhaps, of frustrated love. Jealousy as such, in other words, is primarily a matter for verbal rather than visual representation. And most accounts of jealousy in the harem — as of love — take the form of narrative.

Just how ready some Europeans were to imagine jealousy in the harem, and to tell stories about it, may be suggested by a bit of writing that once accompanied a picture we have already seen — a picture far removed, one might think, from the erotic violence of the French Orientalist. The work is Thomas Allom's *The Odalique, or Favorite of the Harem, Constantinople* also known simply as *The Favourite Odalique* (fig. 14); and despite the masculine preference conveyed by its title, no hint of female jealousy appears in the image itself. The principal figure, whose rich costume and central position presumably designate her as the favorite, calmly faces the viewer; two other women absorbedly peer through the lattices; a small slave or child holds out a flacon of perfume, and another small person, with her back to us, obscurely carries out some task. Apart from the vaguely solicitous gaze which accompanies the gesture of the perfume-bearer, the only evidence of the women's relations with one another is the way in which the favorite places her hand on the shoulder of the woman at the window, while the latter in turn rests her own hand on the arm of the favorite. These gestures may simply evoke a certain intimacy, or perhaps they are meant to convey the effort of one woman gently to restrain the glances of the other. Only that eagerness to peer through the lattices disrupts the elegant stasis of Allom's harem.

But when the chaplain of the British embassy at the Ottoman Porte set out to explain this image to his compatriots in a lavish travel book of 1838, he could not see these "female inmates of the seraglio" without plotting their deadly conflict. For the Reverend Robert Walsh, to identify an "Odalique" was at once to conjure up her rival. While the former is "a simple favourite," he explained, the "Asseki" has also given birth to a son; and between them, "a jealousy and a mortal animosity exist, which often cause frightful results." The "annals of the seraglio" are predictably "full of those tales of horror" — one of which, of course, he immediately proceeds to relate. By the close of Walsh's brief commentary, a "dominant Asseki," suffering "those pangs of jealousy so congenial to the place in which she lived," has taken advantage of the sultan's absence to arrange a fatal encounter with a bowstring; and Allom's stately odalisque — or her hallucinated equivalent — lies "dead at the feet of her rival."[34] While one imagination calmly opens the harem to view, another responds with a secret plan and an act of violence behind closed doors. Whatever other impulses drove the West to conjure up such rivalries, "those pangs of jealousy so congenial to the place" were also well adapted, evidently, to the desire for plotting.

17
Manley's Almyna *and Other Dreams of Sisterhood*

Europeans never tired of speculating on the jealousies of the harem. Yet even as they continued to see the place as inevitably riven by the conflicts of its women, some imaginations were prepared to conceive quite different visions of harem community. Harriet Martineau might recoil from the thought of sisters "thus connected for life," but the "domestic sisterhood" of the harem, as one twentieth-century writer called it, could also inspire more utopian fantasies.[1] That such fantasies inevitably prove harder to sustain than plots of jealousy did not prevent some wishful efforts to entertain them.

As early as 1706, the British playwright Delarivier Manley rewrote the tragedy of harem rivals as an heroic drama of sisterly devotion and sacrifice. Though the first English translation of Racine's great harem tragedy would not appear until a decade later, Manley was fluent in French, and her *Almyna: or, the Arabian Vow* bears some notable resemblance to its predecessor.[2] As in *Bajazet,* the principal triangle in Manley's play centers on the brother of the sultan; and as in *Bajazet,* one of its female participants struggles nobly, though unsuccessfully, to subdue her own desire in favor of her rival. But the most immediate inspiration of Manley's own harem drama was another and more recent literary text — the frame tale of the *Arabian Nights' Entertainments* (c.1706–21), as Antoine Galland's *Mille et une Nuits* (1704–17) was called by the anonymous translator who quickly rendered its first volumes into English. Western readers would have to wait another decade to learn how Scheherazade finally succeeded in curing the sultan Schahriar of his murderous rage against women, but the original account of his jealousy and her sacrifice had scarcely appeared in London before Manley seized the occasion to dramatize her own version of that history — thereby laying claim, in fact, to have produced

the very first in the long line of England's imaginative responses to these influential tales.[3]

Though Manley has moved the action from the "capital of the Indies"[4] to a yet more imaginary "Capital of Arabia," the *donnée* of *Almyna* otherwise follows that of the *Arabian Nights* very closely. Like Schahriar, Almanzor, "Sultan of the East," has responded to the discovery of his wife's adultery with a Moor by vowing to marry a new woman every evening and to have her strangled the next morning. This is the "Arabian vow" of the play's title, and when the first act opens, the grand vizier is lamenting his own role in the daily murder of the innocents. As in the *Arabian Nights*, the heroine of the piece is the vizier's older daughter, here called Almyna, who determines to marry the sultan herself and put an end to "this cruel ravage, of the fairest Lives."[5] But Manley complicates this fable with a second plot, in which loving sisterhood struggles to overcome the passions of rivalry. Whereas the *Arabian Nights* gives Scheherazade a sister, Dinarzade, primarily to serve as the nightly prompter of her tale-spinning, *Almyna* makes its heroine's sister, Zoradia, the rival of the heroine. While Almyna was away at Memphis, Zoradia succumbed to the secret wooing of the sultan's brother, Abdalla — only to find herself abruptly abandoned for Almyna when the latter returned in all her glory to the court. Despite her misery, however, Zoradia remains devoted to her sister. Just as *Almyna*'s principal action transforms Scheherazade herself into an inspired champion of female honor, who risks her life in "Attonement . . . for all the Sex" (3.29), the rival's subplot confirms that this harem of the mind has been constructed for the glory of its women.

Indeed, Manley rewrites Scheherazade's story as if she were determined to draw out the sexual politics of the original: emphasizing both the lethal misogyny of the sultan and the latent feminism of the heroine, she turns her play into an open battle over the spiritual equality of women. Like its source, *Almyna* traces the sultan's wholesale revulsion from the sex to the trauma of a double betrayal. Not only did he witness the late queen's amorous engagement with "a vile Moorish Slave," but his brother, the king of Tartary, anticipated that disappointment, when a sudden return to Samarcand disclosed his own "curst Adultress" (1.11).[6] After another encounter with the lecherous lady of a genie, the brothers in the *Arabian Nights* conclude that no woman is chaste and that "there is no wickedness equal to that of women."[7] But Manley at once Orientalizes that conviction and psychologizes it — allowing Almanzor to justify himself with the pseudo-doctrine that women have no souls, even as the language in which he elaborates that belief bespeaks the anxieties that underlie it. To

Abdalla's declaration that he wishes to marry Almyna, his brother responds with the first of several extended denunciations of the sex. Women are "nothing," the sultan insists:

> Form'd as our Prophet says, without a Soul . . .
> Their Shining out-side but a gawdy bait,
> To make us take the toyl from Nature to our selves,
> And do her drudgery, of propagation.
> Had she not produced those glittering Ills,
> We had like Trees and Plants, from Sun, and Earth:
> Our Common Parents rose; masculine, and wise.

With its dream of vegetable propagation, its evident yearning to be free both of "the Mother-vices" and the mother (1.9), this speech makes clear how closely man's hatred of woman is identified with the hatred of her body — a loathing of sexual reproduction that is at bottom, as Manley also knows, a fear of mortality itself. Women, according to Almanzor, are "Born to no other end, but propagation" (1.13), which is to say, as the dervish elsewhere explains, that they are "born to Dye" (1.2). Together with the ritual murders it justifies, the doctrine that women have no souls — as *Almyna* imagines it — becomes the sultan's way of confirming his own immortality.

More than female lives are at stake, then, when this Scheherazade chooses to sacrifice herself for her countrywomen. Though Manley makes her drama turn on a vulgar misconception of Muslim belief, she also represents an East that is itself significantly divided on the subject. The sultan may confidently announce that women are "Form'd as our Prophet says, without a Soul" (1.9), but the chief dervish implies that it is the imperial will rather than the Koranic text that demands this reading; and Almanzor's councilors, we later learn, have often tried to reason with him on the question. Almyna herself strikingly anticipates some modern efforts to rescue Islam from the misogyny of its interpreters,[8] when she implies that Almanzor has allowed his own sexual anxieties to pervert his understanding of Holy Writ: "Had not thy beautious, faulty Queen done Ill . . . / Woudst thou the Letter, e're have so expounded?/Revenge, and Jealousy, arrests the Text" (4.44). Though Almanzor has earlier dismissed a learned woman as a "Contradiction" in nature (1.10), the very fact that this woman can stand before the sultan and dispute the Koran with him makes a potent argument for her sex.

Like the first Scheherazade, in fact, this one is something of a prodigy:

just as her formidable predecessor has "successfully applied herself" to all the learned disciplines, from physic to poetry,[9] so "What ever *Greek* or *Roman* Eloquence, / *Egyptian* Learning and Philosophy can teach; / [Almyna] has, by Application, made her own" (1.10). Instead of devoting that prodigious learning to the varied invention of Scheherazade's tales, however, she merely follows up her lecture on the Koran with a brief catalogue of great women, from Semiramis to Cleopatra, whose achievements all serve to illustrate the same moral: "Had she not a Soul? And an exalted one?" (4.45). No doubt the constraints of genre help to determine this strategy: since Almyna's ability to talk her way to victory can only be granted a limited exhibition on stage, the dramatist must perforce find some alternative to the *Arabian Nights'* dilatory tale-spinning. But Manley also wants a heroine less concerned with delaying action than with taking it — which is only to say, perhaps, that in her revision of Scheherazade the imperatives of genre and of ideology coincide. Rather than a prolonged exercise in storytelling, what finally converts this sultan is a theatrical performance he himself stages with the collusion of the dramatist: a mock-execution scene designed, he later confesses to Almyna, "as a Tryal, / How far thy bravery of Soul cou'd reach." He of course spares her at the last minute, but not before her courageous acceptance of death has redeemed her sex in a double sense — at once putting an end to the collective slaughter and conclusively demonstrating, in his words, that "Women have . . . Souls, divine as we" (5.64). Though Manley's harem, like Racine's before it, is essentially a two-woman enterprise, an entire community materializes in the fifth act to witness this supreme act of female heroism.[10]

Even as Almyna bravely atones for her sex, her loving sister performs a more familiar version of female sacrifice. Zoradia affirms her honor by noble suffering rather than glorious action: dying from grief and abandonment in the early acts of the play, she is finally dispatched by an accidental thrust from Abdalla's own sword, amidst the confusion of a failed attempt to rescue Almyna that results in the fatal wounding of the would-be rescuer as well. But whether she is courageously struggling to conceal her grief, or generously forgiving both her own murder and that of her lover, Zoradia consistently demonstrates that she too belongs among the immortals. A woman's adultery may have initially prompted the sultan's murderous campaign, but Zoradia's case is clearly designed to cancel that history: when Almyna scornfully dismisses "Inconstancy" as "a Vice . . . so natural to all the Sex," the sex in question is Abdalla's, and she is implicitly contrasting his betrayal to the loyalty of her sister (3.27). Later she follows up her catalogue of famous heroines by instancing

the nobility with which Zoradia has borne her abandonment — "Without a Soul, cou'd she support such Wrongs" (4.46)? And just as Zoradia's love proves stronger than her desire for vengeance, so it overwhelms any impulse of jealousy. Despite the fact that Almyna "robb'd" her of Abdalla's "Heart," Zoradia explains, she still "so truly lov'd" her sister, "that all the rougher Passions,/ Revenge and Hate, like routed Armies fled before her!" (5.54). Zoradia begins by speaking of Almyna, eloquently enough, as "My potent Rival, ever in my sight . . . / And never from my heart" (2.23), but by the final scene, even the semblance of rivalry has been swallowed up in sisterhood. "Come to my Arms, and take a Sister's leave," says the dying Zoradia: "I clasp thee like a Lover, not a Rival!" (5.67).

Yet if *Almyna* seems designed to counter Racine's assumption that jealousy and love must always accompany one another in the harem, the very thoroughness with which love trumps every other passion in the place raises questions of its own. For the more that Manley exalts the power of love, the more she threatens to undo the spiritual authority of her heroines. Like Racine, in fact, Manley suggests that love's empire surpasses even that of the despot. When Zoradia learns, too late, that Almanzor has ordered his brother to marry her, she responds by denying that the sultan has any power to control amorous feeling: "tho' he be on Earth Omnipotent . . . He cannot give me back, a Heart estrang'd" (5.66). Nor does the owner of the heart, as Manley represents him, have any more say in the matter. "Did it depend on me, I would be thine," Abdalla characteristically tells Zoradia at one point, as he berates that traitorous organ for its apostasy (3.35). Pursued logically, of course, this doctrine of love's dominion not only absolves the guilty party but puts the very honor of the loyal one into question: if Zoradia simply cannot help continuing to love both Abdalla and her sister, what heroism attaches to her position? Indeed, by contending at one point that she and Abdalla are both victims of the same hopeless passion — he in his desire for Almyna, she in her adherence to him — Zoradia renders her own devotion the moral equivalent of his treachery: "The same the Cause, the same is our Despair, / Hopeless the Cure, and vain is our endeavour" (5.55). Even Almyna's own act of heroism seems compromised by this insistence on the supreme force of love, since in several speeches she confesses herself passionately enamored of Almanzor. "Without thee dying, dying if I have thee," as she tells him, she is all too ready, by this account, to sacrifice everything for one night with the sultan (4.43).

The very structure of the play suggests that Manley's vision of harem community had its limits. By comparison with *Bajazet,* the selective

slaughter that concludes *Almyna* hardly qualifies as tragedy, since both the heroine and the hero survive the action unscathed. Only their unhappy siblings perish in the end, despite the fact that Almanzor clearly bears the principal responsibility for the disaster. But while the sultan regards his own guilt as duly "expiated" by the death of his brother, Manley seems more intent on eliminating the expendable rivals in her love triangles than on fulfilling generic expectations (5.68).[11] Or perhaps it would be more accurate to say that the tragedy as she imagines it finally inheres in the rivalry, as if the true conflict of her play were not the struggle over the souls of women but the impossibility of reconciling the arbitrariness of the heart with the imperatives of heterosexual coupling. Scheherazade also had a sister, after all, yet she never figured as a rival. Indeed, the history of the original pair offers an instructive alternative to *Almyna*: while Dinarzade simply disappears from the final pages of Galland's version, the Arabic manuscripts translated in the nineteenth century end by happily uniting heterosexual love and sororal affection. Not only is Scheherazade's marriage to the sultan doubled by Dinarzade's to his brother, but Scheherazade agrees to this arrangement only on the condition that the sisters never be separated. "I cannot brook to be parted from my sister an hour," she says in Burton's translation, "because we were brought up together and may not endure separation from each other."[12] Though Manley could not have known this ending, she may have sensed how something like it was implied in the initial episode of the *Arabian Nights*, when Scheherazade first summoned Dinarzade to share the sultan's bedchamber. Even if the mutual devotion of *Almyna*'s heroines had its origin in an Eastern tale, the antagonism over which they triumphed was Manley's own invention.

Not every vision of sisterhood in the harem originated in such aggressively feminist impulses. In a charming Oriental tale composed on the other side of the Channel, a near-contemporary of the dramatist showed how a harem without rivalry might also be constructed to the specifications of masculine fantasy. Like Manley, Thomas Simon Gueulette evidently took his inspiration from Galland, though his *Mogul Tales, or the Dreams of Men Awake* — originally published in French as *Les Sultanes de Guzarate* (1732) — set out to imitate the *Arabian Nights* rather than to revise them. While Scheherazade spun her tales to divert a sultan from killing women, Gueulette presented his collection as "told to divert the Sultana's of *Guzarat*, for the supposed Death of the Sultan." In his frame tale, Gueulette at once constructed his communal idyll and imagined how a mid-life crisis might nonetheless disrupt it. Having succeeded in establishing throughout

his dominions "the Religion of the *Great Prophet*," the sultan of Guzarat agrees to confirm the peace by arranging for an alliance through marriage. Reluctant to offend any of the rulers whose daughters have been proposed to him, he accedes to his ambassadors' plan that he should arbitrarily choose his bride, still veiled, from among the available candidates. Happily for him, Gehernaz proves a dazzling beauty, and he immediately falls in love with her, though the accidental unveiling of the others confirms that they too are "the most lovely young Creatures in the World." Still more happily, his new wife reveals that she will only give herself to him if he marries all four of them. At her own instigation, they each have taken the same vow: whoever is lucky enough to be chosen will never "converse" with him as wife until she persuades him "to share his Inclination equally among the other three and herself." Though they arrived at the palace "as so many rival Beauties" contending for his favor, Gehernaz explains, they were so taken with one another that they swore an inviolable oath of friendship and followed it up by committing themselves to this second vow she proposed to them. As she reports her own words,

> You know, dear Ladies, our *Prophet* allows every Man four lawful Wives, let us unite sincerely in this Project, and laying all Jealousies and Envy aside, the usual Concomitants of Women in our State, let us act in Concert, in order to establish our own Felicity, and that of the *Sultan*.[13]

Despite the seeming appeal of this proposal from a masculine point of view, Gueulette's sultan is at first wary of the arrangement, as if he had been reading too many Western accounts of the disadvantages of the harem. When he worries that marrying more than one woman will encourage "the Angel of Discord" to enter the seraglio, Gehernaz promises him that "no Jealousies" will ever disturb his repose or interrupt his pleasure. And when he protests that he loves her too much to divide up his heart, she responds by commending the others' beauty and urging him to imagine their misery if he fails to love them. Reassured, he settles down to enjoy "such . . . Bliss, as left him no Room to doubt, but that he was one of the most happy *Princes* in the World" — only to worry the issue once again when each member of his harmonious harem manages to produce a beautiful son on the very same day.[14] Anticipating Adam Smith's argument that the attachment of each mother to her own child will make her "look . . . on all the other wives and their children as her rivalls and opposers," the sultan tricks the nurses into abandoning their charges

long enough for all distinguishing marks to be eliminated.[15] If this device suggests that even Gueulette is not fantasist enough to imagine that the women might otherwise subsist in utter harmony, the ease with which Gehernaz succeeds in consoling them for their individual losses quickly restores the harem utopia.[16] Urging them to love the children equally, she pronounces the event "the most happy Accident imaginable, since our Affection for each other can now have no shorter Date than that of our Lives." Predictably, the three other sultanas "found the Sentiments of *Gehernaz* so reasonable, and so perfectly adapted to the rendering them all happy, that they could not help approving them," and "a Profound Peace" reigns for twenty years in the sultan's household.[17]

What finally disrupts this peace is not the rivalry of the women but the restiveness of the sultan, who "at near Fifty Years of Age" finds himself suddenly enamored of an adolescent slave, a scheming Circassian named Goul-Saba. Yet even as the remainder of the tale turns into a cautionary fable about the sexual vanity of aging men, it also manages to imply that the best measure of a woman's love is her willingness to share you with a harem. Besotted with Goul-Saba, the sultan attempts to make her his concubine, only to learn that she is determined, Roxeana-like, to hold out for marriage. But in this tale the harem rather than the couple is the standard of felicity, and a slave who announces that a sultan will "never obtain the intire Possession of my Heart, unless he Espouse me solemnly" testifies not to the genuineness of that heart but rather its opposite. The sultans of Guzarat are apparently the marrying kind, but this one, of course, already has the maximum number of wives permitted by Mohammed. Though the self-serving newcomer suggests that he simply repudiate one of them, the sultan prefers to salve his conscience by obtaining a special dispensation to marry again from a terrified imam. But if Goul-Saba thus becomes the fifth wife, she never really becomes part of the harem — which is only to say that she continues to act solely for herself. She in turn duly produces a son, and for the next fifteen years, she lords it over the rest, while the sultan neglects his four faithful wives and obsessively devotes himself to her. Eventually, however, "the Mortifications which the *Sultana's* received by little and little, opened his Eyes," and he begins to doubt whether his youngest wife is altogether sincere. Finally unmasked by means of an elaborate scheme in which the sultan feigns his own death so that he may observe his wives in secret, she proves to be the "Daughter of a Common Woman, and former Mistress of a Player," who had already been pregnant on her arrival in the seraglio. While the four devoted wives genuinely mourn the imagined death of their husband, Goul-Saba reveals,

rather comically, that she has always hated "this dismal Place" and announces her intention to marry her lover. Having dismissed the interloper to the "Theatrical Throne" her talents deserve, the sultan resumes his life with his perfect harem of four, their youth and beauty all magically restored to the time when they collectively fell in love with one another.[18]

If Gueulette's cheerful fiction suggests that Mohammed knew what he was about when he determined just how many wives a man could marry, its ideal of love also has a vaguely Christian aura: she loves best, it appears to argue, who loves her co-wife as well as herself. But this is a harem fantasy, not a moral fable, and the injunction to share and share alike certainly does not apply with the same force to men. While jealousy is not a virtue in either sex, the sultan's sons are hardly expected to imitate the example of their mothers. Though the young men set out in harmony to battle a neighboring tyrant, the marriage of one to a beautiful princess immediately turns the others into grudging rivals, who listen dutifully but without conviction when their father scolds them for their lack of generosity toward their brother. Knowing that the princess "could be but enjoyed by One," the sultan remarks, they should have conquered "a Jealousy so unworthy of their Birth" — a lesson that implicitly underlines the collective sacrifice of their mothers, even as it takes for granted that the model of the harem does not allow for the reversal of the sexes.[19] Despite the paternal lecture, the young men are only cured of their jealousy when the sultan orders up a collection of beautiful slavewomen to divert them. A willingness to share your partner may be the supreme virtue in this tale, but Gueulette was hardly the only male fantasist to impute moral superiority to women, especially when the merits of the other sex were so well adapted to the gratification of his own.

Of course, the *Mogul Tales* openly confess themselves "the Dreams of Men Awake," and the "perfect Union" of which they dream evidently belongs to the same order of enchantment as the fountain of youth from which the entire harem drinks at the end.[20] But if even the most wishful of travelers did not claim to have encountered the sultanas of Guzarat, at least some Europeans of both sexes managed to find the harem far more harmonious than otherwise. "Tartarian and Turkish women ... have none of that envy which prevails in European female breasts," Elizabeth Craven announced sweepingly, after a visit to a Tartar household in 1786; and though her syntax is somewhat obscure, she seems to attribute this phenomenon to their very confinement in the harem. Rather than bitter rivals, she describes women who lavish "extravagant encomiums" on one another — a representation evidently prompted by a compliment

to herself that she coyly declines to repeat. Craven is not the most consistent of writers, however, and no memory of her exception for the Tartars and the Turks apparently prevents her from remarking later in the *Journey* how "female envy . . . spoil[s] every thing in the world of women," as she complains of a harem in Constantinople whose inhabitants ruin the style of their dress by attempting to outdo one another in magnificence.[21]

Writing in 1822, Lady Hamilton would likewise hover between spiritedly denying and obliquely confirming the harem's reputation for jealousy. Having dismissed "the intrigues and jealousies of the ladies" as so many travelers' tales about the Grand Seraglio — "stories," in her words, of those "who seek rather to surprise than to convey the truth to their readers" — she elsewhere endorses Baron de Tott's account of the women in Turkish harems as "without any employment but that furnished by jealousy."[22] Since Hamilton's *Marriage Rites, Customs, and Ceremonies* is essentially a compendium of other writers, the author does not so much contradict herself, perhaps, as fail to reconcile her sources. Even as her work thus testifies to how opposing accounts of the harem continued to circulate, it also helps to suggest how representations of harem community inevitably conjure up what they seek to deny — as if they could only define the bonds of the women by echoing Manley's emphatic "not a Rival!"

Especially in the nineteenth century, as rumors of the Grand Seraglio were replaced by actual visits to ordinary households, travelers began to describe a harem more prosaically contented and less fraught with intrigue than their readers had been led to expect. So Julia Pardoe, for example, impatiently dismissed another traveler's lurid account of jealous conflict by contending that "the very arrangements of the harem," in her words, "render it impossible." In a wealthy establishment, she explained, "each lady has her private apartment, which . . . no one has the privilege to invade," and where "her life, should she so will it, is one of the most monotonous idleness." Since the slaves in such an establishment are so numerous that most of their time, too, is "unemployed," there is clearly no occasion, Pardoe implies, for the hard labor with which her unnamed antagonist claimed that one rival typically punished another. "And as, in the less distinguished ranks, no Turk indulges in the expensive luxury of a second wife," so here, too, "there is little opportunity afforded for female tyranny."[23] Obviously, this account does not so much evoke the bonds of the harem as explain how domestic arrangements among the Turks render jealous intrigue impracticable — or superfluous. (As we shall see, nothing did more to demystify the harem than the discovery that it was hardly synonymous with polygamy.) Pardoe's emphasis on the "idleness" of women in the

harem is familiar enough, but she evidently refuses to imagine that female jealousy must always rush to fill the vacuum.

Victorian men also contended that the rivalries of the harem had been much exaggerated. Unlike Pardoe, they presumably received their impressions at second-hand, even if David Urquhart, whose *Spirit of the East* (1838) followed her *City of the Sultan* by one year, did report excitedly on a brief visit with the veiled ladies of his Turkish host. "As far as I have been able to judge," Urquhart wrote, "the general tenour of the life of the Harem is . . . one of tranquil, but contented and happy equanimity; excepting the case, by no means common, when more than one wife divides its authority and prerogatives." Though this manages to dismiss the possibility of rivalry by dismissing the existence of rivals, a later passage suggests that in polygamous homes, too, the conflict is muted: even when "rival queens" divide "the authority" of the harem between them, "the scenes of discord and the storms of passion are not such as our fancies would portray, or our manners warrant." Despite the faint note of condescension, Urquhart was not arguing that women in Turkey naturally feel these matters less than "ours" do, but that custom and "the constraining presence of a numerous retinue" combine to regulate their emotional temperature: "The passions, it is said, that are suppressed are half subdued; and the Turkish wife, who could not tolerate the slightest wanderings of her spouse if the object of it is illegitimate . . . is obliged quietly to submit to share all her prerogatives with her legitimate rival." The *Spirit of the East* said little about the imperial court, preferring to concentrate on humbler households, but "even a Sultan's Harem," Urquhart suggested in passing, would confound the expectations of his readers by presenting a scene of formal restraint and tranquillity.[24]

Less than a decade later, Charles White followed up this lead by discoursing at length on the elaborate rituals through which the decorum of the imperial harem was maintained. Despite an allusion to the "frequent explosions of ill-humour" that the sultan endured from his numerous women, the bulk of the account emphasized how court ceremony and etiquette were designed to obviate "jealousies" — assuring, for example, that presents were distributed among the women with "the utmost impartiality." After all, the sultan "is as desirous as other men to preserve concord in his family, and to avert frowns and ill-humour from the brows of his beautiful partners." As for those other men, White agreed that the majority kept harems which afforded no cause for jealousy, while the "rare" exceptions were wealthy enough to purchase peace through separate establishments. In fact, if there was any conflict in a harem of more

than one wife, he immediately went on to suggest, it was not among the women: "It generally occurs . . . that these ladies live on good terms, and are more disposed to unite in establishing joint ascendancy over their husband than to quarrel, separate, and thus enable him to put in force the old maxim of *divide et impera*." While there is no reason to think that he knew Hume's discussion of the subject, this image of female alliance effectively counters the argument addressed by "Of Polygamy and Divorces" — that the more women a man possesses, the easier he will find it to govern them. Not surprisingly, then, White pronounced it "impossible . . . to reconcile this fraternity [sic] or copartnership with our notions of domestic concord" — by which "notions" he clearly meant the happiness of men. "Indeed those few, who may be thus doubly or perhaps trebly provided for," he reported, "are said to be infinitely less happy and less at liberty than the majority who have only one helpmate."[25] For some European men, evidently, thoughts of the harem united could evoke no less anxiety than accounts of endless jealousy and bickering.

From the perspective of a European woman, of course, such female confederacy might look quite different. While Harriet Martineau could see even the collective raising of harem children as a premonition of jealous murder, Julia Pardoe took nothing but pleasure in observing how "an infant is common property in a Turkish harem — a toy and a treasure alike to each." In Pardoe's account, the fact that "it is difficult to decide which is really the mother of the rosy, laughing, boisterous baby . . . welcome to the heart and arms of all," only confirms the maternal idyll — "the beautiful devotedness of every inmate of a Turkish harem to the comfort and happiness of infancy!"[26] Pardoe was describing the harems of Constantinople and Martineau one in Cairo, but Sophia Lane Poole, who also traveled to Cairo in the 1840s, saw primarily "cheerfulness" in the harems she visited. Composed at the urging of her brother, the noted Arabist Edward Lane, Poole's *Englishwoman in Egypt* (1844) takes the form of letters to an unnamed female friend, who is encouraged to share her vision of the amicable tranquillity in these upper-class households. Though here, too, many appear to have been monogamous, her first encounter with polygamy prompts a burst of admiration for how they manage these things in Egypt. "But look and wonder, as an Englishwoman," she exhorts her correspondent, "how harmony can exist where the affection of the husband is shared by — I do not like to say how many wives." In another letter, she remarks, like others before her, on how the wealthy encourage "order and discipline" in their harems by separate apartments for the women — only to underline her admiration by conceding that

"*even Eastern* wives might manifest jealousy under circumstances of constant intercourse with each other."[27] An illustration that accompanies the same letter conveys a still more unqualified impression of harem sisterhood, as two "Eastern" women, their veils drawn back into a sort of continuous canopy, embrace cheek-to-cheek, or perhaps cheek-to-forehead — the dreamy effect of their intertwined forms oddly heightened by the fact that this is the only illustration in Poole's two volumes to lack an identifying caption (fig. 33).[28]

Despite her "wonder" at such harmony, Poole gave no evidence of wishing to share it: *The Englishwoman in Egypt* never for a moment suggests that she would like to change places with her Eastern counterparts. Very occasionally, however, more imaginative women writers did entertain such a fantasy. In a review published in *Blackwood's* for 1873, Margaret Oliphant paused briefly to comment with some appreciation on the cooperative benefits of the harem. The comments come, suitably enough, in the midst of an admiring tribute to another woman, the "remarkable" London hostess, Lady Ashburton. Though Oliphant was reviewing some biographical sketches of "persons connected with literature," the figure she chose to quote at length was not herself a writer but a friend of writers and a lively conversationalist, and the bit of talk she singled out for special praise was a speculation on the pleasures of sharing the role of wife. "I am strongly in favour of polygamy," Oliphant quotes Lady Ashburton as announcing. "I should like to go out, and the other wife to stay at home and take care of things, and hear all I had to tell her when I came back." On which the novelist herself comments:

> This last is delicious. It gives an altogether new view of the subject, rather more true, we daresay, than the prevailing idea. The harem must have its advantages in this aspect; and it whimsically corroborates the lamentation which we have often heard uttered by another lady well enough known in literature, upon the immense and unspeakable advantages her male competitors have over her, from the fact that they can have wives while she cannot! This novel disability of women has not, so far as we are aware, struck any of the agitators on the subject.[29]

If by the end of this passage the "advantages" of joining the wives look more like the advantages of having one, that is perhaps because the writer herself had long been the sole breadwinner of her family. Oliphant was no feminist, but her writings make abundantly clear that she thought women in every way the more competent sex, and that her imagination would have turned to another wife rather than a drone-like husband

or father had she wanted help in keeping things going. Despite the ironic allusion to women "agitators," it is not surprising that she would have thought Lady Ashburton's vision of wifely cooperation "delicious" — and truer to the reality of the harem than "the prevailing idea" of indolent eroticism.

A half-century after Oliphant briefly invoked a harem to assist the writer in her labor, Virginia Woolf conjured up the place to represent women writers' imaginative relations with one another. On the partly ironic premise that "now perhaps it may be pertinent, since women not only read but sometimes scribble a note of their opinions, to enquire into their preferences," she set out to speculate about the elective affinities of female readers and critics. "Indiscretions" (1924) is a light essay — no more than a sketch, really — and as in Oliphant's review, the harem makes only a fleeting appearance in the argument. After declaring, rather implausibly, that "no woman ever loved Byron" — "to enjoy *Don Juan* and the letters to the full, obviously one must be a man; or, if of the other sex, disguise it" — and pronouncing the otherwise lovable Keats "a little sultanic" in his relation to Fanny Brawne, Woolf had apparently prepared herself for her metaphoric passage to the Orient:

> Then, inevitably, we come to the harem, and tremble slightly as we approach the curtain and catch glimpses of women behind it and even hear ripples of laughter and snatches of conversation. Some obscurity still veils the relations of women to each other. A hundred years ago it was simple enough; they were stars who shone only in male sunshine; deprived of it, they languished into nonentity — sniffed, bickered, envied each other — so men said. But now it must be confessed things are less satisfactory. Passions and repulsions manifest themselves here too, and it is by no means certain that every woman is inspired by pure envy when she reads what another has written. More probably Emily Brontë was the passion of her youth; Charlotte even she loved with nervous affection . . .

The roll call continues, as Woolf specifies the different kind of love that each writer in turn evokes from her female readers: Anne Brontë inspires "a quiet sisterly regard," Elizabeth Gaskell "wields a maternal sway," George Eliot "is an Aunt, and, as an Aunt, inimitable," while Jane Austen prompts our helpless adoration, though she betrays no need of it. "As for loving foreigners," the passage concludes, "some say it is an impossibility; but if not, it is to Madame de Sévigné that we must turn."[30]

Perhaps because "some obscurity still veils the relations of women to each other," some obscurity still veils the trope that figures them: though it is apparently intended as a metaphor of the reader's relation to women writers, Woolf's harem tends to look more like an image of the writers' communion with one another — the "ripples of laughter" and "snatches of conversation" from which "we," who still tremble on this side of the curtain, have so far been excluded. Or, perhaps, with her usual fluidity of gender identification, Woolf approaches her figurative harem from the very viewpoint of the masculine culture that has long managed not to see it. Yet if it is not altogether clear whether "we" are inside or outside the curtain, sharing in the ripples of laughter or wistfully overhearing them, there is no doubt that the story of jealousy has given way to quite another fiction of the harem. "Men said" that the women of the place "sniffed, bickered, envied each other" — but "men," as Woolf tells it, were evidently mistaken. She herself may allude to both the "passions and repulsions" of the literary harem, but the only relations she chooses to imagine are varieties of love.

18
Disenchantments with the Myth

In an early chapter of Joyce's *Ulysses* (1922), Leopold Bloom steps into the Dublin streets in search of his breakfast kidney and briefly wanders off on a fantastic passage to the Orient. Inspired by the "happy warmth" of the June morning and the momentary sense of youthfulness that accompanies it, he imagines himself setting out "somewhere in the east" to steal a day's march on the sun. Strolling along the "awned streets" of an unnamed city, the would-be traveler makes his way through a dreamy haze of Eastern *topoi* to the "high wall" of a harem:

> I pass on. Fading gold sky. A mother watches me from her doorway. She calls her children home in their dark language. High wall: beyond strings twanged. Night sky, moon, violet, colour of Molly's new garters. Strings. Listen. A girl playing one of those instruments what do you call them: dulcimers. I pass.

But what begins with a fantasy of eternal youth and the vague anticipation of erotic adventure quickly ends in a rueful dismissal of such bookish enchantments. "Probably not a bit like it really. Kind of stuff you read."[1] The turn is characteristic of Bloom, who habitually checks his imagination against the mundane probabilities. Yet by the time Joyce's modern hero set out on his odyssey, he had ample precedent for thus arresting his harem fantasy with an assumption of the commonplace. If Bloom's exotic imaginings could be found among the "kind of stuff you read," so too could nearly a hundred years of exercises in disenchantment. By the first decades of the twentieth century, "not a bit like it really" was itself a familiar part of Western literature on the harem.

In one sense, of course, writers had been denying the accounts of other

writers ever since the West had begun to describe the harem at all. The *topos* by which each traveler routinely refuted the claims of his predecessors characterized the literature, as we have seen, from the start. With the partial exception of Lady Mary, however, it was not until the nineteenth century that Europeans undertook to demystify the harem in earnest. While earlier writers tended to replace one rumor about the Grand Seraglio with another, nineteenth-century travelers began to report on daily life in more or less ordinary households, and to register, often with shock, the gap between what they discovered and the fantasies they had inherited. Between the sheer volume of travelers and the relatively quotidian experiences they recorded, more and more accounts of the East presented themselves as deliberate refutations of exotic mysteries. This is not to say that Europe now discarded its imagination of the harem for unmediated reality: even the most ethnographically observant of travelers saw partially at best, while many others registered only, or primarily, their own disillusionment. The century's growing preference for realism may well have encouraged such reports, but realism, whether literary or visual, has conventions of its own. Nor did the old tales and images disappear: the nineteenth century was also, after all, the great age of romantic Orientalism in French painting; while on either side of the Channel, fantastic representations of the harem, both verbal and visual, continued to proliferate — as in the "kind of stuff" that Leopold Bloom apparently reads. Indeed, the very degree to which so many Europeans felt called upon to record their disenchantment testifies to the persistence of other images, even as it suggests how lifting the veil, to adopt one of their favorite metaphors for the process, became in its turn another fiction of the harem.

As so often in nineteenth-century writing, realism certified itself by the rejection of romance. "I am quite conscious that more than one lady-reader will lay down my volume without regret, when she discovers how matter-of-fact are many of its contents," Julia Pardoe announced in 1837: "The very term 'Oriental' implies to European ears the concentration of romance; and I was long in the East ere I could divest myself of the same feeling." For Pardoe, who subtitled her work *Domestic Manners of the Turks in 1836*, the matter-of-fact could presumably be found, for example, on the "floor . . . crowded with withered old women and stupid children" or in the "atmosphere . . . impregnated with onions, tobacco, and garlic" that she registered together with the graces of a dancing-girl and an elegant woman at one harem reception. Relatively speaking, however, Pardoe's impulse to "divest" herself of romance was a mild one: the East was still, in her words, "a scene of enchantment," its "web of tints too

various and too brilliant to be wrought into the dull and common-place pattern of every-day existence."[2] The following year, an anonymous report from a more thoroughly disenchanted harem visitor relegated all such colorful visions to the "fairy dreams" of the poets. "Byron and Moore have thrown the *prestige* of their brilliant imaginations over scenes which they never could have beheld," she complained after describing her own reception in the harem of a Turkish pasha. "But the reality, like almost all realities in 'this working day world,' partakes more of the character of prose than of poetry."[3]

A quarter century later, Emmeline Lott's *Harem Life in Egypt and Constantinople* (1866) was still staking its claim to truth by denouncing the illusions ostensibly fostered by "Tom Moore" and his cohort. At least three times in her jaundiced account of her stint as a governess in the harem of the Egyptian viceroy, Lott paused to declare the "ladies" of the place nothing like the beauties represented in Moore's *Lalla Rookh*. "On the contrary," she added at the first such occasion, "most of their countenances were pale as ashes, exceedingly disagreeable"; their figures were "fat and globular," and "many of them looked like old hags." The "bath of the poets" was also "a myth" — the unwashed bodies and dirty muslins in Lott's report being only matched by the "filthy manners" and "disgusting habits" of all around her. Between the "total absence of all the appendages necessary for a lady's bedroom," the "fumes of tobacco, into which large quantities of opium and other deleterious narcotics were infused," and the "incessant clattering of the tongues of upwards of two hundred women and children, jabbering away like monkeys," the "delicacy of a European female" was bound to be perpetually offended.[4] As for mealtimes in the viceregal household, the reviewer for *Chambers'* aptly summed up Lott's account by remarking that "a harem dinner is devoutly to be avoided by all who wish to retain their illusions."[5] Indeed, so unmitigated is Lott's record of "disgust and disappointment" with every aspect of harem life that her final dismissal of the poets' version comes as something of an anticlimax: "Brilliant as are the pen-and-ink sketches that our poets have painted of Harem life, I have visited and resided in three of them . . . and I have no desire to visit or live in a fourth." Though Lott believed herself a creature of "sensitive feelings," her disagreeable book testified more to her inflated expectations and dreary prejudices than to the reality she purported to describe. Having "uplift[ed] that impenetrable veil," as she boasted in her preface, she could only manage to see, evidently, with the eyes of a self-pitying governess and all too insular tourist.[6]

Less provincial travelers than Lott nonetheless shared her disenchant-

ment. "Seen from a little distance, and shaded by the flattering folds of the 'yashmak,' Oriental women almost always look pretty," Annie Harvey wrote in 1871; "but when, as they often do, the fair dames let the veil fall a little . . . the illusion is lost at once." Despite her relative sympathy for the Turks among whom she visited, she too professed to find "not . . . one native woman with any claims to beauty."[7] And a few years before these Victorian accounts, an Italian-born aristocrat writing in French had likewise threatened to "destroy some illusions" by describing the grim reality of the harem. In her version of the disenchantment narrative, it was the *Arabian Nights* rather than Byron and Moore that had ill prepared her for the truth:

> We are familiar with descriptions of it in the Arabian Nights, and other oriental tales; we have been told that it is the abode of love and beauty . . . and that it is in these mysterious retreats one is to find collected together all the wonders of luxury, art, magnificence and pleasure. What a mistaken idea! Imagine blackened and cracked walls, wooden ceilings split in various places, covered with dust and cobwebs, torn and greasy sofas, ragged curtains, and everywhere traces of oil and candles. When I first entered one of these delightful bowers, it almost sickened me.[8]

From the horrors of the housekeeping, the visitor would immediately turn her disgust to the excesses of paint by which the inhabitants of the harem marked their own features. Like the English governess, the Continental princess expected "luxury" and "magnificence" and saw instead only dirt.

We cannot know, of course, just how much dust and grease the princess Belgiojoso actually saw. Disenchantment, clearly, can bias the vision just as much as its opposite, and it is hardly surprising that the accommodations looked shabbier and the women less pretty than the visitors' imaginations had led them to expect. Even the most luxuriously appointed of harems was not likely to measure up to the fairy-tale wealth and beauty of the *Arabian Nights,* or to the only slightly less fantastic reports that had circulated about the imperial palaces of Turkey and Persia. And the more that European travel writers focused on the humbler ranks of Eastern society, the more dramatic was the gap between the imaginary harem and domestic reality.[9]

Nor is it surprising that nineteenth-century women should have been among the principal authors of such narratives of disenchantment. For only when significant numbers of European women began to travel to

the Middle East could some immediate impressions begin to challenge several centuries of collective fantasizing.[10] Though the harem of the Ottoman sultan remained "a sealed book," in Julia Pardoe's phrase, a growing number of books were being written about other harems, as a visit to one private household or another became an increasingly familiar part of the itinerary.[11] When Pardoe wrote about the "domestic manners" of the Turks in 1836, the first edition of *Murray's Handbook* to the Middle East had not yet been published; but by 1871 the guide took for granted that "lady travellers" might wish to make "a visit to one of the principal harems" during a stay in Constantinople and its environs.[12] In 1890 "A Voice from the Harem," to whose authenticity the editor testified, began her article in the *Nineteenth Century* by announcing, "So many English ladies have lately visited the Turkish harems, and . . . been able to write the truth about us, that it is really difficult to say something new" — all the more so, she implied, because they had consistently found that truth disappointing. "The veil being literally lifted, the mysteries of Orient appeared little by little before the world and were found wanting in the element of beauty which had been ascribed to them."[13]

David Urquhart was more inclined to see exceptional cleanliness and tranquillity in Turkish domestic arrangements than any sign of dirt, but his *Spirit of the East* (1838) also represents a brief visit to the women's quarters as a demystifying experience: "It was not till I crossed the threshold that I believed in its reality; and no sooner was I seated by the fire, than I asked myself, what is all this mystery about? The veil at once was rent, and the mystery had vanished."[14] While Urquhart obviously valued his host's invitation to step inside a harem, all his knowledge of Turkish women came, by his own account, from his conversations with the men.[15] But a nineteenth-century European need not possess even so much inside experience in order to adapt his image of the harem in the direction of realism, or at least to de-emphasize "romance" in favor of the humble and the commonplace. There is no evidence that the author of *Three Years in Constantinople* (1845), for example, ever followed Urquhart across the threshold; but having set out "to describe the every-day existence and ordinary customs of the metropolitan Turks, in familiar and matter-of-fact terms," Charles White rather sweepingly pronounced "the poetry or romance of the passions . . . less known in Constantinople than in any other city" and declared "the amusements of the ladies" correspondingly "more prosaic than poetical."[16] According to Thackeray in the following year, the Grand Seraglio itself had "a romantic look in print; but not so in reality." The novelist's tour had not, of course, taken in the imperial

harem, but the buildings "had a ruinous dilapidated look," and reports of the interior were not encouraging: "they are not furnished, it is said, with particular splendour, — not a bit more elegantly than Miss Jones's seminary for young ladies." With his caustic observation that "the place looks like Vauxhall in the daytime," Thackeray manages to dispatch its fabled glory to the realm of illusion.[17]

For a French contemporary of the novelist, the illusion to be abandoned was not so much the romance of the harem as its erotic promise. Gérard de Nerval had scarcely arrived in the East before he was responding enthusiastically to the imaginative provocation of the veiled women of Cairo. "C'est bien là le pays des rêves et de l'illusion!" the narrator exclaims in an early chapter of his *Voyage en Orient* (1851). A subsequent tour of an empty summer palace occasions some sobering discoveries, however. The palace belongs to the Egyptian viceroy, and the Western visitor inevitably wants to know about the sleeping arrangements of the viceregal harem. Having learned that the sexes sleep apart, and that religious law forbids them to see one another naked below the neck, he only desists from his eager questioning when he has managed to outrage his guide and disillusion himself:

> "I understand then," I said, "that the husband does not absolutely desire to pass the night in a room full of clothed women and that he would as soon sleep in his own room; but if he takes away with him two or three of these women..."
>
> "Two or three!" exclaimed the sheik with indignation; "what dogs do you think they would be who would act thus? God alive! is there a single woman, even an infidel, who would consent to divide with another the honor of sleeping next to her husband? And is it thus that people behave in Europe?"
>
> "In Europe!" I answered; "no, certainly, but Christians have only one wife, and they suppose that the Turks, in having several, live with them as with one."
>
> "If there were Muslims depraved enough," said the sheik, "to act as Christians suppose, their legitimate wives would immediately demand a divorce, and their very slaves themselves would have the right to leave them."
>
> "See," I said, to the consul, "what an illusion still persists in Europe regarding the customs of these people. The life of the Turks is for us the ideal of power and pleasure, and I see that they are not even masters in their own houses."[18]

Before the conversation is over, the traveler will suffer yet further disappointments. Most Turks, he will be told, have only one wife in any case, since maintaining several is both terribly expensive and inconvenient. And as for keeping a mistress, that is actually more difficult than in Europe — the very sanction of polygamy affording less tolerance for such illicit arrangements.

"Les Mystères du harem," as the following chapter is entitled, wistfully meditates on these discoveries. "Here then," the narrator begins, "is an illusion it is still necessary to lose: the delights [délices] of the harem, the absolute power of the husband or master, the charming women joining together to make the happiness of one man." According to the remainder of the chapter, the reality of the harem is very different indeed. The wife reigns as absolute mistress over her part of the house; a pair of female slippers at the door suffices to prevent her husband from entering; women possess personal property and have the right to divorce; the veil affords its wearers more liberty for amorous intrigue than their European counterparts, though the Eastern woman is seldom disposed to take advantage of her opportunity. "Quant aux bonnes fortunes des chrétians" — by which Nerval evidently means those erotic "good fortunes" so often attributed to Christian men by previous chronicles — "elles sont rares." Though something very like this account, ironically enough, would inspire many Victorian women to idealize harem life, it seems clear that Nerval believes himself to be renouncing a dream, not creating one. The Frenchman takes for granted that these "Mystères du harem" will prove at once demystifying and disappointing.[19]

This is not the only time Nerval bids farewell to his fantasies. While the evidence suggests that he partly fabricated his account of purchasing a Javanese slavewoman named Zeynab, the story of the Frenchman and his beautiful slave by no means conforms to the wishful scenario one might expect. With her stubborn insistence that she is "une *cadine* . . . et non une *odaleuk*" — a lady, in other words, and not a servant — and her steadfast refusal to engage in any form of domestic labor, the willful Zeynab proves a burden her helpless master can neither manage nor conscientiously abandon. The ironic comedy of their relations makes its own commentary on the narrator's harem fantasies, even as it teaches him the disappointing truth, etymologically at least, about an odalisque — the word he transcribes as "*odaleuk*," so he later explains, merely signifying "femmes de chambre." It is Europe, he goes on to say, that has given "un sens impropre au terme d'odalisque," just as it is Europe, he also reports, that has vastly exaggerated the numbers of the sultan's harem. Yet even at the

very end of the *Voyage* this European has apparently not quite finished the business of renouncing the fictions he has inherited. "If one takes account of the dignity and even the chastity of the relations that exist between a Muslim man and his wives," he writes at the close of the penultimate chapter, "one would renounce entirely that voluptuous mirage created by our eighteenth-century writers" — only to follow with an appendix that again finds it "necessary to renounce completely that idea of the harem represented by the author of the *Lettres persanes.*"[20]

As Nerval's case suggests, Europe's dreams of the harem did not die easily. Throughout the century, the sequence of anticipation and disappointment repeated itself, as collective fantasizing continued to override the testimony of individual witnesses.[21] In 1903 Anna Bowman Dodd reported with some amusement on a conversation between an American woman and a minor Turkish official. "I do so hope the Minister of — may grant me the honour of visiting his harem," the American traveler remarked. "F — Pasha would be too delighted, I am sure," the official responded:

> "only, as it happens, His Excellency has no harem in the sense in which, I presume, most foreigners understand our word. . . . He has but one wife, as, indeed, we mostly all have."
> "Hasn't any one a harem?" The cry was almost tearful.[22]

Despite her plaintive cry, the American persisted in her interrogation: like Nerval in the viceregal palace, she knew what she was looking for, and she would not readily abandon her idea. If her local informant remained more unflappable than his, that may well be because many decades of similar conversations had left an upper-class Turk all too able to understand what most foreigners meant by a harem.[23]

Rather than assume that such a harem had never really existed, many nineteenth-century Europeans chose to believe that it was fast disappearing under the pressures of modernization. And they were not altogether wrong, for the same circumstances that encouraged their own proliferating accounts of harem life — the growth in travel and exchange, the spread of empire, both economic and political — were inevitably affecting the inhabitants of the East as well as the West.[24] As early as 1838, Robert Walsh had warned the reader of his illustrated volume on Constantinople that the "former state of things is hurrying away," and that the Ottoman capital would soon look no different from any other European city: "all the distinctive peculiarities of a Turkish town . . . will soon merge into the

uniformity of European things, and, if the innovation proceed as rapidly as it has hitherto done, leave scarce a trace behind them." Since Walsh was introducing a work that promised to "catch the fleeting pictures while they yet exist[ed]," he had some motive to exaggerate the rapidity with which the distinctiveness of Constantinople was disappearing.[25] But he was hardly the only nineteenth-century European to announce that the East was fast becoming Westernized, or to find himself lamenting the very transformations that his own presence partly heralded. Though Nerval thought Cairo in the 1840s still true to "the tales and traditions of the Orient," he also warned his readers that the city he had seen was about to disappear before the advances of modernity; while more than a half-century later, Pierre Loti predicted the imminent destruction of Constantinople by a Europe that would "spoil [and] disfigure everything."[26] Ironically, however, what was about to vanish for Loti was an Oriental city he had first encountered in the 1870s, several decades after Walsh had proclaimed its impending disappearance.

"I do not like these European customs little by little invading the Orient," Nerval complained. But from his own disappointment with a dinner served "à l'européenne" by a Turkish pasha to the wry observation with which Edith Wharton concluded her account of a visit to the harem of a Moroccan sultan in 1920 — "his Majesty, the Priest and Emperor of the Faithful unhooked a small instrument from the wall and applied his sacred lips to the telephone" — Western visitors repeatedly remarked the invasion of the harem by the customs and contrivances they had left behind. When she had first arrived at the sultan's residence, Wharton had seen "a princess out of an Arab fairy-tale" awaiting her on the staircase, but by the time "his Majesty the Sultan Moulay Youssef" came "shuffling along on bare yellow-slippered feet with the gait of a stout elderly gentleman who has taken off his boots in the passage preparatory to a domestic evening," the promise of Oriental romance had dissolved before the familiar presence of domestic reality. The sober appearance of another Moroccan harem, this one belonging to a high government official, prompted the novelist to a more ambiguous comparison with the rituals of home: "but for the vacuity of their faces the group might have been that of a Professor's family in an English or American University town, decently costumed for an Arabian Nights' pageant in the college grounds."[27] Like Thackeray's vision of the Grand Seraglio as a daylit Vauxhall, her image turns the harem into a familiar performance of itself — a theatrical illusion at once cozily domesticated and slightly fraudulent. Though Wharton seems to have been more amused than bitterly disillusioned

by her visits, she too seems to have thought the harem was beginning to look all too much like home.

The very fact that for more than a hundred years Europeans continued to believe themselves the last witnesses of a vanishing Orient testifies to the force of the imaginative conceptions they carried with them.[28] Though the title page of Walsh's book boasted "a series of drawings from nature by Thomas Allom," among the "fleeting pictures" they promised to capture for their readers was a *Favourite Odalique* that neither man could ever have seen for himself (fig. 14). In the first decades of the twentieth century, editors on both sides of the Channel rejected photographs of contemporary harems on the grounds that they were insufficiently "Oriental" — a standard presumably derived from numerous prior representations and from several centuries of collective fantasizing.[29] Like the hero of *Les Désenchantées* (1906), hesitating to return to Constantinople because "he was afraid of being disenchanted by the new Turkey," the editors evidently feared lest the image of a modern harem fail to satisfy the preconceptions of their readers. In Loti's own case, we may recall, the conspirators managed to forestall such disenchantment by decking out a modern harem with appropriate "décor," thus encouraging the illusion that the Frenchman could at once enter that mysterious space and preserve his Eastern fantasy unviolated. The feminine plural notwithstanding, the prospect of disenchantment in *Les Désenchantées* most obviously threatens not the women of modern Turkey but the Western man who observes them: as Djénane protests when Loti's fictive surrogate first proposes the title, the inhabitants of the modern harem may be "annihilated, sequestered, stifled," but "not disenchanted." Only those who have first entertained a fantasy about a place are at risk of losing it.[30]

Two years after the appearance of *Les Désenchantées*, the Frenchwoman who played the principal part in the deception of Loti published her own account of a sojourn in the harems of Constantinople. "My first impression," Marc Hélys announced in the opening pages of *Le Jardin fermé* (1908), "was a complete disenchantment." Like Nerval, if more explicitly, Hélys associated her disenchantment with the loss of an aura that Europe had attached to certain words:

I had brought from Europe some charming words, in which, from the *Lettres persanes* to *Aziyadé*, are crystallized, novelistically and romantically, all our fantasies about the Orient. For example, the word *harem*. Is there any that could be more flattering and more poetic to Western

ears? All the poetry of Asia sounds in these two syllables. . . . And the word *odalisque,* is it not also evocative enough? Beautiful women, indolent and slightly lethal [un peu fatales], clothed in light silks and pearls, stretched out on divans, and dreaming . . . In reality, an *odalisque* is quite simply a chambermaid [femme de chambre]. She is a chambermaid whom the master often enough makes his mistress, a circumstance which has nothing prodigiously Oriental about it. And as for *harem*, it is the part of the house reserved for the women of the family: the mother, the wife, the sisters, the aunts, and among the daughters, the unmarried ones.[31]

19
Celebrations of Domestic Virtue

Throughout the nineteenth century, the revelation repeated itself: "'Harem' is 'home,'" as one Englishman concisely put it.[1] But disenchantment was not the West's only response to the discovery. The very realism that destroyed the romance of the harem for some imaginations enabled others to discover a more commonplace domestic ideal. For those who wished to view the home as a sanctuary from the world around them, the walls of the harem could appear to enclose the ultimate version of the place — a feminized refuge securely marked off from public conflict and danger. As we might expect, this was a view of the harem particularly congenial to the Victorians, many of whom managed to regard the seclusion of women as the Eastern equivalent of the separation of the spheres.[2] Yet while such a harem often evoked in Western visitors a pleasurable sense of recognition, it was not so much home itself as an idea of "Home" that they were in fact recognizing. Familiar rather than alien, the epitome of safety rather than of dangerous allure, this domesticated harem still remained primarily a harem of the mind.

In an 1844 poem entitled simply "The Hareem," Richard Monckton Milnes apostrophized such an idealized haven:

> Home of the East! thy threshold's edge
> Checks the wild foot that knows no fear,
> Yet shrinks, as if from sacriledge —
> When rapine comes thy precincts near:
> Existence, whose precarious thread
> Hangs on the tyrant's mood and nod,
> Beneath thy roof its anxious head
> Rests as within the house of God.[3]

Though it is by contrast with the imputed tyranny of the East that this domestic peace makes itself so strongly felt, the poem does not so much oppose East and West as assimilate the former to the gendered divisions of the latter. "Thus in the ever-closed Hareem/ As in the open Western home," another stanza of Milnes' poem argues, the same glorious "womanhood" exercises its divine "mission."[4]

Even before Victoria ascended the throne, the structure of the harem was being reinterpreted according to this model of sheltering domesticity. "The precautions used in Turkey to conceal the women from the public view," Lady Augusta Hamilton explained in 1822,

> are less to be attributed to jealousy and suspicion than to respect for the persons, and reverence for the modesty, of women. . . .
> The great corrective of public depravity is domestic manners; and if the women be too scrupulously, yet they are effectually removed from the chief seductions to irregularity. The interior of their houses is pure and untainted with vice and obscenity.[5]

Such an interior, needless to say, was far removed from the erotic dream-worlds still being cheerfully constructed by men like Rowlandson or the anonymous author of *The Lustful Turk* (1828). Yet since Hamilton appears to have collected virtually all her *Marriage Rites, Customs, and Ceremonies* from other sources, this "pure and untainted" harem was presumably not hers alone.

Admiration for the domestic manners of the Turks was not in fact unprecedented. Hamilton herself cited both Lady Mary and Lady Craven, noting especially the latter's claim that women in Turkey "are safe from an idle, curious, impertinent public," and that "what is called the *world* can never disturb the ease and quiet of a Turkish wife." While she also re-peated Lady Mary's witticism that Turkish women "do not commit one crime the less for not being Christians," the nineteenth-century writer immediately went on to emphasize not the ease of sexual intrigue but its difficulty.[6] "The harems of private gentlemen have been frequently visited by European physicians," she declared later in the chapter, "and from none of their descriptions do they appear to be the scenes of vice and debauchery." Among the upper classes, in Hamilton's account, the pastimes of the harem more nearly resemble those of an ideal finishing school:

> The more elegant occupations of the harem are working in embroidery, and superintending the education of young ladies, who are taught to

express themselves with the greatest purity and correctness of language, to read, and to write a neat and legible hand. These qualifications are indispensable to the education of a lady of fashion; and singing, dancing, and music, are also considered as polite accomplishments.[7]

There is no evidence that Hamilton herself ever set foot in a harem, but many women who did wrote in similar terms. Traveling through Egypt on a journey to India in 1825, Anne Katharine Elwood paused to examine two palaces that a Turkish pasha was constructing for his wives. While she does not seem to have encountered the women themselves, her inspection of their "*sanctum sanctorums*" apparently told her all she wished to know. "The seclusion of the Haram," she announced in later summing up the experience, "appears to be no more than the natural wish of an adoring husband, to guard his beloved from even the knowledge of the ills and woes that mortal man betide." That Elwood could refer to the protected wife in one sentence as "the light of his Haram" and in the next as "his ain kind dearie" suggests how readily such Eastern seclusion could be accommodated to the language of the West. Whether in the idiom of Moore's Oriental romance or the Scots dialect of Robert Burns, "the natural wish of an adoring husband" is much the same.[8] As late as 1909, Lucy Garnett's significantly titled *Home Life in Turkey* was still celebrating the sanctuary created by these adoring husbands. "The seclusion of women which accompanies the harem system is by no means, as generally assumed, a proof of their supposed 'degraded position,'" Garnett announced firmly; "but is, on the contrary, in great part the outcome of the regard entertained for them by the men of their nation." Emphasizing not only the husband's desire to protect his wife but the wife's power to limit access — "even the husband refrains from entering," Garnett remarked approvingly, "if one or more pairs of overshoes at the door . . . announces that his wife has guests" — the female visitor could at once feel at home in the harem and take it as a model by which to judge what she had left behind.[9]

With representations like these, it has been argued, nineteenth-century women effectively feminized the harem, transforming an image of domination and exploitation into a vision of female privacy and dignity.[10] But theirs was not the only sex with a stake in this domestic ideal, and men as well as women could locate wishful versions of home in harems of the mind. The "anxious head" that seeks refuge in Milnes' "Hareem" belongs, after all, to the master of the house. And even as the poet implicitly distances himself from the tyranny that requires such a refuge, he represents life "without" the harem as a nightmarish version of the public sphere

conventionally assigned to the Victorian male. Only beneath his own roof, according to Milnes, can the oppressed subject recover his manhood:

> There, though without he feels a slave,
> Compelled another's will to scan,
> Another's favour forced to crave—
> There is the subject still the man:
> There is the form that none but he
> Can touch,—the face that he alone
> Of living men has right to see.[11]

In Ruskin's classic formulation of such gender division some twenty years later, "the man, in his rough work in open world, must encounter all peril and trial"; yet however "wounded, or subdued" by hostilities without, he crosses his threshold to "the place of Peace . . . the shelter, not only from all injury, but from all terror, doubt, and division." The poem's imagination of masculine powerlessness is more vivid, perhaps, than its representation of female influence; but if its protagonist seems less inclined to be "ruled by" his woman, as Ruskin urges,[12] than to be comforted by his exclusive right to her, that woman has "still her mission sure, / To lighten life, to sweeten death." A "sacred place," in Ruskin's terms, Milnes' imaginary harem amply "vindicates the name, and fulfils the praise, of Home."[13]

For Victorians of both sexes, the growing awareness that many Eastern households were in fact monogamous made it easier to recognize them as "Home." Commenting on "The Hareem" in his preface to *Palm Leaves* (1844), the collection of poems inspired by his travels in Egypt and the Levant, Milnes himself took pains to assure the reader that its "picture of ordinary life" could be trusted. "Polygamy is usually spoken of as the universal practice of the East," he explained, but "a little inquiry will inform the traveller that it is a licence almost confined to the very wealthy, and by no means general even among them."[14] In an essay on "The Rights of Women" published the same year, Alexander Kinglake acerbically dismissed this monogamous harem as a poetic fantasy.[15] But most nineteenth-century observers tended to confirm Milnes' claim, despite the fact that they could not always agree which classes were more inclined to a single wife.[16] If it is not always clear whether such commentators believed they were correcting an old misconception about the East or announcing a recent adjustment to Western ways, their approbation is evident enough. It is "now generally the case," Annie Harvey explained in 1871, that "in the best Turkish families, there is but one wife."[17]

That singular wife often figured in admiring depictions of the Victorian harem, even when their authors were not making an explicit point of Eastern monogamy. "The basis of all Mussulman institutions, ideas, and customs, is the hearth, the home — that is the Harem," Urquhart announced in 1838, " — the one spot on earth, which each man holds his own — secret and 'forbidden.' It is his wife, in whose behalf this sanctuary is created, it exists only in her, and it *is* whithersoever she goes." Elsewhere in his book, Urquhart set out to "disprove" the common Western belief in "the inferior. . . moral and social position of women in the East" by offering a representative "sketch" of domestic relations in the harem. Having just recounted how a Turk married for fifteen years declined to accompany him on a trip out of "feelings which we might suppose not capable of surviving the honeymoon," Urquhart appropriately staged his exemplary tableau at a moment of harem homecoming. "Let us suppose a Harem of distinction," his account begins, "where the return of the master is announced, and the wife is seated beside the mother-in-law, surrounded by their attendants." The arrival of "the *Paterfamilias*" is announced; "the slipper-shod and light-footed crowd disperses in an instant" (thus assuring that the young female attendants are not seen by the husband); and there ensues an elaborate exchange of courtesies between man and wife, son and mother. Indeed, even more than Turkish uxoriousness, this particular representation of domestic concord focuses on the extraordinary respect in which mothers are held in Turkey — an attitude that grants woman, as Urquhart puts it, "a much greater degree of authority . . . than is to be found in Europe." And like other aspects of harem life, by his account, this reverence for motherhood is all to the good.[18]

Less frankly hortatory in intent than Urquhart's subsequent tribute to Eastern manners — *The Turkish Bath, with a view to its introduction into the British dominions* (1856) — *The Spirit of the East* nonetheless anticipates its tendency to view the Turks as a model for other nations. Though he is careful to confine his praise "entirely to [their] domestic and passive existence," Urquhart repeatedly suggests that in this capacity, at least, the English might do well to emulate them. Not least among the "domestic virtues" he singles out is that of cleanliness itself, a virtue that extends equally, in his view, to Turkish households and Turkish persons. When this traveler lifts the veil on harem life, he sees not the slightest trace of that dirt so remarked by other visitors:

The floor is as clean as any other part of the dwelling; a spot on the hand is instantly washed off; the accidental ruffle of a curtain or a sofa

is immediately smoothed down; a shred on the floor is no sooner observed than picked off. The habits of order are thus carried to what would be with us a fatiguing excess.

Indeed, so far do the Turks carry their feeling for cleanliness, he continues, that "the water itself must be perfectly pure." Despite his suggestion that keeping up with such standards would only exhaust an English housekeeper, Urquhart has no doubt that this "rage for ablutions" puts his nation to shame. "After getting accustomed to their mode of washing," he flatly announces, "ours has something very revolting in it."[19]

It is one thing to admire all this cleanliness and order, however, and another to admire the system of enforced labor that helps to make such standards possible. Whose hands sweep the floor clean or smooth down the ruffles of the curtain, the approving visitor notably manages not to say. Yet so thoroughly does he assimilate the harem to his domestic ideal that even the institution of slavery becomes in his telling the basis for the superiority of private life in the East. Unlike a European servant, Urquhart reports, a Turkish slave is typically considered "a member of the family" — by which is meant, as this Victorian understands it, that "individual character" and private feeling shape relations that in Europe are governed solely by the impersonal medium of cash. Judged against the model of the harem, in fact, the Victorian home begins to look dangerously like the very public sphere it would exclude, as wage labor and class conflict disrupt the otherwise tranquil space of private life:

> The European servant, with his fixed wages ... and treated as a menial, coalesces with his fellows against his master, because he has nothing particular to expect from his devotedness or his master's regard. ... No friendly or affectionate intercourse takes place between them; their position has rendered them heartless or dishonest; and the character thence accruing contributes still further to lower their station.

Imagining the Eastern home by contrast as a place where all such strife is magically dissolved in the "affectionate intercourse" of the family, the Victorian traveler can only conclude that he and his countrymen are thus "deprived of a great source of enjoyment" — "that species of domestic happiness," in his words, apparently shared by everyone who dwells in the harem.[20]

Indeed for Urquhart, as for other nineteenth-century admirers of Eastern life, the domesticating virtues of the harem extended to the

very practice of polygamy itself. Like Lady Mary more than a century earlier, those who defended the harem at once represented it as typically monogamous and implied that caring for more than one wife was in any case morally superior to consorting with prostitutes. "While we reproach Islamism with polygamy," Urquhart declared, "Islamism may reproach us with practical polygamy, which, unsanctioned by law, and reproved by custom, adds degradation of the mind to dissoluteness of morals." By comparison with the harem, even a polygamous one, the Victorian commentator once again finds the arrangements of his homeland "revolting":

> Have those who speak of the triumphs of Islamism, as resulting from the unbounded gratification of sensual lusts . . . and who denounce polygamy . . . ever dreamt of comparing the moral statistics of this country and of Europe? Have they compared the amount of sensual gratification indulged in London and Constantinople? . . . Have they compared, in the two cities, the numbers of females reduced to the most abject state of human misery, and rendered useless to society; and of unknown beings, cast in helpless infancy on the charity of strangers, and bearing, through life, an indelible stigma of reproach and infamy . . .? England, we believe, is the most moral country in Europe; and we every day hear the revolting exhibition which our public places present, quoted as a proof of that superior morality.[21]

Replacing the suffering of prostitutes and bastards with the protection of wives and children, the public display of vice with the private arrangements of the home, the harem by this account more nearly approaches a Victorian ideal than its English equivalent.

Forty years later, a contributor to *Fraser's* advanced much the same argument: "In Christendom we have monogamy and 'the social evil;' in Moslem Turkey, polygamy and a measure of public morality that may be sought for in vain from the Save to the Pacific." And as we might expect, he only arrived at this conclusion after contending that most harems were really monogamous in the first place. Dismissing "the popular notion . . . that every Turk, above the rank of the poorest, is a Bluebeard, with his full Koranic allowance of four wives, supplemented by concubines *à discrétion*," the article instead stressed "the rarity with which the one-wife rule is now broken" in Turkey. Like more disenchanted contemporaries, in other words — though in a very different spirit — the author set out to correct some widespread fantasies of the harem. Thus far from being "a state of unlimited license on the one hand and of virtual slavery on the

other," as many had previously imagined it, "harem-life," according to this Victorian account, "is essentially *home* life in many of its best and tenderest aspects."[22] That such an account did not so much demystify the harem as substitute one wishful representation for another is an irony perhaps easier to appreciate in hindsight.

20
John Frederick Lewis and the Art of the Victorian Harem

Most model homes of the East were constructed in Britain. When French writers and artists brought the harem home in the nineteenth century, they were less likely to celebrate its domestic virtues than to elaborate, whether lasciviously or ironically, on its long-standing associations with the brothel. One year before the contributor to *Fraser's* identified the harem with "*home* life in many of its best and tenderest aspects,"[1] Guy de Maupassant entertained the Flaubert *cénacle* with a salacious farce whose double entendres repeatedly turn on a confusion between the *maison* as bourgeois household and the *maison* as whorehouse. In Maupassant's "Maison turque" every *odalisque* is in reality a prostitute.[2] Visually, too, the French tradition in the nineteenth century differed radically from the British. By comparison with the vast number of voluptuous odalisques and their attendants given visual form in nineteenth-century France, British versions of the subject were restrained in more senses than one — modest in demeanor and quantity alike.[3] For all the subtlety with which an Ingres stylized and distanced the eroticism of his harem images, a painting like his *Odalisque à l'esclave* of 1839 (fig. 12) has a sensual immediacy altogether absent from Thomas Allom's *Odalique* of three years earlier (fig. 14), for example, or from Richard Bonington's decorously romantic treatment of another performance by a harem musician in his *Eastern Scene* of 1825 (fig. 34). Compared with Ingres's abandoned nude, Bonington's alertly appreciative listener is a model of British propriety.

There are always exceptions to such generalizations about national difference, of course. Just as the witty exercises in harem pornography that Rowlandson produced early in the century hardly suggest that France had a monopoly on erotic license, so the chastely domesticated

harems painted by the Frenchwoman who called herself Henriette
Browne rival anything in the British tradition. With their fully clothed
figures, polite gestures, and austerely undecorated spaces, Browne's
two harem interiors are closer in spirit to the images of nuns that she also
produced in the period than to the work of compatriots like Gérôme or
Ingres. Even the presence of a child in *Une Visite: Intérieur de harem,
Constantinople, 1860* (fig. 35) does not distinguish this picture from her
most successful convent painting, which also domesticates its Sisters
of Charity by showing how they nurse an ailing child. (In a similarly re-
strained image of daily activity, Browne's other harem picture represents
some women listening to a flute-player.) Professional women painters,
especially of Oriental subjects, were comparatively rare in the period;
and between the privileged access presumably granted her sex and the
reputation for ethnographical accuracy Browne had already established
with her convent images, French reviewers were all the more inclined to
take her harems for the real thing — though whether they responded, as
did Gautier, with an excited sense that they had penetrated to the truth
of the place at last, or recorded their disappointment at the absence of
"diamond palaces" and "naked odalisques" seems to have depended
more on their own preconceptions than on the content of Browne's pic-
tures themselves. If those pictures appear to have had less of an impact in
England than in France, one reason may well be that the erotic tradition
they seemed to counter had never really established itself on the other
side of the Channel.[4] By the 1860s, in any case, another painter of domes-
ticated harems had already caught the attention of British viewers.
Crossing Dutch genre painting with Islamic influences, John Frederick
Lewis had begun to create the light-filled images of domestic interiors
in which a peculiarly Victorian art of the harem took visual form.[5]

Though Lewis's first *Hhareem* produced something of a stir when he
exhibited it at the Old Water-Colour Society in 1850, the critics generally
concurred that he had managed to treat a potentially sensational theme
without unduly offending contemporary standards of decorum. "They
whose fastidiousness may reasonably be shocked by the mention of the
subject, will find on inspection that their apprehensions are groundless,"
the critic for the *Athenaeum* reassured his readers when he previewed
the painting several months before the exhibit. "A sight of it . . . satisfies
us how completely the painter has triumphed in his treatment over his
elements — how he has banished everything like grossness and sensual-
ity." The same critic was slightly more cautious in his official review of the
exhibit, conceding that "the picture is voluptuous — or it would not be

true to its theme"; but he persisted in praising the artist for having "realized" the scene so faithfully, "yet so as to give no offence to Western feelings of decorum." The *Illustrated London News* claimed that men were more inclined to "linger around" the picture than women, but immediately added that "there is nothing in the picture, indeed, to offend the finest female delicacy."[6]

That the reviewers went out of their way to praise the *Hhareem*'s "purity of appearance" testifies to a certain anxiety on the subject;[7] and by comparison with Lewis's subsequent variations on the theme, it is not difficult to understand why the picture should have elicited such reassurances. The scene represents, by Lewis's own account, "the upper or women's apartments of a house in Cairo," where a Turkish bey and members of his harem have gathered to witness the unveiling of a new arrival (fig. 36).[8] Clearly this is not a Turk who has adopted what *Fraser's* would later term "the one-wife rule."[9] Both the obvious polygamy of the master and the prurient associations of the unveiling bring the image closer to the French tradition than Lewis would ever venture again. Yet the modest gesture of the new recruit helps to defuse the potential eroticism, and even in this most nearly titillating of his harem scenes, the artist directs attention elsewhere.[10] Lewis is more concerned to document the assorted members of the company, on the one hand, and to detail the interior architecture of these airy apartments, on the other, than to conjure with the viewer's fantasies of sexual relations in the East.

The very crowdedness of the scene helps to counter any erotic suggestiveness, especially given the varied reactions of the parties. The expressions of the three principal women range from "indolent disdain," as the *Athenaeum* termed the response conveyed by the figure reclining on the divan, to the alert curiosity of the kneeling one (a figure the same reviewer chose to see as "the Roxalana of the group"); while both the slavewoman silhouetted against the wall and the eunuch who performs the unveiling register lively amusement at the episode.[11] The small child who rests at the knee of his mother appears only half-conscious of what is transpiring, as he looks sleepily out at the viewer. Despite the ostensible interest of the bey himself, even he does not focus unambiguously on the new arrival, as the *Athenaeum* noted when it included "the somewhat equivocal direction given to the gentleman's look" among the possible defects of the picture. "It seems doubtful," in the critic's words, whether the bey's eye "rests on the newcomer or on an insect on the wall": but if Lewis presumably did not intend the ambiguity, neither did he dedicate what the same critic called his "unsparing consideration and labour"

to remedying the confusion.[12] That labor was instead devoted to the elaborate patterns of fabric and carving that decorate the chamber, and particularly to the intricate latticework through which light filters into the harem.

Its apparent subject notwithstanding, this *Hhareem* has also been shrewdly characterized as a "family scene": whereas the erotic tradition of the French typically divides the harem from the rest of the Muslim home, Lewis, by this account, "reunites" them. The small child especially serves to domesticate the scene, as do, to a lesser extent, the various attendants and pets.[13] The domesticity of the image, if not its internal coherence, is only intensified in a truncated version that belongs to the Victoria and Albert — a picture once thought to be a piece of the original and now recognized as a separate painting (fig. 37). Whether this represents a commissioned variation on the original, or, as seems more likely, a copy cut down by painter or owner — a bit of the new slave's drapery can still be glimpsed in the right-hand corner — the intent was presumably to retain the more "respectable half of the composition."[14] Whoever was the agent of the transformation, in other words, it testifies to a wish to bring Lewis's harem yet closer to home.

For the artist himself, the *Hhareem* evoked home life in a still more immediate sense. For an entire decade — from 1841 until he returned to England in 1851, shortly after the successful exhibition at the Old Water-Colour Society — Lewis had resided in the Ottoman quarter of Cairo, having settled into the city after a year of traveling in and around Constantinople. Though other European artists had of course preceded him to the East, such a protracted sojourn as Lewis's in Egypt was relatively rare.[15] According to Thackeray, who recounted a visit with the artist in his *Notes of a Journey from Cornhill to Grand Cairo* (1846), the former English "dandy" had "established himself . . . in the most complete Oriental fashion" — dressing, eating, and otherwise living after the manner of "an Oriental nobleman."[16] Thackeray's claim that Lewis lived "like a languid Lotus-eater" in an "indulgence of laziness" is clearly belied by the artist's extraordinary output in the period.[17] But if the novelist's account of the Englishman gone native undoubtedly partakes of its share of stereotype, we have no reason to question his general description of Lewis's "long, queer, many-windowed, many-galleried house" or of the large "hall of audience" in which the artist received his visitor, with its ceiling "carved, gilt, painted and embroidered with arabesques" and its "great bay-window" with a "divan . . . round the niche."[18] Lewis lived, that is, in a house very like that represented in the *Hhareem*; and the evidence strongly

suggests that he repeatedly turned to it as a model for his Eastern interiors. A sketch of the bay window remarked by Thackeray is inscribed "Mandarah in my house at Cairo" (fig. 38), and more than twenty years after the artist had returned to England, it clearly reappears in another harem painting entitled *The Reception* (1873; fig. 39).[19]

Lingering in Lewis's courtyard, Thackeray had also managed to glimpse another characteristic bit of harem life — "two of the most beautiful, enormous, ogling black eyes in the world," as they peered down at him through the lattices. Though the *Journey* no sooner hints that those beautiful eyes accounted for Lewis's prolonged exile than it records the latter's denial — "upon his honour she was only the black cook" — the analogous histories of both Lane and Nerval suggest that the unmarried Lewis would have felt considerable pressure to acquire at least one female slave.[20] Yet whether or not the laughing slavewoman in the *Hhareem* is Thackeray's bright-eyed "Zuleika," as one commentator has speculated, there is no reason to believe that Lewis ever possessed anything like the harem represented in that painting.[21] The house may be his own, but most of the figures in the painting are presumably models. That the *Hhareem* happens to be the only one of Lewis's harem paintings to have been completed on location does not prevent it, in other words, from being a deliberate and conventional composition.

Edward Lear presumably spoke with the authority of a fellow artist who had himself traveled in the East when he declared Lewis's work "perfect as representations of real scenes & people."[22] But from the artist's return to England in 1851 until his death a quarter century later, virtually all those "perfect" representations were worked up in his studio from drawings and props that he had brought with him from Cairo. Like *The Reception*, which stages an imaginary visit to a harem in a scrupulously detailed rendition of a room that did not in fact belong to the women's quarters of his house — a *mandarah*, it has been noted, is actually a men's reception room[23] — such paintings freely combine authentic elements of architecture and costume with scenes of domestic life necessarily invented by the artist. Despite the "intensity of observation" for which Ruskin praised *Hareem Life, Constantinople* (1857),[24] for example, the image remains in this fundamental sense a harem of the mind (fig. 40). And despite the geographical precision of its title, the painting has more in common with the nearly contemporaneous *Life in the Harem, Cairo* (1858) — or with the later *Indoor Gossip* (1873), whose subtitle also explicitly sets the scene in Cairo — than with any ethnographically specified reality (figs. 41 and 42).

For all his domestic experience of the East, Lewis necessarily had to imagine and pose his inside representations of the harem. Yet the British artist produced a very different image of the place from his major French contemporaries. Rather than the erotic dream of Ingres's harem paintings or the brooding mystery of Delacroix's, the Victorian artist conjured up a peaceful reverie of domesticity at once exotic and vaguely familiar. That sense of familiarity has many causes, as we shall see, but among the more straightforward is the Western appearance of his women. Though Lewis had taken some trouble to discriminate both visually and verbally among the nationalities in his first *Hhareem* — his own commentary identifies the principal lady as Georgian, and the other two as Circassian and Greek, respectively[25] — most of the later figures manage to look not only remarkably English but virtually interchangeable with one another. In 1847 Lewis had in fact married a countrywoman named Marian Harper in Alexandria; and the evidence suggests that she often served as his model when they later returned to England.[26] In an undated sketch of her head and shoulders (fig. 43) she especially resembles the standing woman in *Hareem Life, Constantinople* (fig. 40) and the solitary figure in *The Bouquet* of the same year (fig. 44); but it would not take much effort to see her as the prototype for almost all the white women who appear in the paintings produced after the Lewises' departure from Egypt.[27] Only the black figure in *Life in the Harem, Cairo* unmistakably originates in another model (fig. 41). So far as their human subjects are concerned, what Lewis's great grand-nephew observes of works like *The Bouquet* applies equally to the indoor harem scenes: "They are intended presumably to shew ladies of the harem, but apart from their costumes they might all be taken for the vicar's wife in a country-garden in England."[28]

Of course, that hypothetical vicar would have been expected to confine himself to a single wife, but even on that score these Victorian images tend to equivocate.[29] As one sharp observer has noted, works like *Hareem Life, Constantinople* give rather ambiguous signals where polygamy is concerned — suggesting by the women's similar dress and facial types that they are "more or less peers" and hence both consorts of the absent master, even as their positions and other cues (such as the different fans in this painting) imply a relation of social hierarchy (fig. 40).[30] Though Lewis would have been well aware that the first wife in a harem often lorded it over the others, he nonetheless enabled his contemporaries to read this hierarchical relation as that of mistress and maid. Indeed, a number of Victorian critics managed to see the standing figure as an "attendant" rather than a second wife — an interpretation all the more plausible when

such a figure is represented as actually engaged in service, as in the Cairo harem the following year (fig. 41).[31] Even the gesture in *Indoor Gossip* by which one of the principals holds out a necklace for the other lends itself to such a reading, though the presence of the listening figure who lurks in the shadows to the left tends to reinforce the suggestion of intimacy between equals (fig. 42). That all these women are decorously if sumptuously clothed also minimizes the erotic associations of their plurality. Without quite effacing the representation of polygamy, in other words, Lewis permitted the Victorian viewer to associate his harems with home.

The domesticity of such images is as much an effect of aesthetic as of social conventions, however. From the first, commentators on Lewis's work have vaguely registered the presence of Dutch and Flemish influences; and both the illusion of reality his paintings convey and their peculiar serenity clearly owe something to his early study of the Northern masters.[32] So, too, does what has been aptly termed the "sub-tow of familiarity" in Lewis's images, though the particular precedent they recall has varied from viewer to viewer.[33] While the meticulous execution of the first *Hhareem* prompted one critic to compare it to interiors by Neefs and Steenwyk, and Ruskin, reverting to an earlier period, repeatedly invoked the work of Van Eyck, more recent commentators have tended to associate Lewis's art with the domestic images of Terborch and Vermeer.[34] Especially when he subordinates narrative content to what an influential study has called the "art of describing"[35] — as he does, for example, in works like *Hareem Life, Constantinople* or *Indoor Gossip* — the British artist appears to filter his Eastern scenes through a lens partly borrowed from the seventeenth-century Dutch. Indeed, for the Victorians, as for us, the faint sense of recognition such images evoke may be as convincingly explained by the tradition of Dutch genre painting — and by the homely associations of that tradition — as by any immediate resemblance between Lewis's exotic interiors and domestic arrangements in the West.

Though Vermeer's comparative obscurity until the final decades of the nineteenth century makes it uncertain how directly Lewis would have encountered him, a comparison with that great master of the Dutch tradition is nonetheless instructive. Like Vermeer, Lewis repeatedly represents female figures absorbed in the ordinary activity — or inactivity — of daily life; and like Vermeer, he often poses their relatively static forms by the light of an open window or lattice, as if the wish to study that light were as strong a motive for arranging his pictures as any story the pictures might tell. Like Vermeer, too, Lewis typically exploits the echoing rhythms of walls, windows and mirrors, both in relation to one another and to the

picture that frames them. Though the principal woman in *Hareem Life,*
Constantinople (fig. 40) is noticeably more idle than her counterpart in
Vermeer's *Woman Writing a Letter, with Her Maid*, for example (fig. 45),
the images resemble one another not only in their concentrated attention
to interior light, but in the quiet pose of the attendants and the prominent
rectangles against which the busts of those attendants are juxtaposed.
So, too, Lewis's play with the mirror here or in *Indoor Gossip* (fig. 42) might
easily remind us of Vermeer's similar use of mirrored images in pictures
like his *Lady at the Virginals with a Gentleman* (fig. 46). (Though there are
of course no gentlemen in Lewis's harems, at least one contemporary
viewer took for granted that the "advancing feet" reflected in the mirror
of *Hareem Life* belonged to a person of the opposite sex — "the guardian
of the sequestered beauties, or, it may be, their lord and master.")[36] Even
the Dutch fondness for Oriental carpets — and the painters' fondness
for depicting them — may have contributed to the sense of recognition
prompted by Lewis's more exotic interiors. By comparison with the
calculated simplifications of a Vermeer, the minute detail of Lewis's
surfaces can seem unduly elaborate; yet if the British painter is hardly
the equal of the Dutch master, the relative openness of these Victorian
harems, their lack of claustrophobia, may well owe something to another
trick he learned from his predecessors — the practice of keeping large
areas of the canvas free of the human figure.

Above all, it is the daylight suffusing these interiors that dispels the
sensation of oppressiveness conveyed by so many other representations
of the harem. Though modern historians have speculated that Lewis
may have found inspiration for his subject by seeing Delacroix's *Femmes*
d'Alger or Ingres's *Odalisque à l'esclave* in the 1830s,[37] a quick glance at
both paintings will confirm how little his images retain of their cloistered
sensuality (figs. 5 and 12). Unlike Ingres's mysterious source of illumina-
tion, Delacroix's handling of light and shade clearly implies the existence
of a window; yet by comparison with Lewis's sun-drenched harems, even
the *Femmes d'Alger* is shrouded in obscurity. Daylight may pierce
Delacroix's harem, but the aperture by which it does so remains invisible
to the viewer. Nor does it seem to penetrate the shadowy corners of the
place, whose walls retain a solidity very different from the glowing
glass and airy lattices of *The Reception*, for example (fig. 38). At its most
intense, in fact, Lewis's light almost manages to melt the walls of the harem
altogether — as the shimmering surfaces of *Indoor Gossip* virtually dis-
solve in the bright radiation of the sun (fig. 42).

Note, too, how both Delacroix and Ingres exploit the horizontal

orientation of their canvases to increase their sense of harem confine-
ment: though neither represents the ceiling as such, the narrow intervals
that divide their standing figures from the upper edge of the frame
produce an impression very different from the liberating spaciousness
of the corresponding distances in *Hareem Life, Constantinople,* or *Life
in the Harem, Cairo* (figs. 40 and 41). The dominant verticals of the latter
undoubtedly contribute to the effect, but the contrast is equally striking
if one looks at a Lewis painting that more nearly approaches the relative
proportions of the French: by placing the figures in *The Reception* at a
considerable distance, and by reserving more than half the canvas for the
airy spaces that soar over their heads, the artist assures that the scene con-
veys the very opposite of low-ceilinged oppressiveness (fig. 39). And like
the open windows of the Constantinople and Cairo harems, the open
lattices in *The Reception* further help to dissipate any suggestion of exces-
sive constraint.[38] The very fact that Lewis also painted a number of garden
scenes like *The Bouquet* or *In the Bey's Garden* (1865) emphasizes the easy
commerce between inside and out that characterizes his harem (figs. 44
and 47). This is not to say that he represents the women as free to wander
where they please, but that his images of the place typically evoke a sense
of privileged seclusion rather than airless imprisonment.[39] It is perhaps
fitting in this connection that *The Bouquet* — then known as *Lilies and
Roses* — was apparently purchased by Ruskin's father, while the son
would soon pay his own tribute to glorified domesticity in "Of Queens'
Gardens."[40]

 In the end, one suspects, Lewis cared more for the visual pleasure of
his painted surfaces than for the subjects they represented: both his
apparent lack of interest in individual portraiture and the absence of
moralizing in his harem images suggest that what repeatedly drew him
to such scenes was above all the occasion they offered for abstract pattern-
making and for experiments with light and color. As early as 1855
Théophile Gautier thought he saw in Lewis not only "the qualities of a
European artist" but "a Chinese patience and a Persian delicacy" — which
vaguely Oriental attributes he associated with the painter's skill in the
execution of silks, embroideries, flowers, arabesques, and latticework,
among other elements.[41] Though it is difficult to separate Lewis's imita-
tion of Eastern art from his representation of Eastern fabric and
architecture, subsequent critics have speculated that he was indeed
influenced by the tradition of Islamic miniature.[42] Certainly a painting
like *The Reception* confirms how much he delighted in the geometric
and organic designs of his Cairo house and how ready he was to subordi-

nate the human figure to their evocation on canvas (fig. 39). For all their familiarity, in other words, Lewis's pictures would clearly have retained a measure of strangeness for the Victorian viewer — an exotic difference inseparable from their visual appeal.

Yet even this difference was beginning to blur, as a vogue for Eastern decoration began to spread among British artists and designers in the second half of the century.[43] Six years after the great success of Lewis's first *Hhareem* at the Old Water-Colour Society, the architect and interior decorator Owen Jones published the first edition of his immensely influential *Grammar of Ornament* (1856), whose colorful illustrations of Arabian, Turkish, Moorish, and Persian motifs, among others, would inspire fashions in wallpaper and carpet patterns for several generations. To compare a plate from *The Grammar of Ornament* with a detail from Lewis's contemporaneous *Hareem Life, Constantinople* (1857) is to see how close were the visual languages these Victorian artists had adopted (figs. 48 and 49). And they were hardly alone in their enthusiasm. By the time that Lewis was painting *Indoor Gossip* and *The Reception* in the 1870s, the London firm of Liberty's was busily satisfying the popular appetite for imported Eastern fabrics and for home-made imitations of Islamic design that the firm had specially commissioned for the domestic market.[44] Without quite losing its aura of remoteness, the art of the harem was also in this sense coming closer to home.

A late painting by Lewis entitled *The Siesta* (1876) suggests just how ambiguous is the place that his domestic interiors finally occupy (fig. 50). Though it is generally taken as a harem picture, neither its Spanish title nor the solitary woman asleep on the divan obviously associates it with the harem.[45] That the woman once again appears to be Lewis's English wife, Marian, further unsettles her presumed location. Is she an odalisque, in other words, who decorously sleeps fully clothed, or merely the lady of the house succumbing to a moment of soporific pleasure? Only her costume, the latticed alcove — and perhaps the hint of opium poppies — seem to place her East of England, though whether the artist's imagination had returned to his early travels in Spain or to his ten-years' residence in Cairo is far from clear. Like everything Lewis had produced for a quarter of a century, *The Siesta* was presumably painted in his English studio, yet it is the vaguely Eastern props — and the artist's memory of how light falls through the lattices — that place this scene at a dreamy remove from its creator. What remains of the cloistered harem, ironically, is above all the memory of interior light; and what remains of the fantasy of leisure, a pleasant sleep.

Part Six
Harem Times

21

The Pastness of the Orient

antasies of the harem defy time in more senses than one. For several centuries, as we have seen, many popular representations of the place remained more or less static: though some accounts might attempt to disabuse their readers of a particular bit of harem lore — that the sultan chose his favorite for the night by tossing out a handkerchief, say, or that the purpose of serving cut-up vegetables was to prevent the women from unspeakable wantonness — others persisted in repeating the same tales and images. More fundamental aspects of collective fantasy showed still deeper resistance to the passage of time: the crucial discovery that possession of a harem need not entail polygamy had to be made again and again, while the very practice of conjuring with "the" harem effectively denied local variation and change.[1] Even the repeated disenchantment of nineteenth-century travelers did not so much put an end to harem fantasies as add another *topos* to the store.

Representations of the harem no doubt share such persistence with other forms of popular fantasizing and myth-making. Yet the seeming timelessness of Europe's fantasies about the harem cannot easily be distinguished from the timelessness often associated with the institution itself. Both as a central feature of a supposedly unchanging Orient and as a place in which the ennui of one sex and the endless waiting of the other were believed to exhaust all action, the harem could figure to Western imaginations as a place virtually outside of time altogether. Montesquieu did not mention the harem specifically when he ascribed "the immutability of religion, customs, manners, and laws in the countries of the Orient" to a prevailing "indolence" of mind and body; but the presumed inertia of those within the harem and the presumed fixity of the culture without were often associated in Western minds.[2] A century after the French

philosopher's account of Oriental immutability in the *Esprit des lois* (1748), the American author of *The Turkish Slave: or, the Mahometan and His Harem* (1850) would begin a new chapter by pointedly remarking how "the passage of time" had made no difference to his Eastern characters: from the generic "Turk," who is "ever the same," the narrative moves automatically to "the most listless and luxuriant inactivity" that characterizes the women of the harem. With the significant exception of the sultan's daughter — who has already been converted to Christianity so that she may prove the heroine of a love story — the author can imagine no function for their static figures but to serve as unconscious models for a painter: "Their forms were carelessly bestowed upon the luxuriant cushions about the regal apartment, and all thoughtless of the fact, not one of them but presented in her fair and beautiful person, and the easy graceful attitude that nature had dictated, a model for art." As in many such fictions, the lovers eventually depart for the West; but in this case the heroine is prepared for the change by being taught to view her native city less as an inhabitant than as an aesthetic tourist, when the Greek slave who will become her future husband opens her eyes to the static beauty of the scene. Like the harem, Constantinople makes "a truly oriental ... picture" — a timeless image "all still the same" years after the loving couple have left it behind.[3]

Yet for Western imaginations, the very timelessness of such scenes identifies them, paradoxically, with the past. It is no accident that the same Greek who teaches the sultan's daughter to appreciate the unchanging scenery of the East also teaches his fellow slaves to see in that landscape "the records of history." Reminded of "the romantic legends that attach themselves to these headlands" as they flee through the Dardanelles on their way to Greece, the hero instructs his bewildered crew on the famous events that once transpired in the scene about them: "Here was drowned Helle, daughter of Athamas. ... And here too, the gallant Leander perished. ... And here between Sestos and Abydos, Xerxes' ill-fated host crossed in their bridge of boats."[4] Though this litany of deaths in times gone by might seem at odds with fantasies of timelessness, the more that the East was imagined as unchanged from ancient days, the more vividly it could appear to conjure up such historical memories for the Western visitor. Precisely because they believed that it had remained fixed while they themselves had changed, Europeans who traveled East could believe themselves traveling back in time as well.[5] To confront the Orient was to confront the presentness of the past — to look directly upon the origins, both classical and biblical, of Western civilization.

The Turkish Slave is a deservedly forgotten romance, but the fact that its hero pauses in his flight from captivity long enough to read the "records of history" into the landscape suggests just how widespread were such responses to Eastern travel. His reminiscences of Leander's drowning or the destruction of Xerxes are not that different, after all, from Lady Mary's recollection of "the Epithilamium of Helen by Theocritus" at the wedding in Constantinople, or her remark to another correspondent of a visit to the ruins of Troy — "While I view'd these celebrated Fields and Rivers, I admir'd the exact Geography of Homer, whom I had in my hand." Nor was it only the Homeric past that thus re-presented itself: just as a letter to Pope observed that she had been reading his translation of the *Iliad* and found "several little passages explain'd that I did not before entirely comprehend the Beauty of, many of the customs and much of the dress then in fashion being yet retain'd," so the same letter also remarked that "the Eastern Manners give a great light into many scripture passages that appear odd to us."[6] Nearly a century and a half later, Lucie Duff Gordon likewise heard echoes of the Old Testament in the local idiom of contemporary Egypt, even as she also testified to the experience of living in several pasts simultaneously. The performance of some dancing girls dizzyingly confounded time altogether: "I never quite know whether it is now or four thousand years ago, or even ten thousand, when I am in the dreamy intoxication of a real Egyptian fantasia; nothing is so antique as the Ghazawee — the *real* dancing girls."[7]

Neither woman explicitly identified the harem with such survivals from the past, though the sight of Fatima's "fair Maids . . . rang'd below the Sofa to the number of 20" suggested to Lady Mary "the pictures of the ancient Nymphs," while the amorous tribulations of a local official prompted Duff Gordon to remark with some amusement that "the poor man is now tasting the pleasures which Abraham once endured between Sarah and Hagar."[8] As that wry allusion might suggest, Europeans had long been aware that the polygamy they associated with the harem could also be traced back to the domestic arrangements recorded in the Old Testament.[9] The amorous Boswell, after all, had been as ready to "soothe" himself "with Old Testament manners" as to be "truly Asiatic" — the temporal displacement serving, like the spatial one, both as a scarcely disguised code for his erotic activities and as their implicit justification. When Rousseau had sternly rejected the plea from "Oriental usage," the would-be polygamist had even managed to suggest that a due sense of historical reverence required the practice: "Still, I should

like to follow the example of the old Patriarchs, worthy men whose memory I hold in respect." Elsewhere in the journals, he had continued to meditate on the subject: "If it was morally wrong, why was it permitted to the most pious men under the Old Testament, nay, specially blessed with fruitfulness?"[10] Arguing more dispassionately, the nineteenth-century Arabist, Edward Lane, would likewise remind his readers that "the Mosaic code . . . forbade neither polygamy nor concubinage." Though Lane wished to urge tolerance for Muslim marital arrangements, rather than to imitate them himself, he shared Boswell's impulse to defend the harem by appealing to history.[11]

But it was primarily an imagined past rather than a real one with which Europeans associated the harem. For some, in fact, the very mysterious-ness of the place—its cultural distance from the West—virtually demanded to be translated as remoteness in time. So at least Racine had argued in the second preface (1676) to *Bajazet*, when he sought to justify his decision to base the action of that tragedy on recent events rather than classical leg-end. Little more than thirty years had elapsed since the incidents recorded in the play; and tragedy, Racine conceded, customarily required that its principal figures "be regarded with another eye from that with which we ordinarily view persons we have seen so near to us." Yet when the French theater represents acts that have transpired behind the walls of the *sérail*, current events, according to Racine, automatically acquire the aura of ancient history.[12]

When Racine chose to substitute the mysteries of the *sérail* for the remoteness of antiquity, it was not the sense of memory that he hoped to stimulate but the communal awe proper to tragedy: there was no pretense that a seventeenth-century French audience would otherwise associate the fall of Roxane, Bajazet, and Atalide with a recollection of the past. But for generations raised on images and tales of the Orient, imagining the harem could indeed be difficult to distinguish from remembering it — or, rather, from remembering what had already been imagined by others.[13] Those who traveled East in the immediate aftermath of Roman-ticism were especially inclined to such hallucinations of memory, as if they were not so much viewing the Orient for the first time as re-viewing it through the representations of the past. Thus Gérard de Nerval, wander-ing in Egypt and Turkey in the 1840s, meditated on the sense of *déjà vu* with which "every dreamer" confronts the Oriental city: "One has already read this in books, one has admired it in pictures . . . but what is surprising today is to find it still so like the idea of it one has formed." And only a few years after Nerval had felt himself retracing the steps of his dreams, the

young Flaubert, recently arrived in Cairo, would assure his mother in virtually the same terms that the Orient more than satisfied his anticipations of it: "Fact has so completely taken the place of premonition that it is often as if I were suddenly recovering old forgotten dreams."[14] So familiar were such encounters with the Orient that the echo hardly needs explaining, though the sources of Flaubert's youthful premonition may well have included Nerval's own report of his sojourn in Cairo.

"Anyone who looks at things with some attention *rediscovers* still much more than he *discovers*," Flaubert wrote to another correspondent at this time: "A thousand notions that one carried within oneself only in a germinal state grow and clarify themselves, like a renewed memory."[15] Hence a visit to the Sphinx, say, might register less as a new experience than as the refreshing of a memory already constituted by acquaintance with its image. But when it came to dreams of "l'Orient! avec ses sérails," as a fifteen-year-old Flaubert had put it, no travel in the East would suffice to render them definite.[16] Though Nerval would claim to have purchased a Javanese slavewoman, and the future novelist would enjoy a brief affair with the celebrated dancer, Kuchiouk-Hânem, a nineteenth-century Frenchman was not likely to find himself behind a harem's walls — still less likely to find himself retracing the steps of its master. "I have seen this dance on old Greek vases," Flaubert observed in his notebooks after watching Kuchiouk-Hânem perform; but despite his repeated sensation that in watching Egyptians dance he was viewing "the old Orient" ("which is always young because nothing changes there"), he said nothing of renewing any memory of the harem in his travels.[17] Though he continued to associate the harem with the past, it was not a past of lived experience but of dreams necessarily impossible to satisfy.

So visions of the harem would briefly recur in Flaubert's last completed novel, *L'Éducation sentimentale* (1869) — itself a narrative largely dedicated to the inevitable frustration of youthful yearnings. In an early chapter of that novel, published nearly two decades after the author's voyage to the Orient, the young protagonist and Flaubertian alter-ego, Frédéric Moreau, shares his quarters in Paris with his fellow provincial and best friend, Charles Deslauriers. Both men have arrived in Paris with grandiose, if vague, anticipations of the future; but while the ambitious Deslauriers would have liked "to make a great deal of noise, have three secretaries under his command, and give a big political dinner once a week," the dreamy Frédéric "furnished a Moorish palace for himself, so that he might live reclining on cashmere divans, by the murmur of a fountain, attended by black pages; and these dreams became at the

end so vivid to him that they desolated him as if he had lost them."[18] If a vision of the harem comes to resemble a memory, in other words, it is a memory of gratifications lost because impossible to be had. What matters here, as in the more famous passage that closes the novel, is the imagination of loss — the "as if" that repeatedly locates an illusion of happiness in the past.

This is not the only evocation of the harem to surface in the narrative. When Frédéric first encounters his beloved Madame Arnoux, a harpist is playing "an oriental romance, a question of daggers, flowers and stars"; and soon after he constructs his Moorish palace, he sometimes "dream[s] of her in yellow silk trousers on the cushions of a harem." In a later scene, a roomful of "half-naked" women in evening dress briefly conjures up "the interior of a harem"; in another, the courtesan Rosanette reclines on a divan in vaguely oriental costume, smoking a Turkish pipe, and leans her head on Frédéric's shoulder, "with the air of a slave full of provocations." At the close of the novel, Frédéric and Deslauriers look back over their lives from the vantage of their subsequent disillusionment, in a passage that deliberately evokes their early dreams of political dinners and Moorish palaces. "They had both failed," we are told, "he who had dreamed of love, and he who had dreamed of power." To the refrain of "do you remember?" the men "exhume" their past together, until they finally arrive at a memory that figures for both the moment when they "had it best" — a moment of adolescence when they made their first visit to a local brothel. While this is not quite the memory of a harem, it is nonetheless a memory of venturing "chez la Turque" — a woman whose real name was "Zoraïde Turc," and whom "many people believed . . . a Muslim, a Turk, which added to the poetry of her establishment." Projecting a "fantastic radiance," in the narrator's telling phrase, and always spoken of in periphrases — "the place you know, a certain street, below the Bridges" — this magical place "was, needless to say, the secret obsession of all the adolescents"; and on the evening in question, the two young men gathered some flowers from the garden of Frédéric's mother and stole by a roundabout way into the house.[19]

For a pair of provincial adolescents, such an experience was rather more commonplace than dwelling in a Moorish palace, yet the scene these old friends are about to recall, it is important to note, has never been actually represented in the narrative: located at a time several years before the novel's opening, it is a moment that exists, as far as the reader is informed, only in memory. And though contemporary readers were scandalized at the suggestion that the best moment of a man's life was

his first visit to a brothel,[20] what Flaubert's protagonists conjure up so nostalgically is not the experience of erotic fulfillment but only a moment of anticipation: Frédéric presented his bouquet, "like a lover with his fiancée," but "the heat of the day, the fear of the unknown, a kind of remorse, and even the pleasure of seeing, with a single glance of the eye, so many women at his disposal, moved him so much that he grew very pale, and stood without advancing, without saying anything."[21] As the entire company bursts out laughing, delighted with his embarrassment, the young man takes to his heels, and Deslauriers is obliged to follow. If "the pleasure of seeing, with a single glance of the eye, so many women at his disposal" resembles the pleasure of a harem, it is a pleasure reserved, Flaubert suggests, for the imagination alone — an elusive dream of fulfillment that can only be registered as happiness lost.

What Flaubert subtly ironizes here, Loti embraces in deadly earnest. It is just because Loti identifies the Orient with the past that he returns to it again and again, and just because he imagines its women as already lost to him that he keeps falling in love with them. The French journalist who inspired Loti's last novel by masquerading as a woman of the harem knew exactly what she was doing when she professed to become "a thing of the past" by committing suicide in the end.[22] Not only did she thus complete her identification with the long-dead Aziyadé, the novelist's first love from the harem, but she simultaneously turned herself into that "dying" Orient for which he was already yearning nostalgically while that first love yet lived. Indeed, despite the fact that the narrator of *Aziyadé* (1879) actually consummates an affair with his Circassian, his relation to the Orient is every bit as phantasmic as that of Flaubert's provincial protagonist. Though the novel ostensibly tells of a youthful liaison between a British naval officer stationed in Constantinople and "the youngest and prettiest" member of a Turkish harem, its world-weary hero, who feels himself "terribly old" at twenty-six, can scarcely approach either his childlike mistress or the Orient she embodies without anticipating their end.[23] And though it takes the form of a journal purportedly kept at the time, its characteristic tense, as several critics have noted, is the *passé simple* — as if even the experience of the moment were already a matter of retrospect.[24] "I am happy," the narrator unexpectedly announces in a letter to a friend, only to dissolve that happiness at once into foreknowledge of loss: "I sense that the present hour is but a reprieve of my destiny, that something funereal hovers over the future, that the happiness of today fatally brings on a terrible tomorrow."[25] As in so many of his subsequent novels, Loti's protagonist appears to make love only to mourn its passing.[26]

While the end of Aziyadé was an invention of the novelist, Loti returned to Constantinople ten years after the affair to discover that in this case life — or rather, death — had duly imitated art. As his sequel to the novel, *Fantôme d'Orient* (1892), represents it, this was no chance discovery but the fulfillment "at once sweet and infinitely desolating" of all he had both desired and foreseen. And still more emphatically than the original, the sequel associates the beloved's death with a past that divides East from West. Between the time that purportedly separates one modern Frenchman from the "ancient Orient" with its "unchanging dreams" and the time that finally separates all lovers in the end, Loti's imagination characteristically registers no difference, as he meditates on the "impossibility, and the fatality of seeking for love down there."[27] Some years after the feigned suicide enabled him to reiterate that fatality at the close of his last harem novel, the novelist once again went in search of those who had gone — a category that now included not only Aziyadé herself but "even the *other one*," in his words, "who later in her turn a little engaged and troubled me," and who "seems to have vanished forever, she too, in the mystery of sequestration or in death."[28] The hesitation in the final phrase may again imply that Loti was not entirely convinced by the story Hélys had spun for him. Yet the more he suspected that the *désenchantées* were not all they had seemed, the more deliberately he appears to have chosen not to penetrate the mystery. *Suprêmes Visions d'Orient* (1921) recorded no discovery of a gravesite to match the culminating revelation of its predecessor, but even when its author had the chance to pursue his quest with one of the other *désenchantées*, he seems to have conspicuously refrained from inquiring as to the whereabouts of "Djénane's" tomb.[29] If the "mystery of sequestration or . . . death" suggests that Loti did not altogether believe in the suicide letter, it also suggests that for the purposes of making the beloved "vanish . . . forever" in his imagination, the bars of the harem had the same force as the barriers that separate the living from the dead.

Few writers have been so determined on "felicity in sadness," in Henry James's phrase, as this nostalgic Frenchman.[30] But a brief passage from James himself suggests that a mood of retrospect might conjure up the harem for a very different kind of novelist. Cosmopolitan though he was, James had never visited Turkey; nor, needless to say, did his own past include anything resembling an affair with a woman from the harem. His rare allusions to "the seraglio" are purely figurative — as when his early novel, *The American* (1876), says of the houses in the Faubourg St. Germain that they "present to the outer world a face as impassive

and as suggestive of the concentration of privacy within as the blank walls of Eastern seraglios," or when the same novel later extends the comparison by identifying the heroine's proud and secretive brother (himself a resident of the district) with the "Grand Turk."[31] In this early novel, the walls of the harem briefly figure the barriers that exclude a naive American from the mysterious and rather sinister world of some European aristocrats. Yet when James returned to the figure more than thirty years later, it was a temporal rather a cultural distance that fascinated him, and the mysteries in question were those of his own past as a writer. Commenting on the process of revision he had undertaken for the so-called New York Edition of his novels and tales (1907–09), he paused to remark, as he often did, how the act of looking over old work evoked memories of the circumstances in which it had been written. The passage appears in his 1908 preface to *The Spoils of Poynton* (1896–97), and though in this case he was turning pages he had composed only a decade earlier, his memories of that process appear momentarily to have eluded him:

> They lurk between the lines; these serve for them as the barred seraglio-windows behind which, to the outsider in the glare of the Eastern street, forms indistinguishable seem to move and peer; "association" in fine bears upon them with its infinite magic. Peering through the lattice from without inward I recapture a cottage on a cliff-side....[32]

For the briefest of moments, James feels himself an "outsider" to his own past, as the very lines of his text metamorphose into harem lattices, while the memories in question take the indeterminate shapes of the harem's inhabitants. Yet he has scarcely constructed his metaphorical seraglio when the obstacle it figures seems to vanish along with the seraglio itself: peering through the lattice, he sees not the interior of an Oriental palace but the small seaside cottage in England to which he had retreated one summer to finish his manuscript. Rather than "the glare of the Eastern street," the remainder of the passage returns him securely to the "dense summer shade" of an umbrella-like ash tree, under whose "exquisite protection," as he recalls, "'The Spoils of Poynton' managed more or less symmetrically to grow."[33] But if the English past appears to have been restored in good form, James's brief glimpse of the harem nonetheless serves to complicate this consoling memory. Behind those barred seraglio windows, after all, "forms indistinguishable" only "*seem*

to move and peer": what the outsider sees is not the harem itself, but the work of "'association' . . . with its infinite magic." Accounts of the harem, James knows, remain the outsider's fantasy — perhaps especially when he imagines that its inhabitants "peer" back at him. Behind the lines of his text, the novelist may appear to recover the past; but to suggest that his memories resemble the harem is to acknowledge that they too are mere phantasms, born through the "infinite magic" of the mind.

22

The Lesson of the Bain turc

It is not only by association with the past that images of the harem seem to resist the laws of time. For a Western man committed, at least officially, to the rule of monogamy, the idea of the harem could hold out the prospect of a fantastic simultaneity — the illusion that he might in every sense possess many women at once. Rather than one woman forever, or at least one woman at a time, imaginary harems tantalize their creators with the dream of abolishing limits both physical and temporal. When Lady Hamilton reported that in Morocco, "it is no uncommon circumstance for princes to have four or five thousand at one time," she presumably did not intend a literal reference to the princes' sexual activities; but the more bodies rumor placed in the harem, of course, the more extravagant such fantasies might become.[1] Though a late nineteenth-century British journal would solemnly dismiss the entire project by remarking, "how possible it is for a man to love even two women at the same time, and in a similar degree, is the test and condemnation of so dreadful a system," others evidently delighted in contemplating such impossibilities.[2]

So the novelist Robert Bage, for example, had clearly amused himself in *Hermsprong; or, Man as He Is Not* (1796), by imagining how an English banker might converse with his wife and daughter on the latest synchronic achievement in the Ottoman palace:

> "There is very extraordinary news from Constantinople, my dear," said the banker; fifty of the grand Signior's wives were brought to bed in one night."
> "Fifty! Mr. Sumelin," said the astonished lady.
> "Fifty," replied the banker.

Though the banker goes on to imply that a skeptical view of the women's fidelity might yield a more plausible explanation of all these simultaneous births than the fantastic powers of the Grand Signor, neither his cynicism nor his creator's quite cancels out their investment in this passing fantasy. As Mr. Sumelin tells it, the mufti diplomatically resolved the delicate situation by ruling that "if God pleased, all the women in the world might be brought to bed in one night."[3] Bage apparently enjoyed the joke about harem numbers, since he had already indulged a variant of it in *The Fair Syrian* (1787), where the knowledgeable heroine describes an old Turk with "only one hundred" as "very moderate in matter of women."[4]

The comic prodigality with which some Europeans populated their imaginary harems bespeaks a certain recognition of the practical difficulties such numbers impose, yet it also testifies to their continued pleasure in the very extravagance of their fantasies. The narrator of *Don Juan* (1819–24) has no sooner pictured the "thousand bosoms" in his imaginary seraglio "Beating for love as the caged birds for air," than he pauses to confess the wishes they inspire in him:

> I love the sex, and sometimes would reverse
> The tyrant's wish, "that mankind only had
> One neck, which he with one fell stroke might pierce:"
> My wish is quite as wide, but not so bad,
> And much more tender on the whole than fierce;
> It being (not *now*, but only while a lad)
> That Womankind had but one rosy mouth,
> To kiss them all at once from North to South. (6:26–27)

In this version of the fantasy, the temporal problem is solved by a dream-like merging of body parts — that "one rosy mouth" that would enable the would-be lover "to kiss them all at once from North to South." Not that the fantasy quite stops at simultaneous kissing:

> Oh enviable Briareus! with thy hands
> And heads, if thou hadst all things multiplied
> In such proportion! — But my Muse withstands
> The giant thought of being a Titan's bride,
> Or travelling in Patagonian lands;
> So let us back to Lilliput.... (6:28)

Having transformed the mouths of all womankind into a single orifice,

the poet evidently contemplates a metamorphosis of his own. Yet whether he wishes that his organ would multiply like the hundred hands of Briareus or merely swell to the giant's proportions is far from clear — perhaps because the imaginary consequences of either transaction are impossible to sustain. It is not a sense of propriety but of tact that prompts Byron's "Muse" to cut short the fantasy.

Though pornography is predictably less shy about specifying the anatomical detail of its scenarios, even *The Lustful Turk* (1828) scarcely approaches the mirage of simultaneity before the narrative of the Dey's erotic career is abruptly terminated. Despite its harem setting, most of the novel consists in the recounting of sequential seductions, as one woman after another falls under the spell of the amorous hero. While we hear from an international selection of his previous conquests, most of the Dey's own attention is devoted to subduing each of the two English heroines in her turn. Only toward the very end does *The Lustful Turk* take advantage of its harem setting to place its hero in the same room with more than one woman at a time; and even then, this fantasy of sexual athleticism can apparently encompass no more than two — with each of whom, as Emily reports, "the Dey would often amuse himself . . . alternately." Though she describes some adroit maneuvers on his part by means of which, in her words, "we were frequently (all three) dissolved at the same time in a flood of bliss," she still speaks of the Dey himself, inevitably, as taking his pleasures in sequence. And no sooner has the novel reached even this minimally synchronic climax than its erotic imagination is apparently exhausted: the very next paragraph brings on the Greek girl with her knife, as Emily recounts the "awful catastrophe," as she says, which "put an end to our enjoyments."[5] We might recall how Gérard de Nerval wistfully speculated that the Egyptian viceroy might enjoy something like the Dey's final happiness, and how rapidly he was disabused of his illusion: when his guide protested that a Muslim woman would no more divide the "honor" of her husband's bed than would a European wife, Nerval sadly bid farewell to his fantasy. But we do not need the sheik's defense of Muslim womanhood to recognize that the nebulous "ideal" Nerval reluctantly abandoned will always prove to dissipate on closer inspection.[6] The tantalizing dream of simultaneous possession will always be defeated, in other words, by the limits of the body and the requirements of narrative.

Yet another fantastic illusion haunts some harems of the mind: that a man might somehow escape death itself through the endless renewal of his women. Like the imaginary conquest of time that might be called

harem synchronism, this is, needless to say, an exclusively masculine fantasy. And like such synchronism, it is less a wish to be articulated than a mirage bound to vanish on closer inspection — though a mirage conjured up by the real conditions of the harem. For if the dream of simultaneous possession measures time by the very disproportion of the sexes that constitutes the harem in the first place, the dream of immortality derives its measure from the comparative freedom of the one sex to replace the other at will. "Those who are weary of their Wives, may turn 'em away when they please, paying their Dowry," as one seventeenth-century Frenchman summed up the practice of Turkish divorce. "'Tis pity that we have not such a Fashion in *Christendom*; for if we had, I believe we shou'd see many a *fatal* Knot unty'd."[7] Though undoing a "fatal" knot is by no means the same as eluding fatality, the masculine wishfulness of the remark is all too evident. A man need only speak the words, after all, (and return part of the dowry) to obtain a divorce, while nothing but a lack of funds could prevent him, theoretically at least, from purchasing as many new concubines as he wanted.[8] As for the Ottoman court, rumors had long circulated of a custom by which aging women and those who failed to please the sultan were retired, together with the harem of the previous ruler, to a building known as the Old Palace — not a palace of the old, it should be said, but one that had been replaced by a new structure in the middle of the fifteenth century.[9] If the feminist insight of Manley's *Almyna* (1706) is to be credited, even the frame tale of the *Arabian Nights* may have contributed to the fantasy, since Schahriar's determination to take a new woman every night only to kill her the next morning can be read as a bloody exaggeration of the usual male privilege — a ritual sacrifice of the sex "born to Dye," whose unconscious aim, as the playwright brilliantly demonstrates, is the "Immortal Life" of the other.[10]

It may not be chance, in fact, that those who come closest to spelling out the logic of this fantasy are its female critics. In an Oriental tale published sixty years after *Almyna*, Frances Sheridan took advantage of the magical associations of the genre to imagine what might follow if a man were actually granted his wish for immortality. The eponymous hero of *The History of Nourjahad* (1767) is an ambitious young man, "the rising star of the Persian court," who one day unguardedly betrays to the sultan his longing for "inexhaustible riches" and a "life prolonged to eternity." When he confesses that he would willingly forego his hopes of paradise in exchange, the sultan sternly dismisses him from his confidence; but that evening a "guardian genius" arrives to grant his wishes, stipulating only that if he abuses these gifts, he will be punished by a sleep that may

last for many years. Nourjahad immediately plunges into the gratification of every appetite — the first of which calls for a "seraglio" of so many "beauties" that "King Solomon himself shall be outdone." Though the constant renewal of this "seraglio" proves not so much the means of Nourjahad's immortality as its consequence, by the end of the tale he will have learned to reject the dream of endless variety for the love of a single woman and the death from which such love is inseparable.[11]

Sheridan's plot requires that her protagonist's excesses never entirely obscure his capacity for redemption; and an early sign that he is not altogether lost to morality as she conceives it is his impulse to choose from "amongst the beauties of his seraglio" one woman to whom he gives "the intire possession of his heart." Since "by Mandana he found himself equally beloved" — "a felicity very rare amongst Eastern husbands," as the narrator dryly reports — the first real blow to Nourjahad's complacency comes when he wakes after an orgy of drunkenness to discover that he has been asleep for several years and that Mandana is dead. Only then does he begin to question the harem principle by which he had imagined he could extend his amorous life forever:

> I knew indeed I must of necessity bury hundreds of succeeding generations; but said I to myself, I shall insensibly contract new amities, as I perceive the old ones are likely to be dissolved by the hand of time. My heart, said I, shall never feel a vacuity, for want of fit objects of desire. A new beauty will naturally take place of her whose charms begin to decline; thus the ardors of love will be supplied with perpetual fewel I considered the world as a flower garden, the product of which was to delight my senses for a certain season. The bloom is not made to last, thought I, but it will be succeeded by a fresh blow, whose sweetness and variety will equal the former, and intirely obliterate them from my memory. I thought not, alas, that before the spring ended, a cruel blast might suddenly destroy my fairest flower.[12]

Despite this passing recognition, Nourjahad is soon embarked on a still more audacious project: an extravagant masquerade of the afterlife, in which his gardens are to mimic paradise, while the women of his harem "personate" the houris ("those beautiful virgins who are given as a reward to all true believers"), and he himself takes the part of Mohammed. His very existence, of course, already amounts to just such a travesty; and the fact that his orders for this "terrestrial paradise" entail a further defiance of time by which the seasons are to be "anticipated," so that his gardens

can include every stage of fruit and flower simultaneously, only makes the entire project a more vivid figure of his delusion. When Nourjahad awakes from the extended sleep that inevitably follows this profane experiment, he finds, as we might expect, that time has once again defeated him: "the beautiful Houriis" have become "a train of wrinkled and deformed old hags." In a comic variation on the theme, he orders up "a new race of beauties" in their stead and finds to his dismay that the taste in female appearance has "quite altered" during the interval. "Were I and my companions, whom you once so much admired, to be restored to our youth again, we should not now be looked upon," a former favorite ruefully informs him: "such is the fantastic turn of the age." Even the attempted murder which occasions Nourjahad's last sleeping punishment partakes of the gendered logic by which one sex alone is expendable, since he angrily stabs this same aging slave when she denounces him as "not fit to live."[13]

Like other British examples of the genre — Samuel Johnson's *Rasselas* (1759), most notably — Sheridan's Oriental tale is at heart a moral fable about "the vanity of all earthly enjoyments"; and though most readers are likely to register the moral long before the protagonist, not until the end do they share his discovery that he has been literally subject to an illusion — an elaborate ruse staged by the sultan to test and reform him. He has not in fact slept for decades at a stretch but only for ordinary periods, nor has time aged his former harem or killed off his beloved: the wrinkled old hags were just some elderly women hired for the purpose, while far from being dead, Mandana has been watching over him as his "guardian genius." The sultan himself has impersonated the loyal male slave whose fortitude in the face of death prompted Nourjahad's fervent prayer that he likewise return to "the common lot of mortals" — the condition, we now realize, to which he has been subject all along. Even as Sheridan thus arranges for a happy ending, in other words, she drives home the reality principle that her hero's fantastic ambitions have violated. And even as she opposes his "dream of existence" to the ordinary limits of human life, so she contrasts the perpetual renewal of the harem to the love of the singular individual — an individual defined by the mortality that renders her irreplaceable. Though Sheridan understands Nourjahad's impiety to encompass far more than his relation to his harem, she never loses sight of the fact that his defiance of death also entails a casually dismissive attitude toward women. Just as she imagines that the unreformed Nourjahad would find himself "insensible" to "a fine elegy written by a lover on the death of his mistress," since he cannot identify with the elegist's

despair of replacing her, so she represents a newly chastened hero who apparently welcomes the limits both of death and monogamy. At the tale's close he is rewarded with the "amiable Mandana . . . for a wife," and we hear no more of the harem.[14]

Only in visual images have artists succeeded in giving something like form to the masculine fantasy of eluding time through the harem — and even then, only by radically translating its terms. Thomas Rowlandson's bawdy etching *The Pasha* (after 1812) has no difficulty imagining women ready, if not eager, to divide the sexual attentions of their master (fig. 51). Yet for all the blatant suggestiveness of Rowlandson's print, it still remains, crucially, an image of anticipation — its excitement that of a simultaneity which appears possible only because its arrested time assures that the pasha, like the viewer himself, will never have to choose. And though the awkward intertwining of these figures may begin to resemble the dreamlike merging of body parts in *Don Juan*'s version of the fantasy, that very awkwardness also produces its share of physical comedy, as if the artist wished to remind us of the still clumsier contortions that would attend any effort to carry out their impossible project. The sketchy figure to the left alone escapes the general awkwardness; but she exists, one might say, solely for the delectation of the viewer. Even in this relatively crude work, in other words, Rowlandson implies what he concisely demonstrates in the *Harem* we have already examined (fig. 25): only the eye can possess countless women simultaneously. Though the Oriental male who sits alone in the latter picture "has" all his women only by never having them, his position coincides, the image wittily suggests, with that of both artist and viewer.

Had Rowlandson's *Harem* not preceded the great outpouring of harem images on the other side of the Channel, it would be tempting to read the British satirist as mocking not only a widespread fantasy of his own sex but the erotic tease of much French art in particular — a tease which often depended on permitting the eye to take in more than one naked woman at once. Ingres's *Bain turc* (1862–63) follows Rowlandson by half a century, but from the stylized gestures of individual figures to the frieze of women in the rear and the truncated forms that imply still more women just beyond the canvas, its crowded interior amply confirms the satirist's prescience (fig. 13). Just as the sketchy marks by which Rowlandson indefinitely extends his female company might be read as a comment on the difficulty of arriving at an accurate count of Ingres's women, so the obvious erection of the male provides a bawdy reminder of the voyeurism that images like the *Bain turc* leave altogether implicit.[15]

Yet Ingres's art has its own means of signaling its status as fantasy. Rather than invite us to mistake an erotic dream for reality (as does, say, the typical production of an Orientalist painter like Gérôme), the formal arrangements of Ingres's work have long encouraged sensitive viewers to remark the dreamlike quality of his images. "Le peintre a représenté son rêve," the marquis de Custine shrewdly observed of the just completed *Odalisque à l'esclave* in 1840: "il n'a ni fait ce qu'il a vu, ni vu ce qu'il a pensé."[16] When in 1855 Baudelaire wished to describe the general impression produced by the painter's work, he wrote, not altogether sympathetically, of the "conscience d'un milieu fantasmatique . . . plutôt d'un milieu qui imite le fantasmatique: d'une population automatique et qui troublerait nos sens par sa trop visible et palpable extranéité."[17] The *Bain turc* had not yet appeared when Baudelaire reached for a neologism, "extranéité," to convey the strangeness or unreality of the painter's images, but the sense of disquiet he sought to evoke is only confirmed by this final dream of the harem. To adopt a related characterization of the *Odalisque à l'esclave,* it is "an orientalist fantasy *avowedly* presented as such."[18]

Critics since Baudelaire have remarked the persistent tension in Ingres's work between his sensuous depiction of his subjects and the highly stylized linearity of their forms—between the illusion of spatial depth and bodily substance, on the one hand, and an almost abstract insistence on the two-dimensional surface of the canvas, on the other. What has been termed "the irrealising effect" of this tension between three dimensions and two can be felt everywhere in the *Bain turc.*[19] The very multiplying and crowding of figures intensify the effect, as the sensuous immediacy of the women's contact with one another is countered by the abstract rhythms of the painting's curvilinear design, the three-dimensional reality of their intertwined bodies unsettled by the flat arabesques of the shapes that define them. Note, for example, the impossible space inhabited by the three women to the right, two of whose figures twist oddly toward the picture plane so that their curves may rhythmically echo one another on the surface of the canvas, while the head of the woman with the diadem floats dreamlike between them. Nor is any plausible space allotted to the torsos of the two slaves behind them. As in the *Grande Odalisque,* whose magnificently curving back prompted contemporary viewers to complain of her extra vertebrae, Ingres willingly distorts the human form to accommodate the demands of his design. A preliminary study of the woman with her hands behind her head makes clear where her right arm would more naturally fall and how anatomically implausible is the gesture by which her arms now rhyme with those of the dancer on

the left (fig. 52). Like other figures in the painting — like the scene as a whole, in fact — she unsettles any attempt to read her illusionistically, to see her as fully present in some real time and space. Ingres's crowded canvas may allow the eye to take in more than two dozen women simultaneously, yet even this tantalizing image of harem synchronism everywhere reminds the viewer that its pleasures necessarily depend on the work of art.

But the true advantage, and I believe the motive, of such a fantastic gathering of women as the *Bain turc* is the escape from death. "'Tis no less than Death for a Man to be found in one of these places," Lady Mary had pointedly concluded her famous description of the naked bathers at Sofia; and the warning was duly registered when Ingres transcribed her account into his notebooks more than a century later.[20] While the evidence suggests that the artist first copied Lady Mary's letters sometime in the 1830s, only after several decades had passed did he permit himself to venture imaginatively upon the scene her warning accompanied.[21] The result, of course, was his greatest harem painting; and when he signed and dated his final version of that painting in 1862, Ingres was eighty-two years-old, a fact he thought of sufficient importance to record in Latin after his signature.[22] Having waited until he was himself near death to look upon his bathers, he implicitly accepted the threatened punishment, even as his very act of painting simultaneously defied it.[23] Though he would continue to paint until his death in 1867, the *Bain turc* is his last major work. And what he chose to see in the end was not a collection of living women, but a harem of memory.

For nowhere is Ingres's celebrated habit of plagiarizing himself, of producing variation after variation on the same image or gesture, more exhaustively in evidence than in this crowded canvas. Virtually every figure in the scene echoes an earlier figure or figures in the painter's canon, and many of these in turn draw on a repertoire of bodies and gestures that derive from his practice of literally tracing the outlines of his predecessors. So the seated musician in the foreground of the painting belongs to a series of such figures that extends over Ingres's work for more than half a century: if her turbaned head and the curves of her naked back most obviously recall the figure known as the *Baigneuse Valpinçon* of 1808 (fig. 9) — a figure who herself reappears, surrounded by subsidiary bathers, in several variations of the 1820s (e.g., fig. 11) — the coy angle at which one breast reveals itself to the viewer repeats that of a still earlier image, the so-called Bayonne *Baigneuse* of 1807 (fig. 53). At the same time, by transforming her into a musician, Ingres also evokes the seated performer of his *Odalisque à l'esclave* of 1839 (fig. 12), this in turn produced in at

least two versions; while the turban itself can be traced back to Raphael's portrait of *La Fornarina*, whose image surfaces repeatedly in Ingres's work. One of the faces that gaze so absorbedly at the musician, that of the woman with the hand at her breast, earlier served for an angel in the *Voeu de Louis XIII* of 1824 (fig. 54) and appeared yet again in the unfinished *Age d'or* of 1862.[24] The woman in the rear who extends her goblet to a slave imitates with her other hand a gesture Ingres had previously adopted for his portrait of *Madame Moitessier* in 1856 — a gesture that can in turn be traced back to a Roman fresco of Hercules and Telephus (figs. 55 and 56). (Like other figures in the *Bain turc*, however, the woman with the goblet owes her general posture to a previous engraving of a Middle Eastern type, in this case one that appeared in a collection of such prints published in Paris in 1714 and 1715. From an illustration to an eighteenth-century volume on travels in Turkey, Ingres took the pose of the woman who rests with her arms behind her head in the right foreground of the painting; still other prints on Eastern themes supplied the prototypes of several of the figures who crowd the space in the rear. Typically, he adapted these figures to his scene by reproducing their postures while removing their clothes, though from one anonymous sixteenth-century engraving whose subject was quite close to his own — that of a Turkish woman on the way to the bath — he retained the headdresses of both mistress and slave.)[25]

"Raphaël, en imitant sans cesse, fut toujours lui-même":[26] Ingres's often-quoted tribute to the painter he regarded as the supreme master of the art clearly served as the creed of his own, and in the *Bain turc* he offered his culminating demonstration of a work whose originality paradoxically depends on its powers of imitation. Whatever living persons may once have inspired these female forms have long since disappeared behind the prior representations on which Ingres drew for his painting. But two partial exceptions to this rule should be noted. Though the woman with her arms crossed behind her head in the right foreground of the painting owes her posture to an eighteenth-century engraving, her face has been persuasively identified as that of the painter's first wife, Madeleine Chapelle, who had been dead for over a decade when the *Bain turc* was painted (fig. 57); while the profile of the woman whose hair is being perfumed in the center of the canvas has been matched with an 1814 portrait of her cousin, Adèle de Lauréal (fig. 58) — a woman whom Ingres is said to have loved before he married Madeleine, and whose resemblance to the latter supposedly prompted his proposal.[27] In this sense too, then, the *Bain turc* is not so much a collection of female nudes

as a re-collection, a harem of memory. That such recollection would have had particular appeal for a man who felt himself near the end of life is hardly surprising, even if the temporality his harem of memory sought to deny had less to do with the lover, ultimately, than with the artist — was less a problem of his Adèles and Madeleines, in other words, than of the sequence of images he and his predecessors had created. Appropriately enough, Ingres's great harem of memory was one of two paintings at the Louvre, according to Jean Cocteau, that the aging Proust ritually ventured out of his apartment to visit.[28]

To judge by the work of a later and very different imagination, Ingres was not the only male artist in the West to respond to intimations of his own mortality by dreaming of the harem. Though the autobiographical protagonist of Frederico Fellini's *8½* (1963) is just forty-three at the time of its action, the fear of aesthetic impotence from which he suffers is clearly a foretaste of death. From the opening sequence at the spa — its rituals pointedly choreographed to the fateful sounds of the Valkyrie music from Wagner's opera — *8½* also identifies Guido's mid-life crisis with his anxiously roving eye for women. The famous harem sequence begins as his fantasy of a reconciliation between his wife and current mistress expands into a scene that takes in all the women in his life: gathered in the farmhouse kitchen of his childhood are not only his wife and mistress, but, among others, the wife's best friend, the rejecting sister-in-law, the young mistress of an acquaintance, an actress in his film, a Danish stewardess whose voice once seduced him, a fading chorus girl, and La Saraghina, the fat whore who memorably danced for him as a boy. This too is a harem of memory, though as a film about a filmmaker obsessed with women, *8½* makes no distinction between its "real" persons and the figures of art: unlike the *Bain turc*'s recollection of the *Baigneuse Valpinçon*, for example, the fat whore in Guido's harem represents both an actual person in his childhood and a character within the film whose production we have been watching. Unlike painting too, of course, film is a temporal art; and in *8½* the foolishness of Guido's dream becomes evident as the momentary harmony of the harem household gives way first to the women's bickering and then to a collective revolt — a revolt significantly prompted by the Ottoman-like "house rule" that banishes a women upstairs when she has passed a certain age. In a grotesquely comic scene, the harem metamorphoses into a circus, as the women rush about to the strains of the Valkyrie music, while Guido, crowned with a cowboy hat, plays the role of ringmaster, cracking his whip to restore order.

Nothing like the overt comedy of Fellini's harem, needless to say,

threatens to disrupt the timeless moment of the *Bain turc*; indeed the example of *8½* confirms that precisely because it must compress time within a single frame, painting may be the preferred medium for such masculine fantasies of the harem. Yet Ingres also forestalls the possibility of mistaking fantasy for reality and may even go so far as to laugh, the more so if his harem of memory pretends however remotely to hedge against death. Kenneth Clark has confessed that "in certain moods" he finds the *Bain turc* a "slightly comic picture"; and the numerous parodies it has inspired over the years suggest that he is not alone in sensing its potential for comedy. Clark himself cites the picture's reproduction on a greeting card, irreverently captioned "The whole gang misses you."[29] In a *Turkish Bath* of 1973, Sylvia Sleigh turned the image to the uses of a more acerbic, and overtly political, satire, when she replaced Ingres's bathers with a collection of naked men, including her husband, all of whom happened also to be art critics (fig. 59).[30] Of course the great champion of nineteenth-century French classicism has hardly been celebrated for his sense of humor; and like the greeting card, Sleigh's painting may be read simply as mocking an image that appears to take itself all too seriously. But it is tempting to suggest that lurking some-where in his crowded and irrational space, his awkward conjunctions of bodies seemingly unaware of one another's existence, the self-conscious fantasy of the aging Ingres also contains a hint of self-mockery. Even the sultan, after all, could sexually possess only one woman at a time — a hu-man limitation that the implicit comedy of the *Bain turc* acknowledges. The greatest fantasists of the harem never quite forget that theirs are harems of the mind.

Notes

Introduction

[1] J[ean] B[aptiste] Tavernier, *Nouvelle Relation de l'interieur du serrail du grand seigneur contenant plusieurs singularitez qui jusqu'icy n'ont point esté mises en lumiere* (Amsterdam: Johannes van Someren, 1678), 238, 250. For the blank space in the plan of the Ottoman harem, see N. M. Penzer, *The Harem* (1936; rpt. New York: Dorset Press, 1993), 51.

[2] Choderlos de Laclos, *Les Liaisons dangereuses*, in *Oeuvres complètes*, ed. Maurice Allem, Bibliothèque de la Pléiade (Paris: Gallimard, 1951), 307 (lettre cxxvii).

[3] William Makepeace Thackeray, *Vanity Fair* (1847–48), in *Works*, ed. Anne Thackeray Ritchie, 13 vols. (Toronto: George N. Morang, 1898–99), 1: 162.

[4] I quote here from the English translation of 1592, *The Historie of the Damnable Life, and Deserved Death of Doctor John Faustus*, as reprinted in *The English Faust-Book of 1592*, ed. H. Logeman (Gand: Université de Gand, 1900), 68–69. The German *Faustbuch* first appeared in 1587.

[5] For a useful summary, see Bernard Lewis, "Europe and Islam," in *Islam and the West* (New York: Oxford University Press, 1993), 3–42.

[6] Bernard Lewis, *The Muslim Discovery of Europe* (New York: Norton, 1982), 119, 240–41.

[7] Boswell's journals, 23 March 1776, in *Boswell: The Ominous Years, 1774–1776*, ed. Charles Ryskamp and Frederick A. Pottle, Yale Editions of the Private Papers of James Boswell (New York: McGraw-Hill, 1963), 294; Boswell's journals, 16 September 1773, in *Boswell's Journal of a Tour to the Hebrides with Samuel Johnson, LL.D, 1773*, ed. Frederick A. Pottle and Charles H. Bennett (New York: McGraw-Hill, 1961), 176, 177.

[8] Clarence Dana Rouillard, *The Turk in French History, Thought, and Literature (1520–1660)* (Paris: Boivin & Cie, [1941]), 207, 325.

[9] Edward W. Said, *Orientalism* (New York: Random House, 1978). Representations of the harem, it should be noted, do not figure in Said's book.

1. Some Travelers' Tales

[1] All citations of Byron's poems follow *The Complete Poetical Works*, ed. Jerome J. MacGann, 7 vols. (Oxford: Clarendon Press, 1980–93). For *Don Juan*, parenthetical references in the

text give canto and stanza number. Extracts from other poems are identified by line number, preceded whenever relevant by canto and stanza number (or, in the case of *Sardanapalus*, by act and scene number).

² See the Penguin edition of *Don Juan*, ed. T. G. Steffan, E. Steffan and W. W. Pratt (Harmondsworth, 1986), 653.

³ As Byron later recalled his voracious reading in matters Oriental: "Knolles, Cantemir, De Tott, Lady M. W. Montague [sic], Hawkins's Translation from Mignot's History of the Turks, the Arabian Nights, all travels, or histories, or books upon the East I could meet with, I had read, as well as Rycaut, before I was *ten years old.*" Quoted in Leslie A. Marchand, *Byron: A Portrait* (1970; rpt. Chicago: University of Chicago Press, 1979), 14.

⁴ Paul Rycaut, *The Present State of the Ottoman Empire* (1668; rpt. Frankfurt am Main: Institute for the History of Arabic-Islamic Science, 1995), 38, 39.

⁵ The first edition of the *Encyclopaedia of Islam*, vol. 4 (Leiden: E. J. Brill, 1934), calls the business of the sultan's handkerchief a "fable." See the entry on the "Wālide Sultān" by J. Deny (1113). In his history of the Grand Seraglio, however, N. M. Penzer contends that "there is . . . considerable evidence that, at one time at any rate, it was no 'traveller's tale'" (*The Harem*, 180–81).

⁶ On travelers' habitual practice of accusing one another of lying, see Percy G. Adams, *Travel Literature and the Evolution of the Novel* (Lexington, KY: University Press of Kentucky, 1983), 87–88. For a very helpful discussion of this and other problematic aspects of the sixteenth- and seventeenth-century sources on the Ottoman harem in particular, see Leslie P. Pierce, *The Imperial Harem: Women and Sovereignty in the Ottoman Empire* (New York: Oxford University Press, 1993), 113–18.

 Something of the same pattern persists in modern attempts to theorize the subject. After shrewdly characterizing Alain Grosrichard's influential study, *Structure du sérail: La Fiction du despotisme asiatique dans l'Occident classique* (Paris: Éditions du Seuil, 1979), as "arguably a Lacanian account of the phallus in Oriental costume," Emily Apter, for instance, goes on to protest that he "never really takes his analysis into the harem." Apter herself proposes to counter his Lacanian and phallocentric myth with a feminist and postcolonial one, by reading French colonial literature about the harem as "an antiphallic, gynocentric fantasy about the thwarting of colonial mastery." See her "Female Trouble in the Colonial Harem," *Differences* 4 (1992): 206–207, 219.

⁷ Aaron Hill, *A Full and Just Account of the Present State of the Ottoman Empire in all its Branches: With the Government, and Policy, Religion, Customs, and Way of Living of the Turks, in General. Faithfully Related from a Serious Observation, taken in many Years Travels thro' those Countries* (London: John Mayo, 1709), xxiv, 147.

⁸ Ibid., 148, 149.

⁹ Ibid., 164, 166.

¹⁰ A century and a half later, Théophile Gautier also described a visit to the seraglio in the sultan's absence, but he made emphatically clear that the harem formed no part of the tour: "male strangers are never admitted there, under any circumstances; not even in the absence of its fair inhabitants." See *Constantinople of To-day*, trans. Robert Howe Gould (London: David Bogue, 1854), 287. Gautier's book first appeared in French the previous year.

¹¹ Hill, *Present State of the Ottoman Empire*, 164.

¹² [Jean] Chardin, *Voyages du chevalier Chardin, en Perse, et autres lieux de l'Orient*, ed. L. Langlès, 10 vols. (Paris: Le Normant, 1811), 6: 8, 12, 17. Though Chardin began to publish his *Voyages* in 1686, the first full edition, including the material quoted here, appeared in 1711.

[13] To the Countesse of —, [May 1718], *The Complete Letters of Lady Mary Wortley Montagu*, ed. Robert Halsband, 3 vols. (Oxford: Clarendon Press, 1965), 1: 405–406.

[14] To Lady —, 1 April [1717], *Letters* 1: 315; To [Anne] Thistlethwayte, 1 April [1717], *Letters* 1: 343.

[15] To Lady Mar, 1 April [1717], *Letters* 1: 327. In Aphra Behn's play, *The Emperor of the Moon* (1687), Harlequin, who pretends to be an ambassador from that celestial body, suggests that morality on the moon is no different from that on earth — though it is not in fact the clever trickster who repeats the phrase Lady Mary recalls but the pedantic doctor who is his gull.

[16] To Lady Mar, 1 April [1717], *Letters* 1: 329–30.

[17] "Sultana" is Lady Mary's term for the favorite of the deposed Mustafa II, though strictly speaking, the word should be reserved for the mother, sisters, and daughters of the sultan.

[18] To Lady Mar, 10 March [1718], *Letters* 1: 383–84, 385, 382, 384, 385.

[19] See, e.g., Ali Behdad, "The Eroticized Orient: Images of the Harem in Montesquieu and His Precursors," *Stanford French Review* 13 (1989): "The fact that Lady Mary was able to enter the harem seems to have cleared away all the repressive fantasies that one finds in the discourse of male Orientalists" (116n). But cf. Billie Melman, who usefully distinguishes between men's text-based descriptions of the harem and women's eyewitness accounts, while acknowledging that the difference cannot be reduced to a simple opposition of fantasy and fact. *Women's Orients: English Women and the Middle East, 1718–1918: Sexuality, Religion and Work* (Ann Arbor: University of Michigan Press, 1992), 62–63.

[20] Elizabeth Lady Craven, *A Journey through the Crimea to Constantinople. In a Series of Letters* (Dublin: H. Chamberlaine et al., 1789), 141.

[21] To Lady —, 1 April [1717], *Letters* 1: 313; Miss [Julia] Pardoe, *The City of the Sultan; and Domestic Manners of the Turks, in 1836*, 2nd ed., 3 vols. (London: Henry Colburn, 1838), 1: 130. The first edition of Pardoe's work appeared in 1837.

[22] Emmeline Lott, *The "English Governess" in Egypt: Harem Life in Egypt and Constantinople* (Philadelphia: T. B. Peterson & Brothers, n.d. [1866?]), xxi–xxiii. Lott's book appeared in England in 1866.

[23] To Sir Alexander Duff Gordon, August 4, 1866, in Lucie Duff Gordon, *Letters from Egypt* (1902; rpt. London: Virago, 1983), 294. These letters were first published in 1865 and 1875.

[24] To Mrs. Austin, February 7, 1864; To Mr. Tom Taylor, March 16, 1864 (*Letters from Egypt*, 112, 140). For Martineau's visits to the harem, see below, chs. 7 and 16.

[25] To Sir Alexander Duff Gordon, January 9, 1864; To Mr. Tom Taylor, April 18, 1863 (*Letters from Egypt*, 98, 55).

[26] "A Visit to a Harem. By a Lady," *Chambers' Edinburgh Journal*, n.s. 5 (1846): 66.

2. Seeing it All: Ingres and Delacroix

[1] Robert Withers, *A Description of the Grand Signor's Seraglio, or Turkish Emperours Court* (London: Jo. Martin and Jo. Ridley, 1650), 70. As N. M. Penzer has shown, Withers' much cited account, which first appeared (in slightly different form) in the second volume of Samuel Purchas, *Purchas His Pilgrimes* (1625), and then as a separate work in 1650, is

really an unattributed translation, slightly embellished, of a report written sometime between 1604 and 1607 by the Venetian diplomat, Ottaviano Bon. (According to Penzer, the 1650 text is the more reliable.) See Penzer, *The Harem*, 34–37. For a modern reprint of the 1650 text, which usefully indicates the places at which it differs from Bon, see Ottaviano Bon, *The Sultan's Seraglio: An Intimate Portrait of Life at the Ottoman Court* (From the Seventeenth-Century Edition of John [sic] Withers), ed. Godfrey Godwin (London: Saqui Books, 1996).

2 Jean Thévenot, *Voyage du Levant*, ed. Stéphane Yerasimos (Paris: François Maspero, 1980), 60. With some cuts, this text follows the first edition of 1665.

3 [Jean] Chardin, *Voyages… en Perse*, 6: 33, 35–36.

4 I refer here to the anonymous English translation of 1696: [Jean] Sieur du Mont, *A New Voyage to the Levant: Containing An Account of the most Remarkable Curiosities in Germany, France, Italy, Malta, and Turkey; With Historical Observations relating to the Present and Ancient State of those Countries* (London: M. Gillyflower et al., 1696), 168. Dumont's *Nouveau Voyage du Levant* had first appeared in French two years earlier.

5 Jean Racine, *Bajazet* (1672), in *Théâtre complet*, ed. Maurice Rat (Paris: Éditions Garnier Frères, 1960), 1. 1, 361. All further references to the play are to this edition and will be indicated by act, scene and page number in the text. Of course what Jean Starobinski has termed "la poétique du regard" in Racine resonates well beyond *Bajazet*. Of the exchange cited above, Starobinski remarks, "If Racine places one of his tragedies in the Seraglio at Constantinople, it is because the Seraglio is the perfect type of a universe where every glance is spied on by some other glance." See "The Poetics of the Glance in Racine" (1954), trans. R. C. Knight, in *Racine: Modern Judgements*, ed. R. C. Knight (London: Macmillan, 1969), 93.

6 Dumont, *A New Voyage to the Levant*, 168.

7 Chardin, *Voyages… en Perse*, 6: 25, 45.

8 Aaron Hill, *Present State of the Ottoman Empire*, 162–63.

9 "Whether these beauties enter the bed of the Sultan by the feet, as some would have us believe, or by the sides, I shall not determine," Tournefort continued; "I content myself with regarding them as the least unfortunate slaves in the world." Joseph Pitton de Tournefort, *Relation d'un voyage du Levant*, 2 vols. (Amsterdam: 1718), 2: 27. The first edition of Tournefort's work had appeared the previous year in Paris.

10 The key text in this regard is probably John Berger, *Ways of Seeing* (London: Penguin, 1972), though many commentators have elaborated on and sophisticated his work in the decades since.

11 Though the separation was initially imposed only on the wives of the Prophet (Koran 33:53), it was later extended to all free Muslim women. J. Chelhod, "Hidjāb," *Encyclopaedia of Islam*, new ed., vol. 3 (Leiden: E. J. Brill, 1971) 3: 359–61. For a useful account of the shifting meaning of the *hijab* — whereby for some Islamic modernists, for example, it has come to signify only a portable veil, rather than women's domestic seclusion — see Barbara Freyer Stowasser, *Women in the Qur'an, Traditions, and Interpretation* (New York: Oxford University Press, 1994), 127–31.

12 Malek Alloula, *The Colonial Harem*, trans. Myrna Godzich and Wlad Godzich (Minneapolis: University of Minnesota Press, 1989), 7. Alloula's book first appeared in French in 1981.

13 All accounts of the visit begin with an article by Phillipe Burty that appeared twenty years after the artist's death in 1863. See "Eugène Delacroix à Alger," *L'Art* 32 (1883):

Notes to pages 25–28 259

76–78, 94–98. Burty in turn cited two sources, an oral communication from the comte de Mornay, whom Delacroix accompanied on his diplomatic mission to Morocco, and a letter (otherwise unidentified) from Charles Cournault, a close friend of the artist to whom he later willed a number of objects that he brought back from North Africa. It was Mornay who alluded to the owner of the harem as a renegade and whose description of Delacroix's harem "fever" (quoted by Burty, 96) is cited above. For a scrupulous weighing of the relevant evidence, see Élie Lambert, *Delacroix et les "Femmes d'Alger"* (Paris: Librairie Renouard, 1937), 5–13.

[14] Charles Cournault, as cited in turn by Burty, "Eugène Delacroix à Alger," 96.

[15] The painting, now in Rouen, has also sometimes been known as *Juive d'Alger à sa toilette*. For a justification of the title adopted here, see Lee Johnson, *The Paintings of Eugène Delacroix: A Critical Catalogue, 1832–1863*, vol. 3 (Oxford: Clarendon Press, 1986), 189. Johnson dates the painting as possibly 1847, and in any case before 1853. On the effect of disclosure in both this and the 1849 *Femmes d'Alger*, cf. René Huyghe, who remarks that the curtain "would hide the scene … if allowed to fall, and one feels that this may happen at any moment." *Delacroix*, trans. Jonathan Griffin (London: Thames and Hudson, 1963), 286.

[16] Charles Baudelaire, "Salon de 1846: Eugène Delacroix," in *Oeuvres complètes*, ed. Claude Pichois, Bibliothèque de la Pléiade, 2 vols. (Paris: Gallimard, 1976), 2:440.

[17] For the genesis of the painting from Delacroix's original sketches, see Lambert, *Delacroix et les "Femmes d'Alger"* esp. 12–33.

[18] Michael Fried, *Absorption and Theatricality: Painting and Beholder in the Age of Diderot* (Berkeley: University of California Press, 1980).

[19] Assia Djebar appends her commentary on the *Femmes d'Alger* as a "postface" to her collection of short stories whose title also pays homage to Delacroix's painting: *Femmes d'Alger dans leur appartement* (1980; 3rd ed., Paris: des femmes, 1983), 170, 172.

[20] John L. Connolly, Jr., finds another moment of voyeurism evoked by the painting. According to Connolly, the "curious" helmet in the lower left-hand corner is a direct quotation from seventeenth-century Persian miniatures that depict two lovers at the moment when the man first happens to see the woman bathing in a mountainside pool. Like the Persian bather, Connolly suggests, Ingres's nude has abandoned the helmet but retains the drapery covering the lower half of her body. See Connolly, "Ingres and the Erotic Intellect," in *Woman as Sex Object: Studies in Erotic Art, 1730–1970*, ed. Thomas B. Hess and Linda Nochlin, *Art News Annual* 38 (1972): 23.

[21] Dated 1839 and first displayed at the salon of 1840, the *Odalisque à l'esclave* has sometimes been seen as the artist's direct response to the triumphant exhibition of the *Femmes d'Alger* six years previously. See, e.g., Marjorie B. Cohn and Susan L. Siegfried, *Works by J.-A.-D. Ingres in the Collection of the Fogg Art Museum* (Cambridge, MA: Fogg Art Museum, 1980), 116.

[22] Formal and psychological attempts to account for this effect include Norman Bryson, *Tradition and Desire: From David to Delacroix* (Cambridge: Cambridge University Press, 1984), 124–75; Connolly, "Ingres and the Erotic Intellect," 16–31; and Wendy Leeks, "Ingres Other-Wise," *Oxford Art Journal* 9:1 (1986): 29–37.

[23] No written testimony from either the artist or his patron confirms the story of the painting's misadventure with Prince Napoléon. For a detailed account of this history, see Hélène Toussaint, *Le Bain turc d'Ingres* (Paris: Éditions des Musées Nationaux, 1971), esp. 7–10.

[24] Radiographic examination for the 1971 exhibit on the *Bain turc* at the Louvre confirmed

that the round painting now hanging in the museum was once a rectangle, whose proportions conform closely to those of the 1859 photograph (Toussaint, *Le Bain turc,* 38–42). The history is further complicated, however, by the disappearance of another photograph of the painting, described in an article at the beginning of this century as also rectangular in shape but dated 1860 and differing in minor details from that of 1859, and by the survival of a fragment of a "Bain turc" painted on wood, which corresponds closely but not precisely to the photograph of the 1859 version. Since this fragment could not have come from the Louvre *Bain turc,* which is on canvas, there appears to have been at least one other version of the painting — hardly an unusual occurrence where Ingres is concerned (Toussaint, 8–10).

²⁵ Arsène Alexandre, "Ingres," *Le Monde moderne* (February 1895): 208, as quoted by Toussaint, *Le Bain turc,* 9.

²⁶ I wish to thank Leo Steinberg for suggesting this possibility to me in conversation.

²⁷ [Sophia Watson], *Memoirs of the Seraglio of the Bashaw of Merryland. By a Discarded Sultana,* 2nd ed. (London: S. Bladon, 1768), 3, 14, 6–7. The British Library copy identifies the "bashaw" as Lord Baltimore. I owe the discovery of this pamphlet to Felicity A. Nussbaum, *Torrid Zones: Maternity, Sexuality, and Empire in Eighteenth-Century English Narratives* (Baltimore: The Johns Hopkins University Press, 1995), 76–77.

²⁸ Much reproduced as a print, Allom's *Odalique* was among the images commissioned by the publishing firm of Fisher, Son and Company for its series of luxury travel books. It appeared in two different collections of Allom's images issued by the company: Thomas Allom and Robert Walsh, *Constantinople and the Scenery of the Seven Churches of Asia Minor Illustrated,* 1st series, 2 vols. (London and Paris: [1838]) and Thomas Allom and Emma Reeve, *Character and Costume in Turkey and Italy* (London and Paris: [1839]). For a useful comparison of the marked differences in the letter-press of the two books, see Joan DelPlato, *From Slave Market to Paradise: The Harem Pictures of John Frederick Lewis and Their Traditions* (Ann Arbor, MI: UMI, 1987), 103–14.

²⁹ Thomas Moore, *Lalla Rookh: An Oriental Romance* (Philadelphia: Carey and Hart, 1845), 26–27, 35. Moore's new preface proclaims this the twentieth edition of his immensely successful poem, which had first appeared in 1817.

³⁰ Henry James, "Pierre Loti" (1888), rpt. in *Henry James: Literary Criticism: French Writers, Other European Writers, The Prefaces to the New York Edition,* ed. Leon Edel and Mark Wilson (New York: Library of America, 1984), 494.

³¹ Pierre Loti, *Aziyadé suivi de Fantôme d'Orient,* ed. Claude Martin (Paris: Gallimard, 1991), 35, 36. Loti's novel was first published in 1879.

³² Pierre Loti, *Les Désenchantées: Roman des harems turcs contemporains* (Paris: Calmann-Lévy, 1906), 363, 364.

3. Documenting the Harem from *Bajazet* to the *Bain turc*

¹ Jean Racine, Première préface, *Bajazet* (1672), in *Théâtre complet,* 354.

² "*Having seen and Examined the Work of the* Turkish Secretary, *I have found nothing therein but what is conformable to the things whereof it treats . . . At* Pera . . . *the Eighteenth day of* April, 1681 . . . Bekir Tchelebi, *the Son of* Hassan," etc. I quote from the anonymous English translation of the same year: *The Turkish Secretary* (London: J. B., Joseph Hindmarsh and Randal Taylor, 1688), 32. The author of the original French text was apparently Du Vignau, sieur de Joannots.

On the line between fact and fiction, it should be noted, the "attestations" collected for the *Turkish Secretary* can be charmingly evasive. The last one reads in full: "*We have examined the History of* Gulbeyaz *and her Lover, and the rest of the Work of the* Turkish *Secretary, according to the Report and just Interpretation that has been made to Us thereof. Wherefore We give it our Approbation*" (34).

³ Racine, Seconde préface, *Bajazet* (1676), in *Théâtre complet*, 355. With the exception of a passage noted later (see ch. 13, n2), this is the preface that appeared in subsequent editions of the play.

⁴ To John Murray, 2 April 1817 and [14 November 1813], in *Byron's Letters and Journals*, ed. Leslie A. Marchand, 12 vols. (Cambridge, MA: Harvard University Press, 1973–82), 5: 203 and 3: 165. I owe the conjunction of these quotations to W. H. Auden, "A That-There Poet," in *Twentieth-Century Interpretations of "Don Juan": A Collection of Critical Essays*, ed. Edward E. Bostetter (Englewood Cliffs, N J : Prentice-Hall, 1969), 19.

⁵ Thomas Moore, Preface to *Lalla Rookh* (1845), xxi. On Byron's sources and his own concern for accuracy, see Wallace Cable Brown, "Byron and English Interest in the Near East," *Studies in Philology* 34 (1937): 55–64.

⁶ Moore, Preface to *Lalla Rookh* (1845), xxii–xxv.

⁷ On the notes and their imitators, see Fatma Moussa Mahmoud, "Beckford, *Vathek* and the Oriental Tale," in *William Beckford of Fonthill, 1760–1844: Bicentenary Essays*, ed. Mahmoud (Cairo: Cairo Studies in English, 1960), esp. 78–83, 109. Cf. also Frances Mannsaker, "Elegancy and Wildness: Reflections of the East in the Eighteenth-Century Imagination," in *Exoticism in the Enlightenment,* ed. G. S. Rousseau and Roy Porter (Manchester: Manchester University Press, 1990), 186–87.

⁸ *Gentleman's Magazine* 57 (1787): 55. I am grateful to Mahmoud, "Beckford, *Vathek* and the Oriental Tale," 82, for directing me to this passage. Beckford would presumably not have appreciated such subordination of his creative work to Henley's more pedantic labors. But despite his severe pruning of the notes for later editions of the text, the evidence makes clear, as Roger Lonsdale puts it, that "Beckford had always considered an erudite apparatus as an integral part of his book." See Lonsdale's own explanatory note in his World's Classics edition of the novel (Oxford: Oxford University Press, 1983), 121.

⁹ David R. Slavitt, *Turkish Delights: A Novel* (Baton Rouge: Louisiana State University Press, 1993). On the copyright page, Slavitt attributes his information about the seraglio to a 1937 edition of N. M. Penzer's *The Harem*.

¹⁰ Charles Cournault, as cited by Phillipe Burty, "Eugène Delacroix à Alger," 97.

¹¹ Letter to Samuel Henley, 13 April 1786, as quoted in Lewis Melville, *The Life and Letters of William Beckford of Fonthill* (London: Heinemann, 1910), 135.

¹² George P. Mras, *Eugène Delacroix's Theory of Art* (Princeton: Princeton University Press, 1966), 57.

¹³ Élie Lambert, *Delacroix et les "Femmes d'Alger,"* 33.

¹⁴ To J.-B. Pierret, 6 November 1818, in *Correspondance générale d'Eugène Delacroix*, 1 (1804–1837), ed. André Joubin (Paris: Librairie Plon, 1935), 32. For the accuracy of Delacroix's costumes, see Georges Marçais, *Le Costume musulman d'Alger* (Paris: Librairie Plon, 1930), 120–24. In his study of the painting, Lambert also credits Marçais with helping to confirm that Delacroix had visited a genuine harem, by identifying the two female names he had noted on the sketches as authentically Turkish in origin (*Delacroix et les "Femmes d'Alger,"* 13).

[15] Lambert, *Delacroix et les "Femmes d'Alger,"* 24–25. "Môunî Bensoltane," is Lambert's transliteration of the name that Delacroix recorded as "Mouney ben Sultane" and "Mouni" on the sketches in question (Lee Johnson, *The Paintings of Eugène Delacroix*, 3: 166).

[16] André Joubin, "Modèles de Delacroix," *Gazette des beaux-arts*, 6e période, 15 (1936): 358–59.

[17] René Huyghe, *Delacroix*, 282. As Huyghe shows, variants of the same face had also appeared in *Les Natchez* (begun in 1822–23, though not completed until 1835) and in *La Grèce expirant sur les ruines de Missolonghi* (1826).

[18] Lambert, *Delacroix et les "Femmes d'Alger,"* 24–26; Johnson, *The Paintings of Eugène Delacroix*, 3: 166, 168. The specific paintings Johnson identifies as possible influences on the figure of the black woman are Titian's *Bacchus and Ariadne* and Gentileschi's *Joseph and Potiphar's Wife.*

[19] Lee Johnson, "The Influence of the Journey on Delacroix's Art," in *Delacroix in Morocco,* trans. Tamara Blondel (Paris: Institut du Monde Arabe & Flammarion, 1994), 118. Lambert's observation that the later work nonetheless follows the original sketches more closely in certain respects — including the arrangement of the architecture and the direction of the light–does not so much contradict the general impression as suggest that the painter was still returning to the early record as a ground for fantasizing (*Delacroix et les "Femmes d'Alger,"* 40–41). Cf. Delacroix's own remarks in his essay on "Réalisme et idéalisme": "The forms of the model, whether it be a tree or a man, are only the dictionary to which the artist goes to give renewed force to his fugitive impressions, or rather to give them a sort of confirmation, for he must have memory. To imagine a composition is to combine elements of objects that one knows, that one has seen, with others that belong to the very interior, to the soul of the artist." Eugène Delacroix, *Oeuvres littéraires,* ed. Élie Faure, 2 vols. (Paris: Les Éditions G. Crès & Cie, 1923), 1: 58.

[20] Delacroix, Journal entry (17 October 1853), in *Eugène Delacroix: Journal, 1822–1863,* ed. André Joubin (Paris: Librairie Plon, 1980), 369. I am indebted to Lee Johnson ("The Influence of the Journey on Delacroix's Art," 118) for alerting me to the relevance of this passage to the second *Femmes d'Alger.*

[21] For the possible influence of the Giorgione, which Delacroix copied at the Louvre early in his career, see Francis Haskell, "Giorgione's *Concert Champêtre* and Its Admirers," *Journal of the Royal Society for the Encouragement of Arts* 119 (1971): 550–51; and Johnson, *The Paintings of Eugène Delacroix*, 3: 168.

[22] Lambert, *Delacroix et les "Femmes d'Alger,"* 27–28; and Johnson, *The Paintings of Eugène Delacroix*, 3: 167.

[23] A. M. Chabour, "À propos de l'iconographie des *Femmes d'Alger*," unpublished ms., May 1993 (Musée du Louvre: Service d'étude et de documentation).

[24] Delacroix, "Réalisme et idéalisme," *Oeuvres littéraires,* 1:58.

[25] Hélène Toussaint, *Le Bain turc,* 11–13, 32–33; and Norman Schlenoff, *Ingres: Ses sources littéraires* (Paris: Presses Universitaires de France, 1956), 281–84.

[26] Toussaint, *Le Bain turc,* 51 n15. The timing of the notebook entries has also been the subject of some confusion. In 1870 Ingres's pupil and first biographer, Henri Delaborde, reported that the painter had been preoccupied with the subject of the *Bain turc* for forty years and that the entries dated from 1819 (*Ingres: Sa vie, ses travaux, sa doctrine* [Paris: Henry Plon, 1870], 239. But Toussaint persuasively argues that the handwriting and other evidence suggest a later date, probably sometime toward the end of the 1830s (*Le Bain turc,* 13, 50–51).

[27] Toussaint, *Le Bain turc*, 13. Ingres's weaving together of the two separated letters (evidence Toussaint does not mention) seems to me more compatible with his own silent note-taking.

[28] To the Countesse of —, [May 1718], *Letters of Lady Mary Wortley Montagu*, 1: 405, 406–407.

[29] Kenneth Clark, *The Nude: A Study in Ideal Form* (1956; rpt. Princeton: Princeton University Press, 1990), 3–29.

[30] Cournault, as cited by Burty, "Eugène Delacroix à Alger," 97.

[31] Though this passage appears second in Ingres's notebooks, his sequence reverses the chronological order of Lady Mary's letters. For more on the temporal liberties taken by the painting, see below, ch. 22.

[32] To Lady —, 1 April [1717], *Letters*, 1: 312, 313–14. In Ingres's notebooks, two sentences from still a third letter are silently appended to this passage: "The Treat concluded with Coffée and perfumes, which is a high mark of respect. 2 slaves kneeling cens'd my Hair, Cloaths, and handkercheif" (To Lady Mar, 18 April [1717], *Letters*, 1: 348). Cf. Touissant, *Le Bain turc d'Ingres*, 13. The *Bain turc* obviously substitutes this gesture for the hair-braiding Lady Mary describes at Sofia. In light of my argument later in this chapter, the reader should note that this letter reports a visit to a harem rather than a public bath, though Ingres's imagination apparently overrides the difference.

[33] Counts range from twenty-three in Patricia Condon et al., *The Pursuit of Perfection: The Art of J.-A.-D. Ingres* (Bloomington: Indiana University Press, 1983), 124, and Bertrand d'Astorg, *Les Noces orientales: Essai sur quelques formes féminines dans l'imaginaire occidental* (Paris: Éditions du Seuil, 1980), to twenty-six in Rana Kabbani's *Europe's Myths of Orient: Devise and Rule* (London: Macmillan, 1986), 84. D'Astorg goes on to assure us parenthetically, "les critiques d'art les ont comptées, moi aussi" (106). In a much-cited early article, Jules Momméja settled for "vingt et quelques." See "Le 'Bain turc' d'Ingres," *Gazette des beaux-arts*, 3e période, 36 (1906): 190.

[34] Delaborde, *Ingres*, 239n.

[35] [Jean] Chardin, *Voyages... en Perse*, 6: 25.

[36] Toussaint, *Le Bain turc*, 11. Reports of Oriental "tribades" did not always confine such practices to the harem, however. Among the other works Ingres knew, Toussaint cites the *Navigations et pérégrinations orientales* of Nicolas de Nicolay (1568), which in one edition, at least, specifically identifies the women's bath as a favorite locus for homoerotic assignations. See *Les Navigations, peregrinations et voyages, faicts en la Turquie, par Nicolas de Nicolay* (Anvers: Guillaume Silvius, 1577), 110. The first edition of Nicolay's book appeared in 1567; the edition cited here is a reprint of the second edition of 1576.

[37] John L. Connolly, Jr., "Ingres and the Erotic Intellect," 31 n12.

[38] Richard Frost, "Jean Ingres' *Le Bain turc*," *Getting Drunk with the Birds* (Athens: Ohio University Press, 1970), 13. Frost, incidentally, sees "twenty-four naked women" in the painting.

[39] Robert Rosenblum, *Jean-Auguste-Dominique Ingres* (New York: Abrams, 1967), 170.

[40] Linda Nochlin, "The Imaginary Orient," in *The Politics of Vision: Essays on Nineteenth-Century Art and Society* (New York: Harper and Row, 1989), 36.

[41] To Lady — [1 April] 1717, *Letters*, 1: 313, 314.

[42] For representative discussions of this episode, see Srinivas Aravamudan, "Lady Mary Wortley Montagu in the *Hammam*: Masquerade, Womanliness and Levantinization," *ELH* 62 (1995): 69–104, esp. 81–89; Joseph W. Lew, "Lady Mary's Portable Seraglio," *Eighteenth-Century Studies* 24 (1991): 432–50, esp. 439–45; Lisa Lowe, *Critical Terrains: French and British Orientalisms* (Ithaca: Cornell University Press, 1991), 46; and Billie Melman, *Women's Orients*, 91.

[43] Quotations from Marie-Christine Boucher, *Dessins d'Ingres du musée Montauban* (Paris: Paris Musées, 1989), 65; Toussaint, *Le Bain turc*, 13; Mommé ja, "Le 'Bain turc' d'Ingres," 197.

4. The Fantastic Facts of *Les Désenchantées*

[1] Cf. Lisa Lowe, who illustrates the habit of "cultural quotation" in Orientalism by remarking how in *Madame Bovary* one of Emma's lovers "rediscovers" (Flaubert's verb is "retrouver") the amber color of an Ingres *odalisque* on her shoulders (*Critical Terrains*, 1–3).

[2] Thomas Moore, Preface to *Lalla Rookh*, xxi. For Aaron Hill and Lady Mary, see Moore's notes on pp. 178–79 and 204, respectively. Leila Ahmed makes a related point about *Lalla Rookh*'s eclectic citation of Eastern sources. *Edward W. Lane: A Study of His Life and Works and of British Ideas of the Middle East in the Nineteenth Century* (London and Beirut: Longman and Librarie du Liban, 1978), 19.

[3] Byron, *Complete Poetical Works*, 3:423. The plagiarized notes in question appear in John Hamilton Reynolds' *Sofie, An Eastern Tale*. See Fatma Moussa Mahmoud, "Beckford, *Vathek* and the Oriental Tale," 109–14.

[4] On the necessity of relying on Western sources for information about the imperial Ottoman harem, see Leslie Pierce, *The Imperial Harem*, 113–18; and Gülru Necipolğlu, *Architecture, Ceremonial, and Power: The Topkapi Palace in the Fifteenth and Sixteenth Centuries* (New York and Cambridge MA: Architectural History Foundation and MIT Press, 1991), 159. For the general absence of first-person testimony from Eastern women until the later nineteenth century (and the consequent usefulness of Lady Mary), see Leila Ahmed, *Women and Gender in Islam: Historical Roots of a Modern Debate* (New Haven: Yale University Press, 1992), 104, 121–23; and Anne Marie Moulin and Pierre Chuvin, *Lady Mary Montagu: L'Islam au péril des femmes: Une Anglaise en Turquie au XVIIIᵉ siècle* (Paris: Éditions La Découverte, 1987), 44–49.

[5] Adalet, "A Voice from the Harem: Some Words About the Turkish Woman of Our Day," *Nineteenth Century* 28 (1890): 187, 188. A note from the journal's editor certifies the authenticity of the document: "This paper is absolutely genuine. It is the first attempt at writing on the part of its authoress, a young lady who has been shut up in a harem for ten years" (186).

[6] Taj al-Saltana, *Crowning Anguish: Memoirs of a Persian Princess from the Harem to Modernity*, ed. Abbas Amanat, trans. Anna Vanzan and Amin Neshati (Washington, DC: Mage Publishers, 1993), 134, 61–62. Written in 1914, Taj's memoirs were first selectively published in a series of journal articles that appeared in Iran in the 1970s.

[7] Zeyneb Hanoum, *A Turkish Woman's Impressions*, ed. Grace Ellison (London: Seeley, Service & Co.: 1913), 38. "There are two great ways, however," she added, in which we have become too modern for Lady Mary's book. In costume we are on a level with Paris, seeing we buy our clothes there; and as regards culture, we are perhaps more advanced than is the West, since we have so much leisure for study, and are not hampered with your Western methods" (39).

[8] Melek Hanoum, "How I Escaped from the Harem and How I Became a Dressmaker," *Strand Magazine* 71 (1926): 129, 130, 132.

[9] Claude Martin, Préface, *Aziyadé*, 19.

[10] According to Alain Buisine, 419 editions of the novel had appeared by the author's death in 1923. See *Tombeau de Loti* (Paris: Aux Amateurs de Livres, 1988), 243.

[11] Marc Hélys, *Le Secret des "Désenchantées," révélé par celle qui fut Djénane* (Paris: Perrin, 1924), vii. Future references to this work will appear parenthetically in the text.

[12] In Melek's account of how she eventually fled Turkey and became a Parisian dressmaker, she claimed that "Djénane" had no real original — that she was simply a collective fiction, sometimes impersonated by one friend and sometimes by another, since Loti had never seen any of his *désenchantées* unveiled. All the letters, she insisted, were written by her and her sister; Hélys only appeared in her account as an unnamed "French lady we took into our confidence" who "corrected them" ("How I Escaped from the Harem," 133). But the documentary evidence provided by Hélys in *Le Secret* and backed up by the manuscripts she deposited in the Bibliothèque Nationale (not to mention the stylistic evidence of *Le Jardin fermé*) makes clear that this aspect of Melek's narrative, at least, was another fiction. For a balanced assessment of Hélys's role in the deception, see Pierre-E. Briquet, *Pierre Loti et l'Orient* (Neuchatel: Éditions de la Baconnière, 1945), esp. 427–36

[13] Pierre Loti, "*Les Désenchantées*," 37.

[14] As a modern editor of *Aziyadé* aptly puts it: "Loti n'inventait pas, n'aimait pas inventer. Il vivait, regardait, sentait, jouissait, notait dans son *Journal* . . . et y puisait régulièrement pour en faire des livres, avec un travail minimal de mise en oeuvre" (Martin, Préface, *Aziyadé*, 7). That later journal entries appear to have been already shaped by the novel in prospect only emphasizes how little their author came to distinguish between them. See Clive Wake, *The Novels of Pierre Loti* (The Hague: Mouton, 1974), 13.

[15] Loti, *Les Désenchantées*, 177, 167–68, 177.

[16] By translating this visit from Zennour's harem to the far more old-fashioned household of his heroine, Hélys protested, Loti's fictionalized version of the episode made it "absolument invraisemblable" (*Le Secret*, 206).

[17] Loti, *Aziyadé*, 180.

[18] My attention was originally drawn to these overt echoes of Loti by Briquet, *Pierre Loti et l'Orient*, 371, 389.

[19] Buisine, *Tombeau de Loti*, 228n. But cf. Raymonde Lefèvre, "*Les Désenchantées*" *de Pierre Loti* (Paris: Éditions Edgar Malfère, 1939), whose notably unsympathetic account of the affair also accords much less credit to Hélys as a writer: "L'argument des *Désenchantées* est de Mme Léra. Leur charme est de Loti et de Loti seul" (10).

[20] There is also something of an ironic reversal of the usual plot in the conspirators' initial difficulty in approaching the hidden subject of their quest — a Loti who had the art, as Hélys tells it, of enveloping himself in mystery and of seeming inaccessible: "On le disait d'approche plus difficile que le Sultan" (*Le Secret*, 9). The marked sense of disappointment the women felt when they finally penetrated his shipboard quarters and found them distinctly deficient in the luxurious trappings they had expected likewise has its parallels, as we shall see, in many nineteenth-century accounts of visits to the harem.

[21] See especially Lefèvre, "*Les Désenchantées*" *de Pierre Loti*, 8–9.

[22] Lufti Bey Fikri, *Les Désenchantées de M. Pierre Loti* (Cairo: 1907), as cited in Lefèvre, "*Les Désenchantées*" *de Pierre Loti*, 110.

23 Sefer Bey, "Les 'Désenchantées' de Pierre Loti," *Revue* 82 (1909): 72, 74, 75, 76, 80, 77. Sefer Bey was right, of course, to sense something comically extravagant in the novel's representation of its heroines' learning. Not only was Djénane's prodigious fluency in French readily explained by the fact that Hélys had spoken it since childhood, but as Hélys herself later testified, Loti had exaggerated the literary and linguistic sophistication of her friends. Though they did indeed read "les grands détraqués modernes," as the novel had claimed, she denied that they had ever mastered "Dante, ou Byron, ou Shakespeare dans le texte original" (Loti, *Les Désenchantées*, 32). Hélys's unpublished letter is cited by Briquet, *Pierre Loti et l'Orient*, 397.

24 Sefer Bey, "Les 'Désenchantées' de Pierre Loti," 81, 80, 81, 77. It is worth noting that doubts about the originals of Loti's characters go all the way back to *Aziyadé*, whose Circassian heroine has sometimes been suspected of having really been Jewish or Armenian and sometimes (by Edmond de Goncourt and André Gide among others) of having really been a man — Loti in the latter case having presumably performed a fictional sex-change on his lover in order to cover up a homosexual affair. For generally persuasive refutations of these theories, see Briquet, *Pierre Loti et l'Orient*, 344–49, and Martin, Préface, *Aziyadé*, 20–22.

25 Lefèvre, "*Les Désenchantées*" *de Pierre Loti*, 95–96.

26 Hadidjé-Zennour, "La Vérité vraie sur les 'Désenchantées,'" *Figaro*, December 21, 1909, 1. Though Lefèvre comments indignantly on the "cynisme" of the article's claims about Djénane (Zennour even managed to suggest that it was precisely her pure Circassian blood that had prevented her from fleeing her country with the others), she tends to support the speculation that Sefer Bey was not in fact Turkish. "Un vrai Turc," she suggests, was very unlikely to have felt such hatred for Loti, and a Turkish acquaintance of hers who had heard of the author had concluded that he was "très probablement un Arménien" ("*Les Désenchantées*" *de Pierre Loti*, 119n, 116).

27 Lufti Bey Fikri, *Les Désenchantées de M. Pierre Loti*, as cited in Lefèvre, "*Les Désenchantées*" *de Pierre Loti*, 135.

28 For further evidence as to "la vérité sociale" in the novel, see Lefèvre's helpful, if somewhat jaundiced discussion of the question in "*Les Désenchantées*" *de Pierre Loti*, 131–41; and Fanny Davis, *The Ottoman Lady: A Social History from 1718 to 1918* (Westport, CT: Greenwood Press, 1986), 77–79. Davis briefly remarks the spread of Western education among the upper classes and notes how some late nineteenth-century Turks, both women and men, began to criticize the harem system, especially arranged marriages and the practice of polygamy. As she also observes, however, "certainly the *désenchantées* must have been far fewer in number than the girls who accepted the old arrangements" (79). In "The Making and Breaking of Marital Bonds in Modern Egypt," *Women in Middle Eastern History: Shifting Boundaries in Sex and Gender,* ed. Nikki R. Keddie and Beth Baron (New Haven: Yale University Press, 1991), 275–91, Beth Baron traces an analogous shift away from polygamy and toward an ideal of companionate marriage among the urban middle and upper classes in turn-of-the-century Egypt, though she argues that "this was primarily a consequence of internal changes in Egyptian society rather than a product of European example" (277). For a helpful account of the ambivalence with which Turkish novelists themselves approached the "woman question" and anxieties about Westernization in the period, see also Deniz Kandiyoti, "Slave Girls, Temptresses and Comrades: Images of Women in the Turkish Novel," *Feminist Issues* 8: 1 (1988): 35–50.

29 Sefer Bey, "Les 'Désenchantées' de Pierre Loti," 80.

30 Demetra Vaka (Mrs. Kenneth Brown), *Haremlik: Some Pages from the Life of Turkish Women* (Boston: Houghton Mifflin, 1909), 12, 153, 164, 168, 147, 16. In a prefatory note to the text, Vaka declared that "the contents of this book are not fictitious, unusual as parts of it may appear to American readers." There had been "some rearranging of facts, to make for compactness," she conceded, but "substantially... everything is true as told."

31 There is ample evidence that Loti half-suspected the truth, from his fictional surrogate's response to the first letter he receives from the *désenchantées* — "ah, no, that woman was making fun of him, surely! Her language was too modern, her French too pure and easy" (Loti, *Les Désenchantées*, 6) — to his own plaintive letter to one of the sisters several years after "Leyla"'s "suicide": "You wouldn't have played this odious game with me, would you? And yet how could a woman of the world, and of the elegant world like Leyla Hanoum, have been able to disappear so tragically without being remembered?... In that case, what?" (as cited in Briquet, *Pierre Loti et l'Orient*, 429). Fanny Davis has even speculated that in naming his fictional novelist "Lhéry," he coyly paid tribute to the writer whose real name was Marie Léra (Davis, *The Ottoman Lady*, 86n).

32 Zeyneb Hanoum, *A Turkish Woman's Impressions*, 237, 109, 186, 236, 194, 238–39.

33 Mme L—Pacha, as quoted by Marcelle Tinayre, "Notes d'une voyageuse en Turquie," *Revue des deux mondes,* 1 November 1909, 156.

5. A Prison for Slaves

1 See, e.g., Jean Thévenot, whose *Voyage du Levant* first appeared in 1665: "Serraï, en turc, veut dire palais, et les Français par corruption disent sérail, le prenant, ce semble, seulement pour l'appartement où sont serrées femmes; comme s'ils voulaient dériver ce mot du français serrer, ou de l'italien serrar, qui veut dire fermer; mais ce mot est turc et signifie palais, et celui du Grand Seigneur est appelé Serraï par excellence" (57). Nearly two centuries later, an Englishwoman was still correcting the same error: "The Harem of the Sultan (for Seraglio is an improper word, Serai simply meaning palace...) usually contains about five hundred females." Emma Reeve, *Character and Costume in Turkey and Italy*, 24.

Compare also Elizabeth Craven's somewhat baffled response to the problem of linguistic and cultural difference when she visited Constantinople in 1785–86: "It is strange... how words gain in other countries a signification different from the meaning they possess in their own. Serail, or Seraglio, is generally understood as the habitation, or rather the confinement of women; here it is the Sultan's residence." Elizabeth Lady Craven, *Journey*, 269.

2 Charles-Louis de Secondat, baron de Montesquieu, *Lettres persanes*, ed. P. Vernière (Paris: Éditions Garnier Frères, 1975), vii. 20, ix. 23. All further page references to this text are to this edition and are likewise preceded by letter numbers in roman numerals.

3 [Jean] Chardin, *Voyages*, 6: 18. Cf. the remark in his chapter on eunuchs: "Ils commandent l'entrée et la sortie du haram, qui est l'habitation des femmes, ou pour mieux dire, leur prison" (6: 40).

4 But too much heat, according to Chardin's climatology, also led to a relaxation of vigilance, since it weakened desire. For opposite reasons than the Turks, the inhabitants of the enervating Indies therefore also guarded their women less jealously than the Persians. See *Voyages* 6: 8–9.

5 I am relying on the anonymous English translation of the same year, which twice uses the phrase "perpetual prison." [Du Vignau, sieur de Joannots], *The Turkish Secretary*, 57, 70.

6 *The Turkish Secretary*, 70.

7 On the *Kafes*, see N. M. Penzer, *The Harem*, 197–200. The practice of confining the princes rather than engaging in dynastic fratricide when a new sultan ascended the throne began in the reign of Mehmed III (1595–1603). For a sophisticated account of the transformation of the system of royal succession, see Leslie Pierce, *The Imperial Harem*, 97–103.

[8] Samuel Johnson, *A Dictionary of the English Language*, 2 vols. (London: W. Strahan, 1755), s.v. "seraglio."

[9] See, e.g., Robert Withers, *A Description of the Grand Signor's Seraglio*, 40; and Chardin, *Voyages*, 6: 13–14.

[10] Mrs. [Henry William] Pickersgill, *Tales of the Harem* (London: Longman et al., 1827), title page.

[11] William Shakespeare, *The Tragedy of King Lear*, 5.3.8–9, in *The Riverside Shakespeare*, ed. G. Blakemore Evans et al. (Boston: Houghton Mifflin, 1974).

[12] Miss [Julia] Pardoe, *City of the Sultan*, 1: 101, 102, 205.

[13] Ibid., 1: 206.

[14] Ibid., 1: 33. Forty years later, Fanny Blunt routinely repeated the same figure, asserting that Turkish ladies on an outing "can only be compared to a flock of strange birds suddenly let loose from their cages, not knowing what to make of their new freedom." [Fanny Janet Blunt], *The People of Turkey: Twenty Years' Residence Among Bulgarians, Greeks, Albanians, Turks and Armenians. By a Consul's Daughter and Wife*, ed. Stanley Lane Poole, 2 vols. (London: John Murray, 1878), 1: 113–14.

[15] Thomas Moore, *Lalla Rookh*, 67, 72–73, 71.

[16] Joan DelPlato, *From Slave Market to Paradise*, 258. Though the work reproduced here is a watercolor, Lewis also painted a version in oil the same year. In 1878, as DelPlato notes, the London *Art Journal* alluded to Lewis as the painter of "latticed harems with caged doves," thus implicitly extending his metaphor to include all his harem women (265n). DelPlato's helpful discussion mentions several further examples of the caged bird image, both verbal and visual (257–66).

[17] *Englishwoman's Review* (London: 1877), 8: 42. For related observations about the way in which the etymology of *seraglio* reinforced the canard that Muslims regarded their women as soulless animals, see Joyce Zonana, "The Sultan and the Slave: Feminist Orientalism and the Structure of *Jane Eyre*," *Signs* 18 (1993): 600.

[18] William Makepeace Thackeray, *Notes of a Journey from Cornhill to Grand Cairo* (1846), in *Works*, 5: 649.

[19] Predictable as they are, the "gilded cages" of Pickersgill's poem may also recall the "birds i' th' cage" evoked by her epigraph from *Lear* (5.3.9). See *Tales of the Harem*, 9.

[20] Withers, *A Description of the Grand Signor's Seraglio*, 37.

[21] It was not only the West that conflated various forms of Eastern slavery. For a sophisticated account of how the nineteenth-century Ottomans defended themselves from European abolitionism by assimilating various categories of slave (including agricultural laborers) to the relatively privileged types in the harem or the military and administrative system, see Ehud R. Toledano, "Late Ottoman Concepts of Slavery (1830s–1880s)," *Poetics Today* 14 (1993): 477–506.

[22] See Bernard Lewis, *Race and Slavery in the Middle East: An Historical Enquiry* (New York: Oxford University Press, 1990), 72, 80; and Ehud R. Toledano, *The Ottoman Slave Trade and Its Suppression: 1840–1890* (Princeton: Princeton University Press, 1982), 141–91.

[23] Linda Nochlin, "The Imaginary Orient," 44–45.

[24] According to Pierce, sixteenth- and seventeenth-century European commentators

tended to trace the Ottoman avoidance of marriage to the shaming of Bayezid I after his defeat in 1402 by the Turkish-Mongul conqueror known to the West as Tamerlane, when the sultan was forced by his captor to watch his royal consort perform menial tasks. Foreign observers (including Withers) also cited the potential drain on the royal treasury that marriage might entail, given the protection of married women's property under Islamic law. Pierce herself chooses to emphasize the growing consolidation of the empire, which effectively dried up the potential pool of interdynastic marriage partners and meant that no other power was seen as worthy of marital alliance. She cites a Muslim proverb: "kingship is bereft of ties." See *The Imperial Harem*, 28–39.

25 Withers, *A Description of the Grand Signor's Seraglio*, 162.

26 Pierce, *The Imperial Harem*, 31–32, 40–41. "It might seem odd that a woman whose career had begun as a slave concubine should be thought to bear 'the honor of inherited nobility,'" Pierce observes of the sultan's mother; but "her blood tie to her son provided her with a kind of retroactive lineage" (284).

6. Rebellion in the *Sérail* of Montesquieu's Persian

1 The translator was Charles Johnson.

2 Alain Grosrichard, *Structure du sérail*, 26–33.

3 Alan J. Singerman, "Réflexions sur une métaphore: le sérail dans les *Lettres persanes*," *Studies on Voltaire and the Eighteenth Century* 185 (1980): 181–98.

4 For a history of the French word "despotisme" and its changing associations, see Grosrichard, *Structure du sérail*, 8–11. Grosrichard emphasizes the irony by which a term originally identified with the domestic sphere was so thoroughly transferred to the politics of the state that its use for familial relations in the eighteenth century became strictly metaphorical. On the identity between familial and political despotism in Montesquieu's text, see Mary Lyndon Shanley and Peter G. Stillman, "Political and Marital Despotism: Montesquieu's *Persian Letters*," in *The Family in Political Thought*, ed. Jean B. Elshtain (Amherst: University of Massachusetts Press, 1982), 66–79. Cf. also Aram Vartanian, "Eroticism and Politics in the *Lettres persanes*," *Romanic Review* 60 (1969): 23–33.

5 See Montesquieu's own note to this effect, *Lettres*, vii. 19 n3.

6 The quotation comes from a letter attributed to the chief eunuch that Montesquieu apparently decided not to publish, on the grounds that it too closely resembled material elsewhere in the collection. It is reprinted in the appendix to the Garnier edition, 340–43; the quotation appears on 341. For Montesquieu's account of why he excluded it, see 340 n3.

7 See, e.g., Robert F. O'Reilly, "The Structure and Meaning of the *Lettres persanes*," *Studies on Voltaire* 67 (1969): 120–21; Jean Starobinski, "Les *Lettres persanes:* Apparence et essence," *Neohelicon* 1–2 (1974): 101–103; and Singerman, "Réflexions sur une métaphore," 194.

8 Charles-Louis de Secondat, baron de Montesquieu, *De l'Esprit des loix* [sic], ed. Jean Brethe de la Gressaye, 4 vols. (Paris: Société les Belles Lettres, 1950), 2: 16.11. All future references to this text will likewise give the volume number of this edition, followed by Montesquieu's book and chapter numbers.

9 For a thorough analysis of the "fantasme" of Eastern despotism and its self-defeating logic, see Grosrichard, *Structure du sérail*. Though he often draws on Montesquieu, Grosrichard does not so much explicate any particular writer's texts as analyze what he takes to

be the deep "structure" of the seraglio in the imagination of seventeenth- and eighteenth-century Europe. Highly abstract and relentless in its internal consistency, his brilliant demonstration of how the fiction of Eastern despotism could serve as a metaphor for the double-binds of power is finally closer in spirit to the Lacanian theory that inspires it than to the miscellaneous travel writers and philosophers who provide its occasion.

[10] Montesquieu, *L'Esprit des loix* 1:4.3.

[11] Cf. Ibid., 5:16, on "the communication of power" in a despotism: "In a despotic government the power passes entirely into the hands of the person to whom one confides it. The vizier is the despot himself; and each individual officer is the vizier." Shanley and Stillman also cite this passage as a gloss on the position of the eunuchs in the *Lettres* ("Political and Marital Despotism," 68).

[12] Singerman, "Réflexions sur une métaphore," 191–92. Strictly speaking, there are two chief eunuchs: letter cxli reports the death of the first and cliii appoints Solim in his place. But apart from the fact that the new place-holder has a name, the two are for all intents and purposes indistinguishable. On the eunuch as Montesquieu's principal figure for "l'absurdité du despotisme," see also Tzvetan Todorov, "Réflexions sur les *Lettres persanes*," *Romanic Review* 74 (1983): 313–14.

[13] Despite the fact that the sequence of letters reporting the trouble in the harem clusters together at the end of the collection, the letters are actually dated over a period of three years. As Elizabeth Heckendorn Cook has argued, the reader who follows Montesquieu's implicit invitation to redistribute them according to chronology further exposes the "glaring disjunction" between Usbek's liberal theory and his despotic practice. See "The Limping Woman and the Public Sphere," *Body and Text in the Eighteenth Century*, ed. Veronica Kelley and Dorothea E. von Mücke (Stanford: Stanford University Press, 1994), 39. At the same time, of course, the force of the peripeteia is intensified by the letters' displacement to the end of the volume. The dating of the letters was first worked out in Robert Shackleton, "The Moslem Chronology of the *Lettres persanes*," *French Studies* 8 (1954): 17–27.

[14] Starobinski, "Les *Lettres persanes*," 103.

[15] For a feminist critique of Roxane's "radically privatized" gesture, see Cook, "The Limping Woman and the Public Sphere," 41. Cf. also Sheila Mason, "The Riddle of Roxane," in *Women and Society in Eighteenth-Century France: Essays in Honour of John Stephenson Spink*, ed. Eva Jacobs et al. (London: Athlone Press, 1979), 28–41; and Julia V. Douthwaite, *Exotic Women: Literary Heroines and Cultural Strategies in Ancien Régime France* (Philadelphia: University of Pennsylvania Press, 1992), 88–102.

[16] A more equivocal bequest may be apparent in the self-destructive gesture that concludes Loti's modern harem novel. Like Roxane, the heroine of *Les Désenchantées* chooses suicide rather than submit to continued oppression, and like Roxane, she records her act in a farewell letter, even as the pen drops from her hands. "Le poison me consume; ma force m'abandonne; la plume me tombe des mains," Roxane writes (clxi. 334), while Djénane reports, "le flacon d'oubli est vide," and, a little later, "le sommeil vient et la plume est lourde" (Pierre Loti, *Les Désenchantées*, 431–32, 433). Like Roxane, too, Djénane defies the harem in the name of her freedom to choose for herself, though her act has nothing of the political force that made the *Lettres persanes* resonate so strongly for readers over more than two centuries. For all their literary self-consciousness about the text they were constructing, neither Loti nor Hélys appears to have registered these echoes of Montesquieu.

[17] Joyce Zonana, "The Sultan and the Slave," 599, and Mary Wollstonecraft, *Maria or the Wrongs of Woman* (New York: Norton, 1975), 116. Wollstonecraft's novel was first published posthumously in 1798. Doubtless the heroine of Defoe's *The Fortunate Mistress* (1724),

who also wishes to be known as "Roxana," owes at least her choice of name to this tradition. In "Rewriting Roxane: Orientalism and Intertextuality in Montesquieu's *Lettres persanes* and Defoe's *The Fortunate Mistress*," *Stanford French Review* 11 (1987): 177–91, Katie Trumpener argues, not altogether convincingly, for an intertextual relation that connects Defoe's Roxana with both Racine's and Montesquieu's heroines.

[18] The historical "Roxelana," named "Hurrem" in Turkish, may have acquired the name by which she was known in Europe from a Polish term meaning "Ruthenian maiden." Leslie Pierce, *The Imperial Harem*, 58–59.

[19] Jean-François Marmontel, "Soliman II," *Trois Contes moraux* (Paris: Éditions Gallimard, 1994), 33.

[20] "Point d'esclaves chez nous; on ne respire en France / Que les plaisirs, la liberté, l'aisance. / Tout citoyen est roi, sous un roi citoyen." [Charles-Simon] Favart, *Les Trois Sultanes ou Soliman II: Comédie en trois actes, en vers* (Paris: Librairie Stock, 1926), 2.3, 36.

[21] Isaac Bickerstaffe [sic], *The Sultan, or A Peep into the Seraglio: A Farce, in Two Acts* (London: C. Dilly, 1787), 7, 9, 12.

[22] Johann Gottlieb Stephanie the Younger, Libretto for *Die Entführung aus dem Serail*, based on an opera by Christoph Fredrich Bretzner, trans. Susan Webb, music by Wolfang Amadeus Mozart (New York: Metropolitan Opera Guild, 1991), 2.1, #9. All further references to the libretto are to this edition and are indicated by act, scene, and where relevant, musical number in the text. Translations, however, are my own. For Stephanie's changes to Bretzner's libretto, see Thomas Bauman, *W. A. Mozart: Die Entführung aus dem Serail* (Cambridge: Cambridge University Press, 1987), 36–61.

[23] Thomas Allom and Emma Reeve, *Character and Costume*, 14.

[24] [Anon.], *The Lustful Turk or Lascivious Scenes in a Harem Faithfully and Vividly Depicted: In an Series of Letters from a Young and Beautiful English Lady to her Cousin in England* (New York: Canyon Books, 1967), 159. First published in 1828, *The Lustful Turk* was reprinted several times in the course of the nineteenth century. The edition quoted here is based on one published in Amsterdam and London in 1893.

7. Visions of Oppression from Wollstonecraft to Nightingale

[1] Malouk Alloula, *The Colonial Harem*, 21. The photograph itself is reproduced on page 24.

[2] "A Visit to a Harem. By a Lady," 67.

[3] Mervat Hatem, "Through Each Other's Eyes: Egyptian, Levantine-Egyptian, and European Women's Images of Themselves and Of Each Other (1862–1920)," *Women's Studies International Forum*, 12 (1989): 183.

[4] "Women in the East. By an Oriental Traveller," *Bentley's Miscellany* 27 (1850): 384.

[5] Mary, Lady Chudleigh, "To the Ladies" (1703), in *Eighteenth-Century Women Poets*, ed. Roger Lonsdale (Oxford: Oxford University Press, 1990), 3.

[6] Mary Wollstonecraft, *A Vindication of the Rights of Woman*, ed. Carol H. Poston (New York: Norton, 1988), 22. All further references to this text, which is based on the second edition of 1792, appear parenthetically in the text.

[7] Joyce Zonana, "The Sultan and the Slave," 599.

⁸ Ibid., 601. Unfortunately, the editor of the Norton Critical Edition twice perpetuates the myth about the souls of women in Islam in her footnotes to the relevant passages. See Wollstonecraft, *The Rights of Woman*, 8, 19.

⁹ Zonana, "The Sultan and the Slave." "By figuring objectionable aspects of life in the West as 'Eastern,'" Zonana argues, "Western feminist writers rhetorically define their project as the removal of Eastern elements from Western life." As a result, she suggests, "the Western feminist's desire to change the status quo can be represented not as a radical attempt to restructure the West but as a conservative effort to make the West more like itself" (594). For a related discussion of how some aspects of Western feminism were adopted for essentially exploitative ends in late-nineteenth-century Egypt and elsewhere, see Leila Ahmed, *Women and Gender in Islam*, 144–68.

¹⁰ [Julia] Pardoe, *City of the Sultan*, 1: 195, 194. Though she firmly dismissed the claim about women's souls as "false," Pardoe hedged a bit on the similarly vexed question of an afterlife, remarking that while the Muslim woman was apparently not shut out from some form of paradise, "there is a little harem-like mystery flung over the destiny that awaits her" (2: 52). A subsequent anecdote points the moral that Turkish women really do believe "a happy immortality awaits them" if they don't forfeit it by their misdeeds (3: 63–64).

¹¹ Ibid., 1: 98; 3: 109.

¹² Mrs. [Annie Jane] Harvey, *Turkish Harems and Circassian Homes* (London: Hurst & Blackett, 1871), 91.

¹³ Harriet Martineau, *Eastern Life, Present and Past* (Philadelphia: Lea and Blanchard, 1848), 259, 260, 262, 267. This is a one-volume edition of the three-volume work published in England the same year.

¹⁴ Ibid., 260, 263.

¹⁵ Ibid., 263–64. How close to home this concern was for Martineau may be sensed in the similar language with which she later responded to the publication of Charlotte Brontë's *Villette* (1853): "All the female characters, in all their thoughts and lives, are full of one thing, or are regarded by the reader in light of that one thought — love . . . There are substantial, heartfelt interests for women of all ages, and under ordinary circumstances, quite apart from love." *Daily News*, 3 February 1853, 2.

¹⁶ Martineau, Eastern Life, 267, 268, 269.

¹⁷ See, e.g., a dialogue reported earlier: "In answer to our question what they did in the way of occupation, they said 'nothing;' but when we inquired whether they never made clothes or sweetmeats, they replied 'yes.'" Martineau, *Eastern Life*, 269.

¹⁸ Ibid., 270. Cf. Richard Burton's contemptuous response to Martineau in the lengthy "Terminal Essay" he appended to his translation of the *Arabian Nights* in 1886: "a learned lady, Miss Martineau, once visiting a Harim, went into ecstasies of pity and sorrow because the poor things knew nothing of — say trigonometry and the use of the globes. Sonnini thought otherwise, and my experience, like that of all old dwellers in the East, is directly opposed to this conclusion." Richard F. Burton, *The Book of the Thousand Nights and a Night: A Plain and Literal Translation of the Arabian Nights Entertainment*, 3 vols. (New York: Heritage Press, 1934), 3: 3742. Burton's edition of the *Thousand Nights* was first published in England in 1885.

¹⁹ Florence Nightingale, *Letters from Egypt: A Journey on the Nile, 1849–1850*, ed. Anthony Sattin (New York: Weidenfeld & Nicolson, 1987), 205, 208. Though Nightingale's letters were privately printed by her sister in 1854, they were not actually published until this 1987 edition.

[20] Martineau, *Eastern Life*, 269; Nightingale, *Letters from Egypt*, 208; Martineau, *Eastern Life*, 267. On the resemblance between Nightingale's description of the harem and the language with which in *Cassandra* (1852) she later evokes female oppression at home, see Zonana, "The Sultan and the Slave," 605.

[21] Samuel Johnson, *Rasselas: The Prince of Abyssinia, A History* (1759), in *Samuel Johnson*, ed. Donald Greene (New York: Oxford, 1984), 399.

[22] [James J. Morier], *Ayesha, the Maid of Kars* (London: Richard Bentley, 1846), 46, 417. This is a one-volume edition, in Bentley's Standard Novels series, of Morier's 1834 novel.

8. Looking for Liberty: Lady Mary Wortley Montagu and the Victorians

[1] To Lady Mar, 1 April [1717], *Letters of Lady Mary Wortley Montagu*, 1: 329, 327–28.

[2] Aaron Hill, *Present State of the Ottoman Empire*, 110.

[3] To the Countesse of —, [May 1718], *Letters*, 1: 406.

[4] To Lady Mar, 1 April [1717], *Letters*, 1: 328.

[5] For another traveler's observations on the women's clothing, see Robert Withers, *A Description of the Grand Signor's Seraglio*, 200. Robert Halsband also instances Sieur Du Loir's remarks in his *Voyages* of 1654 (*Letters* 1: 328 n2). Cf. as well Wortley's account of the same phenomenon, as quoted by Halsband, *Letters* 1: 329 n3.

[6] For the argument that "Liberty" in the embassy letters "spelt out *sexual freedom*," see Billie Melman, *Women's Orients*, 86.

[7] To Wortley [20 August 1710]; [?c. 26 October 1710]; [16 August 1712]. *Letters* 1: 53, 61, 161–62. For other variations on this theme in the correspondence with her future husband, see *Letters* 1: 141–42, 147, 152, 156.

[8] As quoted in Robert Halsband, *The Life of Lady Mary Wortley Montagu* (Oxford: Clarendon Press, 1957), 56.

[9] Lady Mary's assumption of Turkish dress for the purpose of freely circulating partly anticipates a similar understanding of the veil among late-twentieth-century Islamic women. See Leila Ahmed, *Women and Gender in Islam*, 224: "In adopting Islamic dress, then, women are in effect 'carving out legitimate public space for themselves.' . . . The adoption of the dress does not declare women's place to be in the home but, on the contrary, legitimizes their presence outside it."

For a related argument about Lady Mary's Turkish costume, which reads her "literal and symbolic appropriation of the veil" as "a sign of resistance to the omnipotent European male gaze," see Wendy Frith, "Sex, Smallpox and Seraglios: A Monument to Lady Mary Wortley Montagu," in *Femininity and Masculinity in Eighteenth-Century Art and Culture*, ed. Gill Perry and Michael Rossington (Manchester: Manchester University Press, 1994), 110. Cf. also Marcia Pointon, "Killing Pictures," in *Painting and the Politics of Culture: New Essays on British Art, 1700–1850*, ed. John Barrell (Oxford: Oxford University Press, 1992), 63–64. As Pointon suggests, the fact that Lady Mary's own encounter with smallpox had left its marks on her face would no doubt have added to the pleasure with which she assumed the veil.

[10] To Lady Bristol [10 April 1718]; To the Countesse of —, [May 1718]; To Lady —, 1 April [1717]. *Letters* 1: 397, 405, 312. Joseph W. Lew has suggestively contrasted the mobile

seeing enabled by Lady Mary's vehicle with the apparently closed "boîtes," in which Montesquieu, following Chardin, represents his Persian women as traveling ("Lady Mary's Portable Seraglio," 438–39).

[11] To the Countesse of —, [May 1718]; To Lady Mar, 18 April [1717]; To Lady Mar, 10 March [1718]. *Letters* 1: 407, 349, 350, 352, 350, 386.

[12] To Lady Mar, 1 April [1717]; To the Abbé Conti [February 1718]. *Letters* 1: 329, 375–76. Though the letter to Conti does not appear in the manuscript of the embassy letters (it was separately printed, with a translation in 1719), Halsband judges it genuine. In a previous letter to Conti, written in English and dated 29 May [1717], Lady Mary had corrected "our Vulgar Notion that they do not own Women to have any Souls." *Letters* 1: 363.

[13] Mary Louise Pratt, *Imperial Eyes: Travel Writing and Transculturation* (New York: Routledge, 1992), 166–67. Though her examples come from two nineteenth-century women writers, Flora Tristan and Maria Graham, Pratt speculates that Tristan had been influenced by Lady Mary (167–68).

[14] To Lady Mar, 18 April [1717], *Letters* 1: 351. Of course, Lady Mary did not consistently idealize what she saw in Turkey, even what she saw of Turkish women. Another letter follows up a tribute to the freedom of the women by acknowledging how the very anonymity that protected them could turn mortally dangerous: "no woman's face being known," a husband who wished to take revenge on an unfaithful wife could murder her with impunity. After reporting on the discovery of one such corpse, she goes on, however, to pronounce such cases "extreamly rare." To the Countesse of —, [May 1718], *Letters* 1: 407, 408.

[15] To Lady R[ich], 20 September [1716]; To Lady Bute, 20 October [1755]; To Lady —, 1 April [1717]. *Letters* 1: 270, 3: 97, 1: 314.

[16] Lew, "Lady Mary's Portable Seraglio," 441. On Lady Mary's idealizing and aestheticizing of Turkey, see also Cynthia Lowenthal's discussion of "the veil of romance" in the embassy letters: *Lady Mary Wortley Montagu and the Eighteenth-Century Familiar Letter* (Athens: University of Georgia Press, 1994), 80–113; and Elizabeth A. Bohls, *Women Travel Writers and the Language of Aesthetics, 1716–1818* (Cambridge: Cambridge University Press, 1995), 27–45.

[17] To the Abbé Conti, 31 July [1718], *Letters* 1: 423.

[18] In *L'Islam au péril des femmes*, Anne Marie Moulin and Pierre Chuvin attempt to follow up the various clues Lady Mary provides to the identity of her beautiful friend and conclude that Fatima must be a composite — "un personnage vraisemblablement composé," in their words, "dont Lady Montagu a vécu ou imaginé la rencontre." As they argue, "Pour aimer la Turquie, il fallait d'abord lui donner un beau visage" (19).

[19] For all the distortions and biases in their individual accounts, these writers thus constitute a significant exception to Leila Ahmed's generalizations about the West's stereotyped vision of Eastern "oppression" and its failure to recognize the potentially liberating effects of the harem for Muslim women. See "Western Ethnocentrism and Perceptions of the Harem," *Feminist Studies* 8 (1982): 521–34. (Ahmed does make a partial exception for Lady Mary.)

[20] Elizabeth Lady Craven, *Journey . . . to Constantinople*, 270, 272, 304.

[21] Ibid., 270.

[22] [Julia] Pardoe, *City of the Sultan*, 1: 96, 97. For another mild case of slipper-envy, see Sophia [Lane] Poole, *The Englishwoman in Egypt: Letters from Cairo, Written During a Residence There in 1842, 3, & 4 . . .*, 2 vols. (London: G. Cox, 1851), 2: 23–24. Poole's book was first published in 1844.

23 I borrow the apt term "fetishized" from Melman, *Women's Orients*, 121.

24 Ibid. Though I agree with Melman that Victorian women writers tended to desexualize the "liberty" they identified with the harem, her salutary emphasis on the complexity of their accounts leads her, in my view, to oversimplify their differences with their eighteenth-century predecessors. Lady Mary, at least, adumbrates virtually all the themes touched on by the nineteenth-century women Melman cites. I am nonetheless indebted to her wide-ranging and suggestive study.

25 Mrs. Colonel [Anne Katharine] Elwood, *Narrative of a Journey Overland from England, by the Continent of Europe, Egypt, and the Red Sea, to India; Including A Residence There, and Voyage Home, in the Years 1825, 26, 27, and 28*, 2 vols. (London: Henry Colburn and Richard Bentley, 1830), 1: 154.

26 Pardoe, *City of the Sultan*, 1: 97, 96.

27 Miss [Julia] Pardoe, *The Beauties of the Bosphorus* (London: Virtue and Co., 1838), 127.

28 "Mysteries of the Serai," *Bentley's Miscellany*, 54 (1863): 84. This article, which also appeared as "Mysteries of the Seraglio" in the New York *Eclectic Magazine* of the same year, acknowledges its origins in a recent French work: [Olympe Audouard], *Les Mystères du sérail et des harems turcs* (Paris: E. Dentu).

29 [Annie Jane] Harvey, *Turkish Harems*, 91, 90. Harvey goes on to concede the physical liberty of Turkish women but to contend that it "does not at all compensate for the slavery of mind which they have to endure" (91).

30 Class, for example, made a difference in whether the women of the household ventured out to the marketplace. While upper-class harems relied on slaves to buy food and acquired other kinds of goods through visiting female peddlers or merchants who sent their wares for inspection, middle- and lower-class women often appear to have done their own shopping. See Ahmed, *Women and Gender in Islam*, 118. Cf. also Melman, *Women's Orients*, 105; and Judith E. Tucker, "The Arab Family in History: 'Otherness' and the Study of the Family," in *Arab Women: Old Boundaries, New Frontiers*, ed. Tucker (Bloomington: University of Indiana Press, 1993), 195–207.

31 To the Countesse of —, [May 1718]; To Lady Mar, 1 April [1717]. *Letters* 1: 406, 329.

32 See Halsband's note, *Letters*, 329n.

33 Anna Bowman Dodd, *In the Palaces of the Sultan* (New York: Dodd, Mead and Company, 1903), 448, 447, 434.

34 Melman, *Women's Orients*, 109. For some first-hand testimony to this effect, see Melek-Hanum's rather jaundiced account of her travails as the repudiated wife of a Turkish pasha, *Thirty Years in the Harem; or, the Autobiography of Melek-Hanum, Wife of H. H. Kibrizli-Mehemet-Pasha* (New York: Harper & Brothers, 1872): "But if from the written law we turn to the living one, from theory to practice, it is there one sees of what little use for the woman are her pretended rights" (282).

35 To Lady Bristol [10 April 1718], *Letters* 1: 401–402.

36 On the abolitionists, see Ehud R. Toledano, *The Ottoman Slave Trade*.

37 Emma Reeve, *Character and Costume*, 29.

38 Harvey, *Turkish Harems*, 10. For another account of the relative benignity of Eastern slavery, focused in this case on Egyptian examples, see Poole, *The Englishwoman in Egypt*, 2: 21–23.

[39] Harriet Martineau, *Eastern Life*, 265, 266. Only three years before Martineau, Charles White had observed of slaves in Turkey that "under every circumstance, their condition may be considered as consummate felicity, when compared with that of the vast majority of slaves in Christian colonies and in the United States." See *Three Years in Constantinople; or, Domestic Manners of the Turks in 1844*, 3 vols. (London: Henry Colburn, 1845), 2: 304–305. For the view that the two systems of slavery have "hardly a feature in common," see, e.g., the pair of articles by J[ames] C[arlile] McCoan, "Slavery in Egypt," and "Slavery and Polygamy in Turkey," in *Fraser's Magazine* n.s. 15 (1877): 563, and n.s. 18 (1878): 403, respectively. Though Billie Melman repeatedly characterizes Martineau's views as uncharacteristic of harem literature, it should be clear that by "harem literature" she refers only to the records of English women travelers, and that women as well as men could be found on both sides of the issue. In his decidedly unsympathetic *Turkey and Its Destiny: The Result of Journeys Made in 1847 and 1848 to Examine into the State of that Country*, 2 vols. (Philadelphia: Lea and Blanchard, 1850), Charles Mac Farlane, for example, protested that "perhaps too much has been said about the mildness of domestic slavery in Turkey" (2: 248). Unlike Martineau, however, he reserved his chief outrage for the trade in whites.

[40] Pardoe, *City of the Sultan*, 3: 133, 132; 1: 100–101. Cf. her *Beauties of the Bosphorus* (1838), where Pardoe protests the sort of visual clichés that Gérôme and others would continue to exploit in their paintings of the slavemarket later in the century: "a pretty picture may be readily produced when the formal quadrangle of the market is relieved by groups of beautiful Georgians or Circassians, habited in flowing draperies of white muslin, and unveiled by the coarse hands of the dealer to gratify the whim of every lounging passenger; but surely if the creators of these flimsy prettinesses were to reflect for a moment that they are not only violating good taste in their own persons, but moreover libelling a whole people, and distorting truth at the same time, they would consent . . . to dispense with an effect, in order to be at once more decent, more veracious, and more just" (128).

[41] See Melman, who calls the analogy between the slave and the domestic servant "as poignant as it is revealing" and "a comment on the British class system" (*Women's Orients*, 147).

[42] Pardoe, *City of the Sultan*, 1: 206, 114

9. Pleasure in Numbers

[1] John Gay, *The Beggar's Opera* (1728), in *Dramatic Works*, ed. John Fuller, 2 vols. (Oxford: Clarendon, 1983), 2: 63, 65–65. Quotations are from act 3, scenes 15 and 17.

[2] Cf. Martin Price, who characterizes Macheath as a "natural aristocrat," and suggests that the Peachum household "anticipates the family of Clarissa Harlowe in its righteous distrust" of such a figure. *To the Palace of Wisdom: Studies in Order and Energy from Dryden to Blake* (1964; rpt. Garden City, NY: Anchor Books, 1965), 249, 247.

[3] Samuel Richardson, *Clarissa or, The History of a Young Lady*, ed. Angus Ross (New York: Viking, 1985), 872. Further page references to this edition, which follows the first edition of 1747–48, are given in the text.

[4] Lovelace's rooster and his harem would make an instructive comparison with the seemingly monogamous pigeons from whose sexual behavior Rousseau attempts to deduce the naturalness of female modesty in the *Lettre à M. d'Alembert* a decade later. See Ruth Bernard Yeazell, *Fictions of Modesty: Women and Courtship in the English Novel* (Chicago: University of Chicago Press, 1991), 28–29.

[5] Aaron Hill, *Present State of the Ottoman Empire*, 98, 103. On the number of "*Lawful*

Wives" Hill was accurate enough, but by erroneously attributing the restriction to Turkish "Policy" rather than Islam, he managed to contribute to the Western stereotype of Mohammed's unbridled sensuality. While Hill claimed that "polygamy was by *Mahomet* allow'd them, freely and unbounded" (98), the Koran specifically limits the practice. According to the letter of the law, a man may only take more than one wife — up the maximum of four — if he can treat them equally.

For an account of the conflicting interests at work in the subsequent history of Islamic polygamy, see Leila Ahmed, *Women and Gender in Islam*, esp. 41–123. On the origins of Western misrepresentations of Islam, see Norman Daniel, *Islam and the West: The Making of an Image* (1960; rev. Oxford: Oneworld Publications, 1993).

6 To Lady Mar, 1 April [1717], *Letters of Lady Mary Wortley Montagu*, 1:329.

7 Leslie P. Pierce, *The Imperial Harem*, 290 n6.

8 To Lady Bristol, [10 April 1718], *Letters* 1:402.

9 John Cleland, *Memoirs of a Woman of Pleasure*, ed. Peter Sabor (Oxford: Oxford University Press, 1985), 95. Sabor's text follows the first edition of 1748–49.

10 Samuel Johnson, *Dictionary*, s.v. "seraglio." For the "Maison Orientale," see Isabelle Julia, "Daughters of the Century," in *La France: Images of Woman and Ideas of Nation, 1789–1989* (London: South Bank Centre, 1989), 95.

11 Henry Home, Lord Kames, *Sketches of the History of Man*, 2nd ed., 4 vols. (Edinburgh: W. Creech and London: W. Strahan and T. Cadell, 1778), 2: 79, 77. For the tendency of Western commentators to project male promiscuity onto the inhabitants of the harem, see Joan DelPlato, *From Slave Market to Paradise*, 329–31.

12 See *Byron's "Don Juan": A Variorum Edition*, ed. Truman Guy Steffan and Willis W. Pratt, 4 vols. (Austin: University of Texas Press, 1957), 2: 496. Something of the same confusion persists even in a modern critic, who terms Gulnare, the slave-concubine in Byron's *Corsair*, a "harlot." See Nigel Leask, *British Romantic Writers and the East: Anxieties of Empire* (Cambridge: Cambridge University Press, 1992), 49.

13 [Martin Madan], *Thelyphthora; or, A Treatise on Female Ruin, in its Causes, Effects, Consequences, Prevention, and Remedy . . .* , 2nd ed., 3 vols. (London: J. Dodsley, 1781), 2: 80n, 79. This is an expanded version of the original two-volume edition published in 1780.

Madan was of course neither the first nor the last Christian advocate of polygamy. In the thirty-fifth letter of the *Lettres persanes*, Usbek himself alludes to an earlier work in the same tradition, the *Polygamia Triumphatrix* (1682) of Johann Leiser. For a useful if rather breezy overview of the subject, see John Cairncross, *After Polygamy Was Made a Sin: The Social History of Christian Polygamy* (London: Routledge, 1974).

14 [Madan], *Thelyphthora*, 2: 85. The anecdote about the Turkish ambassador to France came from a passage in Hume's "Of Polygamy and Divorces" that he omitted from his last corrected edition of the *Essays*. Hume himself was quick to counter the implication of the ambassador's remarks: "The known virtue of our BRITISH ladies frees them sufficiently from this imputation." See David Hume, *Essays Moral, Political, and Literary*, ed. Eugene F. Miller (Indianapolis: Liberty Fund, 1985), 627–28.

15 Boswell's journals, 15 February 1775; 23 March 1776; 19 March 1775, in *Boswell: The Ominous Years, 1774–1776*, 65, 294, 82. Boswell's journals, 12 September 1777, in *Boswell in Extremes, 1776–1778*, ed. Charles McC. Weis and Frederick A. Pottle, Yale Editions of the Private Papers of James Boswell (New York: McGraw-Hill, 1970), 146.

[16] Boswell's journals, 18 March 1775, in *Boswell: The Ominous Years*, 81; 1 September 1776, in *Boswell in Extremes*, 28.

[17] Boswell's journals, 14 December 1764, in *Boswell on the Grand Tour: Germany and Switzerland, 1764*, ed. Frederick A. Pottle, The Yale Editions of the Private Papers of James Boswell (New York: McGraw-Hill, 1953), 254, 253.

[18] Boswell's journals, 18 March 1775, and 19 March 1774, in *Boswell: The Ominous Years*, 81, 82.

[19] See, e.g., Boswell's journals, 7 April 1777, and 12 September 1777, in *Boswell in Extremes*, 107, 146.

[20] Marquis de Sade, *Aline et Valcour, ou le roman philosophique: Écrit à la Bastille un an avant la révolution de France,* in *Oeuvres complètes*, ed. Annie Le Brun and Jean-Jacques Pauvert, 15 vols. (Paris: Pauvert, 1986–91), 4: 236–37 (ellipsis in the original). Though a fair copy of *Aline et Valcour* probably dates from 1789, and it began to appear in 1791, the official date of full publication is generally given as 1795.

[21] Ibid., 4: 216, 214.

[22] Paul Rycaut, *Present State of the Ottoman Empire*, 38–39.

[23] Slave-concubines were also drawn from non-Muslim communities under Islamic rule, though this practice was technically forbidden. See Pierce, *The Imperial Harem*, 31.

[24] Thomas Moore, *Lalla Rookh*, 27–28, 67. Cf. the last tale of the poem, "The Light of the Haram," whose similar catalogue of international beauties reads in part: "Maids from the West, with sunbright hair, / And from the Garden of the NILE, / Delicate as the roses there; — / Daughters of Love from CYPRUS's rocks Every thing young, every thing fair / From East and West is blushing there" (353–54).

[25] Linda Nochlin, "The Imaginary Orient," 47. Though Nochlin also asserts that "the conjunction of black and white, or dark and light female bodies . . . has traditionally signified lesbianism" (49), she offers no evidence for this claim.

[26] Though it is ostensibly Nerval himself who attempts to acquire a slave, the entire episode appears to be a heavily fictionalized account of the experience of his friend. See Norman Glass's introduction to his selection and translation of Nerval's text, *Journey to the Orient* (New York: New York University Press, 1972), 17, and the editors' "Notice" to the Pléiade edition of the *Voyage en Orient* in *Oeuvres complètes*, ed. Jean Guillaume and Claude Pichois, 3 vols. (Paris: Éditions Gallimard, 1984–93), 2: 1381–82.

[27] Nerval, *Voyage en Orient,* in *Oeuvres complètes*, 2: 323. Though parts of the *Voyage* were in print as early as 1840, *Scènes de la vie orientale* first appeared in the *Revue des deux mondes* of 1846–47, and a complete edition was not published until 1851. See the editors' "Notice" to the Pléiade edition, 2: 1369–76. Like other travelers in both Egypt and Turkey, Nerval testifies to the racial hierarchy reflected by the price scale at the slave market; when he expresses some interest in purchasing an Abyssinian, he is told that these are much more expensive (2: 234). For more on the racial categorization of slaves in the Ottoman empire, see Bernard Lewis, *Race and Slavery in the Middle East*.

10. A Climate for Pornography

[1] For a related discussion of some eighteenth-century associations between geography and sexual passion, see Felicity Nussbaum, *Torrid Zones*, esp. 7–14. Reinhold Schiffer,

*Turkey Romanticized: Images of the Turks in Early 19ᵗʰ Century English Travel Literature,
with an Anthology of Texts* (Bochum: Studienverlag Dr. N. Brockmeyer, 1982), 30–31, specifically remarks the resemblance between the *Don Juan* passage and Montesquieu's theorizing.

² [Jean] Chardin, *Voyages . . . en Perse*, 6: 8-9.

³ Montesquieu, *L'Esprit des loix*, 2: 16.12, 16.11.

⁴ Ibid., 16.8. A previous chapter traces the origins of polygamy in hot climates to the early sexual maturation of the women — the theory being, apparently, that since a woman acquires her sexual attractions well before she has reached the age of reason, at which time her beauty is no more, she can never manage by herself wholly to command the loyalties of her husband (16.2).

⁵ Paul Rycaut, *Present State of the Ottoman Empire*, 39; Aaron Hill, *Present State of the Ottoman Empire*, 163.

⁶ Montesquieu, *L'Esprit des loix*, 2: 16.10. The second citation appears in one of Montesquieu's notes to this chapter.

⁷ Hill, *Present State of the Ottoman Empire*, 111, 112, 115.

⁸ Joseph Pitton de Tournefort, *Relation d'un voyage du Levant*, 2: 52.

⁹ Henry Home, Lord Kames, *Sketches of the History of Man*, 2: 81. I am grateful to Schiffer, *Turkey Romanticized*, for directing me to this passage (31).

¹⁰ In her *Marriage Rites, Customs, and Ceremonies, of All Nations of the Universe* (London: Chapple and Son et al., 1822), Lady Augusta Hamilton duly passed on similar accounts of Turkish women's appetite for Christians, including one in which a young Frenchman is smuggled into the harem disguised as his lover's slave, and only departs — "loaded with jewels and money," like Hill's British sailor — when the growth of his beard threatens discovery (48n).

Even the ethnographically scrupulous Edward Lane, whose sober *Account of the Manners and Customs of the Modern Egyptians* pointedly observed "the difficulty of carrying on an intrigue with a female in this place," could not help repeating some of the "innumerable stories" he had heard about the exceptional licentiousness of Egyptian women. Among the principal causes of such licentiousness, however, Lane did single out not only the climate of Egypt but the encouragement of Egyptian men. Edward William Lane, *An Account of the Manners and Customs of the Modern Egyptians, Written in Egypt During the Years 1833, –34, and –35, Partly from Notes Made During a Former Visit to that Country in the Years 1825, –26, –27, and –28*, 3rd. ed., 2 vols. (London: Charles Knight and Co., 1843), 1: 455, 457. While the first edition (1836) of Lane's book had associated the libidinousness of all Eastern women with the degree of restraint imposed upon them, this expanded and revised edition retracted that explanation, on the grounds that the very women "who are commonly considered the *most licentious* (namely, those of Egypt) are those who are said to have *most licence*" (1: 456n). A half-century later, one of the many fantastic notes that Richard Burton appended to his translation of the *Arabian Nights* was still solemnly contending that in "hot-damp" climates like Egypt the "venereal requirements . . . of the female greatly exceed those of the male" — an imbalance reversed by the dryer conditions of Arabia, according to Burton, where men are more amorous than women. But both dry climates and damp ones, by Burton's account, require the harem: where male appetite is the greater, he explains, polygamy prevails, but where the female's threatens to dominate, "the dissoluteness of morals would be phenomenal, were it not obviated by seclusion." Richard F. Burton, *Thousand Nights and a Night*, 1: 1231.

¹¹ Marquis de Sade, *Aline et Valcour*, in *Oeuvres complètes*, 4: 242, 243, 247.

¹² Marquis de Sade, *Les Cent vingt Journées de Sodome*, in *Oeuvres complètes*, 1: 20, 65, 83, 84. For other uses of "sérail" see, e.g., 68, 89, 312, 325, 411, 440, 447; for "sultanes," 89, 273, 325, 343, 344, 383, 411, 412.

¹³ Though the exploitation recounted in the *Memoirs* seems positively genial by comparison with the mutilation and torture Sade's libertines methodically inflict on their victims, the English text also describes a world in which male sexual excitement is closely identified with the thrill of systematic rule-making. Its third chapter provides a list of the "Laws to be observed by all members of the Seraglio of the Bashaw of Merryland," some of which —"No communication whatever to take place between the male and female part of the seraglio," for example—clearly do take their inspiration from the arrangements of an Eastern household. Others, however — like "No toasts to be drunk, but the bashaw's health," or "No more than four glasses of wine to be allowed after dinner . . . except for the sultana chosen for the evening, to whom the bashaw allows eight" — evidently belie the suggestion that the gentleman in question had adapted all his "regulations, laws, and customs" from an Eastern model. See [Sophia Watson], *Memoirs of the Seraglio of the Bashaw of Merryland*, 8, 9, 6.

¹⁴ Even in *Les Cent vingt Journées*, it should be said, a "sérail" can sometimes mean merely a brothel, as when Duclos, summoned to excite the company by recounting tales of her adventures as a prostitute, alludes to what in a whorehouse [une maison] is called the "sérail," or speaks of five young and pretty girls who composed the "sérail" of a certain madam (*Oeuvres complètes*, 1: 296, 175). But the relentless brutalizing of all sexual acts in *Les Cent vingt Journées* makes the distinction between an ordinary brothel and a torture palace not very easy to sustain.

¹⁵ Sade, *Aline et Valcour*, in *Oeuvres complètes*, 4: 219.

¹⁶ Ibid., 4: 237–38.

¹⁷ For the ancient sources, see Byron, *Complete Poetical Works*, 6: 624. On the originality of Delacroix's conception, see Jack J. Spector, *Delacroix: The Death of Sardanapulus*, Art in Context Series (New York: Viking, 1974), esp. 67–73; and Linda Nochlin, "The Imaginary Orient," 43. As Spector notes, it is Delacroix who places the recumbent king on a huge bed, rather than the throne on which Byron's hero, like most versions of the king, has himself immolated (69).

¹⁸ Nochlin, "The Imaginary Orient," 43. For speculations on the private sources of Delacroix's association of eros and violence, see Spector, *The Death of Sardanapalus*, 89–105.

¹⁹ Cf. Lynne Thornton's brief remarks on the women of *Les Chérifas* in *La Femme dans la peinture orientaliste* (Paris: ACR Édition, 1993), 126.

²⁰ Though it is far from clear that Sarmiento consistently speaks for his author, his comments on the sultan's solitary *jouissance* are solemnly supported by a learned footnote, which cites a related account in Fontenelle and informs the reader that a similar contempt for the importance of reciprocal pleasure "can be found in Montesquieu, in Helvétius, in La Mettrie, etc., and will always be the view of true philosophers" (*Aline et Valcour,* in *Oeuvres complètes*, 4: 237n).

²¹ Ibid., 238.

²² [Anon.], *The Lustful Turk*, 40. Any discussion of *The Lustful Turk* must begin by acknowledging Steven Marcus's shrewd and witty reading of the novel in *The Other Victorians: A Study of Sexuality and Pornography in Mid-Nineteenth-Century England* (1966; rpt. New York: Norton, 1985), 197–216.

²³ Marcus, who places *The Lustful Turk* at "the juncture of literature and pornography,"

calls specific attention to echoes of Byron, the Gothic romance, and even Keats's "Eve of St. Agnes" (*The Other Victorians*, 215).

²⁴ *Lustful Turk*, 98, 117, 86.

²⁵ Ibid., 150, 31, 35, 38, 142, 150, 153.

²⁶ Marcus, *The Other Victorians*, 204–209; *Lustful Turk*, 22.

²⁷ For a fuller account of such contradictions, see Ruth Bernard Yeazell, *Fictions of Modesty,* esp. 12–32.

²⁸ *Lustful Turk*, 54, 40.

²⁹ Marcus, *The Other Victorians*, 211.

³⁰ *Lustful Turk*, 92, 125.

³¹ Marcus, *The Other Victorians*, 201.

³² *Lustful Turk*, 153.

³³ *Lustful Turk*, 159, 70, 159, 160. Sylvia quickly lands a baronet, but the novel closes with Emily still looking, though she currently has great hopes, she reports, of "an Irish Earl" (160) — the ethnic joke marking the homegrown equivalent, evidently, of a lustful Turk.

³⁴ Ibid., 27, 28, 57, 160.

11. Multiplying Effects: Lesbians and Eunuchs

¹ Leila Ahmed briefly comments on such "prurient speculation" in "Western Ethnocentrism and Perceptions of the Harem," 524–25. For some suggestive remarks on the persistence of the sapphic motif in twentieth-century French postcards of Algerian women, see Malek Alloula, *The Colonial Harem*, 95–103.

² [Jean] Chardin, *Voyages... en Perse*, 6:25.

³ Nicolas de Nicolay, *Navigations*, 110.

⁴ George Sandys, *A Relation of a Journey begun An: Dom: 1610... Containing a desscription of the Turkish Empire, of Aegypt, of the Holy Land, of the Remote parts of Italy, and Ilands adjoyning* (London: W. Barrett, 1615), 69.

⁵ Charles White, *Three Years in Constantinople*, 1:304. For Lady Mary's account, see To Lady—, 16 March [1718], *Letters* 1:387–89.

⁶ Richard Burton, *Thousand Nights and a Night*, 3:3856; 1:923; 2:1528.

⁷ Havelock Ellis, *Studies in the Psychology of Sex*, 2 vols. (New York: Random House, 1942), 1–4:207. The first number indicates the volume of the 1942 edition; the second, after the dash indicates a "part" number, each of which corresponds to what was originally a separately published volume of the *Studies*. "Sexual Inversion," the part quoted here, first appeared as Volume 1 in 1897; but after Ellis's bookseller was tried for obscenity in 1898, he reissued "The Evolution of Modesty" (1899) as the first volume of the *Studies*. Subsequent editions have preserved this order.

⁸ This is the solution of Diana J. Schaub, *Erotic Liberalism: Women and Revolution in Montesquieu's* "Persian Letters" (Boston: Rowman & Littlefield, 1995), 48–49. For Zachi's boastful account of the "querelle" among Usbek's wives, see Montesquieu, *Lettres persanes*, iii. 14–15.

⁹ Cf. Suzanne Rodin Pucci, "Letters from the Harem: Veiled Figures of Writing in Montesquieu's *Lettres persanes*," in *Writing the Female Voice: Essays on Epistolary Literature*, ed. Elizabeth C. Goldsmith (Boston: Northeastern University Press, 1989), 123–24. As Pucci remarks of these episodes, "To retain the same slave's name with respect to the conduct of two harem wives, whose own names are themselves so similar, intensifies the structure of replaceability of each harem woman for another" (124).

¹⁰ Though Lisa Lowe rightly notes how Roxane's final letter deliberately goads Usbek's imagination by refusing to name the "acts and pleasures" with which she has subverted the harem, Lowe's attempt to associate Roxane's rebellion with the transgressive "specter of female homosexuality" succeeds only by suppressing the letter's specific reference to a male lover. See *Critical Terrains*, 73. Lowe claims that the novel constructs "the figure of sapphism ... as the most powerful threat to the sexual economy of the harem" (72), but Diana Schaub's response seems to me very much to the point: "While we tend today to think of lesbianism as the most radical rejection of the male, Montesquieu suggests that, at least in the context of the harem — that is, of women organized communally for the pleasure of a man — lesbianism is less revolutionary than adultery" (*Erotic Liberalism*, 49).

On female homosexuality in harem literature, cf. also Emily Apter, "Female Trouble in the Colonial Harem," 205–24. Like Lowe's wishful reading of Montesquieu, Apter's attempt to detect in colonial fiction a sapphic "haremization effect" (208) that challenges phallic mastery is closer to the late-twentieth-century fictions discussed below than to the texts it analyzes.

¹¹ The passing thoughts of a character in Maureen Duffy's novel, *The Microcosm* (1966; rpt. Harmondsworth: Penguin Books–Virago Press, 1989), briefly suggest how prior fantasies of the harem might be rewritten from a self-consciously lesbian perspective:

> Fancy them harems too and all the men thinking it's such a sexy idea dozens of beautiful women just sitting about all perfumed and painted waiting for the lord and master to crook his little finger and say, "I'll have you tonight," and all the time they weren't waiting at all. Wonder what happened if he found out or perhaps he didn't mind. After all they go in for little boys a lot in eastern countries I heard somewhere so maybe they take it all for granted. Must have been rather a comedown having to put up with a fat old man if you was used to someone younger and better-looking. You'd have to think of it as just a job to earn your keep like the pros do and if there were enough of you it wouldn't come round all that often. (196)

For an extended deployment of such a fantasy in contemporary lesbian fiction, see Jan Carr, *Harem Wish* (New York: Dutton, 1994).

¹² For Lady Mary as Pope's "Sappho," see Robert Halsband, *The Life of Lady Mary Wortley Montagu*, 113, 141–42, 149, 150, 152.

¹³ To Lady Mar, 18 April [1717]; To Lady —, 1 April [1717]; To Lady Mar, 18 April [1717]. *Letters of Lady Mary Wortley Montagu* 1: 351, 352, 314, 350–51. Cf. Nussbaum, *Torrid Zones*, 135–41. Though Nussbaum includes Elizabeth Craven as well as Lady Mary in her generalization that "the seraglio's innermost quarters ... evoke heightened libidinal desire with homoerotic overtones in the Western women who describe them" (137), the only evidence she offers of "homoerotic desire" in Craven is a passing wish that Sir Joshua Reynolds had been present to draw two "charming" Greek brides that the traveler observed in Constantinople (139).

[14] The fantasy of lesbian sex as a prelude to heterosexual activity is a staple of pornography, as the example of Fanny Hill's sexual initiation in the opening scenes of Cleland's *Memoirs of a Woman of Pleasure* famously illustrates. See Lillian Faderman, *Surpassing the Love of Men: Romantic Friendship and Love between Women from the Renaissance to the Present* (New York: William Morrow, 1981), 17, 28.

[15] For a brief history of the association of lesbianism with female seclusion in the convent as well as the harem, see Georges May, *Diderot et "La Religieuse": Étude historique et littéraire* (New Haven: Yale University Press and Paris: Presses Universitaires de France, 1954), 118–34. See also Erica Rand, "Diderot and Girl-Group Erotics," *Eighteenth-Century Studies* 25 (1992): 495–516.

[16] Peter J. Manning, *Byron and His Fictions* (Detroit: Wayne State University Press, 1978), 223.

[17] Chardin, *Voyages*, 6: 23–24.

[18] In a note to the Garnier edition of the *Lettres persanes* (112–13), Paul Vernière suggests that Montesquieu's treatment of the desiring eunuch may owe less to Chardin than to another book in his library, the *Traité des eunuques* published by Charles Ancillon in 1707.

[19] For the echo of Rycaut, see Vernière's note (Montesquieu, *Lettres persanes*, 113).

[20] For the anecdote of the sultan and the horses, see, e.g., Jean Thévenot, *Voyage du Levant*, 59–60. For the two kinds of eunuchs — both of which were ambiguously termed khāsī — and the evidence that some may have retained a capacity for sexual pleasure, see the entry under the latter term in the *Encylopaedia of Islam*, new ed. (Leiden: E. J. Brill, 1978), 4: 1087–93.

[21] Emmeline Lott, *Harem Life*, 55. Later, when she herself uneasily settles to into the harem of the Egyptian viceroy, Lott returns to the accusation of fraudulence: "Then I remembered Mr. B.'s narrative of the eunuch, Dafay, whose wife had a numerous family; and having myself witnessed several of these spectres of mankind 'toying and wooing' with the black female slaves, I doubted their infirmity of body, and kept a watchful eye over them" (121).

12. Anti-Erotics: Frustration and Ennui

[1] Robert Withers, *A Description of the Grand Signor's Seraglio*, 51–52, 59.

[2] J[ean] B[aptiste] Tavernier, *Nouvelle Relation de l'interieur du serrail*, 248.

[3] To Lady Mary Wortley Montagu, 10 November [1716], *The Correspondence of Alexander Pope*, ed. George Sherburn, 5 vols. (Oxford: Clarendon Press, 1956), 1: 368.

[4] [Jean] Sieur du Mont, *A New Voyage to the Levant*, 269–70.

[5] Aaron Hill, *Present State of the Ottoman Empire*, 112, 113.

[6] Aaron Hill, "Epilogue" to Eliza Haywood, *The Fair Captive: A Tragedy* (London: T. Jauncy and H. Cole, 1721), xiv–xv.

[7] Given the conventions of female modesty in the period, it is hardly surprising that when women imagined the problem of number in the harem — when they imagined it *as* a problem, that is — they focused on the inhabitants' rivalry with one another rather than on their erotic frustration as such. See ch. 16.

[8] Cf. [Jean] Chardin, *Voyages . . . en Perse*, 6: 29; and Montesquieu, *Lettres persanes*, cxiv. 240.

⁹ Ibid., ix. 23. For a reading of *Les Lettres persanes* that arrives by way of Lacan at a similar conclusion about the identity of the master and the eunuch, see Josué V. Harari, *Scenarios of the Imaginary: Theorizing the French Enlightenment* (Ithaca: Cornell University Press, 1987), 67–101. In a brilliant variation on this theme, James Merrill's autobiographical novel, *The Seraglio* (New York: Knopf, 1957) also ends by identifying the eunuch and the pasha. Even as the protagonist defies his father's sexual voraciousness by dramatically castrating himself, the novel makes clear that his violent protest is also an act of identification and of love; and at the novel's close, the self-made eunuch — or "unique" as he punningly suggests (66) — has inherited his father's estate and become the keeper of the "seraglio."

¹⁰ Montesquieu, *Histoire véritable*, in *Oeuvres complètes*, ed. Roger Caillois, Bibliothèque de la Pléiade, 2 vols. (Paris: Éditions Gallimard, 1949), l: 435, 436. Though its exact date of composition is unknown, the evidence suggests that the *Histoire* was written after the *Lettres persanes*; it was first published in fragmentary form in 1892. When a contemporary noted how disproportionately the narrative dwelled on the eunuch sequence and how closely it duplicated the material in the *Lettres*, Montesquieu appears to have made substantial cuts; but the Pléiade edition restores the omitted passages, on the grounds that Montesquieu himself might well have done so had he decided to publish the text. For a detailed account, see Roger Callois' preface to his critical edition of the text (Lille and Genève: Librairie Giard and Librairie Droz, 1948), vii–xxvi. Aram Vartanian, "Eroticism and Politics in the *Lettres persanes*," uses these passages to comment on the political identity of eunuch and despot (31–32).

¹¹ [Germain-François Pouillan] de Saint-Foix, *Lettres turques*, in *Oeuvres complettes*, 2 vols. (Maestricht: Jean-Edme Dufour & Phillipe Roux, 1778), 2: 368. The *Lettres turques* in this edition run together what were originally two series of such letters — *Lettres d'une Turque à Paris écrites à sa soeur au serrail, pour servir de supplément aux "Lettres persanes"* (1731) and *Lettres de Nedim Coggia, secrétaire de l'ambassade de Méhémet Effendi à la cour de France, et autres lettres turques* (1732).

¹² [Sophia Watson], *Memoirs of the Seraglio of the Bashaw of Merryland*, 28.

¹³ Robert Bage, *The Fair Syrian*, 2 vols. (1787; rpt. New York: Garland, 1979), 2: 89, 86.

¹⁴ [Anon.], "The Sultan's Reverie: An Extract from the Pleasures of Cruelty," *Pearl*, No. 18 (1880), rpt. in *The Pearl: A Journal of Facetiae and Voluptuous Reading* (New York: Grove Press, 1968), 617.

¹⁵ Crébillon fils [Claude Prosper Jolyot de Crébillon], *Le Sopha: Conte moral*, ed. Françoise Juranville (Paris: GF-Flammarion, 1995), 31; Denis Diderot, *Les Bijoux indiscrets*, ed. Antoine Adam (Paris: Garnier-Flammarion, 1968), 36.

¹⁶ Théophile Gautier, "Sultan Mahmoud" (1845), in *Poésies complètes*, ed. René Jasinski, 3 vols. (Paris: Firmin-Didot, 1932), 2: 238.

¹⁷ David R. Slavitt, *Turkish Delights*, 79.

13. Free Hearts in Montesquieu, Mozart, and Byron

¹ [Jean] Sieur du Mont, *A New Voyage to the Levant*, 273. Dumont, whose work had first appeared in French two years earlier, had originally written that "tout est amoureux en elles, & ne tend qu'à se faire aimer." *Nouveau voyage du Levant* (La Haye: Etienne Foulque, 1694), 322.

² I quote from the second preface (1676) to *Bajazet*, though in his *Théâtre complet* of 1697,

the text otherwise followed by the edition cited here, a more pious Racine apparently decided to omit the final paragraph in which these lines appear (*Théâtre complet*, 356n).

³ For "triangular" desire, see René Girard, *Deceit, Desire, and the Novel: Self and Other in Literary Structure*, trans. Yvonne Freccero (1965; rpt. Baltimore: Johns Hopkins University Press, 1976), esp. 1–52. Girard's book originally appeared in France as *Mensonge romantique et vérité romanesque* in 1961.

⁴ A slave in more senses than one, Roxane is an exemplary instance of Paul Bénichou's observation that love in Racine is "the negation of liberty." See *Man and Ethics: Studies in French Classicism*, trans. Elizabeth Hughes (New York: Anchor Books, 1971), 147. Bénichou's work first appeared in French as *Morales du grand siècle* (1948).

⁵ Cf. Roland Barthes' apt remarks on the relations of power and sexuality in the play and on how Bajazet is thus "transformed from a man into a woman." *On Racine*, trans. Richard Howard (1964; rpt. New York: Octagon Books, 1977), 99. Barthes' book originally appeared in French in 1960.

⁶ Johann Gottlieb Stephanie the Younger, Libretto for *Die Entführung aus dem Serail*, 2.1, #9. For discussions of some of the lesser-known predecessors of Mozart's opera, see Eve R. Meyer, "*Turquerie* and Eighteenth-Century Music," *Eighteenth-Century Studies* 7 (1974): 474–88; W. Daniel Wilson, "Turks on the Eighteenth-Century Operatic Stage and European Political, Military, and Cultural History," *Eighteenth-Century Life* 9:2 (1985): 79–92; and Thomas Bauman, *W.A. Mozart: Die Entführung aus dem Serail*, 27–35.

⁷ For more on the implications of this conflict, especially for English fiction, see Ruth Bernard Yeazell, *Fictions of Modesty*.

⁸ Though other members of the harem appear nowhere as such in the libretto, Mozart did write the two "Janissary" choruses (1.6, #5; 3.9, #21) for both male and female voices — a departure from verisimilitude which does allow briefly for the presence of other women on stage. See Bauman, *W.A. Mozart: Die Entführung*, 33, 71.

⁹ As several commentators on *Die Entführung* have noted, by the close of the eighteenth century such representations of the noble Turk were themselves quite conventional, as was the strategy by which his crude underling conveniently absorbed the negative stereotype. See Meyer, "*Turquerie* and Eighteenth-Century Music," 481; Wilson, "Turks on the Eighteenth-Century Operatic Stage," 85–88; Bauman, *W.A. Mozart: Die Entführung*, 32–35. Cf. also Bernard Lewis, *Islam and the West*, 95: "The eighteenth-century Enlightenment had two ideal prototypes, the noble savage and the wise and urbane Oriental." Both Meyer and Wilson note that the weakening of the Ottoman Empire as a political threat to the West, especially after the failed siege of Vienna in 1683, helps to account for the new prevalence of the more benign figure. Wilson also remarks more specifically on the coincidence of most of the pre-Mozartian "abduction operas" with the increasing demonstration of Turkish impotence in the Russian-Turkish war of 1768–74 (81–82).

¹⁰ Bauman, *W.A. Mozart: Die Entführung*, 33.

¹¹ Ibid., 1.

¹² Ibid., 52.

¹³ See Richard F. Burton's note to page 339, line 37, of "The Reeve's Tale," in his *Thousand Nights and a Night*, 1: 413. In the tale itself, however, the man actually arrives hidden in a chest of clothes.

¹⁴ The term is Byron's own, from the French *mobilité*, and appears in his description of the Lady Adeline in canto 16: "So well she acted all and every part / By turns — with that

vivacious versatility / Which many people take for want of heart. / They err — 'tis merely what is called mobility" (16.97). Byron himself defined it in a note as "an excessive susceptibility of immediate impressions — at the same time without *losing* the past" (*Complete Poetical Works*, 5:769). For the association of this "mobility" with *Don Juan*'s improvisatory style, see George M. Ridenour, *The Style of "Don Juan"* (1960; rpt. Hamden: Archon Books, 1969), 162–66.

[15] For the various authorities on the East Byron claimed to have read, see ch. 1, n3. De Tott, for one, could have told him that the sultan was not in fact married to any of his women. See the anonymous English translation of the *Memoirs of the Baron de Tott, on the Turks and the Tartars*, 2 vols. (London: J. Jarvis, 1785), 1: 107.

[16] Cf. the observations of Juan's worldly fellow-captive, John Johnson, in the previous canto: "Most men are slaves, none more so than the great, / To their own whims and passions, and what not" (5.25).

[17] According to one account, this episode had its origins in a story Byron heard from a friend at Lisbon about his stealing into a convent dressed as a nun: "and as he possessed good features, he was declared to be one of the best-looking among those chaste dames." Cited from *The Reminiscences and Recollections of Captain Gronow* (London, 1892), in Truman Guy Steffan and Willis W. Pratt, *Byron's "Don Juan": A Variorum Edition*, 4: 140. If Leigh Hunt is to be believed, the sultan's error as to Don Juan's sex gains added piquancy from Byron's own experience at the Ottoman court: "The visible character to which this [Byron's] effeminacy gave rise appears to have indicated itself as early as his travels in the Levant, where the Grand Signior is said to have taken him for a woman in disguise." See *Lord Byron and Some of His Contemporaries; With Recollections of the Author's Life, and of His Visit to Italy*, 2 vols. (London: Henry Colburn, 1828), 1: 156–57. I would like to thank Susan J. Wolfson, "'Their She Condition': Cross-Dressing and the Politics of Gender in *Don Juan*," *ELH* 54 (1987): 58, for directing me to the latter quotation.

[18] For a nuanced discussion of the ambiguities of gender in the poem, see Wolfson, "'Their She Condition,'" 585–617; cf. also Marjorie Garber, *Vested Interests: Cross-Dressing and Cultural Anxiety* (New York: Routledge, 1992), 316–21; and Peter W. Graham, *Don Juan and Regency England* (Charlottesville: University Press of Virginia), 82–88.

[19] The tradition of reading *Lara* (1814) as a sequel to *The Corsair* somewhat mitigates the apparent harshness of Gulnare's fate by granting her a second life and the opportunity to redeem herself as the loyal Khaled — the hero's adoring page who proves at the end to have been a woman in disguise.

[20] As Wolfson puts it, "the destiny of biology... prevails" ("'Their She Condition,'" 609)

14. Taming Soliman and Other Great Ones

[1] See Jean Starobinski, "Les *Lettres persanes*," 94; Suzanne Rodin Pucci, "Letters from the Harem," 123–24; and Julia Douthwaite, *Exotic Women*, who remarks how "the stereotypical exoticism of the women's names — Zachi, Zéphis, Zélis, Fatmé — further suggests that their identities are interchangeable" (95).

[2] Montesquieu, *Lettres persanes*, 342.

[3] Starobinski, "Les *Lettres persanes*," 103, 105.

[4] Despite the *Lettres'* relative lack of interest in an ideal of marriage, Usbek's account of the festivals at which young Troglodytes "discovered how to give the heart, and how to

receive it" (xii. 33) briefly anticipates Rousseau's celebration of virtuous courtship in the *Lettre à d'Alembert*. Compare Usbek's description of these festivals with the "fêtes publiques" that Rousseau wishes to institute at Geneva "so that young marriageable persons will have the opportunity to take a liking to one another." Jean-Jacques Rousseau, *Lettre à M. d'Alembert sur son article Genève* (Paris: Garnier-Flammarion), 236 and ff. The *Lettre* was originally published in 1758.

⁵ I rely here on the lucid account of Hurrem and her history in Leslie P. Pierce, *The Imperial Harem*, 58–65. Though the exact date of the marriage is not known, Pierce estimates that it must have taken place in or before June 1534 (62). Cf. also Barnette Miller, *Beyond the Sublime Porte: The Grand Seraglio of Stambul* (New Haven: Yale University Press, 1931), 86–95.

⁶ As cited by Pierce, *The Imperial Harem*, 59–60. She is translating Bernardo Navagero's account as it appears in *Relazioni degli ambasciatori veneti al senato*, ed. Eugenio Albèri, Series 3, vol. 1 (Florence, 1840), 75.

⁷ Pierce, *The Imperial Harem*, 60.

⁸ For Roxelana's contemporary reputation, see Pierce, *The Imperial Harem*, 63, 84–90. In two of the more notable of the tragedies based on Süleyman's reign, Gabriel Bounin's *La Soltane* (1561) and Fulke Greville's *Mustapha* (1609), she figures as Rose and Rossa, respectively. For detailed summaries of Roxelane's appearances on the French stage before 1660, see Clarence Dana Rouillard, *The Turk in French History*, 421–66.

⁹ Jean-François Marmontel, "Soliman II," in *Trois Contes moraux* (Paris: Éditions Gallimard, 1994), 19. (I am at a loss to explain the title of Marmontel's tale except by assuming that he confused the history of the first Süleyman, also known as "the Magnificent," with that of his seventeenth-century successor, Süleyman II.) The *Contes* were first collected in 1761, but the text of this edition follows that of the three-volume *Contes moraux* published in Paris in 1765, with some orthographic modifications. According to Martha Pike Conant, a direct translation of "Soliman II," with no mention of its source, appeared in an anonymous English collection of Oriental tales in 1773. See *The Oriental Tale in England in the Eighteenth Century* (New York: Columbia University Press, 1908), 106. Future page references to the Gallimard *Trois Contes* appear parenthetically in the text.

¹⁰ Though several details imply that Roxelane is French, Marmontel never specifically identifies her as such.

¹¹ "I must laugh at the good sultan, and yet he deserves my heartfelt pity. If after he has enjoyed Elmire and Delia, they all at once lose everything that previously charmed him, what then will Roxelane retain for him after this critical moment? . . . I greatly fear that the very first morning, as soon as he has rubbed the sleep from his eyes, he will see in his adored sultana nothing more than her confident impudence and her turned-up nose. It seems to me I hear him exclaim: 'By Mahomet! where have my eyes been?' See "Hamburgische Dramaturgie," no. 34, in Gotthold Ephraim Lessing, *Werke 1767–1769*, ed. Klaus Bohnen (Frankfurt am Main: Deutscher Klassiker Verlag, 1985), 350. These remarks originally appeared in a 1767 review of Favart's play, which Lessing thought a distinct improvement on Marmontel's tale.

¹² Charles Favart, *Les Trois Sultanes ou Soliman II: Comédie en trois actes, en vers* (Paris: Librarie Stock, 1926), (3.10). All future references are to this edition and will likewise be given by act and scene number in the text. Favart's play was first performed in 1761.

¹³ Other additions to Marmontel's tale at once heighten the theatricality of the piece and elaborate on familiar accounts of seraglio intrigue, like the bit of palace conspiracy between

Elmire and the eunuch, or the plot complication in which the angry sultan bestows his intractable slave on her rival.

¹⁴ Soliman has a predecessor of sorts in the tragic hero of Voltaire's *Zaïre* (1732), Orosmane, who opens the play by announcing his intention to give up the "lâches amours" and "langueurs" of his *sérail* in Jerusalem for a loving marriage with his slave, Zaïre (1.2. 187–88). Despite Voltaire's claim to represent "les moeurs turques opposées aux moeurs chrétiennes," however, the remainder of the play turns not on the contrast between Western marriage and the customs of the *sérail*, but on the conflict that ensues when Zaïre discovers that she was born a Christian, and Orosmane jealously misinterprets her new-found reluctance to marry him. For a helpful discussion of these and other issues, see Eva Jacobs' introduction to her edition of the play (London: Hodder and Stoughton, 1975), 7–55. (The quotation from Voltaire's correspondence appears on 19). Jacobs cites an amusing parody of the play given at the Comédie italienne the same year, *Les Enfans trouvez, ou le sultan poli par l'amour*, in which the Orosmane-figure disclaims his resemblance to other sultans: "Si je tiens un Serrail, ce n'est que pour la forme . . . / Tout usage ancien cede à ma politique, / Et je suis un Sultan de nouvelle fabrique" (48).

¹⁵ Isaac Bickerstaffe [sic], *The Sultan, or A Peep into the Seraglio: A Farce, in Two Acts* (London: C. Dilly, 1787), 21. Bickerstaff's farce was first performed on the London stage in 1775. A facsimile of the 1787 text is reproduced in volume 3 of *The Plays of Isaac Bickerstaff*, ed. Peter A. Tasch, 3 vols. (New York: Garland, 1981). All future page references to this edition will appear parenthetically in the text.

¹⁶ Favart elaborates here on a briefer exchange in Marmontel, "Soliman II," 35.

¹⁷ Though Favart's play had first captured audiences with song and dance music by P. C. Gibert, and with Mme Favart, dressed in authentic Turkish costume, in the role of Roxelane, *Les Trois Sultanes* was sufficiently popular in its own right to be repeatedly staged without music well into the following century. See Eve R. Meyer, "*Turquerie* and Eighteenth-Century Music," 478; and Otto Kurz, "Pictorial Records of Favart's Comedy 'Les Trois Sultanes,'" *The Decorative Arts of Europe and the Islamic East: Selected Studies* (London: The Dorian Press, 1977), 311–17. In addition to Bickerstaff's English version, which itself served as the libretto for a comic opera with music by Charles Dibdin, Favart's play was performed in translation at Vienna in 1770 and at the Esterháza palace in 1777. The evidence suggests that Franz Haydn first composed his Symphony No. 63, popularly called *La Roxelane*, as incidental music for the latter occasion: the symphony takes its name from the title of its second movement, a set of variations on an old French melody. For the complicated history of No. 63 and its composition, see H. C. Robbins Landon, *The Symphonies of Joseph Haydn*, 2 vols. (London: Universal Edition & Rockcliff, 1955), 1: 359–64.
 In 1799, Favart's Roxelane reappeared on the Viennese stage in an opera with music by Mozart's pupil, F. X. Sussmaer. See John Sweetman, *The Oriental Obsession: Islamic Inspiration in British and American Art and Architecture, 1500–1920* (1987; rpt. Cambridge: Cambridge University Press, 1991), 81.

¹⁸ Gérard de Nerval, *Voyage en Orient*, in *Oeuvres complètes*, 2: 610.

¹⁹ In "Jane Eyre's 'Three-Tailed Bashaw,'" *Notes and Queries* 227 (1982): 232, Peter A. Tasch briefly mentions Bickerstaff's heroine as a possible prototype of Brontë's. For a searching discussion of the harem allusions in the novel, see Joyce Zonana, "The Sultan and the Slave," 592–617. Though I think Jane Eyre's resemblances to Roxalana worth remarking, I also agree with Zonana that "the image of a harem inmate demanding liberty had by 1847 become so ingrained in Western feminist discourse that Brontë need not have had any specific text in mind" (598). The Brontës' general familiarity with the Eastern imagery of the *Arabian Nights* has long been noted.

[20] Charlotte Brontë, *Jane Eyre*, ed. Jane Jack and Margaret Smith (Oxford: Clarendon, 1969), 338, 339. All further page references to this edition appear parenthetically in the text. Brontë's novel was first published in 1847.

[21] Zonana, "The Sultan and the Slave," 596.

15. Leaving the Harem Behind

[1] Some commentators have suggested that dreams of the couple are hardly confined to the West. Gérard de Nerval, for one, remarked that the East too had its literary tradition of faithful lovers, and that "ces fidèles amours ressemblent, dans la plupart des détails de la vie, à ces belles analyses de sentiment qui ont fait battre tous les coeurs jeunes depuis Daphnis et Chloé, jusqu'à Paul et Virginie" (*Voyage en Orient*, in *Oeuvres complètes*, 2:794). In brief but provocative remarks, Anne Marie Moulin and Pierre Chuvin have suggested that precisely because the institution of the harem effectively discourages the intense attachment of a single pair of lovers, "ce qui fait rêver les Orientaux, ce n'est pas le harem, c'est le couple." See "Voyage à l'intérieur des harems," *L'Histoire* 45 (May 1982): 70. For the argument that Islam deliberately weakens the conjugal unit, see also Fatima Mernissi, *Beyond the Veil: Male-Female Dynamics in Modern Muslim Society*, rev. ed. (Bloomington: Indiana University Press: 1987), 113–20.

[2] For a brief account of these, see W. Daniel Wilson, "Turks on the Eighteenth-Century Operatic Stage," 79–92.

[3] [James J. Morier], *Ayesha*, 35, 62. Though the revelation that Ayesha's real name is Mary Wortley can scarcely be an accident (her brother happens also to be an English diplomat in Constantinople named Edward), the point of the reference, if any, is far from self-evident. Morier's virulent Orientalism has so little in common with the cosmopolitan tolerance of the historical Lady Mary that he could almost have intended a deliberate rebuke, though it seems more likely that the allusion signifies nothing beyond a lame joke.

[4] Lieutenant [Maturin Ballou] Murray, *The Turkish Slave: or, the Mahometan and His Harem. A Story of the East* (Boston: F. Gleason, 1850), 24.

[5] Marquis de Sade, *Aline et Valcour*, in *Oeuvres complètes*, 5:81,70,80,82,85.

[6] Ibid., 5:84,90,91.

[7] Ibid., 5:36.

[8] Its modern editors conclude that *Aline et Valcour* had little circulation in the nineteenth century, though it was not banned until 1815, two years after the first production of Rossini's opera. There was at least some interest in the adventures of Léonore and Sainville, however, since by 1800 Sade could complain of two plagiarized editions of this portion of his novel. See the editors' "Notice bibliographique" to *Aline et Valcour* in *Oeuvres complètes*, 4:15–17.

[9] Gioacchino Rossini and Angelo Anelli, *L'italiana in Algeri: Comic Opera in Two Acts* (New York: G. Schirmer, 1966), 1:2, 5. All further references are to this edition and are indicated by act and scene number in the text. While I have been greatly assisted by several available English translations, including the lively but free version by Ruth and Thomas Martin in the Schirmer edition, all translations from the Italian are my own. Rossini's opera was first performed in 1813, though an earlier version of Anelli's libretto dates from 1808, when it was originally set to music by Luigi Mosca.

[10] See *Oeuvres complètes de Molière*, ed. Robert Jouanny, 2 vols. (1962; rpt. Paris: Éditions Garnier, 1980), 2:911n.

[11] To John Cam Hobhouse, Oct. 3, 1819, in *Byron's Letters and Journals*, 6:226.

16. Plotting Jealousy from Racine to the Victorians

[1] Cf. William Makepeace Thackeray's uneasy joke about those bodies, as he floats by the summer palace of the Ottomans in his *Notes of a Journey from Cornhill to Grand Cairo* (1846): "This tumultuous movement [of curiosity to have "*one* peep" at the women in the palace] was calmed by thinking of that dreadful statement of travellers, that in one of the most elegant halls there is a trap-door, on peeping below which you may see the Bosphorus running underneath, into which some luckless beauty is plunged occasionally, and the trap-door is shut, and the dancing and the singing, and the smoking and the laughing go on as before. They say it is death to pick up any of the sacks thereabouts, if a stray one should float by you. There were none any day when I passed, *at least, on the surface of the water*" (*Works,* 5: 645).

[2] *The Corsair* (1814) suggests a more subtle role for masculine jealousy in harem narrative, since Gulnare claims to have fallen in love with the intruder not despite but precisely because she has been suspected of doing so: "the jealous well / . . . Deserve the fate their fretting lips foretell" (3.8.326–28).

[3] Jean Racine, *Théâtre complet,* 356n. On the history of these lines, see ch. 13, n 2 above.

[4] Jean Racine, *Phèdre* (4.6), in *Théâtre complet,* 581.

[5] See Leslie P. Pierce, *The Imperial Harem.* Beginning in the late sixteenth century, Pierce notes, "the importance of women as power brokers is reflected in the fact that the greatest tension within the dynasty now existed among rival mothers" (24).

[6] See the editor's introduction to the play, *Théâtre complet,* 352.

[7] To Lady Mary Wortley Montagu, 10 November [1716], in Alexander Pope, *Correspondence,* 1:368.

[8] Victor Hugo, "La Sultane favorite" (1828), rpt. in *Les Orientales, Les Feuilles d'automne, Les Chants du crépuscule* (Paris: Librairie de L. Hachette, 1867), 71. The collection entitled *Les Orientales* first appeared in 1829.

[9] [Jean] Chardin, *Voyages . . . en Perse,* 6: 10, 11, 43.

[10] Ibid., 25, 26.

[11] Aaron Hill, *Present State of the Ottoman Empire,* 114, 115, 165, 169.

[12] [Germain-François Pouillan] de Saint-Foix, *Les Veuves turques, comédie en un acte,* in *Oeuvres complettes,* 2: 100, 99. Though the title page in this edition gives the first performance as 1742, Saint-Foix's own preface appears to date its presentation before the Turkish ambassador to sometime in 1741. *Les Veuves turques* does not seem to have been published until 1748.

[13] Ibid., 110, 111.

[14] Ibid., 125.

[15] David Hume, "Of Polygamy and Divorces," *Essays Moral, Political, and Literary,* 181–82, 183, 184.

[16] Ibid., 184.

[17] Ibid. More explicitly than Montesquieu, Hume attributes the absence of love in the seraglio not only to the compulsion its women suffer but to their inherent inequality with the

master. As against the argument that only polygamy succeeds in preserving male authority, Hume observes, "it may be urged with better reason, that this sovereignty of the male is a real usurpation, and destroys that nearness of rank, not to say equality, which nature has established between the sexes. We are, by nature, their lovers, their friends, their patrons: Would we willingly exchange such endearing appellations, for the barbarous title of master and tyrant?" (184).

[18] Ibid., 184–85.

[19] See, e. g., Edward William Lane, *Modern Egyptians*, 1:303–11; 441–45; [Julia] Pardoe, *City of the Sultan*, 3:46–48.

[20] Hume, "Of Polygamy and Divorces," 185–86. In fact, Tournefort did not claim to have visited the Grand Seraglio, though he did draw an analogy between reports about the sultan's physician and his own attendance in the houses of unnamed "great men," whose wives he was expected to cure simply by examining their arms. Nor did he describe those arms as naked, but as "covered with gauze" (Joseph Pitton de Tournefort, *Relation d'un voyage du Levant*, 2:28).

[21] Hume, "Of Polygamy and Divorces," 187.

[22] Adam Smith, *Lectures on Jurisprudence,* ed. R. L. Meek, D. D. Raphael, and P. G. Stein, The Glasgow Edition of the Works and Correspondence of Adam Smith, vol. 5 (1978; rpt. Indianapolis: Liberty Classics, 1982), 151, 153, 154. The edition reproduces two sets of contemporary notes from Smith's lectures. I cite the more extensive report of 1762–63, though virtually identical points also appear more briefly in the report dated 1766. For a detailed account of the provenance of these reports, see the introduction to this edition (1–42).

[23] Ibid., 151, 152, 153.

[24] Ibid., 154.

[25] Ibid., 154, 151; Hume, "Of Polygamy and Divorces," *Essays*, 190; Smith, *Lectures on Jurisprudence*, 160, 153.

[26] James Morier, *The Adventures of Hajji Baba, of Ispahan* (1824), rev. ed., Standard Novels, No. 44 (London: Richard Bentley, 1835), 414, 399.

[27] Ibid., 332, 111, 110, 112, 136. As it happens, male rather than female jealousy finally destroys poor Zeenab. Though Hajji speculates about the terrible fate she may suffer at the hands of the doctor's wife — he has, of course, "heard horrid stories of the iniquities performed in harems" (136) — she is instead given as a gift to the shah, who has chanced to be attracted to her, and on whose orders she is brutally executed when her pregnancy is discovered. But even this end is also vaguely attributed to her own rivalrous passions, since she is so blinded by her triumph over her enemies, Hajji suggests, that she fails to anticipate the danger of her situation.

[28] Leila Ahmed, *Women and Gender in Islam*, 108. Ahmed cites several instances of harem rivalry, including two fatal struggles in the royal palace, from a biographical dictionary of learned women produced in fifteenth-century Cairo. Polygamy figures "only rarely" in these biographies, she reports, but "when it does, it generally precipitates drama or disaster" (107). Despite a general emphasis on the peacefulness of polygamous households, Fanny Davis also provides brief accounts of a few unhappy rivalries among nineteenth-century Turkish women (*The Ottoman Lady*, 92). For a first-person record of jealous contentions in the Turkish harem, see Melek-Hanum, *Thirty Years in the Harem; or, the Autobiography of Melek-Hanum*. Written by a Greek woman whose husband, a Turkish official, repudi-

ated her after a scandal that partly originated in her own jealous fears, the *Autobiography*'s rather lurid revelations are finally compromised by their author's obvious bitterness and consistently jaundiced view of the Turks.

[29] Hugo, "La Sultane favorite," *Les Orientales*, 71, 72.

[30] Hill, *Present State of the Ottoman Empire*, 102, 165.

[31] Emmeline Lott, *Harem Life*, 354, 355.

[32] Harriet Martineau, *Eastern Life*, 261–62.

[33] Ibid., 262, 267. In fact, the Koran forbids marriage with sisters (4:23). Whether Martineau misinterpreted the relations of this family, or whether the marriages in question actually did violate Islamic law, it is of course impossible to know.

[34] Robert Walsh, *Constantinople and the Scenery of the Seven Churches*, 2:79. The title page goes on to attribute the "Series of Drawings from Nature" to Thomas Allom, while Walsh is credited with "an Historical Account of Constantinople, and Descriptions of the Plates." Prints of Allom's *Odalique* in fact appeared in two different works of Victorian travel writing, both issued by the same publisher: in addition to Walsh's *Constantinople*, the image was also reproduced as a lithograph in Thomas Allom and Emma Reeve's *Character and Costume in Turkey and Italy* the following year. For Reeve, however, the image evoked not a narrative of women's jealousy but a reminder of their oppression in the harem: "what dreary ideas of captivity are conjured up by the word 'Odalique!'" (18).

I am grateful to Joan DelPlato, *From Slave Market to Paradise*, 103–107, for identifying these two appearances of Allom's image and for her shrewd remarks on some crucial differences between the texts.

17. Manley's *Almyna* and Other Dreams of Sisterhood

[1] Harriet Martineau, *Eastern Life, Present and Past*, 267; Grace Ellison, *An Englishwoman in a Turkish Harem* (London: Methuen, 1915), 26.

[2] Though much information about Manley's life and career remains uncertain, we do know that she spent time in France in the 1680s, and that she could both write and speak French fluently. For a brief account, see Fidelis Morgan, *The Female Wits: Women Playwrights on the London Stage 1660–1720* (London: Virago, 1981), 32–43, esp. 33.

[3] There is no mention of *Almyna* in Peter L. Caracciolo's edited collection, *"The Arabian Nights" in English Literature: Studies in the Reception of "The Thousand and One Nights" into British Culture* (Houndsmill, Basingstoke: Macmillan, 1988). On Manley's priority in introducing the *Arabian Nights* to the English stage, see David D. Mann and Susan Garland Mann with Camille Garnier, *Women Playwrights in England, Ireland, and Scotland, 1660–1823* (Bloomington, Ind.: Indiana University Press, 1996), 35.

[4] *Arabian Nights' Entertainments*, ed. Robert L. Mack (Oxford: Oxford University Press, 1995), 2. All references to the *Arabian Nights* are to this edition, which is based on the anonymous translation of Galland's *Mille et une Nuits* that appeared in England from about 1706 to 1721. Though Galland has been both praised and criticized for the style and spirit of his French collection, most of the tales themselves, of course, derive from Arabic originals. For the complicated history of their transmission, see Robert Irwin, *The Arabian Nights: A Companion* (London: Allen Lane, 1994). For a spirited defense of Galland's artistry, see Georges May, *Les Mille et une Nuits d'Antoine Galland, ou le chef-d'oeuvre invisible* (Paris: PUF, 1986).

⁵ [Delarivier Manley], *Almyna: or, the Arabian Vow. A Tragedy...* (London: William Turner and Egbert Sanger, 1707), 2.20. All further references to *Almyna* are to this edition and give only act and page numbers, since the printers failed to indicate scene divisions until act 5. The play was first performed in December 1706, but not published until the new year; a second edition appeared in 1717. In her preface, Manley claims that "the Fable is taken from the life of that great Monarch, *Caliph Valid Almanzor*, who Conquer'd *Spain*, with something of a Hint from the *Arabian* Nights Entertainments"; but the play itself offers more than "a Hint" of the *Arabian Nights* and very little evidence of the known facts about Almanzor.

⁶ The speech in which Almanzor recounts this double betrayal follows the *Arabian Nights* quite faithfully, but at some expense to the consistency of Manley's own plot, since we never again hear that the sultan has any brother but Abdalla — who does not, of course, appear in the original.

⁷ *Arabian Nights' Entertainments*, 9.

⁸ See, e.g., Leila Ahmed, *Women and Gender in Islam,* esp. 88–101; and Fatima Mernissi, *Women and Islam: An Historical and Theological Inquiry,* trans. Mary Jo Lakeland (Oxford: Blackwell, 1991). As Ahmed puts it at one point: "a reading by a less androcentric and less misogynist society, one that gave greater ear to the ethical voice of the Quran, could have resulted in — could someday result in — the elaboration of laws that dealt equitably with women" (91).

⁹ *Arabian Nights' Entertainments*, 10. While Scheherazade appears to have spontaneously educated herself, Manley goes out of her way to rationalize her heroine's extraordinary scholarship by attributing it to a period of intense study with the chief dervish at Memphis.

¹⁰ The directions call for an unspecified number of "*Ladies in Mourning*" to enter with a train of mutes and eunuchs, and to rank themselves, "*Weeping,*" on either side of the stage — where they remain, presumably, as a silent reminder of the "many Lives" for whose sake Almyna undertakes her sacrifice (Manley, *Almyna*, 5.59, 61).

¹¹ Almanzor began the play by naming Abdalla his successor, on the sensible grounds that the daily execution of his partners was not likely to produce any more immediate heir. Now he suggests that he has been punished for his "cruel Vow" by the fact that his brother's death has "robb'd" him of his "Succession" (5.68). Though some versions of the *Arabian Nights* conclude by reporting that Scheherazade has managed to produce three sons in the interval, the sultan himself appears never to have considered the problem of heir-making. Yet if Manley seems to have worried an issue unremarked in her source, she does not seem to have noticed how her own conclusion ignores the continuing existence of Almyna.

¹² Richard F. Burton, *Thousand Nights and a Night,* 3: 3636–37. In a note appended to Scheherazade's demand that the sisters continue to live together, Burton asserts that "many Moslem families insist upon this before giving their girls in marriage, and the practice is still popular amongst Mediterranean peoples" (3: 3652).

¹³ Thomas Simon Gueulette's *Les Sultanes de Guzarate, ou les songes des hommes éveillés, contes moguls,* first appeared in France in 1732. I quote from the anonymous English translation that quickly followed, *Mogul Tales, or the Dreams of Men Awake: Being Stories told to divert the Sultana's of Guzarat, for the supposed Death of the Sultan,* 2 vols. (London: J. Applebee et al., 1736), 1: 2, 4, 7, 6, 5, 6–7. A modernized version of this text was in turn reproduced in Henry Weber's popular nineteenth-century anthology *Tales of the East* (1812), where it appeared together with translations of the *Arabian Nights* and other Oriental tale-cycles, as well as a number of European imitations.

[14] *Mogul Tales*, 1:8, 12.

[15] Adam Smith, *Lectures on Jurisprudence*, 152. Though his concern is the same, Gueulette's sultan puts it less cynically than Smith: "I am afraid, lest that happy Union hitherto subsisting in my *Seraglio*, should be disturbed by that Tenderness and Indulgence, which as is natural, every Mother will have for [her] own Offspring" (*Mogul Tales*, 1:12).

[16] Gehernaz believes that the sultan "cannot but look with equal Tenderness on all these amiable Boys, seeing they are all alike related" to him, but the narrative also adds a touch of realism by noting that he secretly marks the children for himself (*Mogul Tales*, 1:15).

[17] *Mogul Tales*, 1:16, 17.

[18] Ibid. 1:29, 33, 36; 2:230, 227, 231.

[19] Ibid., 1:27.

[20] Ibid., 1:15.

[21] Elizabeth Lady Craven, *A Journey through the Crimea to Constantinople*, 228–29n, 294.

[22] Lady Augusta Hamilton, *Marriage Rites, Customs, and Ceremonies*, 37, 53. I have corrected the obvious error of "jealously" rather than "jealousy" in the second quotation from Hamilton's text.

[23] [Julia] Pardoe, *The City of the Sultan*, 1:115.

[24] D[avid] Urquhart, *Spirit of the East*, 2nd ed., 2 vols. (London: Henry Colburn, 1839), 2:358, 386, 387, 356. Urquhart's work first appeared in 1838.

[25] Charles White, *Three Years in Constantinople*, 3:7, 8, 39. White's resemblance to his immediate predecessors is not accidental: his introduction explicitly praises Urquhart as reliable (1:vi), while his subtitle, *Domestic Manners of the Turks in 1844*, simply updates by a few years Pardoe's *The City of the Sultan; and Domestic Manners of the Turks, in 1836*. All three works were issued by the same publisher.

[26] Pardoe, *The City of the Sultan*, 3:208–209, 208. As though she had uncannily anticipated Martineau's gloomy vision of infanticide in the Egyptian harem some ten years later ("the child always dies, — killed with kindness, even if born healthy" — *Eastern Life*, 262), Pardoe ends her brief account of Turkish child-rearing by making clear that such "killing" is only metaphorical: "it is certain that, if children could really be 'killed with kindness,' the Ottoman Empire, in as far as the Turks themselves are concerned, would soon be a waste" (3:209).

[27] Sophia [Lane] Poole, *The Englishwoman in Egypt*, 2:40, 42, 67, 68. According to her preface, the book had its origins in her brother's suggestion that she take advantage of her decision to accompany him to Egypt, by recording "many things highly interesting in themselves, and rendered more so by their being accessible only to a lady" (v). Poole's tranquil harems, it should be said, belong almost exclusively to the higher reaches of Cairo society. Though she later appears sharply to modify the general picture by alluding to "the most abominable acts of cruelty and oppression" on the part of both sexes, the rest of the letter implies that such cruelty is largely confined to "the middle and lower classes" (2:94–95).

[28] Ibid., 72. The numerous other illustrations carry such helpful if prosaic captions as "Nile-Boat," "Shop," "Lady embroidering," "A Turkish Lady in the summer dress of white muslin," "The Door curtains," "A Marriage," etc. (1:50, 146; 2:26, 54, 65, 88).

[29] [Margaret Oliphant], "New Books," *Blackwood's Magazine* 114 (1873): 388, 389. The

book under review was *Monographs Personal and Social* (London: 1873), by Richard Monckton Milnes, Lord Houghton.

[30] Virginia Woolf, "Indiscretions," *The Essays of Virginia Woolf,* Vol. 3, *1919–1924,* ed. Andrew McNeillie (London: The Hogarth Press, 1988), 460, 461, 462–63. The essay was first published by *Vogue* in 1924.

18. Disenchantments with the Myth

[1] James Joyce, *Ulysses,* ed. Hans Walter Gabler (New York: Vintage Books, 1986), 47. Joyce's novel was first published in 1922.

[2] [Julia] Pardoe, *The City of the Sultan,* 1: 101–102, 2: 266, 1: 102, 103.

[3] "A Visit to the Harem of the Pasha of Widdin," *Fraser's Magazine* 18 (1838): 686.

[4] Emmeline Lott, *Harem Life,* 63, 65, 135, 68, 134, 138, 135. For the other allusions to Moore's beauties, see 136 and 308–309.

[5] "An Abode of Bliss," *Chambers's Journal* 128 (1866): 367.

[6] Lott, *Harem Life,* 77, 351, 52, xxiii.

[7] [Annie Jane] Harvey, *Turkish Harems and Circassian Homes,* 85, 244.

[8] Princess Belgiojoso [Cristina Trivulzio], *Oriental Harems and Scenery* (New York: Carleton, 1862), 27–28. This is an anonymous American translation of the princess's *Asie Mineure et Syrie: Souvenirs de voyage,* which first appeared in France in 1858. Noting that the author had "made a deliberate attempt to destroy that halo of romance which we have all striven to keep up about the fabled East," a contemporary reviewer singled out the princess's disillusioning accounts of harem life as the most "novel" parts of her book. See [Lascelles Wraxall], "Glimpses of Harem Life," *Bentley's Miscellany* 43 (1858): 508.

[9] Billie Melman detects a "perceptible shift" away from the elite in Englishwomen's writing on the Middle East after 1850, as Mediterranean travel became cheaper and more popular (*Women's Orients,* 105).

[10] For the English and American evidence, see Melman, *Women's Orients.* As one sign of the explosion of women's travel writing in the period, Melman notes that Richard Bevis's *Bibliotheca Cisorientalia; an Annotated Checklist of Early English Travel Books on the Near and Middle East* (1973), lists some 245 printed books by Englishwomen between 1821 and 1914, compared to only four such books before 1821 (7).

[11] Pardoe, *City of the Sultan,* 3: 224.

[12] See Melman, *Women's Orients,* 76; and *Handbook for Travellers in Constantinople, the Bosphorus, Dardanelles, Brousa and Plain of Troy with General Hints for Travellers in Turkey,* new. ed., rev. (London: John Murray, 1871), 111.

[13] Adalet, "A Voice from the Harem," 186. See ch. 4, n 5.

[14] D[avid] Urquhart, *Spirit of the East,* 2: 345.

[15] "Without seeing or conversing with a single Turkish woman," Urquhart wrote, "it is no very difficult thing to form an idea of their state. You must commence by knowing the men; in them, and through them, it is easy to know the women" (*Spirit of the East,* 2: 354).

[16] Charles White, *Three Years in Constantinople,* 1: ix, 305.

17 William Makepeace Thackeray, *Notes of a Journey from Cornhill to Grand Cairo*, in *Works*, 5: 652, 650, 652.

18 Gérard de Nerval, *Voyage en Orient*, in *Oeuvres complètes*, 2: 262, 369 (ellipsis in original).

19 Ibid., 2: 371, 373. For related remarks on this chapter of the *Voyage*, see Mary J. Harper, "Recovering the Other: Women and the Orient in Writings of Early Nineteenth-Century France," *Critical Matrix* 1, no. 3 (1985): 16.

20 Nerval, *Voyage en Orient*, in *Oeuvres complètes*, 2: 374, 611, 786, 793. On the partial fiction of the *Voyage*, see ch. 9, n26 above.

21 Such repeated accounts of disenchantment with the harem necessarily complicate Timothy Mitchell's claim that nineteenth-century Europe "inevitably... grasped" the Orient "as the reoccurrence of a picture one had seen before . . . the reiteration of an earlier description," since the travelers' disappointment would not be possible without a significant deviation from the prior images they carried with them. To the degree that disillusionment with the harem quickly became a *topos* of its own, however, Mitchell is not wrong to emphasize the imitative character of such representations. See Timothy Mitchell, *Colonising Egypt* (Cambridge: Cambridge University Press, 1988), 30.

22 Anna Bowman Dodd, *In the Palaces of the Sultan*, 431. I am grateful to Melman, *Women's Orients*, 142, for alerting me to this passage.

23 But see Grace Ellison's *An Englishwoman in a Turkish Harem*, where a similar exchange understandably produces more impatience on the part of the Turkish respondent. "An officer on board the man-o'-war which brought the Turkish Crown Prince to our Coronation tells me that every Englishwoman with whom he danced at the Naval Ball asked him the same question, 'How many wives have you?' And to every one he replied: 'Just one dozen, and I hope to have one dozen more before I die.' He was a bachelor" (122).

Though India lies outside the purview of this study, it is also worth noting how "the eternal Western question," in Ellison's phrase (122), precipitates the crisis of E. M. Forster's greatest novel. Forster's version of such an encounter finely registers both the innocent brutality of the question and the outraged sensitivity of the response:

> Probably this man had several wives — Mohammedans always insist on their full four, according to Mrs. Turton. And having no one else to speak to on that eternal rock, she [Adela Quested] gave rein to the subject of marriage and said in her honest, decent, inquisitive way: "Have you one wife or more than one?"
>
> The question shocked the young man very much. It challenged a new conviction of his community, and new convictions are more sensitive than old. If she had said, "Do you worship one god or several?" he would not have objected. But to ask an educated Indian Moslem how many wives he has — appalling, hideous! He was in trouble how to conceal his confusion. "One, one in my own particular case," he sputtered, and let go of her hand. Quite a number of caves were at the top of the track, and thinking, "Damn the English even at their best," he plunged into one of them to recover his balance.

A Passage to India (1924; rpt. New York: Harcourt, Brace & World, 1952), 153.

24 For some effects of Western goods and ideas on the nineteenth-century Ottomans, see Fatma Müge Göçek, *Rise of the Bourgeoisie, Demise of Empire: Ottoman Westernization and Social Change* (New York: Oxford University Press, 1996).

25 Thomas Allom and Robert Walsh, *Constantinople and the Scenery of the Seven Churches*, 1: n. p.

[26] Nerval, *Voyage en Orient*, in *Oeuvres complètes*, 2: 396; Pierre Loti and Samuel Viaud, *Suprêmes Visions d'Orient: Fragments de journal intime* (Paris: Calmann-Lévy, 1921), 67. Loti's unfinished text, later edited and published by his son, was originally composed in 1910–13.

[27] Nerval, *Voyage en Orient*, in *Oeuvres complètes* 2: 587; Edith Wharton, *In Morocco* (New York: Charles Scribner's Sons, 1920), 181, 171, 180, 184–85.

[28] Mary J. Harper's shrewd article on some of the nineteenth-century French material comes to similar conclusions: "Confronted with the changing societies of both France and the Near East — the latter marked by the growing influence of Europe — many of these travelers seem caught between their desire to demystify the East, unveil its secrets, and uncover its difference, and a desire to *construct* this difference, and preserve the fictions which cast the Orient as Europe's imagined Other" ("Recovering the Other," 10–11).

[29] Both Loti's secret French collaborator, Marc Hélys, and Grace Ellison, the Englishwoman who later befriended one of the other "désenchantées," told similar stories about such rejected photographs. See Marc Hélys, *Le Jardin fermé*, 3; Ellison, *An Englishwoman in a Turkish Harem*, 19.

[30] Pierre Loti, *Les Désenchantées*, 93; Marc Hélys, *Le Secret des "Désenchantées,"* 64; Loti, *Les Désenchantées*, 183, 184. Though the original of Zeynab later went on to describe herself as "*désenchantée*," the emphasis of her account falls, appropriately enough, on her loss of illusion about the comparative liberty of the West. See above, ch. 4.

[31] Hélys, *Le Jardin fermé*, 3–4 (second ellipsis in original).

19. Celebrations of Domestic Virtue

[1] D[avid] Urquhart, *Spirit of the East*, 2: 381.

[2] Billie Melman, *Women's Orients*, 137–48. I am especially indebted to Melman's account of the desexualization and domestication of the Victorian harem.

[3] Richard Monckton Milnes, "The Hareem," in *Palm Leaves* (London: Edward Moxon, 1844), 16–17.

[4] Ibid., 16.

[5] Lady Augusta Hamilton, *Marriage Rites, Customs, and Ceremonies*, 11, 14.

[6] Ibid., 15, 13. As we have seen elsewhere, Hamilton does not always trouble to reconcile the contradictory accounts she has assimilated. Later she quotes without comment extended passages from the letter in which Lady Mary informs her sister, "You may easily imagine the number of faithful wives very small" (28). For the context of Lady Craven's and Lady Mary's remarks, see above, ch. 8.

[7] Ibid., 34, 9–10.

[8] [Anne Katharine] Elwood, *Narrative of a Journey Overland*, 1: 153–54.

[9] Lucy M. J. Garnett, *Home Life in Turkey* (New York: Macmillan, 1909), 280, 266. For the custom of placing slippers at the harem door as a sign that a man should not enter, see above, ch. 8, and Melman, *Women's Orients*, 121.

[10] Melman, *Women's Orients*, 139–48.

[11] Milnes, "The Hareem," *Palm Leaves*, 17.

[12] John Ruskin, "Of Queens' Gardens," *Sesame and Lilies* (1865), in *The Works of John Ruskin*, ed. E. T. Cook and Alexander Wedderburn, 39 vols. (London: George Allen, 1903–12), 18: 122. *Sesame and Lilies* was first published in 1865.

[13] Milnes, "The Hareem," *Palm Leaves*, 16; Ruskin, *Sesame and Lilies*, in *Works*, 18: 122. The best analysis of this domestic religion is still Alexander Welsh, *The City of Dickens* (Oxford: Clarendon, 1971), 141–63.

[14] Milnes, Preface to *Palm Leaves*, xvi, xvii. Despite his strenuous claims for Muslim monogamy, however, the poet in Milnes refused to abandon the dream of harem variety. Another poem in the same collection contrasts the monogamous thinker, "gifted / With one high and holy Thought," to the imaginatively promiscuous poet, whose delight in "the manifold, the various" requires him to maintain — figuratively at least — quite a crowded harem: "He must give his passions range, / He must serve no single duty, / But from Beauty pass to Beauty, / Constant to a constant change. / With all races, of all ages, / He must people his Hareem...." See "The Thinker and the Poet," in *Palm Leaves*, 79–81.

[15] [Alexander Kinglake], "The Rights of Women," *Quarterly Review* 75 (1844): 106–107. Kinglake likewise dismisses as a poetic fiction the "inviolate sanctity" of Milnes' harem — pointedly contrasting the apparent chastity of its inhabitant with Lady Mary's accounts of sexual license among upper-class Turkish women (104). While he is undoubtedly shrewd about the element of wishfulness in Milnes' representation, Kinglake's own argument treats "the Oriental system," in his words, as everywhere and at all times the same (105). And though the remainder of the essay equivocally praises the domestic advice books of Sarah Ellis for encouraging women in those "worthy thoughts" without which the Englishman's drawing-room is but "a hareem all over" (112), his ideal of a home in which "all who come near are filled and inspired by the deep sense of womanly presence" is not very different from that which Milnes imagines in the East (124). At least one other contemporary also strongly disputed Milnes' "poetical conception." See "Women in the East. By an Oriental Traveller," *Bentley's Miscellany* 27 (1850): 379.

[16] Edward William Lane, for instance, thought polygamy "more rare among the higher and middle classes than it is among the lower orders," though he was quick to add that "it is not very common among the latter" (*Modern Egyptians*, 1: 274; cf. also 1: 199, 268–69). For accounts of the Turks that accord with Milnes' generalization about Eastern polygamy, see [Julia] Pardoe, *City of the Sultan*, 1: 97; Urquhart, *Spirit of the East*, 2: 366; Charles White, *Three Years in Constantinople*, 1: 306–307; 2: 299; 3: 7; Garnett, *Home Life in Turkey*, 221–22; and Grace Ellison, *An Englishwoman in a Turkish Harem*, 119–22.

For some modern estimates, see Judith E. Tucker, *Women in Nineteenth-Century Egypt* (Cairo: The American University in Cairo Press, 1986), 53; and "Ties that Bound: Women and Family in Eighteenth- and Nineteenth-Century Nablus," in *Women in Middle Eastern History*, ed. Nikki R. Keddie and Beth Baron, 239. According to Tucker's essay, "concurrent multiple wives were not the rule," and what polygyny did exist "was usually reserved for the prosperous." In the same volume, see also Donald Quataert's "Ottoman Women, Households, and Textile Manufacturing, 1800–1914" for a low estimate of the number of polygynous households among the nineteenth-century Ottomans (162). But cf. Fanny Davis, who contends that among the "higher ranks of society" during this period "the incidence of polygamy was high" (*The Ottoman Lady*, 87).

[17] [Annie Jane] Harvey, *Turkish Harems and Circassian Homes*, 69.

[18] Urquhart, *Spirit of the East*, 2: 396, 359, 358, 359–60, 361. For a comparison of Urquhart's views with a representative French account of the harem in the writings of Napoleon, see Joan DelPlato, *From Slave Market to Paradise*, 38–63.

[19] Urquhart, *Spirit of the East*, 2: 400, 370–71.

[20] Ibid., 2: 375, 376.

[21] Ibid., 2: 387, 389–90.

[22] J[ames] C[arlile] McCoan, "Slavery and Polygamy in Turkey," 409, 407, 408, 411.

20. John Frederick Lewis and the Art of the Victorian Harem

[1] J[ames] C[arlile] McCoan, "Slavery and Polygamy in Turkey," 411.

[2] This was apparently the second performance, the first having taken place two years earlier, in 1875. Admired by Flaubert but dismissed as "une pièce obscène" by Edmond de Goncourt, Maupassant's farce was not published until 1984. See Guy de Maupassant, *À la Feuille de rose: Maison turque, suivi de la correspondance de l'auteur avec Gisèle d'Estoc et Marie Bashkirtseff et de quelques poèmes libres*, ed. Alexandre Grenier (Paris: Encre, 1984), 28.

[3] For a useful discussion of how British painters responded to the tradition of French harem imagery, see Joan DelPlato, *From Slave Market to Paradise*, 92–165.

[4] I owe my information on Henriette Browne to Reina Lewis, *Gendering Orientalism: Race, Femininity and Representation* (London: Routledge, 1996), esp. 127–90. Though I disagree with a number of Lewis's claims about European Orientalism, I am grateful to her for calling attention to Browne's harem paintings and for her detailed accounting of the context in which they were received. The disenchanted reviewer who complained of the absence of odalisques was Olivier Merson, *Exposition de 1861: La Peinture en France*; I quote from Lewis, 137. For Gautier's enthusiastic response to Browne, see his *Abécédaire du salon de 1861* (Paris: E. Dentu, 1861), 72–77. Though Lewis identifies several other female Orientalists, a few of whom painted images of the harem or of odalisques, these do not, in her view, significantly challenge prevailing codes of representation.

[5] The fullest guide to these paintings is DelPlato, *From Slave Market to Paradise*. Kenneth Bendiner also deals at some length with Lewis's harem images in *The Portrayal of the Middle East in British Painting, 1835–1860* (Ann Arbor, MI: UMI, 1978). There are especially sensitive, if briefer accounts by Briony Llewellyn, "The Islamic Inspiration: John Frederick Lewis, Painter of Islamic Egypt," in *Influences in Victorian Art and Architecture*, ed. Sarah Macready and F. H. Thompson, Occasional paper (n.s.), 7 (London: Society of Antiquaries, 1985), 121–38; and by John Sweetman, *The Oriental Obsession: Islamic Inspiration in British and American Art and Architecture 1500–1920* (Cambridge: Cambridge University Press, 1987), 131–44.

[6] *Athenaeum* 23 (1850): 210, 480; *Illustrated London News* 16 (1850): 300. Cf. DelPlato, *From Slave Market to Paradise*, 169–171.

[7] *Illustrated London News* 16 (1850): 300.

[8] Lewis's description of the painting appeared in the catalogue for the 1853 exhibition at the Royal Scottish Academy and is quoted from Bendiner, *Portrayal of the Middle East*, 190. Though Lewis's first *Hhareem* was long believed lost after its sale at Christie's in 1909, it has surfaced recently in the possession of an insurance company in Osaka. See Briony Llewellyn, "Two Interpretations of Islamic Domestic Interiors in Cairo: J. F. Lewis and Frank Dillon," in *Travellers in Egypt*, ed. Paul Starkey and Janet Starkey (London: I. B. Tauris, 1998), 151.

[9] McCoan, "Slavery and Polygamy in Turkey," 408.

[10] DelPlato divides the painting up into what she terms "vignettes" — "the slave being unveiled; the master with his wives; the women themselves; and the function of the architectural environment" — and contends that "in each of the vignettes Lewis suggests the French tradition and then mollifies its effect" (*From Slave Market to Paradise*, 171).

[11] *Athenaeum* 23 (1850): 480. Presumably the reviewer calls the kneeling figure "Roxalana" both because she appears to him "intelligent, curious and *esprègle*" and because he thinks her features "of a European cast." In his notes for the Scottish exhibition, Lewis himself called her a "Greek" (Bendiner, *The Portrayal of the Middle East*, 191).

[12] *Athenaeum* 23 (1850): 480.

[13] DelPlato, *From Slave Market to Paradise*, 191.

[14] Rosemary Treble, *Great Victorian Pictures: Their Paths to Fame* (London: Arts Council of Great Britain, 1978), 52.

[15] According to Michael Lewis, this "unbroken sojourn for a decade in Egypt is unique among English artists of the nineteenth century." See *John Frederick Lewis R. A., 1805–76* (Leigh-on-Sea, England: F. Lewis, Publishers, Ltd., 1978), 22.

[16] William Makepeace Thackeray, *Notes of a Journey from Cornhill to Grand Cairo*, in *Works*, 5: 725, 727.

[17] Ibid., 5: 729; [Richard Green and Michael Lewis], *John Frederick Lewis, R. A. (1805–1876): Painter of the Desert and Harem* (Guildford, Surrey: Guildford House Gallery, 1977), 10. Michael Lewis counts almost 600 works from this period (*John Frederick Lewis*, 24).

[18] Thackeray, *Journey from Cornhill to Grand Cairo*, in *Works*, 5: 726, 727.

[19] Lewis, *John Frederick Lewis*, 40; Llewellyn, "Islamic Inspiration," 133; Sweetman, *Oriental Obsession*, 132.

[20] Thackeray, *Journey from Cornhill to Grand Cairo*, in *Works*, 5: 726, 729. For the relevance of Lane's account, see Llewellyn, "Islamic Inspiration," 130–31. Nerval's testimony is, of course, rather more suspect, since the evidence suggests that his own adventures with a slavewoman may be at least partly fictional. Given his indebtedness to Lane's work elsewhere in his *Voyages*, it is also possible that his account of the pressures exerted on an unmarried man in Egypt owes more to his English predecessor than to his own experience.

[21] Llewellyn, "Islamic Inspiration," 132. That the black-bearded master may represent "an ideal projection of Lewis himself," as Llewellyn has also suggested, only intensifies the fantasy.

[22] Edward Lear to J. F. Lewis, 22 June 1875, as quoted by [Green and Lewis], *John Frederick Lewis*, 15.

[23] Llewellyn, "Islamic Inspiration," 133.

[24] John Ruskin, "Notes on Some of the Principal Pictures Exhibited in the Rooms of the Royal Academy…" (1857), in *Works*, 14: 130.

[25] Bendiner, *Portrayal of the Middle East*, 191.

[26] Both Lewis, *John Frederick Lewis*, 22, and Sweetman, *Oriental Obsession*, 143, make

passing allusion to Marian's frequent role as Lewis's model, though they single out different paintings to exemplify this fact: Lewis sees her in the principal figure of the Cairo harem (39); Sweetman in a late painting, *The Siesta.*

[27] That so many of Lewis's women resemble one another may in part be attributed to his relative lack of interest — or skill — as a painter of faces. Ruskin, who pronounced the faces in the first *Hhareem* "the worst painted portions of the whole" (*Times* of May 30, 1851, in *Works,* 12: 326), twice reverted to the theme in his commentary on later paintings ("Notes on Some of the Principal Pictures" for 1855 and 1857, in *Works,* 14:13 and 132–33); and he was not the only contemporary to register Lewis's weakness in this respect. See the remarks on *Hareem Life, Constantinople* in the *Athenaeum* 30 (1857): 571, and the *Spectator* 30 (1857): 463.

[28] Lewis, *John Frederick Lewis,* 40.

[29] Apart from the first *Hhareem,* the most significant exception is *An Intercepted Correspondence* of 1869, a variation on the former picture that replaces the unveiling of the slave with the exhibition of a woman whose floral token or "correspondence" is being presented to the bey as evidence of an illicit affair. While the relative simplicity of her dress suggests that the guilty woman is a servant or slave rather than a wife, the group to the left closely resembles the original trio. Though Joan DelPlato terms both these paintings "melodramatic" to distinguish them from "aestheticized" harems like *Hareem Life, Constantinople* or *Indoor Gossip,* the mood of *An Intercepted Correspondence* is notably sunny. Indeed, several of the onlookers seem to share the amusement of the laughing slavewoman, who also makes another appearance. As Kenneth Bendiner remarks of this painting, "Lewis depicted polygamy as he did slavery — in a lighthearted and amoral fashion that nevertheless respected British propriety." See DelPlato, *From Slave Market to Paradise,* 166–311, and Bendiner, *Portrayal of the Middle East,* 200.

[30] DelPlato, *From Slave Market to Paradise,* 239–40; see also 245–46.

[31] Ibid., 240. DelPlato contends that "by placing a black woman in the role of menial" in the Cairo harem, "Lewis by default makes the white woman another wife," though she acknowledges the ambiguity introduced by the latter's role as coffee-bearer (*From Slave Market to Paradise,* 245). But apart from the fact that it is by no means clear whether the black is a woman or a eunuch, the presence of the third figure does not automatically elevate the status of the second: the Victorians surely knew that there were white slaves in the harem as well.

[32] According to his great grand-nephew, Lewis "had closely studied the Dutch and Flemish Masters." See Lewis, *John Frederick Lewis,* 36.

[33] Julie Lawson, "The Painter's Vision," in *Visions of the Ottoman Empire* (Edinburgh: Scottish National Portrait Gallery, 1994), 31.

[34] *Athenaeum* 23 (1850): 480; Ruskin, "Notes on Some of the Principal Pictures" (1857), in *Works,* 14: 94, 132; Sweetman, *The Oriental Obsession,* 132; Lawson, "The Painter's Vision," 31. On Lewis's use of Dutch and Flemish prototypes, including Vermeer, see also DelPlato, *From Slave Market to Paradise,* 234–38, esp 238 n28.

[35] Svetlana Alpers, *The Art of Describing: Dutch Art in the Seventeenth Century* (Chicago: University of Chicago Press, 1983).

[36] *Spectator* 30 (1857): 463.

[37] [Green and Lewis], *John Frederick Lewis,* 7; Lewis, *John Frederick Lewis,* 38; Bendiner, *Portrayal of the Middle East,* 71–73.

[38] Cf. Bendiner, *The Portrayal of the Middle East*, 196.

[39] Only the truncated version of the first *Hhareem*, perhaps, and the titular implications of *Caged Doves* might be cited as partial exceptions in this regard.

In a personal communication, Emily M. Weeks has argued that the painting now known as *The Reception* further opens up Lewis's harem, insofar as some nineteenth-century viewers (and certainly Lewis himself) would have recognized that the painter had permitted his women to wander into the men's quarters of the house. (When *The Reception* was originally exhibited in 1873, it was identified as "a lady receiving visitors" in a "mandarah" — a term whose definition had been available to interested Victorians at least since Edward Lane's *Modern Egyptians* nearly forty years earlier.) Weeks has also noted that the great airiness of this particular painting owes something to the fact that the lattices of a *mandarah* or *mandara* are not designed to screen its inhabitants from view. She will elaborate these arguments in her forthcoming dissertation, tentatively entitled, "The 'Egyptian Years' of John Frederick Lewis (1805–1876): An Orientalist Painter Reconsidered."

[40] See Ruskin, "Notes on Some of the Principal Pictures" (1858), in *Works*, 14: 159, 180, and the identification in Lewis, *John Frederick Lewis*, 93.

[41] Théophile Gautier, *Les Beaux-Arts en Europe*, première série (Paris: Michel Lévy Frères, 1855), 100.

[42] Bendiner, *The Portrayal of the Middle East*, 209–10; Sweetman, *The Oriental Obsession*, 135–43.

[43] See especially Sweetman's chapter, "After 1850: The Design Reformers," in *The Oriental Obsession*, 160–210.

[44] Ibid., 187–88. That Lewis's Middle Eastern interiors included such "foreign" objects as Chinese vases and figurines, Japanese bowls or European mirrors would have further blurred the distinction between harem and home for Victorian viewers. Though Bendiner argues that such objects (presumably owned by Lewis himself) make the pictures "seem more like art collections than ethnographic documents" (*The Portrayal of the Middle East*, 206), and that the cultural "hodge-podge" they reflect conforms to Victorian preconceptions about the Near East ("Albert Moore and John Frederick Lewis" *Arts Magazine* 54 [Feb. 1980]: 78), the evidence suggests that they would not have been out of place in a comfortable Ottoman household of the period. In *Three Centuries: Family Chronicles of Turkey and Egypt* (London: Oxford University Press, 1963), Emine Foat Tugay recalls her grandfather's country house near Istanbul, "furnished in the solid style of the mid-nineteenth century" with "silver plate, which came from England . . . and a number of exquisite Chinese bronzes" (31). On the diffusion of Western goods (including mirrors) among eighteenth- and nineteenth-century Ottomans, see Fatma Müge Göçek, *Rise of the Bourgeoisie*, 40; 98–107.

[45] Cf. DelPlato, who rather implausibly associates the title with an anecdote of Lady Mary's about a Spanish woman and a Turk (*From Slave Market to Paradise*, 313–14).

21. The Pastness of the Orient

[1] By presuming that nineteenth- and twentieth-century memoirs of life in the imperial harem hold true for earlier periods, even modern historians of the Ottomans perpetuate this tendency. See Leslie P. Pierce, *The Imperial Harem*, 118.

[2] Montesquieu, *L'Esprit des loix*, 14.4. As Reinhold Schiffer remarks of this passage, "Indolence, more than any other trait of character, was made to serve as the true cause of the timelessness and immutability of the East: the assertion is one of the most durable,

frequent, and ideologically loaded *topoi* of Oriental description." See *Turkey Romanticized*, 27. Andrew Wheatcroft, however, contends that "the quality of timelessness which Western commentators attributed to the Ottomans . . . was exaggerated, but it came close to the truth. When Ottomans began to travel to the West, as they did in the eighteenth and nineteenth centuries, they were shocked by the sense of change and mutability that seemed to dominate every aspect of life" (*The Ottomans*, 70–71).

³ [Maturin Ballou] Murray, *The Turkish Slave*, 47–48, 14, 82. Cf. Linda Nochlin, "The Imaginary Orient," 35–36, on how "time stands still" in Orientalist paintings by Gérôme and others.

⁴ Murray, *The Turkish Slave*, 37.

⁵ Johannes Fabian, *Time and the Other: How Anthropology Makes Its Object* (New York: Columbia University Press, 1983). See also James Clifford, "On Ethnographic Allegory," in *Writing Culture: The Poetics and Politics of Ethnography*, ed. James Clifford and George E. Marcus (Berkeley: University of California Press, 1986), 101–102. By pointing out that Muslim visitors to Europe often sought out Muslim inscriptions, remains, and other survivals of their former presence in the area, Bernard Lewis suggests that such time-travel was not altogether one-way, however. See *The Muslim Discovery of Europe*, 181.

⁶ To the Countesse of —, [May 1718]; To the Abbé Conti, 31 July [1718]; To Alexander Pope, 1 April [1717], in *Letters of Lady Mary Wortley Montagu*, 1: 406, 420, 332, 333.

⁷ To Sir Alexander Duff Gordon, January 25, 1869, in Lucie Duff Gordon, *Letters from Egypt*, 380.

⁸ To Lady Mar, 18 April [1717], *Letters of Lady Mary Wortley Montagu*, 1: 351; To Mrs. Austin, April 29, 1865, in Duff Gordon, *Letters from Egypt*, 238.

⁹ Billie Melman, *Women's Orients*, 60.

¹⁰ Boswell's journals, 28 November 1776, and 10 November 1776, in *Boswell in Extremes*, 61, 53; 14 December 1764, in *Boswell on the Grand Tour*, 254; 18 March 1775, in *Boswell: The Ominous Years*, 81.

¹¹ Edward William Lane, *The Modern Egyptians*, 1: 139. Lane might urge tolerance, but Harriet Martineau would have none of it. Despite her admiration for her distinguished predecessor, her own account of nineteenth-century Egypt would impatiently dismiss any attempt to defend the harem by appealing to history: "It is not a phase of natural early manners" (*Eastern Life*, 264).

¹² Jean Racine, *Théâtre complet*, 355.

¹³ Edward Said makes of this tendency a general law: "One always *returned* to the Orient . . . seeing it as completion and confirmation of everything one had imagined" (*Orientalism*, 167).

¹⁴ Gérard de Nerval, *Voyage en Orient*, in *Oeuvres complètes*, 2: 471. Flaubert's letter to his mother, dated from Cairo, 5 January 1850, appears in *Les Lettres d'Égypte*, ed. Antoine Youssef Naaman (Paris: A. G. Nizet, 1965), 169.

¹⁵ To Dr. Jules Cloquet, Cairo, 15 January 1850, *Lettres d'Égypte*, 173.

¹⁶ Gustave Flaubert, "Rage et impuissance," in *Oeuvres de jeunesse inédites, 183.. -1838: Appendice aux oeuvres complètes* (Paris: Louis Conard, 1910), 154.

¹⁷ Gustave Flaubert, Notebook entry of 6 March 1850, *Voyage en Égypte*, Édition intégrale

du manuscript originale établie et présentée par Pierre-Marc Biasi (Paris: Bernard Grasset, 1991), 283; To Dr. Jules Cloquet, 15 January 1850, *Lettres d'Égypte*, 174.

[18] Gustave Flaubert, *L'Éducation sentimentale: Histoire d'un jeune homme*, in *Oeuvres*, ed. A. Thibaudet and R. Dumesnil, Bibliothèque de la Pléiade, 2 vols. (Paris: Éditions Gallimard, 1952), 2: 85. It is just possible that Flaubert was partly relying upon his own experience here. A letter to his friend Louis Bouilhet, written from Cairo on 1 December 1849, describes a dinner given by a local official for himself and his traveling companion, Maxime du Camp, in which there were "ten negroes to serve us" and at which they were seated on divans, with the windows open on the water (*Lettres d'Égypte*, 133–34). But if there is a sense in which the novelist was conjuring with a real memory, he deliberately withheld any such experience from his character: the purely fantastic nature of Frédéric's loss remains the same.

[19] Flaubert, *L'Éducation sentimentale*, in *Oeuvres*, 2: 38, 100, 191, 290, 455, 457, 456.

[20] On the contemporary response to the ending, see Robert Baldick's introduction to his Penguin translation of the novel, *Sentimental Education* (1964; rpt. Harmondsworth, 1982), 12.

[21] Flaubert, *L'Éducation sentimentale*, in *Oeuvres*, 2: 456. For a related reading of the novel's Oriental motifs as an implicit critique of Flaubert's own Orientalist sentimentalism, see Lisa Lowe, *Critical Terrains*, 95–101.

[22] Marc Hélys, *Le Secret des "Désenchantées,"* 262. "Je suis déjà une chose du passé," she wrote in the guise of the dying "Leyla," as the supposed poison took effect; and her line was predictably incorporated word-for-word into the novel. Cf. Pierre Loti, *Les Désenchantées*, 432.

[23] Pierre Loti, *Aziyadé*, 108, 46.

[24] See, e.g., Claude Martin, Préface, *Aziyadé*, 28; and Chris Bongie, *Exotic Memories: Literature, Colonialism, and the Fin de Siècle* (Stanford: Stanford University Press, 1991), 85.

[25] Loti, *Aziyadé*, 153.

[26] "'Au revoir,'" as Alain Buisine has aptly written of the novelist: "telle est sa devise" (*Tombeau de Loti*, 252). Buisine's entire book is a brilliant if somewhat repetitive account of such mortuary effects in the novelist.

[27] Loti, *Aziyadé suivi de Fantôme d'Orient*, 249, 255. Though a limited edition of *Fantôme d'Orient* first appeared in 1891, the complete text was not generally available until 1892.

[28] Pierre Loti and Samuel Viaud, *Suprêmes Visions d'Orient*, 118–19. An earlier passage constitutes a veritable *ubi sunt* for his disenchanted ones: "Hélas! où sont-elles aujourd'hui, ces 'désenchantées' qui avaient été le charme de ma vie d'alors… Où sont-elles?… Dispersées, évadées ou mortes!" (39; second ellipsis in original).

[29] Pierre-E. Briquet, *Pierre Loti et L'Orient*, 570. On Loti's need to believe in the hoax, see also Briquet, 290–91; and Buisine, *Tombeau de Loti*, 221 n.20.

[30] Henry James, "Pierre Loti" (1898), rpt. in *Henry James: Literary Criticism: French Writers…*, 520.

[31] Henry James, *The American*, ed. William Spengemann (Harmondsworth: Penguin, 1981), 79, 119. *The American* originally ran as a serial in the *Atlantic Monthly* from 1875 to 1876; Spengemann bases his text on the first English edition of 1879.

[32] Henry James, Preface to *The Spoils of Poynton*, (1908; rpt. Fairfield, N J: Augustus M. Kelley, 1976), x–xi.

[33] Ibid., xi.

22. The Lesson of the *Bain Turc*

[1] Lady Augusta Hamilton, *Marriage Rites*, 267. The same passage attributes "eight thousand wives and concubines" to one Moroccan emperor.

[2] Walter C. James, "Woman in Turkey," *Contemporary Review* 34 (1879): 110.

[3] Robert Bage, *Hermsprong; or, Man as He is Not*, ed. Stuart Tave (1796; rpt. University Park, PA: Pennsylvania State University Press, 1982), 150, 152.

[4] Robert Bage, *The Fair Syrian*, 2:78–79.

[5] [Anon.], *The Lustful Turk*, 158, 159.

[6] Gérard de Nerval, *Voyage en Orient,* in *Oeuvres complètes*, 2:369.

[7] [Jean] Sieur du Mont, *A New Voyage to the Levant*, 267.

[8] Though Edward Lane was among the nineteenth-century commentators who insisted on the prevalence of monogamy, "especially among the middle ranks," even he conceded that "there are few of middle age who have not had several different wives at different periods, tempted to change by the facility of divorce." Lane went on to cite "on most respectable authority" the case of one legendary figure, said to have married more than nine hundred women by the time he died at the age of eighty-five. See Edward William Lane, *Arabian Society in the Middle Ages: Studies from the "Thousand and One Nights,"* ed. Stanley Lane-Poole (1883; rpt. London: Curzon Press, 1987), 223–24.

[9] See, e. g., [Michel Baudier], *The History of the Imperiall Estate of the Grand Seigneurs... Translated out of French by E. G. S. A.* [Edward Grimeston Serjant at Armes] (London: William Stansby, 1635), 67–69; or Robert Withers, *A Description of the Grand Signor's Seraglio*, 51–56, 156–59. Baudier's French text originally appeared in 1624. On the Old Palace, see Leslie P. Pierce, *The Imperial Harem*, 119–25, and Gülru Necipoğlu, *Architecture, Ceremonial, and Power*, esp. 175.

[10] [Delarivier Manley], *Almyna*, 1.2. For a fuller discussion of this aspect of the play, among others, see above, ch. 17.

[11] Frances Sheridan, *The History of Nourjahad*, in *Oriental Tales*, ed. Robert L. Mack (Oxford: Oxford University Press, 1992), 117, 119, 121, 127. Mack's text slightly modernizes that of the first edition, published by Dodsley in 1767.

[12] Ibid., 131, 141–42.

[13] Ibid., 149–51, 155, 159, 163.

[14] Ibid., 190, 181, 194, 161, 194. Though Sheridan does not explicitly condemn the institution of the harem, it should be clear that I disagree with Felicity A. Nussbaum's contention that Nourjahad's "sexual virtue is not under contest and his maintaining a seraglio is never questioned" (*Torrid Zones*, 133). For an account of Sheridan's handling of time that addresses its feminist implications from a somewhat different angle than my own, see Margaret Anne Doody, "Frances Sheridan and Annihilated Time," in *Fetter'd or Free: British Women Novelists 1670–1815*, ed. Mary Anne Schofield and Cecilia Macheski (Athens, OH: Ohio University Press, 1986), 324–58.

[15] For the problem of numbers in Ingres's painting, see above, ch. 3, n33.

[16] From a letter to the Varnhagens von Ense (10 December 1840), quoted in Hans Naef, "*Odalisque à l'esclave* by J. A. D. Ingres," *Fogg Art Museum Acquisitions 1968* (Cambridge MA: Harvard University Press, 1969), 93.

[17] Charles Baudelaire, "Exposition universelle (1855)," in *Oeuvres complètes*, 2: 585. Robert gives the first use of the word "extranéité" as 1870 and then only in the sense of the juridical situation of a stranger in a given country.

[18] Norman Bryson, *Tradition and Desire*, 144.

[19] Ibid., 147.

[20] To Lady —, 1 April [1717], *Letters of Lady Mary Wortley Montagu*, 1: 315. For Ingres's transcriptions of Lady Mary, see above, ch. 3, n31–n32.

[21] On the probable dating of the notebook entries, see Hélène Toussaint, *Le Bain turc*, 13, 50–51.

[22] In fact, he seems to have continued work on it for still another year: a letter of 1863 to his niece announces that he has just that moment concluded "mon tableau des femmes turques!" (Toussaint, *Le Bain turc*, 42).

[23] The French of Ingres's notebook reads: "Il n'y va pas moins de la mort pour tout homme que l'on trouverait dans un bain de femmes" (Toussaint, *Le Bain turc*, 13). Though Richard Wollheim also singles out this "chilling sentence" in connection with the painting, his claim that the *Bain turc* adheres to its proscription by showing the women "released, even if only temporarily or fictitiously, from the overbearing exigences of men," takes no account of the implicit voyeurism of the painter himself; while his further argument that "Ingres devised a striking correlate to the freedom that these women enjoyed from male sexuality in the holiday ... that he gave their bodies from the constraints of female anatomy" strikes me as merely the whimsical metaphor of the critic. See Richard Wollheim, *Painting as an Art* (Princeton: Princeton University Press, 1987), 260–61. For a different account of the *Bain turc*'s relation to death, which reads the painting in light of Freud's *Beyond the Pleasure Principle*, see Bryson, *Tradition and Desire*, 156–57.

[24] Bryson, *Tradition and Desire*, 24–25.

[25] First identified by Hans Naef, "Monsieur Ingres et ses muses," *L'Oeil*, January 1957: 48–51, these sources are also reproduced and discussed in Toussaint, *Le Bain turc*, 11–31. For an illuminating study of the painter's lifelong practice of copying and repetition, see Marjorie B. Cohn's introduction to Patricia Condon et al., *The Pursuit of Perfection*, 9–33. On the *Bain turc* in particular, cf. also Aileen Ribeiro, *Ingres in Fashion: Representations of Dress and Appearance in Ingres's Images of Women* (New Haven: Yale University Press, 1999), 226-228.

[26] Recorded in Henri Delaborde, *Ingres*, 140.

[27] Toussaint, *Le Bain turc*, 23–24, 25–26. By juxtaposing an early (1815–18?) portrait of Ingres's first wife with a study from approximately the same period of the nude figure that would eventually finds its way into the *Bain turc* (fig. 52), Toussaint and her colleagues confirm the identification of Madeleine originally made by Henri Lapauze, *Ingres: Sa vie & son oeuvre* (Paris: Georges Petit, 1911), 515. Yet the face of the woman in the *Bain turc* also strongly resembles that of Ingres's second wife, Delphine Ramel, at least as she is represented in a portrait executed by him in 1856; and presumably this is why Robert Rosenblum identifies the figure in the painting with Delphine (*Jean-Auguste-Dominique Ingres* [New York: Abrams, 1967], 172). Though the same "pudeur conjugale" that Toussaint

speculates prevented Ingres from incorporating the nude study of Madeleine into any of his paintings when she was alive (*Le Bain turc*, 24) makes it unlikely that he deliberately intended the identification of the *Bain turc* figure with his then living wife, Delphine, the features of this woman seem remarkably overdetermined. Both the uncanny resemblance of the second wife to the first and the purported resemblance of the first to her cousin would suggest that, in love as in art, Ingres was driven by a certain compulsion to repeat.

[28] Jean Cocteau, *La Difficulté d'être* (Paris: Éditions Paul Morihien, 1947), 107. The other goal of these pilgrimages to the Louvre was Mantegna's *Saint Sébastian.*

[29] Kenneth Clark, *The Romantic Rebellion: Romantic versus Classic Art* (New York: Harper and Row, 1973), 142.

[30] For a brief comparison of Sleigh's *Turkish Bath* with its predecessor, see G. M. Pincuss et al., *Explorations in the Arts: An Introduction to the Humanities* (New York: Holt, Rinehart, 1985), 347–49. For other parodies, see Toussaint, *Le Bain turc*, 46–49. I wish to thank Sylvia Sleigh for permitting me to reproduce her painting and Marlies K. Danzinger for originally alerting me to its existence.

Index